GIGS from HELL

Art: Richard J Smith

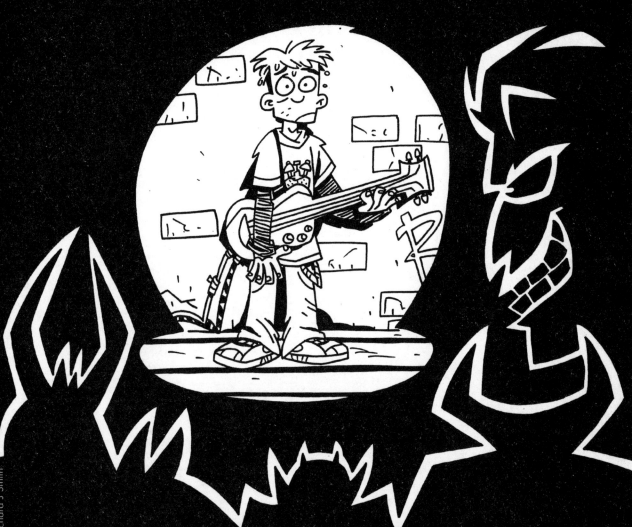

Gigs From Hell

True tales of rock and roll gone wrong

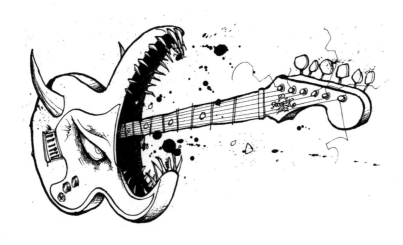

Edited by Sleazegrinder

Critical Vision
An imprint of Headpress

www.headpress.com

A CRITICAL VISION BOOK
Published in 2003
by Headpress

Headpress/Critical Vision
PO Box 26
Manchester
M26 1PQ
Great Britain

[tel] +44 (0)161 796 1935
[fax] +44 (0)161 796 9703
[email] info.headpress@zen.co.uk
[web] www.headpress.com

GIGS FROM HELL

Cover art © Wayne Musson
Frontispiece © Richard J Smith
Guitar from hell © Dogger
Back cover photo: The Brimstones' bloody organ

BRITISH LIBRARY CATALOGUING IN
PUBLICATION DATA
A catalogue record for this book is available from
the British Library

ISBN 1-900486-34-2

*The publisher would like to thank Joeseph Coughlin, who
came up with the title and set the wheels in motion.*

Contents

Foreword by Vadge Moore

Sex, drugs, rock'n'roll; three great tastes that taste great together. Having played drums in the Dwarves for eleven years I've had the chance to taste all three excessively. Cunt culinary school, drug addled deviancy and constant musical mayhem. I've seen and done things that most people don't want to dream about, let alone think about. When I was asked to write the forward to this book I put my mind into rewind: people, pussies, chemicals, smells, tastes, fights, alleyways, bathrooms, hospitals, police stations, angry parents, angry boyfriends, angry girlfriends. You name it, I've been through it all, I've done it all, and I've done 'em all. Not all bands have sampled the heaven and hell of the road like I have. But, any musician that has taken even a short trip out of town has experienced at least a dose (pun intended) of what it's like to be a touring band.

To be a real band, a band that puts out recordings, tours every year and has fans or at least enemies, the road becomes a beautiful and scary animal. I emphasize the word animal 'cause, from my experience, that's what touring turns you into: an animal, an angry, ravenous beast. On the road one is reduced to the most primal elements of human nature. After even a few weeks on the road an atavistic resurgence occurs that can only be compared to the Jekyll & Hyde syndrome. If you're doing it right you become a beast. A beast that only cares about two things: sex and violence.

The sex part is obvious: girls like bad boys. Girls like guys who are onstage. Girls like guys who are horny and moving on to another city, county or state the very next morning. The violence part comes from an even more primitive place: tribalism. When you are on the road your band is your tribe. You are bound together like some kind of nomadic group that cares only for the survival of its members. You are traveling to new towns, new states, new countries and you must protect one another. You're all alone out there with only your band mates and road crew to cover your back. Violence inevitably happens. I became more in touch with these two most primal instincts after two months on the road with the Dwarves then I ever could after a year at Survival Camp.

The stories in this book draw a picture of exactly what the road is like. It takes a special kind of person to live this life. It takes an interesting crossbreed of Nietzschean Superman and degenerate Decadent. Frankly, I wouldn't want to live any other kind of life. We only go 'round once so we might as well go all the way! Touring musicians are like sick anti-heroes and this collection of stories form an infernal bible for those who don't have the guts to live like we do. It is our duty as rock musicians to live up to this archetype. We are the degenerate superheroes who are obligated to take the drugs, drink the booze, and screw the whores, so that you don't have to.

These stories may repulse you or they may inspire you. Regardless, never forget that no matter where you are there is a band that is drunk, high, hungry and looking for your wife, your girlfriend or your daughter.

7

Introduction

"Damnation is a holy transformation"
—Brothers of Conquest

I was about fifteen or sixteen years old, standing in the middle of the Cambridge YWCA, watching it get systematically torn to pieces by a couple hundred berserk punk rockers, when I had my first muzzle to muzzle brush with the messy glory of rock and roll decadence, my first of many glimpses of the tragi-comic thrills of a gig From hell. This was before the local authorities and community planners were clued in to the rather obvious alchemy inherent in all ages shows: PUNK ROCK + UNDERAGE KIDS = RAMPANT DRUNKEN VANDALISM. As a row of wall-length mirrors in the dance studio cum concert hall were ripped from their foundation, shattering like razor sharp dominoes, it was certain that they'd learn this simple equation many times over this night. But not before a lethal dose of *The Rock* boiled the joint into a hormone-fried inferno of screaming and flailing.

Boston's own kings of lousy American beer Gang Green were on stage, strutting their boozy stuff in celebration of the release of their latest puke colored single, an ode to mayhem called Skate To Hell. Their signature triple speed AC/DC rip-off riffola bounced off the walls like sweaty threats, and the kids responded with punches and kicks and the dance of the crazies, enthralled in fits of fervent worship. I'm not sure if he knocked himself out with the microphone, or the pre-gig debauchery just finally caught up with him, but at one point, Gang Green's singer Chris Doherty dropped dead right there on the stage — or at least it looked that way. Fittingly, he was singing a song called Alcohol at the time. He keeled over and landed face-first on the stage floor. The band cranked through a few more lurching power chords, figuring he'd just shake it off and get back up, but he didn't. They all stopped and stared at the puddle of beer, blood, and puke pouring out of their frontman's mouth. We all did. What else was there to do?

After a few minutes of this, my friends and I left the makeshift club. Walking out into the Road Warrior-esque landscape that the parking lot had become. Mohawks, used leather, skinhead scuffles, speed metal boots, a gnawing vampire hunger on everyone's faces. We trawled the area for teenage kicks, ran into a couple Indian chicks we knew from an upper class high school two towns away. They had somehow managed to score a bottle of Peach Schnapps. We all got real drunk, real fast. The one with the big tits passed out, so we propped her up in a chair in the hallway, and went back in. It was a good fifteen minutes later, at this point. As we all gawked at the car accident on stage, Mr Doherty miraculously snapped out of his coma, dragged himself up on shaky knees, and finished the goddamn song. Just like nothing even happened. In that moment, I was absolutely certain that I had finally found my tribe.

Back in the fifties, this feral new beast known as American rock and roll was introduced to the rest of the world through violent, sleazy juvenile delinquent movies. When early rockers like Eddie Cochran and Gene Vincent first toured Europe, the fans rioted, tearing the clubs — and very nearly the performers — to pieces. Later on, somebody sat them all down and explained the rules to them. Those were just movies, they told them. These cats aren't *really* about hot rods to hell and switchblade justice. But you know what? Those crazy ass Europeans had it right the first time. Rock'n'roll is a loser's game, the last refuge for wayward fuck-ups, petty criminals, and obsessive freaks, and it's about time we stopped pretending otherwise.

A few years back, I was interviewing some band — *who knows which one?* They were probably from Seattle or Gothenburg, somewhere rock and roll like that. I was giving stock questions and getting stock answers about things like studios, touring plans, and record labels.

Thoughts on both ends were buzzing more about deadlines and record sales than they were about flesh and fire. When rock and roll becomes work, then something's got to give. Suddenly, I flashed back, before Gang Green even, to when I was ten-years-old, staying up late to watch the ill-fated gonzo sketch comedy series *Fridays*. This one particular night, the musical guest was the Plasmatics. Over the gnashing din of buzzsaw riffs and raspy shemale grunts, the queasy lust missile that was Wendy O, all tits and mohawk and snarls, chainsawed a fucking Fender in half. Then she blew up a car. It was amazing. Everything I'd ever been told about how to function in a civilized society was obviously terribly wrong. Turns out that as long as you've got a 4/4 beat behind you, you can pretty much do whatever the hell you want.

Snapping back to the present, I realized just what the fuck it is that I was doing here, and I finally got down to the brass tacks. Cutting the rock star off in mid sentence, I took an entirely different route of questioning. "Forget all that," I said. "What I really want to

know is: Have you fought your way out of a gig?" He hadn't, but I pressed on. "Ever punch a cop? Fuck an underage groupie? Vomit right into your own drum kit?" This became my standard line of questioning. Sometimes the bands had answers, sometimes they didn't, but it sure did feel like rock and roll again to ask.

Because it's always been this way, this rock and roll business. Rock is the only true anarchy, a roving, mobile circus of horrors with an intensity level that's dictated by the whims of madmen and deranged drunks. From Axl Rose riling up thousands of red-eyed punters into a howling, sexual frenzy and then abandoning them without explanation, leaving his legions with no option but to destroy the stadium out of frustration; all the way down to just about any seedy local dive, where some tiny antichrist in a leather jacket from across town decides then and there that he's the new King of Rock and Fucking Roll, and is blessed with a flurry of flying beer cans for his efforts. Nasty Ronnie, the gutter-charismatic frontman for Floridian thrash metallers Nasty Savage, nailed it back in the mid eighties when he named his column in sorely missed sleaze metal fanzine *Sledgehammer Press*, "The Wage of Mayhem". It wasn't so much about the actual gig to him — they showed up, they played, if they were lucky they got paid — it was what happened afterwards that defined his version of winning and losing. His band and a jive cotillion of their fans would crash some suburban party like invading hordes of Vikings and claim their bloody victory for rock and roll. "Pool balls were flying through microwave oven windows," he would report. "Sofas were dragged outside and thrown into the pool. People were fucking on the floor, in the bushes, everywhere…"

This, then, is the true story of rock and roll, for once, presented without useless editorializing, hidden agendas, or a hint of regret. The bands included in *Gigs From Hell* are the ragged survivors of a self-imposed war on everybody, fueled by an ephemeral, ill-advised belief that R&R is more than just cheap noise created to engorge the loins of teenagers. For them, it's a profane religion, an improbable mission, an unquenchable thirst, the very stuff of life.

Since I started this book, at least one of the storytellers here has died from his own wretched excess. By the time you read this, a good portion of these bands will have already imploded for exactly the reasons that they've written about. Hearts will be broken, eyes will be blackened, contracts will be shredded, and dreams will be shattered. But that's all part of the game,

and everyone here is cheating like mad.

So what is it that drives these rockers to such absurd heights of criminal intent and narcotic bliss; such depths of low budget addictions and anti-social behavior? It can't be for the lure of fame and fortune, because there's scant evidence of that in these pages. After all, if it was all free cocaine and nubile groupies and money to burn, they wouldn't be gigs from hell at all, would they? No, the prime motivation here is, quite simply, the call of the wild. It's about channeling the werewolf within, dressing him up in spikes and leather, and letting him loose in front of a few hundred bewildered onlookers, who'd all be just as much of a preening jackass, if only they had the guts. The meek of heart among us may cringe and squeal "career suicide" when they read some of these stories, but for the fearless warriors who have penned these terrible true tales, it's merely the crystallization of a real cool time, and even after the fall, when the days of pillaging and plundering are through, they can all look back with a self-satisfied smirk and say, "Well, at least I was an asshole on the way."

You may notice a similar musical thread in the bands in the contributors of this book. This is absolutely by design. When I started this project, I decided I only wanted to include bands that I actually liked, listened to, or would write about. Which means there are plenty of bands that fall under convenient genre tags like Sleaze Metal, Glam Punk, Stoner rock, Cowpunk, Trash rock, and the ever popular plain old "rawk". Who better, after all, to spill their guts about the underbelly of rock and roll, than genuine rock and rollers? It may well have been more profitable or commercially viable to ask some of these new fangled nu-metal, pussy emo, or pre-fab pop punk bands that rule the day what it's like out there, but I seriously doubt they even know. If those kinds of bands have any fun at all, I'm sure it's not the kind of unhinged Bad Fun we like anyway. So fuck them.

Down here with the plastic booze bottles and guitar string tattoos, they might not have the greatest of musical chops, but one thing's for sure about all these bands — they *mean* it, man. I salute them. And so should you. After all, they are fearlessly carrying on a noble tradition of sin, savagery, and rampant volume in the face of insurmountable odds. They are truly the last of the rock and roll motherfuckers.

So welcome, brothers and sisters, sinners and saints, to a few hundred nights when it all went wrong, when bad luck and cosmic mayhem wrote the rules, and the devil ran the soundboard.

Sleazegrinder

Dedicated to Cranford Nix (1969–2002),
who lived every word of it.

Part 1

WEIRD FINNISH
LOVE BITES

On the Road to Ruin

We lost our dog on the road. At least Montana's a good place to get lost, if you're a dog Curtis Armstrong, Bad Wizard

Pizzaman

We got a gig in the back of a pizzeria in Memphis, because there was nowhere else to play. So there we were, in the back of this pizzeria, trying to rock without disturbing the welfare mother and her kid, who were eating pizza right in front of us. A very ill tempered middle-aged woman owned the place and seemed to hate the bands. I dunno why we were there. She was mad as hell the whole time. They had a gigantic Pepperoni Pizzaman costume hanging up on the wall in the back by the "stage." The costume was worn by an employee walking up and down the main street of town to advertise the place. We had

She made us
pay for our
pizza.
THE PEASANTS

been on the road awhile and thought, hey, wouldn't it be funny to play the set dressed in the Pizzaman suit? I put the suit on. It blended in really well with my cherry red Sunburst Les Paul. We started playing and the band couldn't stop laughing. The owner woman came back and started yelling at me. She made us pay for our pizza and I don't think we got paid anything. Billy O'Malley, our bassist at the time, hooked up with the welfare mother who was sitting right in front of us. Her kid was running all over the place, obviously needing a father figure in his life to rein him in. We went home with her. The drummer, Steve, and I crashed in the living room. Billy was in the bedroom with Welfare Mom. The strange thing is, her little boy was right there in the bed with them while Billy and mom were getting it on. Billy told mom it was gonna be weird him fucking her in

front of her son so she *put the kid in the bedroom closet.* They took care of business. I think they let the kid out of the closet after the fuckfest. They do things a little different down south.

Pete Cassini, The Peasants (Boston)

World's Darkest Asshole

It was our last date after a whole week tour. Great clubs, good concerts, you know. We were opening for some big American band and every night we had hotel, restaurant, parties, good drugs, the not-so-usual "Yeah, I'm a rock-star" big shit. We even had a hotel with a swimming pool! It was the first time in my life I could use a swimming pool at night! Our brains still were on "off" position, and we were looking at this gig with no special expectations. We had booked this show just to have a last date on Saturday night. The last show… The Gasolheads all alone, just on the way back to Marseille, our hometown.

Just to let you know, Brive-Charensac is a very small town in deep France, something like the world's darkest asshole. No big town around, just the vegetation and the green hills… We break the van's engine twenty kilometers before destination on a mountain road. Luckily, we can reach the club on free wheels, we just have to push when there's not enough speed to drive. We arrive totally exhausted at the club, actually a crappy bar where workers go to take their morning coffee. The owner says: "Hey! I expected the band yesterday!" Long silence. "Hey! Sorry, but on the telephone, we dealed for today." There was no food or drinks, and he just tells us "OK, I'll try to find a PA system, I'll be back in half an hour!" Two hours later he comes back with a pizza and a PA system we had to plug ourselves. And we're not very good at doing this. That's when Nicolas, our bass player, begins to freak out. He was doing amphetamines for a week and speed leaves traces. While plugging the cables he slowly starts to cry. "Sob, Sob, it's the last time I do that… Sob Sob!" Anyway, we all sniff several lines, and when it's time to play we are ready to rock but there are only four persons in the place. Ah ah! The boss, a friend of his in a wheelchair, and two really drunk lovers. But because we are on speed, we play as if it were our last gig, and the handicapped guy starts pogo danc-

Spoka Vegas

ing with his chair. He falls down and gets up, falls again and gets up. While dancing he screams "Rock and roll! Rock and roll!" Totally surreal. Even more when I see the lovers starting to fight. The coupled man starts to scream, "You're a bitch, you're just a bitch!" And they start to fight. Of course, we absolutely don't care, and finish our set in a cool way. We try to be cool and punk rock. But they keep on going to fight and the lover just slides in a puddle of beer. And while he gets up he cries, "Haaa my arm's broken! Haaa my shoulder is dislocated!" And his girlfriend starts to dance while he's moaning. She also slides. And then they go out, embracing, and we finish the set in front of the bar manager and his handicapped mate. After the show, we go and take a walk through the village, but Nicolas is still stressing, screaming and shaking like a frog in the morning frost: "Boo hoo, you don't like me, I knew! Nobody loves me!" We want to kill him, so we are happy to find the village hall with music coming out. But as soon as we are in, the people stop dancing and stare at us as if we were climbing out of our UFO. Guillaume the drummer, just does not care, and starts to dance in a silly way. I get myself a drink and hear people whisper, pointing at the funny punk: "Who's that guy? He's fooling us! I'm going to show him, that bastard!" I tell the others we better leave before they become real angry. So we do. And we are there, stranded in Brive-Charensac, early at night, with absolutely nothing to do. So we guess it's time to sleep, and where do we sleep? Above the bar, in the owner's little boy's room, full of ninja turtles posters and Pokemon pillows...

After a really bad night, at seven in the morning, we jump out of our beds, because of a sonic blast! Disco and supermarket music is screaming loud from the streets. Que pasa? Actually, there was a party in the village; it was something like their communal day, just like in *The Prisoner*, with loud music at every corner. Aaargh! Crazy countrymen! Not to mention the big shit it was to deal with the insurance on Sunday for loaning us a new van just to go back home, and the garage owner we had to find to repair our van... Even now, we don't talk that much about that night. The night of the living Gasol boys in Brive-Charensac...

Gasolheads (Marseille)

The Authorities left Seattle Saturday, June 15, 2002, for Spokane, Washington. Spoka Vegas, one time home to each of the Authorities, at once a source of unspeakable terror and good times. We had a show to do. This was our first out of town show with our recently purchased (via Shawn's credit) bright red, extended, 1986 Ford Econoline. We love our van and were excited to take it out for its maiden voyage. The chrome, mag wheels and oversized tires gleamed in the sun even as oil leaked from a blown rear main seal.

About thirty miles up Snoqualmie Pass, a plume of smoke appeared behind the van — a dark cloud following us. We made the best of it; the looks on people's faces as they passed us or drove by in the opposite lanes were priceless. We listened to music, tried not to breathe the noxious fumes and put oil in the van at every stop. We passed a state trooper at one point. Lucky for us, we were going downhill which meant no smoke. Our luck and our oil ran out ten miles from Ritzville. The oil pressure dropped and the feeling was like your plane had just started going down. A mayday was issued via cell phone. General panic ensued, everyone yelling and throwing things around the cabin. We calmed ourselves, deciding to limp along the highway side to Ritzville, knowing we were destroying our engine. The other option was to call AAA and wait. We were only an hour away from Spokane and, with any luck, a heady night of Spokanarchy. We weren't going to give up now.

We coasted down the exit into Ritzville, bought oil, let the engine cool, filled 'er up and got back underway. The in-line, straight-six engine was running noticeably louder but we apprehensively pressed on.

Our arrival at The Thai Way Lounge was a much-anticipated reunion with old friends. The gang was all there. Shawn was already in Spokane, having driven over earlier to run reconnaissance and gather intelligence. He'd been receiving updates by cell phone on the unfolding oil debacle and had been keeping the locals posted.

Chinese Sky Candy went on immediately. Next up was Gorilla & Rabbit. Gorilla thrashed the guitar like only a guy in a gorilla costume can. Rabbit's furious drunken drum pounding was incredible for someone in a rabbit suit. You'd have to see it to

believe it.

After the crap trip over and the joyful reunion with our old compatriots, The Authorities took the stage more than ready to rock. Thankfully, we played a great set! Folks got right up in front, right in our faces and let us know they were having a good time. Beers took flight. The ladies shook their groove thang. The show rocked. We heard again and again how there hadn't been a show like that in Spokane for years and we felt *good*.

The party moved to Steve and Shane's place and we all got drunk. *Bad* drunk. Stinkin' drunk. Aaron showed up with Jagermeister and things got decidedly worse. Ralph and Shawn eventually headed to Ralph's dad's house for some sleep. Josh passed out on the couch. Justin decided to stay too but by the time he got back from the van with his sleeping bag the door was locked. He passed out on the lawn.

Sunday morning, The Authorities and crew ate breakfast at the Second Ave Grill, picked up a new rear main seal at the auto parts store, and returned to the house. If you've never changed a rear main seal, we do *not* recommend it. Steve and Shane offered up their driveway and tools. By 5:30pm, we'd removed the drive shaft, transmission, flywheel and seal. Ralph and Justin left to pick up dinner.

Josh and Shawn were working installing the new seal when a greasy, long-haired, aging, hippy-looking guy showed up. This was Steve and Shane's neighbor and we were parked in his space. His first words were, "Uh… yeah, I guess it's OK if you cats park there. That's cool." We said, "Thanks," wondering if he knew we couldn't move the van if we tried. As we got back to work under the van, Shawn looked over to see the neighbor literally dragging an obviously wasted, aging, hippy woman across the lawn. He was cursing, she was mumbling, and all the while, her pants, caught between her shoe heels and the ground, were slowly being pulled off and eventually lost entirely. Shawn nudged Josh and pointed at the unfolding scene; Josh just shook his head and got back to work.

The neighbor managed to get his lady up the narrow stairs to his apartment, losing only her pants and a little of her dignity along the way. Ten minutes later, he was back with an electric guitar plugged into a walkman. He rocked out to the excellent sounds in his head, dancing around the yard while we worked. He told Josh how awesome the guitar sounded through the headphones and insisted that Josh try them on and take a listen. He listened for a moment, took them back off, and informed the guy there was no sound coming through the headphones. The guy acted surprised and pranced away upstairs.

Ralph and Justin showed up with dinner. We ate fast and got back on it. While installing the new seal, Shawn and Ralph realized it had broken, and it was too late to go back to the auto parts store to get another one. We huddled and decided we had to go home that night. Shawn and Ralph set off in Shawn's car, hell bent for home. Josh and Justin cleaned up the mess and followed soon after with Amy, who offered the use of her car.

The next day, Monday, June 17, Josh, Justin and Amy headed back to Spokane, buying two rear main seals on the way out of town. Things went fine until Ritzville. Always Ritzville. At Ritzville, The Devil pulled us over. While it's true the officer resembled a typical Washington State Patrolman, his badge number was 666. Rather than take our souls, The Devil issued Justin a speeding ticket.

We were in Spokane an hour later. With the aid of master mechanics Steve and Shane, we began the torturous process of putting the driveline back together. The cursing reached new dimensions as it began to rain. Lying in puddles of water, we paused at times to reflect on the discomfort of soaking wet underwear. Hours later, the driveline, bells and whistles were reassembled. Triumphantly, we tried turning the engine over. There was a sickening thud. Subsequent attempts were fruitless. Wet, tired and defeated, we gave up and went to sleep on Shane and Steve's floor.

Tuesday, June 18, 2002, Josh and Justin woke up having had enough. Josh's mother arranged for Greyhound tickets. The van was towed to an auto shop. We hauled our gear into the house, taking only the guitars, said so long and thanks to Shane and Steve and adjourned to the Swamp Tavern for beers with Amy. We played pool and pinball, ate nachos and consumed beer quietly. Amy drove us to the bus station where we said our final goodbyes. Finding no lockers at the station, we lugged our crap to Mootsy's, the nearest watering hole, where we had several beers and a whiskey each.

The bus ride back to Seattle was grueling but we occupied ourselves by staring in horror at our fellow passengers and pondering the overall state of the Greyhound subculture. Mile after mile crept by, each rest stop equal parts blessing and torture. Eight

hours later, we reached the downtown Seattle Greyhound station. Our friend, Allison, picked us up. It was too late for a drink so she drove us straight home.

Two weeks later we paid $542.41 to fix the rear main seal and the oil pump we smashed (the sickening thud) when we tried to start the van. Additionally, the crank was damaged from running the engine on so little oil. We couldn't afford any more work, so our only choice was to get the van back to Seattle and do the remaining work here.

Three weeks later, Ralph borrowed his brother's truck and rescued our gear. Five weeks after that, Shawn rented a fourteen-foot U-Haul truck and a tow bar and dragged the van back from hell. Thankfully, this was a rather uneventful trip aside from Shawn being nearly blown off the bridge at Vantage, WA, by an unusually strong gust of wind.

We made $180.00 at the Spokane show. We've spent close to $800 on that trip as of August 29, 2002, and the van still ain't completely fixed. The Authorities look forward to rocking Spokane again and we've learned an important lesson; never pay someone to do a job properly that you can completely fuck up all by yourselves.

Justin, The Authorities (Seattle)

anyway. I guess it comes with the territory of playing the music that we do, the fans just wants a piece of you... literally!

Fredrik, Dozer (Borlange, Sweden)

Trouble In Turku

We did a gig a couple of years ago in Turku, Finland. Halfway through the gig were some slower, moodier songs. The crowd was very responsive, swaying back and forth. I noticed one guy that was a little bit more drunk than the others, maybe under some kind of other influence than alcohol? Anyway, after those songs we decided to "punk" things up a bit. The guy went crazy, flying around not knowing what to do with himself. He jumped up on stage and bit me on the cheek, not hard but kind of like a weird Finnish love bite. He shocked the hell out of me! As a result I didn't know what to do. Should I throw away the guitar and kick his ass or should I finish the song? Well I just stood there mad, numb, wondering what the hell had happened. When I came to I had totally forgotten the words to the song. We finished the gig

Titties And Milk

Are we out of our fuckin minds? Rock'n'roll bands, for fuck's sake, touring around in shitty vans playing for rooms only a quarter filled with equally insane band fuckers you only know because they came through your shithole town on a gig three months ago, kicked ass to seven people, and you're hoping they'll remember they owe you a favor and give you a couple cheap ass beers and a hit off a seedy black roach and let you sleep on *their* bongwater stained carpet. Having to beg bartenders for gas money when you didn't do a damn bit for business but show up and drink your three free Miller High Lifes and run up the electricity bill rockin' out with your cock out for the other two bands and their girlfriends.

The answer is yes, I am out of my fucking mind

Art: Dogger

15

just like every other cognitive animal on this floating wet stone. And I love it. What else am I gonna do today when I accept the reality that tomorrow it might be all said and done? Squat down on that stool in the mud, grab them titties and milk that bitch for all she's worth.

It was June 24, 2001 and we were closing in on Cincinnati, and I think we were all becoming nauseated and stricken with uncertainty upon crossing the border into Ohio, a natural reaction for native Pennsylvanians. I mean, shit. This is the home state of the Cleveland Browns and bastards who drive forty in the fast lane, and when you pass them on the right you notice they are driving a 77–80–84

field.

The gig was at a combination bar/laundromat called Sudsy Malone's in the Corryville neighborhood of Cincinnati. It was sort of a tense place to be at that point in time. Two months earlier the riots sparked by a cop killing an unarmed black kid were burning full force on the same street of the club. The night before our show some poor bastard was shot and killed in a drive-by that occurred in front of the next door. The stage being in front of the front window put a little spark in our asses. We had a song called "Get My Gun" and another where we yelled "Shoot! Shoot!" during the chorus. One of the bartenders said the attendance would probably

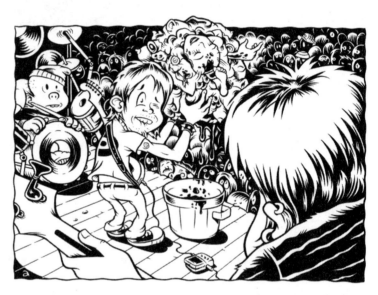

Someone had the bright idea of throwing dismembered dolls covered in "blood" into the crowd.
SOUTH OF NOWHERE

welded and duct-taped together tri-colored (two of which are gray and rust) sedan of some origin, with the driver's side door missing and a rag where the gas cap is supposed to be, and it's perfectly legal under state law.

The nausea may have had something to do with the night before. We had a fifth of whiskey each and were beating the fuck out of each other in a hotel in the middle of Kentucky. All in good fun of course. The bar we were supposed to play in Lexington shut down because the liquor police busted them for underage and we had shit to do but make beasts of ourselves.

We spent the day of the 24th on a little league field in an Anytown, USA called Grove City, OH, throwing a football around and shitting our Kentucky Tavern Whiskey hangovers all over the out-

be low since it wasn't a desirable part of town to be in that particular evening, so she hooked us up with free beer all night (hell yeah!), and did we need anything else? "Got any bullet proofing for the window?" She laughed.

We talked to Redneck Mike for a while, the singer for the rockabilly band we played with, Rip Rock'n'Raunch, who told us about how Icky Woods (remember the Shuffle?) now sells meat and poultry out of a truck. Vee wondered if he spikes the turkey when he makes a sale. I guess gimmicks can only carry ya so far in the world of football. We didn't meet Dice Face. She's some annoying chick they told us about with Dice on her face. She grew up in Brooklyn and everyone hates her. One person we met had a spoon in her pocket. I guess that was because she liked cereal so much that she carried a

Art: Anton Edmin

spoon around with her in case there was cereal but no spoon.

In Columbus the next night the pussy ass other bands didn't even show. Neither did anyone else except the sound guy and a couple locals. Including a dude named Arson. That wasn't his family name or anything. He showed us around to some music stores and record stores on High Street. Matt and Jeff split to the bar and Vee and I stuck with Arson and went over to his house. He gave us some beers and we listened to some punk rock like the Pink Lincolns and a couple of Arson's bands. It became evident that our new buddy was getting really drunk and he made me and Vee sing a part of a Pink Lincoln's song over and over again until we got it right. What the hell? The man was hospitable and I'll do anything for a couple beers. It was getting late and we thought we should be heading back to the bar, and Arson wanted to come along with us. By the time we got back to Bernie's, we almost got into about five different fights with wiggers, muscle heads, brothers, frat boys and a guy on a bike that was hit by glass from a bottle that Arson threw on the street. Vee and I started to hightail it and made it safe back to Bernie's with our nuts in tact. That was fun.

So no one showed, not even the bitch-ass other band. Except for Sparky. Sparky's a dude we used to know up around Oil City, PA. He had a Dynamos shirt on. He was staying in Columbus with his brother. And of course Bernie was there. Bernie's an old guy and the only song he likes is Batman. He wanted me to play Batman. I used to know Batman but I forgot it. I've heard of other bands who learned Batman and played it just for Bernie. When they closed up the bar, Bernie came around and Donovan poured him a shot and they went "Nananananananananana Batman!". So we called it off, and went up the street to Dow's, where Donovan proceeded to buy us shots and shots, and all the guys that worked at the bar hung out and we had a helluva time and played some Foosball with the Foosball King of Columbus. Then we went over to Sparky's and he sparked up about ten bowls for us. Show? Who needs a show?

And on to Pittsburgh. The Steel City. My hometown. Hell yeah. That was the show that made up for the last few shows being shitty. We ended up going on last for some reason. Bunch of friends and we played like motherfuckers. People jumped on the stage at the end. We got drunk and high all night

long. A night like this is why we put ourselves through this shit.

Sloov, Buzzsawyer (Pittsburgh)

Looking For A Gimmick

Battle of the Bands, Newport, 1993. We were looking for a gimmick to catch the eyes of the judges and crowd, and someone (Stan, drums) had the bright idea of throwing dismembered dolls covered in "blood" into the crowd at the height of the frenzy we were hoping to whip up. Well, doubting we'd whip up but we were going to give it a go. We got our dolls, cut them up, put them in a bucket, tipped red paint over them and put 'em to one side ready for Cal (lead guitar, vocals) to pick the right moment.

It came, he reached for the bucket, tried to pull out a severed member and throw it out into the crowd and the whole mass came up with it. It had been the wrong kind of paint so the plastic all melted together and Cal ended up with about a hundred legs, arms, torsos, heads all joined together and useless for throwing. End of attention-grabbing gimmick and we lost the battle of the bands.

I like to think we'd have made it big except for that.

Tom Vetch, South of Nowhere (Newport, UK)

Every City Is Sleazy

Being in a band is like being married to five people. Every song is the same, every city is sleazy and every gig is from hell!

First, I must admit to you, that I am writing this during a colossal post-tour traumatic stress syndrome or should I say, "post band break-up haze". The stories I am about to unfold my friend; well, they are coming from deep drunken pits of hellish memories that I've spent countless hours trying to forget. I've contemplated over which gig of my five-year touring career would be suitable for publication... just thinking about it sends bizarre pains straight to my spine.

I could tell you about the one where we drove for twenty hours to play for twenty minutes opening for some over forty cover bands in the middle of nowhere USA, or the illegal warehouse gig in our home town where young punks broke glass, burnt

books and flags and threw trash at us, or about the one where the manager went missing at the end of the night when we were looking for our measly $50 guarantee, so we decided to suck down as many South Carolina mini bottle shots as we could before we ran screaming out the back door... Simply, that left us very drunk with no money and no where to go but the dumpster outside of the club.

What about the one where unbeknownst to me, we pissed off all the other bands because our guitar player was purposely late for the gig so we could get a later time slot, caught up in all the free keg beer you want, no, I mean, caught up in the drama... the excitable drummer threw his entire drum set on me and turned my pristine white princess outfit into a blood spewing mess.

Or the one where a crazy fan supposedly dumped pounds of glitter into the brand new speakers and the hopped-up screaming club owner locked our drummer in the jello wrasslin' cage demanding money back and threatening to ban us from rock'n'roll forever for being too messy with jello. Or when the Virginia Beach police came into the club looking for our singer who was allegedly whipping innocent tourists that strolled by the club. Or when that always fun New York gig ended with us owing the club $100.

Or the one where we all smoked so much funny stuff after the show we ate pounds of pate and left in a huff because we "thought" we were being stalked by every French Canadian in Montreal. Or maybe it's that great beach gig that we never made it to because the shnicket (our van) broke down for the fifth time in three days, so we caught a scary ride back to civilization with Mousa the drunken gas station owner.

Or maybe it was the one in Iowa where we were so scared of the cops pulling us over that we declined the post gig invite to the mansion outside of town and ended up outside of some high school party house a block away from the club; sitting in the van, high on opium, staring at each other. Worse than that is when we drove forty-five minutes the wrong way (in our home state no less) on a drive that only takes forty-five minutes! We were so bored and annoyed that we spent that unnecessary driving time snorting crushed up painkillers.

Oh, what about the rainy night in New Orleans when we rammed the guitar player's brand new RV into a huge tree right outside of the club, now that

was a great entrance! Or the one where we had to skip town because a drunken roadie spray painted "Ultra Bait Rules" all over a beautiful mural outside of the club.

What about the one, where I threw the singer's luggage into the streets of Washington DC proclaiming "Get your own fucking ride home bitch!"

Better than that, is the one where I took every bourbon shot the crowd sent to the stage just to prove how little fun it is dealing with a drunken bass player, and inevitably, minutes later the bass playing ended and I was left face down in the street with some late night plain clothes EMS person manually pumping my stomach with his index finger. Apparently, sometime between the end of the show and belching on the sidewalk, I was screaming, shouting and chasing my singer around the bar only to be pummeled by pool balls and stomped on by big silver boots. I was left with a bruised body and a bloody eyeball all the way to Los Angeles. But even better than that, is the career-ending gig where red bull and vodka (and maybe a percoset) sucked the life out of our singer and bonked her and our sound onto the pavement next to the stage in front of a hometown crowd.

Or, I could just tell you that *all* gigs are from hell; but sometimes heaven and hell converge, I think it's called Rock'n'roll.

Tammie True, Ultrabait (VA)

Pre-Puke Position

The Cowslingers have been together since 1990. We have averaged about 100 shows a year for most of that time. We have played every two bit, piss-smelling punk rock bar you can think of in thirty-two states and five countries. We've played rib burn-offs, 7,500 seat outdoor sheds, food festivals, private parties, television programs, radio shows, and cultural events like the Turkey Testicle Festival. To summarize, we've played a lot of shows.

When I think of the worst gigs of all time, I immediately think about a few in particular. There's the time when we opened for a band in Pontiac, Michigan that featured a frontman in mime face paint and wearing some sort of frock. That band was a combination of the worst aspects of Peter Gabriel and America brought together as one fabulous entertainment vehicle. Or the time we played in front of ten people at Ronnie P's in Pittsburgh and one of

the guys got bit by a weird looking bug in the men's room and puffed up with a rash. At the Electric Banana when Johnny Banana's wife wanted to pull a pistol on Leo because he answered the phone. At the Penguin Pub, I got a lump on my head the size of a baseball when the soundman opened the dressing room door on my face. On another occasion, our van looked like a smoking, shot up B-17 heading for the white cliffs of Dover on an ill fated trip to the 40 Watt in Athens GA. There's also the time we drove seven hours to Louisville to play with our friends Southern Culture on the Skids and were delayed by the never ending construction on I–71 outside of Cincinnati. Since we missed the 6pm "load in" for the 10:30pm show, the promoter would not allow us to play. (As an aside, why can a 10,000 room resort be constructed in Las Vegas within two weeks, while this particular road construction has gone on as long as anyone can remember? I mean, it's been over a decade with no apparent change.)

The worst gig of all time stands alone unchallenged. It was 1993 and we had a total of one self made 7-inch to our credit. We had played Lili's in Detroit once before, opening for Th' Flyin Saucers. Anxious to return, we took a show in February. There was a catch though. We had to play a show on January 1 as well. I'm not talking about New Year's Eve, I'm talking about the day after New Year's Eve. OK, so we figure it will suck, but we'll get the good February show out of it and it will be worth it.

We loaded up our band vehicle of the time, a Dodge Caravan. There's not enough room for all the gear in the back, so our solution is to strap the bass drum down to the roof. Ten minutes into the drive, the drum falls off the roof onto the Shoreway at sixty-five MPH. Cars behind us are frantically making high-speed maneuvers to avoid the exploding drum fragments spraying all lanes behind us. Seeing no other option, we give up the drum for dead and keep moving.

While speculating if we'll be able to borrow another band on the bill's kit, the heater goes out on the van. Since it's three degrees outside, the van gets cold pretty quick. Minutes later it is so cold in the van you can see your breath. Shivering from the cold, we pull up in front of the club and unload.

When I pull a guitar amp out, I feel a twinge in my back. Not a painful twinge, but an odd "out of sorts" feeling. After the load in, I am sitting at the bar with Tony writing set lists (our bass player at the

time and owner of the piece of shit Dodge Caravan). I still can't get my back to loosen up, and I feel "off". Out of nowhere, I feel violently ill and have to be assisted to the men's room. When I bend over the toilet to puke, I suddenly feel all the nausea leave me. Great news! That's when I discovered I couldn't move my back upright, and was stuck in the bent over "pre-puke" position. Bad news!

The guys dragged me to the pool table and threw me on top of it. The twelve people that had come to the show all kind of sidled over to look at me like a zoo animal. The guys would walk over occasionally, bring me a beer, and ask how I was doing. I felt OK, I just couldn't move. I figured since we were there, we might as well play.

When it was our time to play I told the guys to drag me on stage and I'd sing while laying on my back. It was sort of the reverse James Brown. I had two people carry me *on* the stage. So there we were. The guys in the band were playing their ass off, and twelve people stared me while I stared at the ceiling and sang.

After the show I got loaded into the van like a piece of luggage. When we were about an hour outside of Toledo the van broke down. The manifold was so hot it was glowing red in the unbelievably freezing night. We had to sit in the cold for about an hour so the van would cool off enough so we could drive another forty minutes. We hopscotched our way home like that until 9am.

We made $50.

Greg, Cowslingers (Lakewood, Ohio)

Metal Fest

How nice it was to see a different city as we cruised into Milwaukee for our first mini-tour. Scheduled to play at 2001's Metal Fest, we were convinced that we were in for a great show and nothing would bring us down.

Upon our arrival at your typical rockstar hotel, we quickly unloaded and took to the streets to check out the town. The drummer, a medium-sized boy with bleached spiky hair; the guitarist, a tall, thin man with a broodish goatee and piercing green eyes; the keyboardist, a tall, hairy technological kinda guy with glasses and an afro; myself, the singer, a tall, leggy, blonde chick; and last but not least, the bassist, a round, obnoxious, loudmouth who thought he was a skinhead. Together, we abounded around

19

Milwaukee on the Friday afternoon before our show. After looking around at the venue and listening to some of the other bands, we decided to split up and go see what kinds of fun we could find. The drummer and bassist walking back towards the bands, while the rest of us window-shopped all the other bands' merchandise until we got bored.

By this time, tired from all the walking, the three of us decided to walk back towards the hotel and hope that we ran into the other two along the way. We weren't so lucky as to find the guys on the way back, so we went on up to the room. I was only able to get the cap off my beer when there was a knock at the door. Answering, there in front of me was the bassist, inebriated and belligerent, smiling and eager to boast his good times. I looked out into the hallway, and saw that he had picked up a band of wandering homeless teens and brought them back to the hotel with him. After confirming that they would not be sleeping in the same room as me, he and the drummer holed up in the separate room we'd reserved for them.

During the night, I slept with the guitarist, who's also my boyfriend, and the keyboardist slept on the floor, every so often peeking up over the side of the bed to see if anything was going on. And in the morning, instead of waking up with the sun on my face in the arms of the guitarist, I awoke to the squeaky cackle of the bassist, who hadn't slept and was still drunk from the night before. Upon opening my eyes, I saw at least four faces I didn't recognize, and everyone else standing around my bed. The four faces were the squatters that the bassist had recruited for his edutainment the evening before. All of them drunk or high, possibly both, and totally enthused because the bassist had graciously offered them positions as official roadies for New Fangled Black.

Eleven am, time for the show! The squatters were a big help in carrying all our shit from the car to the other side of the auditorium. I was worried that half the equipment was going to be shorted out from it all being dropped in our roadies' drunkenness. The show took on a life of its own when the bassist began stumbling around the stage and missing key parts of songs. And where he didn't miss parts, he screwed parts up. So, to put it lightly, he made us suck.

Eleven-thirty am, show's over, we're hungry. Well, half of us are, anyway. So, after reloading the van I'd borrowed, again, we split up. The bassist off with the

squatters, and the rest of us going to chow down at the worst breakfast buffet we'd ever eaten. We'd agreed to meet back at the venue at one o'clock to see another couple of bands together before we took off. So, after eating our dog puke for brunch, the rest of us had some time to kill. Needing to calm our stomachs down, and add a little spark to the afternoon, we grabbed the nearest empty Coke can and started crafting.

One pm, back at the auditorium, we find our bassist in a room watching a speed metal band, by this time, completely obliterated. Banging his head and throwing his fists wildly without concern, he punched a couple people in the crowd. After being repeatedly asked to calm down and compose himself, he threw a fit and led several security guards on a chase from one end of the room to the other, ending with him being caught and escorted out of the room. Now in our custody, the drummer tried to hold him steady as we walk towards the exit. Seeing that the fun's about to be cut short, the bassist broke free from the drummer's grip and stormed off with a powerful "Fuck You!" Amused, we followed him outside towards the corner stoplight. He stumbled off the curb and across the street garbling obscenities the whole way.

As we followed him from a safe distance, he crossed a parking lot, and pretending to be Jesus, tried to walk through a hedge of bushes, only to succeed in falling on his face. After a second, he popped back up, yelled another annoyed "Fuck You!" and kept on walking. By this time, the rest of us had noticed that he was heading straight towards the Milwaukee Police Station, and the paranoia set in. I ordered the keyboardist to go over and keep an eye on our liability while the rest of us headed back to the hotel to dispose of anything incriminating.

The three of us jogged back to the hotel and in a flurry of motion began the clean up. The guitarist took care of all the beer bottles and the left over Coke can while the drummer ran around wiping tables and lighting incense. Meanwhile, I was on the phone trying to get a hold of the bassist's parents, since he was still underage. Finally able to reach his family to explain the situation, it was agreed that he would be picked up.

The next phone call was to the keyboardist to hear about what was going on with our drunk friend. What I heard on the other end of the line was priceless. Turns out, after we left, the bassist decided he

needed to sit down. After sitting on the steps of the police station stewing for a while and giving the keyboardist his sob story, our genius bassist stands up and pukes, all over the steps and himself. And, did I mention that it was just in time for the officer coming out for a breath of fresh air?

Disgusted, I hung up the phone and turned to see how the cleanup was coming. There were streaks of blood now on the walls next to the light switches and on the doorknobs as well. The guitarist had slit his hand open on the rim of the Coke can, (see kids, just say no!) in the process of cleaning, hadn't noticed and smeared the blood everywhere. The whole room looked like a mass murder had just been committed. Realizing that it was going to take a woman to clean things the *right* way, I grabbed a couple of hand towels from the bathroom and began to wipe up the blood. I mended the guitarist's hand and made him take every garbage bag in the room downstairs personally and bury it in the bottom of the dumpster.

The phone rang. It was the keyboardist calling to give me the play-by-play on what was going on at the pen. Apparently, after heaving on the steps, an officer stepped outside to see what the commotion was and to talk to our fubar'd friend. And, as soon as officer friendly got too close, the bassist let loose and started swinging. Several officers appeared and cuffed him, telling the keyboardist that they'd take care of the problem. So we hung up, did a last-minute check on the room, threw the squatter's bags out into the hallway, checked out and hit the road. We picked up the keyboardist at the Police Station on the way out, cruised, and didn't look back.

What happened to our skin-headed-ex-bassist friend, you ask? He was detained and taken to a local hospital, where he was treated for alcohol poisoning and severe dehydration, later picked up by his parents, who had to cut their vacation short to come and get him. There are some large lessons to be learned from this little gig from hell...

Angel, New Fangled Black (Chicago)

Wet Pimps

Our story begins on the Texas stretch of I-10 leading to Houston. As any touring band that has traveled through the south will know, Texas highways are littered with pot-holes and constant construction. So by the time we get to Houston, we're ready for a swimmin' hole. Unfortunately, all Houston had to offer was a public pool, but we made the best of it. The temperature outside was surprisingly cool considering it was June. In the distance, we could see dense black clouds headed our way. So we packed it in and left for the club we were playing that night, Mary Jane's. Tropical storm Allyson had blown through a couple of days earlier, and we didn't think of the thunderclouds then — the worst was over, or so we thought. We're from the Florida swamps and thunderstorms are an everyday occurrence, so we didn't give it much thought. We unloaded our gear, did a sound check, and knocked back a few beers with our friends from Transmaniacon MC, the absolute baddest band from Texas. As the evening wore on, people started filing in, and Transmaniacon fired through a smokin' set, always a hard act to follow. We began to notice that everyone who came in were soaking wet. Whenever the door would open, you could see sheets of rain coming down, nothing new to us. We soon changed into our pimp duds and hit the stage. About this time, the owner of the club was telling us to cut it short because there was a flood brewing and everyone should try to get home soon, or they would be stranded there. Around about the third song, Sexy Swimmin' Hole (a crowd favorite), the doors to the club that were facing directly in front of us suddenly burst open. Within seconds Mary Jane's was in two feet of water with plenty more rushing in. The crowd went nuts splashing around and singing "Sexy Swimmin' Hole Whiskey Rock'n'Roll Party", till the owner shut us down in case anyone got electrocuted. By this time the water level was almost as high as the electrical outlets. We were lucky enough to be on a high enough stage and managed to avoid any equipment loss. Our van was also spared, being on high ground. Everybody else's car or truck were already under water. Carson, "Bubba C", from Transmaniacon, loaded us up (ten in all) in his van and proceeded to drive through a strong flood current about four feet high. We rescued a couple of people along the way but the van kept stalling and eventually died. As soon as we stopped for good, water started flooding into the van and everyone freaked and jumped out into the stank-ass street river. Carson's guitars were floating around in the van as we pushed it to higher ground. We finally made it to a two-storey bar called Rudgers and took shelter there looking like stranded street rats. No one on the second floor had a clue that the streets were flooded and laughed at us when

we came in. We were later laughing at them. Needless to say, Tropical storm Allyson came back to Houston with a vengeance, drowning sixteen people and left all highways closed. We barely made it out of there the next day. The last thing we saw as we were leaving was an overturned Budweiser semi-truck with people on jet skis looting all that sweet beer.

Leroy Mullins, Syrup (Tallahassee, FL)

Erotic Twister

This past summer, we toured in Europe, playing in Netherlands and on the German and Belgian borders. The final Sunday of our tour, we played at a big festival called the Oerkracht Festival in Lichtenvoorde, NL for 3,000 people under a big top tent. The fans ranged from thirteen-year-old punk boy music fans to beautiful twenty-something Dutch women, to sixty-year-old farmers. Well, given the cheap price of beer at the festival (about one euro each) the fans would drink half their beers and buy the other half to throw at the live entertainers. Well, Porn Rock, being the theatrical music extravaganza it is, usually uses lots of props and does costume changes. The exotic dancers and I were about to get changed into our naughty school girl outfits and play erotic Twister, where normally, we invite audience members on stage to participate, but could not at this show, since there were six foot barricades between the band and the security and crowd. So, we decided to put on an erotic twister ourselves for the onlookers, when a storm of beers began to shower us on stage! The fans had mastered the art of throwing them so that the beer in the cup would stay inside until impact. The twister mat became so slippery that we said, "the hell with the costumes", and just got naked and slipped and slid all over the stage. However, I was thrown a pair of wooden shoes from the audience, so I put them on and began to dance around, with my hair in long blonde braids, and got the crowd of 3,000 people chanting "Porn Rock! Porn Rock! Porn Rock!"

Pink Snow, Porn Rock (NYC)

Pissicles

In my early days of touring with Seka, we were such hard-ons about traveling. On long hauls, especially at night, we didn't waste time stopping at rest areas to piss. No, that precious ten to fifteen minutes spent in the comfort of an actual bathroom meant less time till we arrived in whatever shithole town we were playing in. And, because we were such drunks, we couldn't make said long hauls without drinking, either. So, we devised plans for proper piss disposal while on the move. We found, if you kneel behind the passenger's seat, you can use it to rest your forehead on and steady yourself while urinating into a bottle. At first, it worked. Drink a beer and then use the bottle to piss back into. But several complications arose. One, its easier to crush cans down and hide them from cops. Secondly, the mouth of beer bottles was too small for accuracy and any 'spillage' was completely unacceptable. Lastly, stacking bottles of hot piss in the wheel well without caps on them is simply asking for trouble. Soon we brought our filthy roadways and daily survival to a closer harmony. Every morning we were hung over, and discovered quick relief tossing down three Advils and washing them down with Gatorade instead of regular water. It contains electrolytes, necessary in replenishing your body's energy. It was also tasty. But the real treat, we discovered, was the mouths of the bottles were wide enough to get your whole cock head into. We saved the bottles from the morning to piss into at night. Most importantly, they had resealable twist-on caps. As long as we remembered to throw out our own piss jugs at gas stations, we were fine. Canada. Freezing fucking cold. Even with the heat on and sporting long johns and thick jackets, our collective breathing was turned the insides of the windows to a light frost. Worse still was the gas stations weren't carrying Gatorade. Plenty of Labatt's Blue, but no Gatorade. We're driving at night between God knows where and who knows why, trying to keep from wetting ourselves after a twelve-pack disappears. "Pull Over!" We screamed at JJ, our tour manager at the wheel. "I can't! It's a blizzard out there, and if I stop, we'll never get moving again! We have to keep going!" He's right. The snow in the headlights is coming down sideways. All looks hopeless. Then Billy gets an idea. Standing in the moving van, swerving down the highway, he opens the side window open just a peek. Then he thrusts his hips forward and presses his head of his dick to the outside edge of the glass and lets loose. When he's done, he jumps back and closes the window quickly behind him. His hands are down the front of his pants holding his frost bitten pole. "It works !"

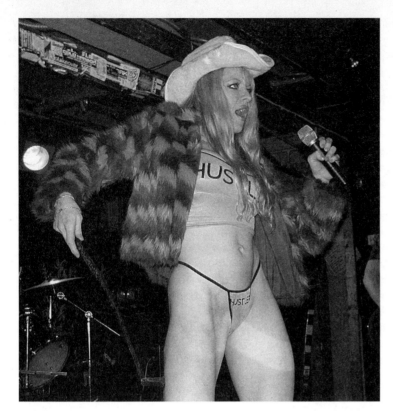

The exotic dancers and I were about to get changed into our naughty school girl outfits and play erotic Twister.
PORN ROCK

He proclaims. "You just have to piss down at an angle to keep it from blowing back in!" As pathetic as it seems, one by one we all try it to much success. Whew! Another crisis diverted. We drive through the night and doze intermittently, until the night becomes day. "Wake up, you assholes!" JJ yells, kicking the side of the van. "Come take a look at this!" I looked around. We were stopped at a gas station. As we stumbled out one by one, we saw in the morning light, the entire side of the van covered in yellow ice, a gigantic 'pissicle' blowing outwards along the backside from a spot at the window's edge into a thick, frozen glacier. I had to laugh. "Holy shit ! Who's got a camera!" I cracked. "So, whose gonna be the lucky fuck to clean it off, boys? "JJ asked, half joking, through clenched angry teeth. "It ain't fucking gonna be me!" One by one we went inside, bought coffees, and brought them out. We took turns dumping them onto the icy mass, but it hardly budged. And, to our dismay, turned parts brown, to go with the yellow and complete it's nasty, sewaged appearance. JJ shook his head as we pumped gas. "What a bunch of fucking clowns" was all he could say.

Tim Catz, Roadsaw (Boston)

Uncle Phil

"600km to New York via turnpikes." That's what the sign read. We were on our way. Regardless of how things actually turned out we were giving it our best shot. CBGB's here we come.

The Ballistics 13 in NYC. It's not a hard thing to imagine. Lots of bands have played CBGB's before and I'm pretty sure that some of them were pretty bad, too. This was just a quick thing. Not a lot of pre-planning involved. It was just the four of us crammed into a Dodge Ram Quad Cab with all our "stripped down" equipment in the back along with the bare essentials in terms of clothes.

We did have a photographer though. Uncle Phil.

He was leaving a few hours after us, because of work, and was going to meet us in Clifton, New Jersey, at the Ho-Jo, right on the highway leading into the Lincoln Tunnel.

We made pretty good time. Around ten hours. We arrived at the hotel around 9am and tried to get settled in and rest a bit before we went onto the island to promote our show for the next night.

I don't remember what time it was when I got the

On The Road To Ruin

call from Phil. You know if you get a phone call in a hotel far away from home and only a limited number of people know your there, the odds are good that it's bad news. And sure enough, it was bad. Phil had broken down in Pennsylvania, and he had already gotten a room at the Emlenton Motor Lodge.

I looked up on the map where this little town with a redneck name was and after a little calculating, I figured that it would be another ten to twelve hours of driving to go get him. We had just gotten in after a ten hour drive! We all needed our rest. We didn't need the pictures that bad.

I told Phil to sit tight and wait for us to do the show the next night and we'd be there around 3 to 5am on the morning after we played. He understood, but I could tell he was really pissed.

Immediately after I hung up with Phil and I told Psycho, Dusty, and Stink what was going on, the jokes started flowing. Punxsutawney Phil this and Punxsutawney Phil that. It was actually kind of funny.

Well CB's was everything that we hoped it would be. We had been there once before to book the show, but actually being there on *that* stage… I think we played extra good that night. The good spirits were everywhere, and we could do no wrong. New York to me seems to be filled with only good people that know how to have a good time. Our experience there went against everything that I figured New York would be.

We finally rolled away from 315 Bowery at around 11pm or so, and after a few crazy turns in and around Manhattan, we made our way through the Lincoln Tunnel, into New Jersey. We made a quick stop to get road munchies and I made a few calls to make sure that "Punxsutawney" Phil was still in the motel there in Emlenton. All seemed well.

Sure enough, at around 4:30am, we pulled off I–80 on to highway 208, and entered the thriving metropolis of Emlenton, Pennsylvania. There was a pretty good-sized truck stop there and we had no trouble finding the Emlenton Motor Lodge, on top of the hill next to the interstate.

But something wasn't right. We drove around the motel and we couldn't see Phil's red Grand Am. We drove back down the hill and drove around the truck stop. Then we drove up and down the highway. Nothin'! Back to the motel? Back to the truck stop?

We finally went into the truck stop. Ooooops! This place was about as *redneck* as you could

get. Phil didn't speak badly of the place except for it being really, really, really boring. He did sound a bit on the crazy side after being here for a couple days, but all he had to do was stay there and wait. We would be there. It sounds simple enough to me.

You have to remember, we had just gotten off the stage from CBGB's and hadn't changed or showered. Psycho and Stink had the fiery Mohawks just blazing away and they had so many studs and spikes in their clothes they looked like stainless steel porcupines. Dusty was decked out in his best stage leathers and I still had my white psycho ward shirt on with "patient no. 666" across the back.

I tried to communicate with these "people" at the truck stop and it was like trying to have a conversation with a piece of chewed bubble gum. I know we looked a little different but at least I like to believe that all of us in the band have some sense in us.

We got nowhere in the truck stop, so we decided to go back up to the motel. After around ten minutes of prowling around and peeking into windows I found what had to be Phil's room. The window was open and it was the only room with some soft porn playing on the TV, "Tool" blaring out of a cheap CD player on the coffee table, and a bunch of black candles burning all over the place. I was able to break into the room without too much trouble. The place was a mess. Empty whip-its on the dresser, liquor bottles all over the place, food and garbage piled up… but no Phil.

I told the guys to sit tight while I drove around some more, on an even more extensive search of the area.

I got back to the motel room at around 5am and things started to get worse. When I got back into the room the guys told me that the state police had Phil and that he was in the county hospital in Clarion about twenty miles back up I–80 towards where we came from.

I told the guys to stay put again while I drove back down to the truck stop to make a call to the state police. I was really getting pissed. This was like a bad dream. The friggin' phone in the motel wouldn't let me dial out. Nothing was going the way it was supposed to. The guys were starting to show the strain also.

I made the call to the state police station in Clarion and talked to the desk sergeant. Things were going from worse to down right horrible. It seems that

they found Phil about five miles down the road on I–80. It looked as if he tried to drive his dead or dying car, for what reason, I don't know, around to break up the boredom. He was sitting on the edge of a bridge on I–80 over the Allegheny river just dangling his feet when they found him. This had all happened around 2 to 3am.

The cops weren't holding him for anything because he had voluntarily gone from the hospital to the mental health clinic next door for an evaluation. The cops said that it appeared that he was going to commit suicide. They started to get kind of curious about me. Where was I and where was I going. This was all on the phone so it's not like the "pigs" could get me. But I was still glad I didn't need to have this conversation face to face.

Then they said that Phil could use the moral support from a family member and they wanted me to drive back towards Clarion twenty miles away and visit with him. We were all still pretty buzzed, even five hours after getting off the stage at CB's, and I didn't think the cops would look kindly on me if I showed up at the county nut house dressed in a white psycho ward shirt with "patient no. 666" on the back.

Under no circumstances would they let him go anyway. One of the last things the desk sergeant asked me was if Phil was known to be a violent person. I told him *"No"*. Then he asked me if I knew why he would be carrying a meat cleaver in his back pocket. That was too much. I told him maybe he was scared to be out by himself at night. I don't know.

That was the final straw. I told the cop I'd be up there soon, then hung up with him. I went back up to the motel room and told the guys what was up. I wanted everybody to either be with me or we wouldn't go. I really didn't want to go, but I felt like I had to. I didn't feel like making the decision for everybody so I asked for a vote. One for going back and getting him, two "I don't give a shit's" and one "Hell no!".

That was it. We threw all Phil's stuff in the back of the truck as quick as we could. The stuff in the room would have bought everybody a night or so in the brink by itself. We jumped in the truck, pointed it west and hit the gas. Sorry Phil. You should have stayed put.

We all got back to Detroit ok, except for one. He stayed a temporary resident in the county nut house for thirty days in Clarion PA, courtesy of the state of Pennsylvania.

We never did get any good pictures.

Q, Ballistics 13 (Detroit)

White Trash Luau

Mountain Lake Virginia. "Spring" 2002… Some nice white trash (I mean that with much respect and love) looker, who shall remain nameless, so as to protect the innocents and the guilty, thought we were a "swell" band when she happened upon our performance one night at the Heavy Rebel Weekender in Winston-Salem, North Carolina. We were a sweaty mess, playing in the sweltering southern heat of an old jailhouse with no air conditioning in the basement of the old City Hall. She was wearing a Mötley Crüe T-shirt. It was a mutual admiration. She got in touch via email once we had hunkered down back home in the comfort of Dayton, Ohio. Seems she's got this fella friend that goes by the name of Dolinger. Dolinger's got a nice little piece of property that rests, literally, at the top of a mountain in Virginia. Twice a year, Dolinger throws a big ol' invite only, white trash, rock'n'roll free for all atop said mountain, complete with a pig in the ground fer' vittles, and all the room in the world to sprawl out, pitch a tent, get drunk, get laid, and possibly fall off the mountain. Sounds like my kinda fun! We Jackalopes being "van-less", due to another rock'n'roll mishap (I'll save that one for the next book!) pooled our resources, and borrowed a Ford Taurus station wagon and Ford F–150 full size pick-up truck (*not* of the four-wheel drive variety…), and headed south. We drove for several hours, and being that we all had worked that day prior to leaving, we stopped for the night at about the halfway point, and got a motel room at a nice little roadside place right next door to the Appalachian Bible College. Strangely, everything went fairly smoothly here, considering what kinda trouble an eyeliner and iron cross wearing punk rock band can get into in a town like this. We woke up the next day, hitched up the ponies, and headed down the road. Before getting back on the highway, we stopped at the local liquor/gas/food mart and loaded up on supplies. Jack Daniels, Jagermeister, Moonshine (the legal kind), and Pabst Blue Ribbon were the order of the day. The whole drive toward our destination was one of much rain and winding roads. We arrived at the base of the

mountain in the early afternoon and started our ascent. We drove up the mountain for what seemed like an hour with our ears popping, opening and closing in only the ways they do there in the south, halfway up a mountain. As we reached a clearing, a huge palatial resort came into view. My wife, being the Patrick Swayze fan she is, recognized it immediately as the resort from that great piece of eighties cinema, *Dirty Dancing*. Did I mention it was raining? We made our way past the resort, past the lake, past some more trees and such, past an old water heater and other Appalachian Stonehenge. By this point in the drive, there's no more pavement, no more black top, just a little bit of gravel, and a fairly well-worn mud path, and we're still not "in". We see the balloons and such up ahead, signifying the entrance to the Luau grounds. I take the left turn and peer down this long, narrow, mud-ditch of a path that leads deeper into the woods. I'm in the lead, driving the truck with my wife at my side and our gear in the back. The rest of the band is following behind in the "Soccer Mom Mobile". I look at my wife, and as she buries her face in her hands and warns me that if we stop we'll be stuck, I take off like a bat outta hell (at about seven miles per hour) down what resembled a creek bed more than a road. Huge rocks jutted out of the ground, throwing us to the left and the right as we hit them. We slide in many directions, narrowly missing trees and larger rocks. I look in the rearview, and see the Taurus behind me is covered in the mud that I'm slinging behind me. Their windshield is a giant mud pie. The front end of the Taurus slams heavily into the ditches carved in this "road". We'll later find out that the left front shock is completely destroyed, along with many other pieces of the underside of the car. We pull into the middle of the campground to stares of disbelief from the many good ol' boys and girls that grew up in the area. They all knew that those particular vehicles were about as useless as a nun's nipple ring. As we slowed in the middle of the area where the stage and bonfire pit were, we, of course, became stuck. "Nice to meet ya'! Name's Dolinger. Get outta the truck!" Dolinger hopped in the truck, and with a little mountain know-how, maneuvered the truck out of its predicament, and into a nice parking spot under some trees near the stage. Did I mention it was raining? Now, the wife and I are campers. We live in the woods. Not woods like these, mind you, but woods, nonetheless. I got a couple

acres and a pretty little creek out back, and big ol' wire spool next to a fire pit. We came prepared. We had a nice tent, air mattress, sleeping bags, blankets, pillows, extra clothes, socks, tons of food, camping stove... We were prepared. Did I mention it's barely spring on top of a mountain, and it's raining? Very cold. My bass player, GeeGee, did his best at being prepared. He and his girlfriend borrowed a tent from his Mom and Dad. Tent hadn't been used since about 1983. It had been sitting in a hot garage since then. No directions for assembly. Didn't need 'em anyway, cuz the damn thing was so dry-rotted, that by that time we figured out how to set it up, it fell apart. Like I said, they had made an *attempt* at preparedness. I didn't say they pulled it off. Neither of them brought a coat, or even a proper jacket. GeeGee had on a hooded sweat shirt, and his gal had no jacket. My guitar player and drummer, Ronnie T and Kyle Thirteen, didn't come prepared, either. They figured that the back seat of the Taurus laid down, and they'd just crash in there. We attempted to build a fire. Got one going pretty well, but it was work to keep it going at all. Wood was soaked. Dolinger said earlier that his Uncle, who was in charge of cooking the pig, might have something we could use to help get the fire going. I sent Ronnie over to get something. Ronnie came back with a Dixie cup of what I assumed to be some kind of lighter fluid, or hard liquor. We already had a small fire going, but wanted it to grow a bit, so I told Ronnie to go ahead and throw the alcohol on the fire and then we'd add more wood. He handed the liquid to Kyle, who spilled a bit on himself, and then chucked it into the fire. I asked Ronnie, "What is that? Lighter fluid?"

"Gasoline" he says.

At that moment, Kyle's arm goes up in flames. He starts flailing around like a maniac. Then goes the leg. Luckily, we got him put out before any real damage was done. Fire burned a little better after that. It continued to rain. I stayed fairly warm, as I was wearing a leather jacket and leather pants. Everyone else shivered. We cooked food on the camping stove on the tailgate of the truck and cracked open the liquor. Kyle guzzled from the bottle of Jagermeister. I drank the Jack. GeeGee had beer. I can't remember what the hell happened to the Moonshine... My troops were getting extremely wet and weary, and wanted to get the show on the road, or go home. The stage was a little wooden stage with some tarps pulled across the top. The tarps would collect about

five to ten gallons of water and then dump them off the sides onto the band and the PA. Sounds like my kinda fun! We got on the stage in the early evening, while the sun was still shining. We were soaked through to the bone, our noses were runny and frozen, and you could see my breath so clearly that I looked like Puff the Magic Dragon while I sang. Ronnie stayed fairly still. More than usual, I think he was in fear of electrocution. Kyle continued to chug

Jagermeister, finished it onstage, and took my bottle of Jack. GeeGee was unfazed. Except for some light tuning problems, GeeGee was bound and determined to rock as hard as usual. So we did. We played a great set, and the crowd was into it (what crowd was left... a lot of people go home when it rains!). We continued to get drunk and eat campfire foods and ingest illegal substances, until it got dark. GeeGee's girlfriend got so drunk that she kept falling over in the mud, ass up. She wore some very fashionable platform shoes that just did not jive with mountain drunkenness. Kyle and Ron retired early to the back of the Taurus. We made a few friends and hung out around the fire. Then it was time to sleep. It was so cold that my sleeping bags and several comforter blankets might as well have been sheets of ice. My wife and I huddled together for warmth and drifted in and out of frozen slumber all night and into early morning. When we woke up, GeeGee decided to burn his tent. He and his gal had slept in the front seat of the Taurus, and were not in any mood to pack up the dry, rotted tent. He threw it on the main fire in the middle of the campground, and it smoldered and billowed black, plastic-fueled smoke into the otherwise fresh mountain air. We packed up all of our gear, said our good-byes, and started back up the path to get to the main path, to get to the drive that lead to the paved drive, that lead to the road... I let Ron and the crew go in front of me, with explicit instructions to *not* stop their car, for that was a sure way to get stuck. Ten feet into our exodus, he stopped. We were good

and stuck. The Taurus made it up and out fine, albeit a lot worse for the wear. The truck was *stuck*. Many hands rushed in to help push. Dolinger hopped in and took the wheel. Me and a buncha other white trash mountain boys pushed and got mud flung solid up our fronts. Once Dolinger got going, he couldn't stop, so there he went, off into the horizon with my wife, my band, and my gear. So I started my walk. I walked about a half-mile that felt more like three

> More than usual, I think he was in fear of electrocution.
> THE JACKALOPES

miles through the muddiest mud ever invented, and I fell a total of five times, caking myself further in mud and muck and skinning my hands pretty severely along the way. I huffed and puffed and sweated my way up the lane, where I met Dolinger at the end. I gave him a hug and thanked him for his hospitality, climbed in the truck, and headed out on the road home. We did it all for no pay (it's a free show/party) and for no glory, other than the memory. We're going back in September.

**Rev Chad A Wells, The Jackalopes
(Dayton, Ohio)**

Knackered and Bleeding

There are so many gigs from hell, that the easiest thing to do is just give you a list of the more memorable ones.

HOUSTON, TEXAS

This was in a really small, hot club, filled to the brim with the Texan alternative kids — and we don't get a straightedge crowd. I remember getting ready to go onstage on the bus parked outside, which was also our dressing room, and changing my tampon (sorry boys) to avoid any embarrassing stage leakage. I know it's not very rock'n'roll, but tough shit. So anyway, after half an hour onstage, under some really hot lights, I was absolutely sweating my tits off, even just wearing a fairly flimsy dress. Sweat was running into my eyes, down my back and especially my crotch. Yes, it's true, we ladies sometimes get

sweaty in the crotch. But I remember thinking at the time that it was a bit extreme. And then I suddenly remembered that I was on my period, and realized that it probably wasn't sweat — it was probably a bloodbath. But how could this be possible? I'd just changed my tampon less than an hour ago. I ran offstage at the end of the set as quickly as possible, straight into the toilets. Thighs bloodstained down to the knees. Luckily, very luckily (thank you God), I was wearing a black dress so (I think) the audience was unaware of the situation. In my state of pre-gig nervous madness (while imagining that I was being really organized), I'd completely forgotten to put a replacement tampon in.

Luckily I didn't actually slip on the blood, so the pitchfork rating is only two out of five (and nobody else noticed).

THE ALBANY, GREAT PORTLAND STREET, LONDON

The Albany was (probably still is) a total dive. The stage was sticky and the size of a postage stamp, the PA was sticky, the size of a postage stamp and sounded like shit. It was my first time singing co-vocals for Moonshake, and we were all extremely nervous. Michael, the drummer, had a terrible time,

The rest of the audience was horrified by what seemed to be an unprovoked attack, and a rumor broke out that the guy was deaf and had been sitting on the stage in order to feel the vibrations of the music. Dave sat on the side of the stage, cursing himself for being a cunt — almost suicidal with drunken remorse, while everyone else agreed that Dave had really overstepped the mark this time etc etc. It turned out that the deaf guy was not deaf at all, but tripping (and a compulsive liar/windup merchant) — but not in time to redeem Dave's reputation that night.

Pitchfork rating — four out of five, an unbeatable combination of horrible venue (very bad onstage sound), horrible audience members and general scuzziness. There's a rumor that people have caught crabs from the sofa in the "dressing room" (relabeled "depressing room") at the Duchess of York — the Albany is very similar in tone, except I don't even remember there being a dressing room.

THE DUBLIN CASTLE, LONDON

This gig wins the prize for nervous breakdown inducing technical failure. We use a DAT machine onstage for some of the more bizarre background noises, and had stupidly left it plugged in after the

When the first verse was supposed to start, I was trapped inside the jacket with both hands above my head.
SNOWPONY

because not only was it incredibly stuffy and hot (if you find yourself in a small venue that isn't, it means there are not enough people there, which is usually worse), but someone had thrown up into the drum monitor. Apparently he nearly fainted because of the stench from the vomit as it cooked under the lights. But nobody noticed, partly because Michael was the drummer, but mainly because Dave (the frontman) had become enraged by a member of the audience sitting on the stage directly in front of him. Dave was a bit drunk, and was overreacting to this man, and ended up literally booting him off the stage.

sound check. One of the other bands must have accidentally knocked it, and broken the phono plugs off in the back, which we discovered about twenty minutes before we were due onstage. Some emergency open heart surgery followed on the DAT player, but we were unable to remove the broken off piece of metal. Already half an hour late onstage, the place was completely packed and the audience was getting pretty drunk. We absolutely had to play, as the idea of having to give these people their money back filled me with fear. They were already getting a bit rowdy at having to wait so long. Our solution was

quite ingenious — we cut down another phono plug and a friend (Jerry) held it in the back of the DAT player to make contact with the bit that was stuck. We started the set, and to my enormous relief, everything seemed to be all right. Against all the odds, we launched into the first song. Then suddenly all the samples cut out, and my heart lurched into my stomach. To my immense surprise, the band kept playing (we were a three piece at the time — with a very highly strung Italian drummer). The samples eventually came back (and then cut out again, but the initial panic was over). Max completely kept his cool and just kept drumming — so we did a mainly drum and bass set, with sporadic samples randomly cutting in and out. It turned out that the movement of Jerry's hand kept breaking the contact, but because Jerry was wearing earplugs, he couldn't really hear when this was happening and was smiling cheerfully back at Max's frantic eyeball signaling. After the gig, I found out that the reason our somewhat hysteria-prone drummer had kept so calm, was because he'd necked a load of Valium just before going on stage, and was chemically incapable of caring about anything much. He also managed not to tell me that he'd done this (or I would have become hysterical). Oddly enough the gig went down really well — possibly because the audience was very, very drunk.

Pitchfork rating — three out of five. It wasn't quite as bad as it could've been, although I was dizzy with fear. This gig was also notable because I was on crutches at the time, having seriously fucked my knee a fortnight earlier, and I wasn't supposed to be walking at the time.

THE ASTORIA, LONDON

This was in the days when I thought it was fun to smash the microphone stand to bits at the end of the gig. It is fun, but this incident made me a lot more careful. I'd done it at quite a few venues already, and the house engineers never seemed too bothered. Usually the mic stands were totally knackered anyway, and it didn't make them any worse. Unfortunately the house engineer at the Astoria got his knickers in a right old twist, and told me off over the PA at the end of the gig, in front of about 1,800 people (we were supporting someone quite big). I was totally humiliated and it was a particularly horrible comedown after what had been quite a good show. What I didn't realize at the time was that he was only broadcasting over the onstage

monitors — I thought it was over the whole PA and the entire audience could hear him saying, "That was clever, now you owe us £49.50." As we were only getting paid £50 for the show it was a bit of a disaster. We paid up (we didn't have much choice), on the condition that we got to keep the "broken" stand. It later turned out that they'd given us a stand for a kick drum mic (i.e a stand that was only about two foot tall), but we didn't notice until it was too late to do anything about it.

Pitchfork rating — only two out of five. It wasn't quite as bad as it had initially appeared, but if I ever see that engineer in a dark alley on his own, then he'd better be quick on his feet.

THE LA2, LONDON AND DENVER, COLORADO.

Much the same thing happened at both of these gigs. In a nutshell, my traditional flimsy frock had (unbeknownst to me) stretched too much to be fully secure. Breasts were falling out all over the place, much to the audience's amusement and my horror. In Denver, I tried to stick my dress to my body with tape, but the only tape onstage was electrical tape — which isn't very sticky (specially not if you're quite sweaty). Every time the dress failed, the audience roared with laughter.

At the LA2, I thought I'd got away with it, because I only noticed when I had my back to the audience, and thought I'd discreetly tucked the errant tit back before anyone saw. Unfortunately this was not the case. After the gig, I found that everyone had been completely fascinated by the squares of black gaffer-tape that I'd stuck over my nipples (in case the dress gave way). Somehow in my head, it seemed that as long as people couldn't actually see any nipples, it would be all right, but actually this is not true.

Pitchfork rating — three out of five. Ticket prices were not high enough to justify that kind of show.

ORLANDO, FLORIDA

It's not unusual for me to forget at least some of the lyrics at every gig, but in Orlando I managed to forget most of the first song. The zip broke on a jacket I was trying to remove just as we started playing, and when the first verse was supposed to start, I was trapped inside the jacket with both hands above my head, trying desperately to wriggle free. Total cock-up. Strangely, the audience didn't seem to mind.

There are other stories — falling off the stage,

On The Road To Ruin

the strange night when lots of very inappropriate people took a strange shine to me, the festival where the interpreter didn't speak any English... etc etc.

Katharine Gifford, Snowpony (London)

Pig Fest

It was a Saturday, in the middle of June, and the weather was beautiful. I was playing with a band in Wilmington, Delaware. The event was called Pig Fest, which is an annual concert to raise money for the needy. Blah, blah, blah. Anyway, it is a pretty big event, and it's well-organized. A ton of people come to this show every year, so we were looking forward to doing a good gig. Well, the bands start playing, the sound is good, and we are amped! Where the fuck is our singer? He finally shows up about ten minutes before we go on, and he is so drunk, he can barely stand. We can't back out now, and a lot of friends, family, and fans have come to see us play. Here goes... We start playing and everything seems to be going OK. Mr Singer is slurring, but at least he can remember the words. Oops, I spoke too soon! At this point the tension is pretty high with the other band members. Two songs later, he doesn't know the words, how to sing, or where he is at! Me and the bass player kept our head to the ground, hiding our faces. We hear no vocals through the monitors, only a growling sound. Our singer is throwing up, hanging off the side of the stage, and his cordless mic is still on! Funny as shit now, but not funny when it happened. The bass player tells me to keep soloing over the groove we are playing, but after five minutes I'm running out of ideas. Finally, puke boy empties out everything in his body, half of it on the stage, with chunks hanging from his mic. Just when I thought it was over... *nope*... We play an original tune, and he says, "If any of you pussies don't like it, you can kiss my ass". OK, now there are about ten bikers in the front row saying they are gonna kick our ass when we get off the stage. My buddy in the audience is also pointing at the radio station van, telling me that we're being broadcast live on the radio. That can't be good. We eventually stopped, we got the hell out of there quick, and the band broke up after the gig. It was a hell of a day at sea. Now I'm with an awesome band called Thunderbrew. We are doing well, having a blast, and we can handle our alcohol during the gigs!

Daran Amos, Thunderbrew (Delaware)

Quintaine's Charge

Rock'n'roll, contrary to my high school fantasies, is not all about naked nymphos and cocaine on every horizontal surface. I learned this long before we ever played a single out-of-town show, but always looked through rose-colored glasses toward that mystical realm where all was possible: The Road. "Once we get on the road," I thought, "that is when all the crazy, unbelievable shit will start happening."

There are success stories from the road. We have played some great shows, done some cocaine and yes, have even gotten laid (this was long before we started going out, honey — at least before we were living together), but these all came later. Our first tour was an exercise in frustration and humility.

It was early in September, about halfway through the tour, and I remember our booking agent saying specifically that the Charlottesville show would be a good one. It was a Saturday night in a college town (University of Virginia) at a really cool place — those of you who may have been fortunate enough to experience this place for yourselves will give a little chuckle — the Tokyo Rose.

"It's a sushi bar upstairs," she said. "You play downstairs in the basement. They are really nice." I remember us looking at each other with a little uncertainty before one of us shrugged our shoulders and said, "We like sushi." This put us at ease. "Yeah... Yeah... Sushi's cool."

Yeah, sushi's fucking cool all right, but the Tokyo Rose is not. The Tokyo Rose aside, I personally remember looking forward to playing in Virginia. Being a native southerner and having never visited the state, I was excited just to go there. The thing about Virginia that I always carried in my head was General George Pickett's famous address to his troops: "Remember, men, on this great day, your land and your homes, your wives, your sons and your daughters, remember your country and your rights, and most of all remember that you... *are from Virginiaaaa!*"

Our charge into Virginia was, much like that of Pickett's brigade at Gettysburg, doomed by ominous foreshadowing from the beginning. I had lost my microphone the night before, the van was running hot, and when we pulled into town we turned on the local college radio station to see if there was any advertising for our show only to find out that Jawbox and some local bands were playing a free outdoor back-to-school festival right down the street

from the Tokyo Rose. We were discouraged but proceeded to the, uhh... club? After all, if there is one thing we must remember, it is that we are... *a rock'n'roll band!*

What little enthusiasm we had left was crushed on our approach to the Tokyo Rose. It appeared, a single lane of parking spaces off the main road, in a small shopping center, a strip mall if you will, wedged in between a dry cleaners and a hair salon. We sat outside for a while and calculated our degree of fuckedness. It took little deliberation for us to decide that we were utterly fucked and we might as well go on inside and deal with it. It was in fact a sushi bar. The restaurant occupied the ground floor and it was just a little too nice to also contain a rock club. The combination just did not work. The club — shit, this is not a fucking club! Why do they call this a club? It's a fucking sushi bar goddammit! The place where bands play was down a narrow turning stairway into a claustrophobic basement with concrete walls, floors and ceiling. The ceiling was low and the stage, however slightly raised, left even less headroom. I am not, by any means, a tall guy, but I was constantly flinching onstage bothered by the thought that I was just about to hit my head.

We go ahead and load in. Up and down narrow stairs. Fun. Fun. Fun. I keep thinking, "this is no place for a bonafide rock'n'roll band such as ourselves. We can't even fit our shit on the stage." I am relegated to a half stack and Jason's drums, not to mention that he can't stand up straight on the stage, hardly allow room for my rig and Marc's. Needless to say, our spirits had not risen.

What does a rock band on the road do after setting up? Yep. Have a beer. What does a disheartened rock band do? Pound beers. Well, we commenced to pounding. Twenty-two ounces (I believe) Kirins (fucking Kirins) at a buck apiece. Years later, when we were telling this story I asked Marc how big the beers were that we were drinking. "I don't know, man," he said, "but they were big. I think like two beers. For a dollar, too. I drank a lot of those things."

We were the first of three bands that night. Even at half power we were apparently too loud. The manager of the place, an Indian guy (go figure) kept coming up to the stage telling us to turn down. "You shouldn't have a 'rock club' completely surrounded by concrete," I kept thinking. Besides, there was a fucking asshole sleeping on a bench right in front of us, so as far as I was concerned it wasn't loud enough. We have always been considered to fall somewhere in between indie rock and hardcore, but to this crowd we might as well have been Winger. They hated us and yelled "You suck" and "Get off metal band." In response we yelled "Fuck you" and "You smell" and "It looks like you've got something on your glasses". You know. The usual shit. We played about six songs and called it a night.

The next band was so indie rock it was sickening. They were so out of tune I thought they were doing it on purpose for the first song. But then they never really played another song because the drummer had to keep coming out from behind his kit to try to tune the guitar for the guitar player. He was only slightly better at it and would take like ten minutes tuning it by ear and then he would give it back to the guitar player still out of tune.

Rather than hit on indie rock girls who would rather read you a poem they wrote than blow you, we just sat there and watched this horrible band in disbelief. I am not kidding you, the drummer had to come out and tune the guitar before each song. Then it still sounded so bad each song would just sort of fall apart rather than end. The alcohol in us had changed our flight response upon arriving at the Tokyo Rose to a full blown fight response. We just got madder and madder as we watched. We could not believe that anyone would yell anything at us and then sit through this, this pathetic display. I remember saying to Marc, "We should have done something outrageous onstage to give these fuckers something to remember us by. We have to leave an impression." Marc said, "I'll take care of it."

During the next tuning interlude, he went up on stage and grabbed the microphone, stepping all over the guitar player's effects pedals and cords in the process and said, "Ladies and Gentlemen of Charlottesville, how about a nice round of applause for Dicks-Are-Us. Dicks-Are-Us, Ladies and Gentlemen! Come On." Jason and I were laughing hysterically, but Marc did not stop there and the tension rose. "Come on goddammit," he said, "Dicks-Are-Us came all the way here from down the street to entertain you folks tonight, now give these pussies a nice round of applause. Dicks-Are-Us... Thank you!"

People did not know what to do. It was beautiful. People stared at us like we were assholes but you could just tell they didn't want to fuck with "that crazy guy". After the band got off stage the drum-

31

mer approached us and said something to the effect of "We're all musicians here, why can't we just all get along?"

"Yeah, fuck you," Marc said, "you guys can't even tune your instruments."

"You sure do like saying 'dicks' a lot," the drummer said. "Are you a fucking homo?"

Marc grabbed him and started humping him, going round and round in a circle, saying, "I'll show you a fucking homo." That's when we almost all got into it. But the manager came over and broke it up.

On our way out, Marc gave the guy a Quintaine shirt to make nice. Jason and I thought it was a waste of a perfectly good T-shirt.

Rob Dixon, Quintaine Americana (Boston)

King of the Flashlights

Las Vegas is the new Mecca for garage bands. There's the big 'Las Vegas Grind' where the roster of bands playing there reads like a "Who's Who" in lo-fi, revved up rock'n'roll. Unfortunately, the only time we ever played in Las Vegas was 1989 and people there probably thought a garage band would valet park their expensive cars.

Touring is difficult, touring when you are sick is hell. This gig was smack in the middle of a problematic trip down the West Coast where each one of us took turns discovering a vicious flu bug. We puked and shit our way down the coast until it was time to head to exciting Las Vegas. This time it was KP's turn to experience this flu fun. The temperature was 100, but our wild show-stopping frontman was huddled in sleeping bags, on top of the equipment box in the hot van, shivering. The only place we should have visited was the hospital. Instead we kept to the schedule and wound up at our next show. Can't let those fans down!

Our radar for a bad gig has gotten pretty sophisticated over the years. Even though it was early in our career, we could smell this one coming a mile away. The place was a brand new venue (often the kiss of death) in what used to be some ill-fated taco restaurant that went belly up and was now converted into a "groovy" club (possibly by the same geniuses). It was a cement block building off the main drag sitting all by itself with a huge parking lot. We were greeted by a bunch of Miami Vice wannabes who might as well have had "asshole" tattooed on their foreheads. The main guy needed a crown to go

with that tattoo as he was definitely the "King of the Assholes". Even though we were only the opening band out of four, the management was obviously disappointed when we knocked on the back door. They suddenly snapped into that "way too important for their own good" routine that is always such a joy to behold when dealing with any club morons. It's especially irritating on tour. "I haven't eaten, I haven't slept, I haven't had a shower, I haven't taken a decent crap in over a week and you want me to snap into obeying some stupid arbitrary rules you made up last week? Oh yeah, that'll work."

But even more interesting than their Nazi-like "obey all rules" mentality was their interest in their flashlights! Yes, you could even say it was fascinating. All the time we were there they spent way too much emphasis on who had their flashlight, who didn't have their flashlight, where their flashlights were located... Obviously the flashlights contained something more valuable than mere Eveready batteries.

If we thought the place wasn't going to be our dream gig in the parking lot we knew it for sure when we entered the building. Apparently some interior decorator experienced a major freak-out deciding that fluorescent day-glo paint would give their club that "oh-so-groovy" New Wave hip motif that was all the rage several years before. It had that "just been painted" look and smell. The paint was still wet on the walls. Overzealous painting combined with backlights made this huge club a nightmare in sickening colors. Waiting inside for even a few minutes brought on actual physical illness. At least it was air conditioned. We had to make the choice: roast out in the van or be "cool but ill" inside the club while you got the big stare-down from the meathead staff. Meanwhile KP was still "freezing" outside in the 120 degree van.

Because we were the first band it was our duty to be the guinea pigs for the always dreaded sound check. We have since learned that a good way to avoid scenes like this is to refuse to do sound checks. It took more than a few of these gigs to teach us that lesson. As we loaded the equipment out of the van and onto the stage we realized that the sound system was probably newer than the stinky fluorescent paint.

Nobody seemed to know how to use this new "strange and complicated technology". They'd mastered the flashlights but flunked the PA system. Like dutiful school kids going to PE class we got up on

stage to individually play our instruments for the mic test and two sound check songs. KP was desperately trying to hold it together. The sound guys (more than one needed to operate this complex system) started having us play our instruments. They couldn't get the mics to work, everything was feeding back, Kahuna's amp was "buzzing too much", they were arguing amongst themselves, it was falling apart. One of them decided that during my drum check we should explore all the ways to play a set of drums, just in case the next three drummers might do the flam or parradiddle that I never bothered to learn. As so often happens the sound check turned out to be more of a critique of my minimal drum stylings than a test or the equipment. After about twenty minutes of drumming the last straw was when the guy told me to do a shuffle on my high hat. Not only would I not be doing a "shuffle" during the show, or ever in my entire drum career, I wasn't going to attempt one for him. Explaining to them that I very seldom even touch the high hat would have been a waste of breath.

So the "sound check" dragged on and on and on and on. After over forty-five minutes of this torture the soundmen said "OK, we'll take a ten minute break and then resume the sound check". The sound check had already lasted about fifteen minutes longer than our set and now we were taking a break to get back up and relive the whole horrible experience all over again. As Kahuna sat at the bar drinking what would hopefully be enough beers to rid his memory of this whole unpleasantness he heard a strange sound coming from his Fender Twin Reverb. He turned around to find three of these brilliant technicians, headed up by King Dumbshit, fussing with the back of his amp in an attempt to "repair" it. They were in the process of poking around at the wires and tubes. Thankfully, Kahuna's reaction got us out of part two of the sound check from hell.

When we saw the crowd pour in we knew we were in trouble. The garage crowd they weren't. A sea of pastel colors floated by us like a nightmare. Shorts and crew socks, polo shirts and sandals for the guys and skimpy strapless summer party dresses for the ladies. They were at the height of that hour's fashion. It appeared as though some kind of tourist prom was meeting in Las Vegas. Theirs was the world of beauty parlors, sports bars, and new expensive cars... the sick smell of cologne overpowered the fumes of the fluorescent paint. Oh yeah, these peo-

ple were going to love seeing a half-dead sweating/ shivering six-foot-five zombie blowing Henry Mancini covers on his student model sax! Nowadays we would have left. Back then, well, how could it get much worse? Needless to say, they hated us. As we have since learned, the longer the sound check, the worse the actual sound at performance time. Our set consisted of PA feedback and panicked sound guys trying to make it stop. The audience was so impressed they started throwing ice from their drinks at us... and that was a high point.

We got out so fast I'm sure we'd win gold during the "load out" competition at the Rock Olympics. As we got our money, the King of the Flashlights came out to the parking lot to beg us not to hate him and his club. Those Eveready batteries he'd been snorting were finally starting to kick in. He was just about crying... and frankly we could have joined him, all except Kahuna who just wanted to hit him with a loose brick he found in the parking lot. "Let us out of here!"

Frank and Sammy, Louie and Keely, Sigfried and Roy... the excitement that is Las Vegas? It was just a little too exciting for us.

Bon Von Wheelie, Girl Trouble (Tacoma, WA)

Hillbilly Disneyland

So, it was Crash and Burn's first tour. We went out with Weedeater for a couple of weeks down south. We were on our way back up the coast when it happened. We were in South Carolina and Jef had to use the can so we stopped at a gas station in some pissant backwoods town. The floor of the van was pretty hot but we hadn't had any major trouble with it. So we pull into this gas station, Jef gets out and goes to the can, Phil and Matt (our roadie) go into the mini mart, and Bombo (our old drummer) and I stay outside. Bombo had just started pumping the gas when he said, "Is that smoke coming from the front of the van?" Sure enough, there was smoke rising out of the hood, so I had him pop the hood and there was a huge ball of flame underneath the engine (which would be pretty crazy anyway, not to mention the fact that we were pumping gas right then, and this town consisted of a couple of gas stations and fireworks places, so if we blew up we would've wiped the whole fuckin place off the map — we could've been on CNN as the band that destroyed a town). So Bombo and I run into the gas

33

station and yell that our van is on fire, and we need a fire extinguisher. The attendant lazily waddles over and says, "Here she is, you boys know how to use it?" He didn't seem to realize that we didn't exactly have time for talking, so Bombo ripped it out of his hands and ran outside and put the motherfucker out. We then pushed it into the parking lot, pulled apart the front and realized that it was completely charred. We called a tow truck and they dropped us off at south of the border (it's like hillbilly Disneyland) because that was the only motel even remotely close. We got a room, stocked up on as much hooch as we could afford (I believe it was two cases of some crappy ice beer, a couple of bottles of Mad Dog, and a bottle of Thunderbird) and proceeded to wreck the place. We did flips from the dresser onto the bed (Bombo was doing back flips by the time both beds were broken), and just all around took out our frustrations on the room. We even found some weed in the room, which was pretty cool. Then next day we sat around shitty small town No 2 while our van was being worked on and ate fried everything because folks down south love to fry everything. After kicking around all day our shit was finally fixed (fixed enough to get us home anyway) and we drove back home after missing our few last shows and way in debt.

Bill Brown, Crash and Burn (Boston)

Mullette

We book a place called "Black Cats" out in South Bend, IN. The only vehicle we can afford to fit all our gear in is an old '83 wood paneled Chevy station wagon. This car was on its last leg when we took off... so as soon as we pull off the expressway (after a three hour trip from Chicago) and stop at the exit toll, it sputters and dies, for good. We manage to shove it off to the side of the road, pay our toll (even though I think we shouldn't have had to pay, since technically we *walked* through the toll). So much for the rest of the tour... at least we were gonna get South Bend taken care of. The kids that ran (and lived at) Black Cats turned out to be very helpful in getting our stuff picked up in a couple of their own cars, and getting our crippled wagon to a hotel parking lot. The show went on... the bands weren't great, but the crowd was glad to be there, at least. Somewhere during our set, a drunken brawl erupted between two close friends upstairs (which are always

the worst of fights) that resulted in one getting a whiskey bottle smashed over his head. Glass flew and cut several others, blood was copious... on the floors, the furniture, the walls, what have you. The kicker is not only did he have Hepatitis C, but this is where we were to spend the next night. So, a trip to the tattoo parlor to pick up some Virucide, some scrubbing, and a whole lot of drinking ensued. We wound up tagging along with the Black Cats gang to the bar, where we met a middle-aged *mullette* (mullet bearing lady) who showed us her pierced rack several times (despite her age, the boobs were pretty great). The next morning, one of the boys we were with got fired from his kitchen job for being drunk and dirty in front of the owner's nephew. Otherwise, things were pretty smooth sailing. We ditched the car, left the gear for a later date, and hopped on a train back to Chicago. The car wound up in a demolition derby, and the dog at Black Cats pissed on our stuff.

Riff Randalls (Vancouver)

Play Batman

You just haven't lived until you've driven across the US in a van and seen Niagara Falls, the Rocky Mountains, the South Dakota Badlands, and Columbus, Ohio. I don't know what it is about Columbus, but we never leave that city without a story. Our bass player, Mason, has had a tough time there, having been electrocuted by a low hanging and broken light on the stage, which literally knocked him off his feet in the middle of a song. I saw him go down out of the corner of my eye, but he missed about two notes and was back up and rocking out. He's also played in Columbus through food poisoning, somehow without collapsing. Yep, he may not look it, but he's a pretty tough dude. But for me, Columbus is really all about Don. The first time we ever played in Columbus, we were introduced to Don "Play Batman". Don is an older fellow than you might expect to find in a smoky rock club; a bit on the round side, with missing teeth, a baseball hat, and a love of the Batman theme song. He appears at most weekend shows at a club called Bernie's. Don will kind of waddle up to the stage as a band is setting up their gear, flash his toothless grin, and grunt, "Play Batman, play Batman," and hope that the band will play his request. If he's really lucky, he might even get to go up on stage with the band. We never pass up an

opportunity to play Batman with Don, and we always show up in Columbus with a new version ready to go. We usually dance while Don groans into the microphone, "Nanananananana Batman!" We're thinking about asking him to go on tour with us.

Meg Wendell, Method and Result (Philadelphia)

Throo A Rod

About three years ago, I had booked a gig at a club in Atlanta for Saturday on Labor Day weekend. A month or so before the gig, the club closed down due to IRS problems, and turned all their shows to a larger, but less popular club. We're based in Nashville, so Atlanta is just a short four-hour cruise down I–24, right? *Not this time.* We have two vehicles, a van with a couple of the guys, and my wife and I driving our car. Everything goes fine until we get to Calhoun, GA and stop for gas. We gas up, get cokes, etc, and get ready to go. The van starts making this horrible noise, and everybody is convinced that it's thrown a rod. As luck would have it, there is a Chevy dealer with a garage right behind the gas station,

hour behind us in Chattanooga, and tell him where to meet us. We then sit down and, figuring the gig is off, start getting seriously drunk. After the booking agent met us, he starts calling all over Chattanooga and North Georgia trying to rent a van. Nothing, it's Labor Day. Then my bass player's girlfriend pipes in, "Wait, my sister lives in Chattanooga! Her boyfriend has a truck!" So she calls her sister, and her boyfriend comes and gets the gear. In a pickup. The entire, legless band get the car with me and Anna, and we proceed to Atlanta, five or six of us in a Cavalier, where we get to the club (which is a three story, cavernous place) too late to get a sound check, and go to the dressing room. As it turns out, Blondie is playing at the Omni, so we have twelve people at the gig. Complete death, plus we're already getting hangovers from our stop in Calhoun. Anyway, the club actually honored our guarantee, so at least it isn't a total disaster, and we go find motels and get something to eat. Now, the guy that drove us to Atlanta had to go home, so he drops the band and all the equipment off in a motel a few miles from Calhoun. Me, Anna, my bass player and his girlfriend get a room in Calhoun. We wake up Sunday morn-

For me, Columbus is really all about Don. METHOD AND RESULT

and we manage to push the van (full of equipment) to the garage, where they listen to it, say "Yea, sounds lahk ya throo a rod awright!" and tell us they can have it fixed by Wednesday, as it's 5pm, and they are closing for Labor Day. We tell them to forget it, park the van, and go to this steakhouse across the intersection. I call our booking agent, who is about an

ing, go back to this steakhouse place from the night before, and start making calls trying to find a trailer on Sunday, Labor Day weekend. And something to haul it with. After about three hours, we find one a half hour away... a *huge* Uhaul truck, and a trailer. We get the equipment into the Uhaul, and begin to push the van onto the trailer, but it doesn't fit, so we

have to back it off ,and take of the running boards. We finally get the van on, and make our way home to Nashville, and Greg takes it to the shop that does his repairs. They look at it, tell him his valve cover had come loose, and fix it in five minutes flat, at no charge. This, after we had spent all the money from the gig on motels, renting the truck, etc. The only good thing about this gig was I only went in the hole for $60 and nobody died.

On the way back from Atlanta, we decided to stop off in Chattanooga for the night, it's a pretty cool little town with some cool clubs. Well, as it was a holiday, pretty much all the hotels were full, so we drive around for about an hour and a half looking for one (we could have made it home to Nashville in that time) and finally find one with two rooms. I go to pay for the room, and I can't find my wallet! We retrace our steps, going back to the restaurant we ate at, gas station where we stopped, etc. Finally, after about another half hour of driving around, I checked one more place we had stopped, and as I'm getting back in the car ,I see one little corner of it sticking out between my seat and the door of the car. We checked in, and immediately went and enriched the owners of the Pickle Barrel (Chattanooga's premier hangout bar) considerably.

Cheetah Chrome (Nashville)

Dutch Courage

Travoltas asked us to tour with them. It was our first tour ever, and Travoltas was one of our favorite bands, so we were hyperactive and drunk all the time. I think I could write a good story about every gig we did, 'cause we really didn't care about anything or anyone except about havin' a blast after doin' a show. Some of us took all kinds of drugs, some of us fell in love, and some of us just tried to keep things together in good hope that the rest of the band would be able to play the next night. Touring in Holland is great, because most of the clubs prepare good meals or order some pizzas. This is really important because, even when you don't drink or do stupid things during the night, you need that dinner more than you *ever* needed one! I remember doing the last show and really being out of my mind because I was totally fucked up. We had a great dinner and I think I couldn't have played that night without it. Some said it was one of our best shows... Well, I wouldn't know! Anyway, we had a gig somewhere in

Enschede during the tour, I think the club is called Atak. We were in a real party mood and people at the club were nice. They gave us a good meal and a refrigerator filled with beers and breezers. After doin' the Riplets show and watching Travoltas, some of us smoked some pot and some of us ate mushrooms. We were having fun at the club, just hanging out backstage, walking the stairs and trying to find the toilets in the dark... but we had to go somewhere else. There was this kid who really wanted to carry my bass guitar and who knew where to go, so he showed us around. The first thing we saw was this big, black church. We felt a little 'unheimisch'. Then we saw this fast food restaurant called Febo and there were a lot of kids hanging out there. It was really strange, because we couldn't understand why all those people were hanging out on the streets in front of a fast food restaurant. It was closed, but you could get food from little boxes in the wall that you can open by putting money in, but there were just a few people eating. Anyway, we thought it was pretty sad. Walking around wasn't any fun and we couldn't find a bar to hang out at. The kid wanted to go home and I had to carry my stuff myself, which bothered me 'cause I was bummed out already. As we walked back to the club we passed a group of guys who were drunk and fucked up by speed or cocaine. We ignored them but they said something nasty to our sweet Riplet guitar player L A Sun. The sound engineer of Travoltas told the guys to shut up but after that things got worse. They started pushing us around. A friend from Rotterdam who was with us that night tried to protect us (The Riplets) 'cause we're girls right? And girls need protection right? But the adrenaline ran through my body and I started to push away the idiot who was saying real stupid things to me. I don't remember exactly what happened then, but one of the guys took a knife out of his jacket, which really scared us. We started walking away as fast but as cool as we could. The fuck ups followed us and started spitting on us. They didn't scare me but the knife did! We tried to go somewhere crowded but we couldn't find a safe spot so we walked in the direction of our hotel. All of a sudden they were gone. I think we walked fast and long enough to make the fuckers tired. We took a cab to the hotel. Back there I took a long shower, smoked a joint and when I was in bed I couldn't stop laughing for an hour or two...

Jane, The Riplets (Rotterdam)

No Sleep To Be Had

We were on tour with Glazed Baby from Providence and La Gritona from Boston. The show was in Old Town, Maine. I don't remember the name of the club. It was small, and run by very young skate kids. And it smelled God-awful. Before we played we went to some guy's house for pasta. It was scary. They were all talking about incest and guns. And watching American Gladiators and Springer.

Showtime.

Nothing really remarkable here. We all played, there were about ten kids there, and it was over. After, all the kids got out their beer. But we didn't get any. These kids were about twelve- to fourteen-years-old. And they got out their skateboards. And proceeded to skate around the place, which was very small, till about seven in the morning. Mind you, we're all pretty old, so it was pretty disturbing to be watching these thirteen-year-olds skating around, drinking beer, having a blast, when we had no beer, no money, and no place to sleep. And a gig in Worcester, MA, at three o'clock the next day. And a long drive to get there. We were supposed to sleep at the club, on the stage. But there was no sleep to be had. So at about 5am Zak and I decided we'd try the van. But it was raining, and there was a leak in the roof. So three hours later we woke up, soaking wet, and it was time to drive. It was one of those nights that really made you question the life you'd chosen.

Las Gritona broke up two weeks later.

And people ask why Craw doesn't tour anymore.

Will Scharf, Craw (Cleveland)

The Trouble With Paw

When I think of the many years of being on the road with bands, there is but one band that took me to the limit. Back in the early nineties right after Nirvana hit the mainstream, majors were all looking for the next big grunge band. The bidding began for the Lawrence Kansas foursome that Butch Vig had touted as the band to watch out for. Vig's attorney LA sleaze ball Bill Berroll started shopping and the frenzy began. Newsweek wrote that half the A&R community was at their set at SBSW in Austin. It was a lot of pressure for four boozers from a small college town. Nonetheless A&M Records Bryan Huttenhower signed them and the journey began.

OK, let's cut to the chase. Despite being an outstanding live band, Paw never became a household name. They had a nice run of touring and a minor hit single in "Jessie", but what the band became famous for was the debauchery and chaos they created on the road. As their label rep, I was able to take part and witness some real insanity. There was always plenty of booze, drugs, and sleazy women around.

First off, I couldn't even show up to a gig unless I had a bottle of Bushmills and of course I was obligated to take the first slug every night. God that shit is horrible. Singer Mark Hennessey was one of those dudes who was not only a dirty fuckin slob (and I mean this in the kindest way) but was lovable enough to score chicks with ease even though he would be his disgusting self around them at all times and that was a rather dangerous combination. Right after the band did fifteen dates with Social Distortion, I was asked to join them in Cleveland for ten dates with The Doughboys. When I arrived in Cleveland, there was a rumor that the band might be banned from some venues because they almost burned down the Blind Pig in Ann Arbor the night before. Turns out drummer Pete Fitch had this new thing were he would pour lighter fluid all over his drum set and start it on fire during the last song. Well, let's just say the roof caught fire in Michigan and the club flipped out. Despite being told not to, of course Pete started his drum set on fire again and the cops the showed up and we somehow got out of the place in one piece. We ending up getting really fucked up after the show and all I remember is that I woke up with two very young naked chicks in my bed and guitarist Grant Fitch banging on my hotel door at 9am with drugs and a bottle of booze ready to go to Pittsburgh. Albany was fucked as well. I couldn't find any Bushmills and had to show up with a bottle of Jack instead. We got totally hammered and after Grant refused to leave the stage and played the riff from Hard Pig for thirty minutes after everyone had left the stage, he came into the crowded dressing room and proceeded to start kissing me and I don't mean little smooches the fuckin brute who was a strong boy was had his tongue in my mouth and I couldn't get loose. Even though I had a very hot Polygram chick with me that night in my room ready for some action, I spent most of the night pucking my guts out. Two day hangover.

Unfortunately I missed one of the great Paw back-

stage moments when a meet'n'greet with the distribution company turned into and eat'n'greet back stage at a show in Baltimore. Apparently Grant stuck a banana up his ass and with it dangling out drummer Pete took a bite of it. This of course with a room full of industry people in attendance. Not to be out done Hennessey was thrown out of his hotel that same night for trying to force his mattress out the window. A couple weeks later in New Orleans after a great set at Tipitina's opening for The Reverend Horton Heat, we really started partying. Hennessey and I picked up three Louisiana chicks that had had lots of drugs and were crazy. We were in a bar and one of them gets up on a table and starts stripping down and one of friends decides she wants to out do her and starts trying to have oral with her right there. We ended up getting thrown out. He took two of them to his room and I took the stripper to mine and after the drugs ran out, low and behold I wake the next afternoon having missed a flight to Houston with Hennessey banging on my door with nothing but a towel on wanting to get some from my stripper friend. He was out of control and the cops showed up and next thing you know they are interrogating me about the hotel sign having a bottle thrown through it. "I don't know how that happened officer." In San Antonio, the band opened for Cheap Trick at a festival. We hung out and partied with Tom Peterson and of course when you are in Texas the women are plentiful. I was out in the crowd watching Cheap Trick with this dude who was a friend of the band's from Lawrence and we had these two honeys that we were making out with each other and Grant comes along and we were so wasted he steals them from us. The next morning he shows up with them, leaves them in my room and of course they need a ride to east Bumfuck, Texas. In Houston, I could no longer stand the fact that Hennessey was wearing the same white dirty T-shirt for the tenth day in a row so in one of my boldest moves I decided to tear the shirt off his back. Big mistake. He started tearing everything off of me and was beating the shit out of me to boot. At least I got that dirty, smelly shirt off of him. Oh those Paw boys were fun. They certainly knew how to party. After doing about twenty-five dates with them, never sober, always high, plenty of sex when I was straight enough to do it, almost arrested but never quite in jail, and enough receipts to get the A&M Records financial office to ask me what the hell I was doing

out there, the fun ended, but the memories live on...
Steev Riccardo, Twisted Rico Management (Boston)

Mobius Trip

We had been on the road for only about a week when our van suddenly began to take a massive shit (fuel pump). It had treated us great up and until this point. We made a little pit stop and did our normal crap at the truck stop in NC. Our destination was Danbury, CT to play with one of our favorite bands, Big Top Low. We eventually got the van running again after Shawn (our drummer) puked his brains out behind the statue of a Bob's Big Boy restaurant, and I passed out from dehydration from drinking too much in the parking lot of Sunoco. We were back on the road. We arrived in Danbury and played a great show, lot's of beer, a couple naked chicks and a whole lotta rock went on. Well, we eventually left the club and were on the road again, unfortunately our roadie (and driver) Magz, drank a few too many oatmeal stouts, and drove us the wrong direction for about an hour (we were all passed out in the van during this) and then he turned around and drove back an hour. To make a long story short, we left the club at 3am, and I wake up at 5:30am about a mile from where we just fuckin' played in Danbury, and Magz says, "Hey bro, can you drive the rest of the way?" I say, "All right, where are we?" Magz's reply: "I don't know." I say, "What the Fuck do you mean you don't know? Well, what road are we on? Magz reply: "I dunno." At this point, I just wanted to go back to sleep, so I said, "Well, how the fuck did we get here?" Magz's reply: "That road." Haha, oh man, well, we finally found a hotel to stay at and sleep for about an hour and a half until we had to get back in the van and drive to Philadelphia for a show the next day. The van actually made it to Philly and we had it repaired. All in all it turned out to be a funny event, and Magz will never live it down, cause every time we are wondering about directions we just tell him "Don't worry, if we just head this way a couple hours, we'll hit 95 south and be on our way."
Moody, Dead 50's (Philadelphia)

Nightmare On Arch Street

It seems every time we have played in Philly, the "City of Brotherly Love", we get lost... maybe there

is a message here. And this time is no different. After driving around for a while we finally found the club. We were fortunate enough to get parking right in front! Yeah! Every band's dream come true. This seemed to be the only good fortune we had all night. The club we played that night is called The Balcony. It is the small, but decent-sized room that is upstairs and off to the side of the main room, The Trocadero Theatre. When there is a big show at "the Troc", they use The Balcony as the after-show party room. We ventured up the steep staircase to get the skinny, you know, the details for that night's event. The guys in the band were already scoping out how much fun it was going to be to hump the gear up and down those stairs, always a plus at any venue. Thank God we had our trusty "Roadie to the Stars", Ames Evil with us to keep the balance. We found the sound man and asked him where he wanted us to put our gear. This guy was anything but in the mood to do his job that night. One simple question, and the guy was already taking his frustration and bad attitude out on us. We were told that he was pissed off because he had to work in the "small" room that night, and he was used to working in the "big" room. His Highness was not pleased, and the bands were going to pay. We moved the gear upstairs and decided to not stoop to this guy's level and maintained an optimistic outlook for this evening's event. One of life's little rules, if you're going to be in a band, is to try not to piss the sound guy off, or tell him off, until after the gig… in this case, it did not matter either way, it was a no win situation. We decided to go and get something to eat and get ready for the show…

Upon returning, the club was quickly filling up with people. There were a lot of old faces and a lot of new faces. I got to meet a lot of people that I had only known through email. It was gonna be a great night! Our friend Pete Santa Maria's band The Stuntmen were getting ready to go on stage. Pete had been out to LA and had seen our band before, and was excited that we were playing together in his home town. We would be staying the night at his house, and we were very grateful for this. The Stuntmen hit the stage. Everything was great! All but one thing, of course. The sound man was doing a terrible job… the mix of the instruments and the vocals (both lead and backup) was awful. Even though people would go up and tell the guy about the sound he could not have given a rat's ass… but The Stuntmen still pulled it off.

We were next, and I was getting a little skeptical at this point, feeling that we were headed for trouble. There is nothing you can do about a sound guy who needs a course in anger management, so we were just gonna have to hope for the best. We hit the stage and were kicking ass despite this guy's bullshit. Situations like this only inspire me to work harder at having a great show just to spite the motherfucker… and after all, it's all about the fans anyway. We were about two-thirds of the way through the set and we were kicking ass when this guy approached the stage. He was six-foot-five and looked very scary and very angry. His head was shaved and it was dripping with blood. He stood right in front of me shooting the finger and yelling obscenities like "fuck you slut, you bitch, you whore!" etc. Oh, great! This was all I needed was some lame ass motherfucker twice my size, dripping with blood, in my face, harassing me. Instead of ignoring him, I let it get to me as a distraction and reacted by jumping into the audience challenging him to fuck off! The dude was even bigger than I thought, and was screaming right in my face now, and I was screaming back. I was hoping that if a fight broke out between me and this guy that the fans would jump in and whip his ass because I knew there was no way I could do it alone! Seeing how I am not a real big fan of bar brawls or getting my ass whipped, I returned to the stage and finished the set despite his bullshit. Where were the bouncers to take care of this? As soon as our set was finished I ran to find one because I wanted this motherfucker out of my sight. When you work so hard to get to the point of touring and you have one half-hour to do the fun part, which is being on stage, the last thing you need is one person fucking it up for you. I had him thrown out of the club.

A couple of minutes later, this really cute little punk rock girl came up to me and asked me why I had had her husband thrown out, that he had not meant any harm, and that I was his wet dream. What the…! I said, "You mean he was flirting with me?!" She said yeah, that they had read in one of many press reviews that I was the female G G Allin and that I was a huge inspiration to them, but after seeing us play, that I was not like G G at all, that I was more like Iggy Pop and Wendy O-Williams (the other comparisons in the press) and that they both love me. I shook my head in amazement. She was so sincere about the whole thing so I told her to go and

find her husband and I would get him back in. I figured the guy could not be all bad to have such a sweet wife that loved him so. I also thought this was a good idea, seeing how our van was parked right out in front, and I did not want to risk some nutcase with blood dripping down his face vandalizing it. That's all we needed at this point.

Well, I got the guy back in. I had some questions for him anyway. He apologized for being an asshole but thought for sure that he was just paying respect to the G G Allin comparison he had read about. I told him that I thought he was some Aryan brotherhood skinhead that had been out head butting people and wanted me dead or something. Where had he gotten the bloody head anyway? He told me that he was in a band called The Woodsmen and they had played across town earlier that night and that during one of their songs, he wraps barbed wire around a drill bit; he then turns the drill on and holds it to his head, hence the blood... OK, that explains it, now I understand... Jesus Fucking Christ! I think G G Allin would have appreciated this guy! I thought for sure he must have been fucked up on something but he said he used to be a heroin addict but was now clean and sober. Thank God! Imagine what he would do if he was still drinking and doing drugs? Or for that matter, imagine what I might do if I was still drinking and doing drugs? Anyway, he asked if The Woodsmen could tour with us; that they had been banned from all the clubs around there... hmm, I wonder why! It only goes to show how the press can make you look like something or someone you are not and that some fans want you to live up to this... even if the impression is not true. I love getting press, any press, and hope I will always live through the consequences. What is rock'n'roll without a little danger anyway?

All in all, the night went well and we met a lot of great people. There were no more mishaps until we were loading out. The sound guy was pushing and shoving all the equipment around at the end of the night and a bottle shattered. He went up to our bass player and accused him of throwing a bottle at him and started another fight. That guy was hopeless. We left the club and went over to Pete's house to crash... some skinheads started to fuck with our van... but that's another story. We got out of Philly alive and swear never to play there again, but you know what they say, "Never say never".

I love to tour and every town has its own special little thing that you remember it by. It is a lot of hard work and long drives. Even on the nights when things get a little out of hand, the adventure is worth it and I won't trade it for anything. Sure beats the hell out of staying at home worrying about the bills.

Texas Terri Laird,
Texas Terri & The Stiff Ones (LA)

Kilted Yaksman

Mercury Pusher headed out for a brief jaunt into Canadian waters last Thanksgiving, but, as none of us are very strong swimmers, we decided to drive instead. After a night of fun at Flint Michigan's Local 432 (all-ages club downtown Flint) we set our sites on the great northern wilderness (Toronto). Now, we'd done this before and we knew the drill: "Pull over, get out of the van. Got any guns? Drugs?"

"Why, you want some?" An attitude like this never gets you anywhere and coupled with that fucking scarf Gary was wearing the ol' Pusher found ourselves in Customs, hot damn! It took nearly two hours for the Canadian kilted yaksman, or whatever they're called, to determine that we were a danger to the national economy and possibly to public safety (Scarfboy has a record) and we were flatly denied admittance. Three shows, a radio spot, and a magazine interview down the tubes.

What's worse is that the American border patrol on the other side of the bridge were kind of suspicious seeing as how the Canadians obviously considered us a threat to national security and all. To their credit it only took them an hour to search the van and some nice lady gave us twenty dollars. We used it to buy a case of the Yeti (Milwaukee's Best Ice, swear by it) which is the only thing that was good about the six hour drive back to Dayton.

Dan Corcoran, Mercury Pusher
(Dayton, Ohio)

Fredonia No Longer Exists

August 17 in Fredonia, OH. The town of Fredonia no longer exists. This is the first problem I have with tonight's show, a two-day punk festival in a big field in or around the exact center of nowhere, Ohio. Let me explain: Fredonia no longer exists, as a town. The few buildings and houses that were Fredonia have been swallowed up by Newark. So my directions are leading us to Lafayette Road in Newark,

Ohio, which is nowhere near where we need to go. By now it's dark, and after driving up and down the same road a few times in search of Lafayette, we head back up the road to a gas station for directions. Some girls buying beer and smokes for a big night out tell us how to get to Fredonia, so we try their directions, and find it's a gravel road we're looking for. We eventually find the place, and the promoter says, "Good, you're here, have a beer, we had a late start, so you won't be playing until 2am or so." No problem. We dig some good bands, and sit through some bad ones. When it comes time for us to play, the two guys doing sound start tearing down the PA! I go up to one of them and ask what's going on. The guy gets right in my face: "Fuck you! No more bands tonight, we've had it, we've been working all day, the cops are gonna come, it's too late!" Then he goes on with, "I spent a lot of money on equipment, I've been out here working all day…" So I respond with, "All right, we've been driving all day, and we spent a lot of money on gas and tolls." He and the promoter start arguing, then the band who is supposed to play after us gets in on it, and it gets out of hand. The thing you have to understand here is that the rest of these people have been here since noon, drinking like a bunch of English school kids, and by now, the alcohol in their brains, combined with the hours of exposure to the sun, has turned toxic, and induced a kind of dementia and rage, like something from a comic book. The kind of rage where someone could end up dead. The argument becomes more heated, things start flying. For a moment, I am tempted to sit back and watch it all go down, maybe even take notes, like a psychology experiment. But then I remember that we came here for a purpose, to play the gig. We drove several hours, searched a few more for a gravel road that doesn't exist on any map, and finally made it here, not to turn back without playing. I see the disappointed looks on the faces of the guys in the band, and remember that I always say something about doing anything for these guys, so maybe it's time to prove it. The sound guys are wasted like everyone else, no point in talking to them. I can't tell from talking to the promoter, he's standing, at least, and he promises that we will play the show. I give him the incentive plan: "Hey, we drove all day and spent some money on gas, which you guaranteed us we would get back at the show. So here's the deal, you're going to pay us, whether we play or not." This changes

everything. There are five of us, plus Steve-o's enormous friend, who happened to come along. I see them setting the speakers up again, and we're on. One of the sound guys is still drunk and tries the "No one touches my equipment" line with me. In his current state, it sounds more like: "No un tusssssess mieee ekimmmmeennn…" I push him aside, and pry his hands off the console. The boys play the show and the crowd loves it. Well, these Midwest farm boys are smarter than I thought, even when they're absolutely slaughtered by booze. I'll never really understand what happened that night; my only guess is that it must have gone something like this. The guy taking the money at the gate owned the land. There were two promoters, the one I mentioned who assured us we would play, and one other guy who just seemed to get in people's faces and piss them off. At some point, he and the guy who owned the joint must have gotten together, and an antique, Edison model light bulb must have gone off over their heads. Ding! We have all this money. All of these bands are drunk, no one is going to remember anything in the morning. The sound guys are drunk. Who is going to ask for their pay? *I did.* Both promoters say they don't have the money. Then the first one tells me that the guy who owns the land has it, but he's gone home, we'll go to his place in the morning and get it, not to worry. I worry. Then the other guy flat-out says, "You're not getting paid". Fuck you. I tell them, "We'll see in the morning", and decide it might be time to prove it again. Morning comes, I wake the first promoter from his tent. We go to the guy's house, wake him up, and I take the money, plus extra for our trouble. I'm generally not a malicious sort of guy, but one thing I won't allow is for these motherfuckers to stiff us on pay. So you pay extra, fuck you. At the end of the night, we're all friends, you just have to know what you can and can not get away with.

Steve (The Sound Guy),
Flour City Knuckleheads (Rochester, NY)

Gray Haired Groupie

We are a three piece band called the Low Budget Screamers from Switzerland and consider our spare time occupation as a serious hobby. We want to be good but it has to be fun, too. Last year we had this idea to take off from work and going on short musical road trip across Europe. Because we do not have

a record deal nor a big management in the back, we had to organize it all on our own. Through the internet we contacted bands and clubs, and at the end we got a two weeks tour together with gigs in Germany, Belgium, Sweden and Finland. We were very much excited about the tour since we had been told by different people and also some promoters that Scandinavians like the kind of heavy southern-style blues rock we play.

It was on Wednesday May 9, 2001, and the three of us had already been on the road for a few days in our fully packed Chevy van with trailer. Although gas prices were almost killing us all the way up to Scandinavia we had great fun on our High Octane Tour as we called it. Just to make it look like real, we designed also some laminated "All Access" backstage passes. Well, people don't really need to know that we are not famous, do they? That Wednesday evening, we were able to get us booked at a place called Fredmans in Uppsala, Sweden. The club is quite big, featuring three stages, and it is fully equipped with a powerful PA and lights system. From their website we had seen in advance that some really famous rock acts had already played there before. No doubt we were excited! Money-wise, the deal was one of that common 'you-get-the-cover-charge'. However, since we looked at our tour as 'active vacation' we didn't mind taking the risk. At least, the promoter paid for the hotel, food and a couple of beers. To our luck, during that week it was perfect and warm spring weather in Sweden. On the other hand, these were, in fact, the first few nice days of the year, inviting everyone to spend the evening outdoors. We were aware that it was going to be tough to encourage the people to come indoors after another long and dark winter up north. And if those circumstances weren't already enough, a jazz quartet started setting up their gear on another of those three stages just next to the main entrance, making sure no one would be expecting a rock'n'roll concert in the back... Anyway, show time got closer and we were very much looking forward to welcoming our first spectator in Scandinavia. But we had to be more patient. The jazz band was already jamming hard up front when we hit the stage for a first of two sets in front of nobody. Since we only made money if any people showed up we couldn't even consider it as a paid rehearsal.

So there we were, driving 1,200 miles half way across Europe, sleeping on amplifier cases or on the floor in our Chevy van just to save some money for no one to show up. That was really devastating! At least we could now honestly say that we had already played in Sweden when we got back home. But what was that? The door opened and we saw our first fan in Sweden! And even better it was a female. Too bad that she was about sixty-years-old and obviously fond of high proof alcohol. And her blonde hair turned out to be gray in fact. Nevertheless, she saved us from a lonesome evening. It was a start at least, so we kept on playing with even more enthusiasm. It didn't take long and we got her shaking a leg on the dance floor. Now we could go back to Switzerland and tell our friends that we even got the entire audience dancing in Uppsala! Actually, we were not quite sure whether it was us or the booze that got her in the mood. Well, we assumed it was the first one, of course.

During the break between our sets, we went up front to see how the jazz band was doing. The guys didn't look very happy. They were about to pack up their instruments and must have been pretty much pissed off by the promoter because he booked them the same evening as us. I think it can't be very funny playing next to a rock'n'roll band separated only by a rather thin wall. Of course, we had advised our sound engineer from the club before to take no prisoners... After the break, our fan was still there, and still alone. But she didn't mind and kept on dancing while we played. At the very end of the concert when they quit trying to get money at the doors to see us, two more guys were curious enough to catch a glimpse at us. To our surprise we could also talk one of them into buying a copy of our CD. Just imagine what happened if there were hundreds of people screaming for us!

Once more, this show proved we had chosen our name right. Lots of screaming for almost no money. At the end, if you think about it positively it wasn't such a bad evening at all; we played in a different country, we had everyone dancing, sold promotional material to fans and thanks to the sorry-feeling bartenders we got quite a good buzz after the show. Luckily the money from the door and the CD selling was just enough to pay for the cab ride back to our hotel. I think we would not have been able to walk for a couple of blocks after they finally let us out of the bar late at night...

Dave, Low Budget Screamers (Zurich)

Gigs From Hell

42

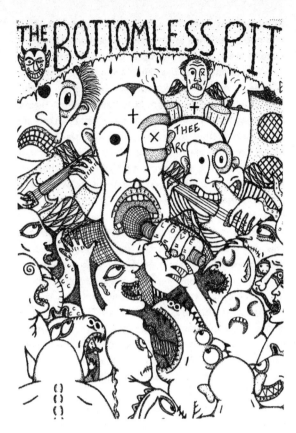

The hole, leading down into God knows what, presented a terrible struggle for the poor drunken Piotr.
THE ROBOTS

The Escaped Murderer And The Rotten Hole

It was one of those makeshift forest festival deals. The stage was some type of post-war leftover in the middle of a mosquito-filled forest somewhere outside of Stockholm. When we first got there there were police helicopters circling the area and word was out that there was an escaped murderer at large in the woods. There were police officers hunting through the trees screaming and waving flashlights. Looking everywhere for this maniac who doubtlessly running naked through the undergrowth with a butchers knife and a can of mace. We arrived pretty early on the set and immediately asked ourselves: how to get drunk? The place was dry like the Gobi. Small groups of teenage black-metallers and fat goth chicks were scattered around the area and they were sipping on cans of weak Swedish folk beer like it was liquid gold. It was obvious that there would be no bar open to the public here. Being the city slickers that we are, we had completely forgotten to bring

any alcohol. We knew that, in order to fight the general boredom and hostility of the place we had to get smashed, and quick!

Fortunately private enterprise came to our help again. This time in the guise of an unscrupulous businessman with a penchant for drunken minors.

Somebody drove a car up to the side of the stage and opened the trunk, from which he sold bottles of wine to the underage kids there. Fortunately this vendor of spirits had forgotten to bring a corkscrew and soon people were asking themselves how to get through the glass and reach the sweet oblivion that was within the bottles. People were tapping on the glass with their ring-clad fingers and listening to the bottles with faces frozen into masks of concentration. Odd, ready as ever, had his trusty Swiss Army knife up at the exact right time. Being quite the entrepreneur he charged a few good gulps from every bottle he opened, Odd knew he would again manage to fight sobriety.

One after the other, more and more impossible bands took the stage. There were hippie bands with flutes, punk skate bands and death metal acts. Time

43

dragged on. As twilight fell, kids started small fires around the area. The smell of burning paper and PVC was heavy in the air. Sitting around one of these stinking campfires, Frank and Peter had gotten friendly with a couple of the leather-clad Satan worshippers. The youngsters were giving praise to all that was dark and mysterious. To prove their point, these gangly and pimply kids soon sacrificed their band flyers to the dark one. Peter and Frank looked at each other and kept quiet. Peter's face grew red with embarrassment. It was too sweet, it really was. The night grew stranger as time slithered like a snail across the night.

When it was finally time for the Robots to take the stage, things had gotten out of hand. Peter found Odd passed out and face down in the grass. Piotr got behind the drums only to discover a rotting hole next to his chair. The hole, leading down into God knows what, presented a terrible struggle for the poor drunken Piotr. While Piotr was hammering away and trying not to fall in the hole, Odd had awoken and started singing and performing his strange stage antics. He spent most of his time laying on a rock beside the stage, half asleep, mumbling into the microphone and smashing bottles. Peter kept his eyes shut in despair and kept on pumping the bass, thinking that the broken glass shards hitting his face was a mild evening rain. Frank stumbled around drunkenly onstage treating his fuzzbox like a sex slave while Odd finally took off his clothes and carved occult symbols into his chest with a broken bottle.

Some of the more rugged customers in the audience had been fingering their knives at the beginning of the show. They now backed off as they saw the abyss that was the Robots open up before them. Piotr finally fell down into the hole and the show was over. Nobody knows what he found down there. Due to lack of interest the band never found out if the murderer was ever caught.

Peter, The Robots (Stockholm)

Kansas City Crackhead

Steel Cage Records label mates Cretin 66 and The 440s were coming off the three week *tour de force* of "Hot Rails to Hell". They played the last show of the tour they'd play together the previous night at Davey's in Kansas City, Cretin 66's hometown. We were meeting at a Kansas City diner for one last breakfast together. None of us looked forward to the goodbyes that had to be said before The 440s headed west toward home in Tucson, Arizona.

We pulled up to the diner and parked alongside Blackie, a converted school bus serving as Cretin 66's much loved tour van. Hot Rails To Hell was a tour that kicked off in Austin then headed through the south hitting New Orleans and Atlanta, then north to Baltimore and Philly, back down through the Midwest via Chicago and Columbus, then to Kansas City, rocking most points in between. We did something like twenty-one shows in twenty-two days.

Throughout the tour, we didn't know if Blackie was going to make it to the next show. If we lost Blackie, we'd lose Cretin 66. Every night threatened to be their last night on tour if Blackie didn't hold up. Blackie had starting, steering, and tire issues, among other things. Luckily, Chuck "The Ox" Tailer, master mechanic, threw his toolbox and some clothes into his truck and left work and home to meet Cretin 66 on the road. He kept Blackie running, and became an invaluable road hand, earning the hard-won title of "Ox".

Blackie was still with quirks that any owner of an older auto learns to live with — little things like staying under sixty MPH on the highway, manually turning the engine to find the flywheel's sweet spot, or jumping the solenoid just to fire the ol' boy up. Blackie wasn't secure either. Until a day or two before Kansas City, there wasn't a lock on the passenger door. To prevent the ultimate tour nightmare of stolen equipment someone — usually Cretin 66's drummer Sardu — slept in Blackie to keep the thugs, thieves and lowlifes at bay.

Those of us who only knew Blackie for the past three weeks grew incredibly fond of the little short bus that could — and did — go all the way back home.

As soon as we pulled up alongside Blackie, 440s' drummer Downtown Dave noticed the newly installed lock was broken off. I saw movement up in Blackie's loft, and wondered who spent the night in Blackie. We piled out of the van intending, on rousing the sleeping Cretin member for breakfast.

G G Titan, co-lead guitarist for The 440s, got the first glimpse of Blackie's intruder — he wasn't anyone from the Cretin camp. It was a drug-addled dirty crackhead, caught in the act of ransacking the tour van, which was still loaded with all of Cretin's equip-

ment, and a few odds and ends from the tour. There's no telling what all was left in that van — spank mags, dirty laundry, itineraries, food — pretty much a jackpot of odds and ends to a jonesin' crackhead.

G G Titan is a big, fierce-looking, fella, standing six-foot-four, weighing in over two bills, a former eight second Airborne Paratrooper, full sleeves of ink, long blond Nordic hair, with a Jersey accent and attitude that gets thicker when he's riled. G G is definitely not someone a sane person would fuck with — he's the guy you want on your team when shit goes down — and we had him.

G G looks the Crackhead dead in the eye and with an ominous, threatening smile snarls, "You fucked up, mother fucker."

Having a few gigs yet to do on our way home, not knowing what that junkie might have on him, knowing that he's as desperate as any trapped animal, and that he could be riddled with all kinds of incurable diseases, it's an unspoken unanimous decision that we're not going to attempt to extract him. He's already in a cage, and we have the advantage of strength, numbers, cell phones, and clear heads to keep him there.

Besides, only half of us are here, there's more on the way, and the cops have been called. This is going to be a good time. We've got this guy. Soon we'll have breakfast, and be laughing about this.

The Crackhead makes for the school bus passenger door, which G G easily holds closed against him. The Crackhead sizes up the situation and makes a break for the driver's door. Seeing this coming, I'm already running to the other side of the bus, he's about halfway out the door, when I mercilessly slam it closed on his face, and his leg — pinning him in the door.

The bus was parked close enough to the back of the diner, allowing me to brace myself against the brick wall of the building while pushing the door closed with all of my might, both hands, one foot, and my considerable frame — for a girl, anyway.

G G came around to help, so now this 160 pound five-foot-ten Crackhead has over twelve feet and approximately 400 pounds of combined pressure crushing his still-trapped leg in the door. G G and I are pushing on the door so hard we can feel it beginning to bend off the hinges and around, or through, the Crackhead's leg.

The Crackhead is desperately pleading for his leg. He swears it's broke. He's so desperate, that at one point he tries to use his face against the window to push against us. G G and I are actually having a pretty good time. The sight of the Crackhead's greasy white face smashed up against the window in agony and desperation caused us to burst out in laughter at the dumb fucker trying to open the door with his face.

Catching a whiff of the Crackhead's stench and hideous breath through the door, I push even harder to try to close off the smell, hopefully ensuring I won't have to touch him, or get any closer.

Eric Degenerate, 440s' bassist arrives. He hears the commotion while crossing the parking lot, drops his backpack, and runs over to Blackie. He's standing at the passenger door, catching up with what's going on. His adrenaline kicks in, killing his buzz and his hangover, and forcing him wide-awake.

It begins to feel like the door is going to give off of the hinges, and since Blackie's been through so much in the past three weeks, G G turns to me and tells me to let off the door, as the guy's not going anywhere. I insist that if we let up, his leg will be free, and he'll try to kick his way out through the window. I try to say this quietly enough, so as not to give the trapped Crackhead any ideas, but I can't keep the images of glass flying into my face from my mind.

We let up on the door so he can get his foot out. Approximately ten to fifteen minutes have passed. The cops have long since been called, and should be rolling up at any minute to save the day — demonstrating their extraction skills. It should just be a couple more minutes before we can go inside for some coffee and laughs.

I notice Eric looks like the best possible way out for our amped up captive, and I holler for someone to watch the passenger door with Eric. Dave is over there with Eric now, so we have two people on each of the two doors. Crackhead's got nowhere to go.

The entire time we've had various exchanges with the Crackhead pleading to be set free from his short bus prison. He tries to explain, "I was just looking for some change." To which Dave growls back, "You better change your life, pal." Dave also snapped at him for doing damage to Blackie when he broke the lock to get in. The Crackhead earnestly states, "I'll pay for it." We get a good laugh out of the Crackhead's irony, I sneer back at him, "What? You gotta job or something?!"

Crackhead moves to the back of the bus, and I

tell G G to go to the front of the bus, to watch through the windshield, to keep an eye on what he's doing, what he's messing with, and what he has in his hands. Soon enough, Crackhead plops back down into the driver's seat.

This seems to make us all feel better, since we can keep a closer eye on him. G G comes back over to the driver's side with me. I notice that Crackhead is messing with the ignition, and at first I think he's trying to hot-wire it, or jimmy it somehow, but his motions seem too familiar, almost as if... He has a key!

I open the door with the intention of head-locking the guy with my right arm, pulling him out to the ground, but just as I get my arm in the door, G G closes the door on my arm, thinking it was the Crackhead who opened the door. The engine starts to turn — Blackie fires up on the first try! Dave yells at everyone, "Let go! Let go!" Crackhead floors the accelerator, and Blackie takes off, kickin' up loose gravel behind him.

We're completely dumbfounded that this is happening. In the midst of the slow motion effects of an adrenaline rush, we watch helplessly as Crackhead makes a gigantic, high-speed U-turn, taking Blackie up on two wheels and careening toward all of us and The 440s' van. Peripherally, Cretins and 440s are scattering in every direction. I look to my right and see Eric's backpack in Blackie's path. Thankfully, I have the presence of mind not to make a dive for it. Sure enough, I watch as it's run over with both the front and rear passenger side tires of Blackie.

Somehow, Crackhead is able to pull out onto a major Kansas City street, without stopping, and hauls ass down the street. He doesn't even come close to hitting anyone on his way — except for all of us in the parking lot. Dave runs for The 440s' van, G G splits for the street to see which way goes. I run out to the street to see G G a couple of blocks down toward the direction that Blackie is headed. Dave pulls up asks, "Where's G G?!" I point down the street, and Dave takes off.

I'm left behind along with Sparkle, Eric, Andrea and Chico Thunder. Other Cretins are showing up for breakfast, and Eric is tearing through his backpack, investigating the damage. Toothpaste is all over everything in his backpack, his CDs are ruined, and more traumatically, his Murray's Pomade is shot. Eric's pissed. He's cussing and trying to assess the damage, while still trying to deal with everything that

just happened.

Wendy gets a call from Dave on the cell — they've found Blackie. G G is in the woods hunting him some Crackhead.

We're relieved Blackie has been recovered, so we start speculating about Crackhead hiding in the woods from G G, who received his US Army Airborne training in the woods of Georgia. The Crackhead doesn't have a chance. G G will hear him breathing if he comes within twenty feet of him, has a knife at his disposal, is trained in hand-to-hand combat, and is well-versed in several crippling submission holds. I hope G G finds the guy, but exercises restraint, using the opportunity to practice his holds, and not his field-dressing techniques.

At least a half hour has passed since we first pulled up next to Blackie, and we've yet to see the men in blue. It's a weekday morning. What could possibly be taking so long?

A well-dressed, business-type fellow steps up to us and asks if we'd like a ride, to find the guys and the van. He introduced himself and explained he witnessed the bedlam from the Blockbuster next door. We girls took him up on his offer, and followed him to his late-model luxury sedan to seek out the fellas — leaving Eric behind amongst his scattered and destroyed belongings.

We drive in the direction the van went and take a left at the designated intersection. We see Blackie pulled up haphazardly on the sidewalk of a public park popular with the seedier aspect of the community — gay hustlers, their sometimes married johns, dope shooters, crack smokers, middle-aged grandfathers trolling for young hustlers — there's one in virtually every community. The park is surrounded by thick woods, residential neighborhoods, with the highway beyond — a good choice for a getaway.

We get out of the car, thanking the nice fellow for the ride. I scan the park for G G, and any movement in the woods. He's walking toward us, folding and putting away his knife. He didn't find him. Crackhead is luckier than he'll ever know.

We pile into the vans to head back to the diner, but Blackie won't start. It takes several tries at starting Blackie, but it finally fires up, and we start to pull out of the parking lot, but everything stops, and Dave says, "They've got their guns drawn."

I turn to see a patrol car with two cops walking toward Blackie, guns drawn. Everybody disembarks the vans and starts talking fast, explaining we're the

46

good guys, and telling the story of the past forty-five minutes. Forty-five minutes! Hell of a response time fellas, thanks for the help.

We give a damned fine description of the Crackhead. G G offers the cops encouragement, suggesting, "Be sure to use the clubs, he'll act like he's submitting, but he isn't, it's a ruse. Use the clubs."

The cops give a chuckle and drive off to look for our long-gone Crackhead, who by now must be holed up with his fellow junkies, telling a wild tale suitable for an episode of *Cops* — minus the cops.

We load up and head for the diner, but again Blackie fails to start. We don't have the criminal's magic touch, or incredible luck. Blackie finally fires up, and we're actually heading toward the diner. By this time the rest of the breakfast party has arrived, and Eric's filled them in on the story — the contents of his backpack still littering the sidewalk.

Nothing is missing from the van, except a hollow-body guitar that was loose in the loft, separate from the other equipment. Eric, G G and I search the area around the parking lot where Blackie was stolen, thinking maybe Crackhead had stashed it for later. All we found was Crackhead's shoe and sock. G G destroys the shoe, in case Crackhead comes back for it, so it will be unusable, making him stick out as a one-shoed limping crackhead.

We later find out the only thing missing was some of Mikey C's dirty laundry. Luckily, Chico unloaded the guitar the night before.

With the entire group together, and everyone debriefed and updated on the morning's events, we head in for breakfast. Dave draws up a composite sketch of the Crackhead. About fifteen to twenty minutes after returning from the park, the two officers from the park enter the diner and head toward our table, "Who broke his leg? He's pressing assault charges."

G G and I look at each other, then back at the cops asking, "Did you get him?!"

The cops laugh at our obvious guilt, "Nah, we couldn't find him."

Relieved we won't be sticking around to argue assault charges, but disappointed at the Crackhead's getaway, we settle in for a great breakfast, filled with goodbyes and a signing session of tour souvenirs. We head outside to say our very, very last goodbyes, and get a few last tour pictures with all of us together.

G G borrows my Sharpie, and heads toward Blackie, calling Dave over to join him. G G and Dave sign the driver side door with: "Recovered by: G G Titan & Downtown Dave."

I add: "Crackheads beware: This van protected by The 440s and Kim Sin."

Kim Sin, Merch Slut for 440s (Tucson)

Gas Is Not Petrol

It happened this winter, somewhere in February or March, I'm not sure anymore. It was really cold that night, snow was falling and it was freezing. We had to do a gig in Beverlo, about a forty-five minute drive from our home. We knew some guys over there and one of them, Marcel, was going to pick us up with the van of another friend, Poef. At 7pm he picked us up at our rockin' place. But first he had to fill the tank with some boostin' fluid. No problem, about three miles down the road was a gas station. But not being his own van, Marcel asked Bloodshed what he had to fill it with: gasoline or petrol? Well, considering it was a very old orange van, we decided to go for gasoline. About a mile and a half mile further we asked God "Why... why, oh why?!" Yes indeed, the motor was running on petrol and we poured gasoline in it. So we stood there next to the road, about three miles from home, in the blistering cold, in the snow, freezing our butts and things off and waiting till the tank had lost all the gasoline... with the speed of drop by drop! We phoned the guy of the gig and he said people were waiting... some even had brought a camera to film the gig. Bloodshed walked back three miles through a snowstorm to the gas station to buy petrol (after he first bought a gas can, because we didn't even have that!). After the tank was finally empty, Marcel tried to start the van... but the battery was down. So... we had to perform at 8pm... at about 1:30am I phoned the guy at the gig that we weren't coming... we never got further than three miles from home. Yes... Spinal Tap lives!

Bloodshed Bob, Bronco Billy (Belgium)

Haunted Hellcats

Every band at one point or another has meet a few sleazy people and played a few horrible shows. But no band has it worse in those situations than an all-girl band on the road. Everything seems a little bit sketchier, and carrying a pocket knife is a must. In summer 2001, my band went on a three week

tour of the south and Midwest. There were only three of us, and we were broke, so we took the only thing we could to travel in… our drummer's pick-up truck. Now as if that's not bad enough, the worst part was that we couldn't sleep in it (as we would in sketchy situations, if we had a van). Instead, we either had to stay with the some of the weird people who offered us a place to crash, or stay in a hotel.

One day in particular on that tour combined all the horrible things you could possible encounter on the road. It was about a week into the trip, and we were scheduled to play in Davenport, Iowa. Now, I had never been to Iowa, and let's just say that I wasn't exactly excited about it. The venue we were booked at was a coffee show in the tiny downtown. There were lots of kids at the show, but not necessarily the kind of kids we usually play to. Most of them had long hair and wore SlipKnot shirts. They weren't there to see us (well, look at us maybe, but not listen to us), they were there to see the local band we played with. While I won't say their name, I will say they described themselves as a White Trash Opera. That might not sound so bad, I mean GWAR, after all, is little more than that description, but when this band got onstage, I was ready to book. The singer, who started off in a head-to-toe robot outfit of sorts, ended the show in a nothing but a diaper, throwing chocolate pudding from it, saying it was shit. All I wanted to do was get out of town, but with little money (oh yea, we also barely got paid for playing), we took the first crash space offered. A kid, who seemed fairly normal, said some people from the show were going camping. He said they had tents and everything, and we could borrow someone's tent just for the three of us. We decided, although it wasn't the best idea ever, we could do it. We followed the guy who owned the coffee shop to the campsite. He weaved in and out of traffic, ran red lights, and made several wrong turns. About a half-hour later, we were on a side road, right next to the highway at "the campsite", which amounted to little more than a picnic table, campfire and beer. No one set up the tents they apparently had.

It was about 2am, and I was ready to pass out, so we decided to take as much of the equipment out of the back of the truck, and fit it in the front. We set out sleeping bags and settled in, as uncomfortable as it was, to sleep, which seemed next to impossible. Within minutes the kid (yes I mean kid, he was only nineteen years old) who owned the coffee shop and

several other guys were banging on the back window. They wanted to know why we didn't want to hang out with them.

Let me get something straight — right here — I have been waiting three years for a podium to voice this opinion. Sometimes, after shows, and after traveling all day, its not that I am trying to be mean, I just want to go to sleep! It seems people never get this, and always think we are anti-social. The truth is, I just need sleep.

All right, back to the story, and this is where it gets really weird. The guy who owned the coffee shop suddenly remembered that we could sleep in his office above the store. He did, after all, own the building over it (and we came to find out he owned many others in the town too. He was a self-made millionaire at nineteen). We "should have just asked him", he said. But the thing is, he knew we needed a place to stay, and he still dragged us out to the woods. This is where I really started to think that he was taking us on some wild goose chase. Maybe to wear us down, so he could take advantage of us, or kill us. I already had a bad feeling about this guy, and this wasn't helping. I have never in my life actually felt that thing called female intuition, but right then, I swear I did. He insisted that we went back with him, I insisted we didn't; but, somehow (perhaps the fact that it was two in the morning and we were all delusional from lack of sleep), he talked us into it.

So we followed him on another chase back to the shop. It seemed like every time something could have been simple, like every time I was only minutes away from laying down my head and dreaming of being somewhere else, he threw in another twist. We tried to go in the front door, then he said no, we had to go through the back. We walked up a dark, messy staircase. He would flip on a light switch, walk down the hall, and then have us flip it off and run to the other end in the dark. He took us down several hallways, old and musty, which winded around endless corners. He showed us a room that apparently hadn't been opened in twenty years, since the innkeeper who used to live there had died. I expected to open the door and see a skeleton hanging from the ceiling. Finally, after nearly an hour of exploring, he said he was taking us to the office to go to sleep. We came to an opening, a lobby straight out of *The Twilight Zone*. The interior was ancient, and the intercom elevator music was still on. Now, not only was the guy creepy, but the building was creepy. I began

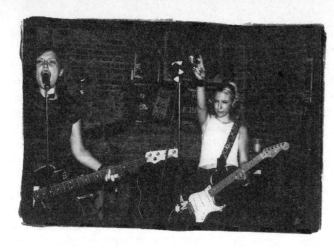

He took pictures with us, in case we "killed him during the night".
HIGH SCHOOL HELLCATS

to believe the place was probably haunted.

Across the lobby, finally, like a mirage in the desert, I saw the office. But we still had a good half-hour before he would let us get to sleep. He told us all about the painting of a naked woman on the wall, and he showed us the two-way mirror in the room we were going to sleep in. He took pictures with us, in case he "killed him during the night", and kept asking if we were psychopaths, which I took as some sick form of reverse psychology. I really thought he was going to try something while we were sleeping. So as I laid down on the floor with a pocketknife in my hand, and finally, somehow, dozed off, after I heard him lightly snoring in the other room.

Before I knew it, I awoke to the sounds of a truck passing outside. It was early morning, and we were all alive. Nothing completely out of the ordinary happened to us… well, OK, something a little out of the ordinary happened. Our drummer swears that sometime during the night, she woke up and felt something pushing her down. She said she couldn't move or breath. While she might have only been dreaming, she thinks it was a ghost. And to be honest, that place was creepy enough that I pretty much believe her.

**Melissa Flanzraich,
High School Hellcats (Baltimore)**

Something Is Rotn In San Francisco

In September 1999, the Reely Rotnz set out from Kingsville, Texas to San Francisco, California to rap up shooting on their video for the single "Masturbation". The first journey for the trio was a milestone in their now five-year commitment. Little did they

know then, that it would be a true test of friendship, loyalty, and the thing we musician's call "Being on the Road". Somewhere in New Mexico it began to get very windy. We had all our equipment in the back of the pick-up and it seemed to be fine. We proceeded to bullshit amongst each other till Henry noticed something fly out of the truck. James reassured us that it was only one of the trash bags that was covering his amp. Again, Henry says he saw something fly out! James quickly turned around and said, "Uh, that was Jimmy's guitar! We immediately pulled into a ditch with tons of traffic speeding by. I then stepped up to my guitar and had to make a decision, step into traffic and save my Les Paul or let the eighteen wheeler semi-truck doing ninety eat it for lunch. James yelled at me to get it, so I reached out and saved my axe! Other mishaps followed, but nothing like what we were in store for. We finally reached San Francisco after thirty-seven hours on the road. That was just the beginning. San Francisco was beautiful, as soon as we woke up the next morning and walked out into the streets, we joked that we didn't want to leave. We had breakfast and went to our first location, an apartment belonging to one of the directors. The model that was doing the scene with Henry didn't want anyone there but her boyfriend and the crew, because of the nude scenes. James and myself were asked to leave. We had only been awake in SF for about four hours and we were being pushed out into the strange streets. So we walked. Porn stores galore! Need I say more? James was hypnotized and I couldn't get him out of the sex shops. So I walked alone. I found a couple of thrift stores, bookstores and talked with a couple of bums before I headed back to the apartment. When

49

I got there, the "crew" had grown from about four people to about twelve. Henry was wasted and dressed in vinyl, rubbing his nipples by a bedpost. An ice chest of beer had appeared and the aroma was dense. The Rotnz were now coining the phrase "when in Rome!" I always try and run a tight ship and felt that it would end up a waste if we drove all this way and we did not accomplish anything due to partying. Well myself, a Rotn, and the film crew, exchanged words. James and I decided to go back to where we were staying. The next morning the tension was thick, we had one more shot to follow up on. We eventually made it through the afternoon without kicking each other's asses. Just then a casting crew member from *Nash Bridges* walked up to us and asked us to be in an episode. As we looked at each other, knowing what one more day with each other meant, we decided to pass and get our asses home. The Reely Rotnz now know what it means to put up with each other on the road and things are a little smoother.

Jimmy, The Reely Rotnz (Kingsville, TX)

Mrs Horny Blonde

Ah yes... the power of radio can be delicious. When small town radio stations have been spinning your songs for three months prior to a live performance, it may sound strange, but the fans, the radio station personnel, and even the hotel employees, treat you like rock royalty. It was a welcome change, from the terminally jaded LA audiences we were used to playing to. Somehow, our first indie CD had two songs in the charts, and we were going on tour to support it. We were hyped. Notwithstanding the serious fun we had on tour, it was not without it's share of hellish moments. The day we were scheduled to leave, a member or our crew, who also owned one of the trucks we were depending on, canceled two hours before departure time. Many frantic phone calls ensued, and we found a replacement. Although he didn't have much experience, we were lucky to find anyone on such short notice. Unfortunately, he didn't have a truck. What he did have, was an old beat up mini-van. Let's see now... who's equipment should we leave behind? Hmmm...

The Mini-Van From Hell: "Is your van in good enough shape to make a 4,000 mile trip?" I asked our new recruit. "Sure, just had a tune up, runs great!" He replied boastfully. Although it ran OK, he had

neglected to mention that his heater, windshield wipers, and defroster were completely shot.

However, that didn't come into play until we were high above sea level, attempting to traverse one of North America's more impressive mountain ranges. Which (surprise, surprise) was also where we hit our first snow storm. (Yep, the tour was off to a great start! Especially if we make it over the mountain alive and without frostbite.) Now I know what "cold as hell" and "snow blind" really mean.

Besides the shivering, and uncontrollable teeth chattering, we had to stop every few miles to clean the windshield off. Every twenty minutes or so, we'd trade vans to let the "Popsicle People" thaw out. By the time we made it to the other side of the mountain range, we had all experienced the joy of being "Popsicle People." A wagon train would have been faster.

One of the dates scheduled, was a town in southern New Mexico. Like the other towns on this tour, the local radio station was promoting it. They had been all over the record for months, along with phone interviews and commercials for our show. The station paid for the hotel and meals, and as with most of these shows, we were to get 100 percent of the door. I was promised by the owner of the station, that it would be a minimum of $1,500 (remember that number). Not a bad deal for a new band on a shoestring promo tour.

As we were pulling into the hotel parking lot, we heard one of our songs on the radio, followed by a commercial for the show. We just sat there spellbound, with the radios in both vans blasting. It gave us all a good rush, and recharged our energy. The journey's exhaustion had vanished, we were up and ready to rock!

We were scheduled for a pre-show interview to hype the concert, so after checking into the hotel, we headed for the radio station. Upon arriving at the station, we were greeted by a lovely young blonde, who's duties, among others, included being the receptionist. From the second we rolled through the station's front door, I could feel the target she was painting on me. With hungry eyes, thirsty words, and no attempt to disguise her intentions, (I'll call her Blondie) Blondie continued to paint her target. By the time we left the station for sound check, I felt like a piece of meat with a freshly painted bullseye on my ass. As the station door closed behind me, I heard her say, "See ya tonight at the show Zak... and after the show too!" She added, with a sneaky

giggle. (OK, this is going to be a fun town!)

The interview had gone well, the sound check went smooth, and the show not only rocked their socks, it rocked some undies too! Afterwards, we signed CDs and T-shirts for an hour or so, and then it was time for dealing with… *the money*. Although the kids lined up around the block to see us, no matter how you do the math, $600, is not $1,500. However, my deal was with the station owner, not the club owner, so I couldn't really bitch about it. I assumed the station would make up the difference. OK, now where's the station owner?

I'm informed, that there was a party being thrown in our honor, and that the owner was going to meet us there. "Let's go have some fun at the party, and I'll work out the money later," I told my band mates. While partying, and waiting for the owner of the radio station to arrive, little Blondie was zeroing in on the target she had painted earlier that afternoon.

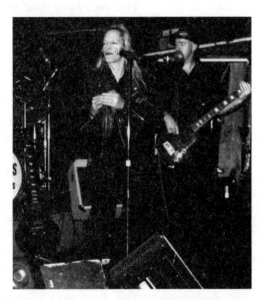

There was at least one problem with this development… I found out she was married, and that her husband was sitting across the room. I had met her husband earlier, when he asked me to sign his CD. So… Hubby is chatting with the other guests, just a few feet away from where his wife Blondie is coming on to me. Yeah, this could be a little strange… maybe too strange, even for me.

I expressed my discomfort with the situation, and as politely as possible, passed on Blondie's offer. However, I did let her know that treating her husband so coldly, right in front of his face, was person-

ally… a real turn off. She tried to convince me that he wouldn't mind, but I wasn't buying it. At this point, I just wanted to get what was owed to me, and grab a few hours of sleep before hitting the road again.

During the next hour of waiting for the illusive station owner, the drinks were flowing, and magic dust was flying. I was starting to feel pretty good, and also relieved that "Mrs Horny Blonde" (Err, ugh, I mean Blondie), had got the message. I hadn't seen her for about twenty minutes, so hopefully she was busy painting a target on someone else's ass, or so I thought… From out of nowhere, Blondie glides across the room, sat down next to me, and with a whisper in my ear, suggested a threesome with her girlfriend. When I didn't chomp on the bait, a hot tub orgy was enticingly offered a few minutes later (this girl was hungry!). She wasn't going to quit the hunt, until she tried every weapon in her arsenal. She was determined to nail her prey.

As she continued to cry, I could only mutter, "Hey, it's no big deal, don't worry about it. I've got plenty of jackets."
ZAK DANIELS AND THE
ONE EYED SNAKES

Now you may think I'm crazy for turning down these wonderful offers, but something didn't feel right. I've had my share of "Groupie Therapy", and a few occasions where more than one really was merrier, but this town was stranger than fiction, and it didn't feel like a story with a happy ending. This was not going to be a *Penthouse* forum letter, where everyone happily orgasms into the sunset.

Seething beneath this veneer of sexual freedom, with its visions of hungry willing flesh, and promise of lusty fun, was something else… and it wasn't pretty. I sensed some heavy baggage, filled with fear, jeal-

ousy, and neurosis driven anxiety. This was a small town, with long and twisted relationship histories, intertwined, and tethered to most of the people at this party. It felt like a soap opera in progress, and I wanted out. But not without my money! The band headed back to the hotel, and I stayed to get paid. (Oh yeah, being your own road manager is so much fun…)

Big Shot finally showed up, and we slipped into another room to discuss the money. He told me that he'd make up the difference in the morning. "Just stop by the station on the way out of town." He said, reassuringly. I could finally leave this Fellini cattle call of a party (Thank you God!), and cop a few hours of sleep.

On the way out of town, we dropped by the radio station to collect the rest of our money, and yes, you guessed right… he wasn't there. Nor was there a check waiting for us. The next show was 300 miles away, so hanging out to haggle, was not an option. It was time to roll. Fortunately, we sold a bundle of CDs and T-shirts, which more than made up the difference. Not to mention, we made a ton of new fans.

(But what about the air conditioning thing Zak? You know… the punch line?)

A few weeks later, after we got back to LA, I called the radio station to find out if I had left my "Fave Stage Jacket" at the party. It was Blondie who I spoke to, and she informed me that I had indeed left my jacket there. She said that she'd be happy to ship it to LA for me. I thanked her, and we said goodbye.

A month had passed, but still no package from New Mexico. I phoned the station, and sounding quite the professional receptionist, Blondie chimed the familiar call letters, "This is KR — can I help you?" I said, "Hi, this is Zak Daniels, just wondered if you've had a chance to ship that jacket yet?" I heard her start to cry, and then she said, "I'm so sorry." I asked, "Sorry about what?" Between her sobs, Blondie replied, "Well, when someone found out that I was shipping your jacket to you, they took it out to the backyard, and… sob, sob… shot it full of holes, sob, sob… I'm sooo sorry." As she continued to cry, I could only mutter, "Hey, it's no big deal, don't worry about it. I've got plenty of jackets. Take care of yourself, OK? Bye now," and I hung up.

I called one of the DJs, and he spit out all of the soap opera dirt. Turns out, the guy who air conditioned my jacket wasn't her husband, it was the sta-

tion owner. It seems that Blondie was the station owner's mistress. To this day, I still don't know if he shot my jacket out of jealousy, or because I wouldn't fuck her? Blondie was probably right about one thing… her husband didn't care. Strange fucking town! If Rod Serling was still alive, he'd not only live there, he'd be Mayor.

Had I decided to take advantage of Blondie's orgy invitation, this story might have had a different ending, and most likely, a different author. I can see the headline now:

"Rock Vocalist Shot Dead in New Mexico Hot Tub."

The moral of this story: Enjoy being young and dumb and full of cum, but listen for the distant rumble of jealousy and fear, before you jump into the tub. Rock'n'roll… it's not a job, it's an adventure.

An adventure in the art of survival.

**Zak Daniels, ZD and
The One Eyed Snakes (LA)**

Dirty And Broke

It was our first tour abroad, The Gore Gore Boys & Splatter Pussies — 2001 tour. The Trashcan Darlings and our driver had been through most of Germany and Switzerland and we were now heading for the last gig of the tour, which was to take place in Berlin.

The day before we had spent thirteen hours in the van to go from Zurich in Switzerland to Bautzen in the east of Germany. We arrived four hours too late for get-in, but the gig was great and we were all very thrilled that we were playing the world famous Wild At Heart Club in Berlin the day after. Everywhere we had been, people had been going on and on about how great this club was, and we were determined to really shake some action there. We were also in a particularly good mood since the drive from Bautzen to Berlin was only a couple of hours, and we had spent way too much time in the car the last few weeks.

That meant that we'd have more time to party after the Bautzen gig, and that's something we really enjoy. We went back to the hotel and had a blast. The last thing I remember is our driver staring at the floor, laughing his ass off, and asking everybody if it was his jacket lying on the floor… then I passed out.

The next day we got up late. Ready to play at the

famous club in the capitol of the country we'd been traveling around for the last three weeks. We managed to get some more beer from the club before we left, just in case. Everybody was, for once, in a good mood. We got out on the autobahn and headed for Berlin. Needless to say, I fell asleep as soon as I sat down in the car, but was abruptly awakened some time later by loud swearing and engine noises. The goddam car was breaking down.

We had to stop on the shoulder of the autobahn. The mood was not exactly great anymore, but at least we had beer. We got hold of a mechanic who thought he could fix it so we'd make the gig, but as it turns out the gas pump was ruined and there was no gas pumps to be found. We made several phone calls to the rent-a-car company in Norway to, for instance, try to get them to pay for a tow truck to take us from where we were stranded to Berlin. The tow truck guy wanted more money to do that than we had paid the rent-a-car company for the entire three weeks of rent, so of course, that was out of the question. We were fine along the autobahn for a while. We had beer, cola and cake (which our record company had made for Strange?'s birthday the day before.)

After seven and a half hours with an acoustic guitar, our patience had come to an end. We didn't have a lot of cash and we were supposed to get free food, drinks and a place to sleep as part of our deal in Berlin. Not having read the rent-a-car contract properly we were not aware that their only responsibility was to get our car fixed "within reasonable time." This being on the weekend, reasonable time would be by Monday. Luckily for us, the guy from the rent-a-car company hadn't read the contract properly, either. As it became bloody obvious that we had no chance of making the gig we phoned the rent-a-car company one last time to make sure we'd get settled for the night. And like a miracle we got them to pay for everything we were supposed to get in Berlin, except the actual cash for the gig.

That meant that we could check into a four star hotel, watched porn on the pay TV, ate a fancy dinner and partied like hell in the little town of Cottbus where we had been towed. We were all very depressed we didn't get to play Berlin, but the nice dinner and beer sure made it better. Our van was supposed to be finished early next morning which meant that we could drive from Cottbus sometime during the day and catch a ferry from Rostock to Denmark or Sweden sometime in the afternoon.

Of course, the car wasn't finished the next morning. It wasn't finished the next afternoon either. Closer to what you would consider night, the car was finished. We had a really short time to get from Cottbus to the ferry in Rostock. Strange? Gentle pushed our driver away and drove like hell the whole way, but unfortunately, we made it there half an hour too late. We desperately needed a boat to take us from Germany to either Sweden or Denmark, so we could drive home. Missing the last ferry meant that we would have to spend one more night in Germany. We were dirty and broke and wanted to go home. We now had a choice between checking into a hotel in Rostock on our own cash, the rent-a-car company who had read the contract by now was sure as hell not gonna pay for another day in a hotel, or waiting for the first Ferry which was leaving in four or five hours. We decided to wait for the ferry. As it turned out the two first ferries leaving were fully booked with trucks, so there was no place for us on a boat until hours later than what we had expected. We had already waited for awhile now, so we didn't want to go searching for a hotel and spend our last cash when we had already waited for a while. We decided to try and sleep for a few hours in the van. The six of us crammed together for about fifteen minutes. We soon figured out that wouldn't work. The van was all right for napping during the long drives of the tour, but not for six people to get a good night's sleep. Especially not when we were considering the fact that our driver would have to drive through the whole of Sweden to take us back to Oslo the following day and he needed rest for that. So me, Frankie and our driver decided to go ask the guy at the terminal building if we could sleep in the cafe. We got permission to sleep there. It was a cafe for truckers and it was connected to the rest of the terminal building. There was no one in there when we entered, we found a suitable place, I turned off the lights and we went to sleep.

The next morning I woke up a little hung-over. I opened my eyes and was immediately pissed that there was a bright light there. Somebody had actually had the nerve to turn the lights back on where we were sleeping! I was just about to make something out of it when I looked around. Suddenly I realized that we were not in the cafe anymore, at all. What had seemed like a quiet corner of the cafe the

night before was actually the customs. The driver and Frankie were sleeping on the tables which are normally used for going through people's luggage and I was blocking the floor between the tables… and nobody had bothered to wake us up.

Chris Damien Doll, Trashcan Darlings (Norway)

Sad Little Monkey

Ah, the rigors of touring, the hard life musicians choose. We stay up till three or four, sleep in till noon, and don't have to go to our putrid, degrading day jobs. Give it to me any day. Except, of course, those days when dealing with shitheads and dumbfucks with an agenda to ruin your fun suddenly, Karmically, coalesce with yours. So many stories, so many assholes. Which one to choose? Maybe the drunkin' idiot in Lawrence who invited us to stay, then yelled at us to leave when he forgot who we were. Or, how about the sleazy pencil dick chickenshit who called me "sand nigger" behind my back in Savannah, but was nowhere to be found when I turned around. So many, but one rings out more annoying than the tinnitus in my ears. It rings sharper than the pain in my ass every time I hear the sentence, "Sorry, we can't pay you tonight." One rings dingalingaling every time I think about it.

We were in Houston, the land of Neanderthal Americanus. The home of the surly male. I think they make them there, and ship 'em out to different parts of the country to make life miserable for normal-sized human beings. I once worked for one of these fuckers. His name was Bubba Hardcock (no shit) and he threatened to kill me. Anyway, Bubbas aside ('cause it wasn't a Bubba that ruined our good time), the show went well. We played at Emo's — RIP — played well, got paid, then got invited by a really cute girl to stay at her house. Esctatic, exciting, fun. We showed up and there were three guys, all cool, the girl — cool, and one sad little monkey — oh well. Everyone was talkative. They offered us beer — awesome, and asked us questions about our tour. Everyone, of course, but the sad little monkey, who just sat brooding in the corner. I should add that the sad monkey had dreads, was trim, good looking, and had the fancy of the cute girl who invited us. I should also add that I didn't intend on getting laid. I'm married, and my wife is in the band. Anyway, the night went on. We talked, listened to music, drank,

then finally succumbed to sweet Senor Sandman, the bringer of all sweet dreams. I can't remember what I dreamt. It was probably pleasant enough. What I do remember is waking up to Cute Girl's voice, and sitting up to see her standing if front of me with a bra and shorts, yelling into the phone something like, "What do I do? There's blood everywhere!" I remember at that moment thinking to myself that she looked really sexy in just a bra. I also remember trying to sneak a peek at her behind when she turned around, and I remember also realizing, suddenly, that I really, really needed to take a shit. I remember standing up, slowly stumbling to the bathroom, then turning on the light. It was at that moment that her statement — "There's blood everywhere" — hit me. Why? Simply because there was blood everywhere. What went through my mind then is a blur. A split second of fear, a moment of reflection unto the brevity of existence, the deep vibrant beauty of the color red. And of course, the all too pressing realization that I was about to shit myself. Without hesitation I grabbed some toilet paper, wiped the blood from the seat, sat, and shit. Bukowski used to write about the wonders of the beer shit. I believe that if a beer shit were a man he would be referred to as handsome, and if it were a woman, perfection. Well, I laid handsome perfection into that toilet water that day. Proud of my accomplishment, I wiped my ass, flushed, then sat in confusion as the toilet refused to work. There was no water to flush it down. So, there I was, in a bathroom in Houston, TX, with a fresh shit floating underneath me, surrounded by some stranger's blood, confused, bewildered, amazed. It was at that moment (like every other self-involved son of a bitch) that I finally wondered what in the fuck was going on.

When I emerged from the bathroom — or shall I say when I emerged from putting insult on top of injury, Cute Girl was still on the phone. I heard her say something about suicide and "No, he's OK, but he's bleeding all over my bed." Something about a "blowjob" and "He freaked out afterward." Then something about the "Construction crew turned off my water." I — rationalizing, figuring, assessing, as it will, the situation at hand, came to the conclusion (like every other self-involved son of a bitch) that it was time to gather the troops and get the fuck out of there. Regardless of the outcome and how interesting it may be — we didn't need to be involved. It was time to *scapeay the omehay*! They all seemed

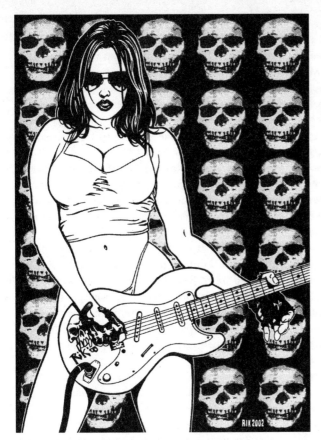

Art: Rik Rawling

Ballad Of Indestructo

In the beginning, there was a tour itinerary, a fully stocked and tuned Indestructo, and four optimistic men with a mission: Go forth and bring the rock to those in need. The eight-hour trip out to WV was filled with joy, merriment and plenty of junk food. When we finally pulled into Morgantown, WV we were more than ready to start fulfilling our mission to rock. It was when we pulled up to the club that our excitement was dulled and a foreshadowing of things to come was observed. If you will, imagine this scene… Indestructo pulls up, Cropduster piles out into the street and attempts to enter the club. The door is locked tight. No one is around, lights are off and there is no sign of life anywhere. On the front of the building, in plain sight, are two posters advertising the Cropduster show. "Cropduster at 123 Pleasant Street — Friday 11/23" You might think this was a good sign. Think again. We are standing on the street, gazing at the posters on a brisk Saturday night — November 24. Whadafuk?! Luckily, the jam band that was scheduled to play that night graciously offered to let us open the show for them. It was a great night filled with twenty people into jam music, a jam band, and indie-pop sensation Cropduster!

The next three nights went off pretty much without a hitch. We got to the clubs on time, brought the rock, and managed to make some new fans and friends along the way. All in all a good time was had by all. There were some nights where we had such a good time that the next day we couldn't even remember how much fun we had!

On Wednesday night we reach our gig in Kansas City, MO. Now, this was a night to remember in both enjoyment, and ultimately, pain. We roll into the club, Hurricane, around 6:30pm. There is barely anyone in the place at this early hour, but you can tell that those who are there are always there. We loaded in and started the ritualistic "waiting around" period of the night. Around 7:30pm, we are approached by one of the barflies who has obviously been there

concerned, I guess some of us were, I wasn't. I'm a prick and I know it. I also know that if the moment ever came when I was ready to end me, to do me into oblivion I certainly wouldn't do it in a house full of people. I also wouldn't fail. The whole act wreaked of bullshit just like he did the moment I laid eyes on him. He wanted attention. Fuckin' guy got blown by a hot babe, and he needs attention. There's real loneliness in this world, people who are really having a hard time. I remembered a conversation I had with a buddy of mine about suicide. The perfect way to do it, we concluded, was to tie your hair tightly to a big balloon filled with helium, then put a shot gun up to your neck and pull. The hope being that the shotgun blast be strong enough to sever your head and the balloon strong enough to carry your head up, up and away, splattering parts of your brain all over town for a little while. Give them all one last piece of your mind — literally. I wanted to relate this to sad little monkey but figured he probably wouldn't appreciate my attempt at reaching out. Anyway, we offered help and last we heard Cute Girl was on the phone with Sad Mon-

since before load in. Before introducing himself to the band, he begins to ask which songs the band will be playing tonight. Although, he didn't mean which songs would Cropduster be playing, but what songs would the band be playing with him leading the group. The name of the group was to be Mr Wilson. We were to be his band. After further inquiry, we find out this guys name is indeed, Mr Wilson, and that he doesn't actually sing or play any instruments. Well, to make a long story sho... uh, not as long, Mr Wilson asks us to prove we are a "real" rock band. It is determined, by Mr Wilson, of course, that the only way to do this is by pounding shots until we hit the stage. Not wanting to disappoint, we oblige and start doing shot after shot... until we hit the stage. The drinking started at 7:45pm. We hit the stage like a fucking lunatics at 11:30pm. I'm not sure how we were still able to walk on stage or manage to operate our instruments, but by some higher authority, we rocked like madmen. And when it was all over, we had totally blown everybody away. It was simply amazing. When it was all over, Mr Wilson declared, "shit... you guys really are a real rock'n'roll band!" All was right in the universe...

After the gig, we put our drunk asses into Indestructo and started out on the eleven-hour trip to Dallas. The details are a little hazy, but I think it was around 3:30am, somewhere near Big-Flat-Zero-Elevation-Landscape, KS that Young Lee and I decide that we have to take a piss break. Marc and Tom are passed out in the back. Now, the road we are on has to be the most remote, desolate road on the planet. The exits are something like fifty miles apart, so when we see the Harry's rest stop approaching, we seize the opportunity to get off the highway.

As we begin to exit the highway the heat in the van suddenly turned off. I mention this to Young Lee... he looks at me sideways and his yellow eyes say, "piss first, heat later." We jump out of Indestructo and start heading towards the building... It's then that we noticed the billowing white clouds of exhaust coming out of Indestructo. Something's not right. We call AAA and wait for two hours in the Hardy's for the tow truck. At some point during that time, the merry dizziness of the alcohol wore off and the hangovers started to kick in. Passed out in the booths of the Hardy's, we must have looked like death warmed over.

An hour later, the tow truck pulls up. We all pile into the van, and the van gets pulled onto the flatbed.

We begin an hour-long journey to the nearest auto-mechanic in Wichita KS. The ride to Wichita was horrible. Stuck in Indestructo with the temperature falling and the sun rising, all four of us were wrapped up tight with sleeping bags pulled over our heads fighting off frostbite. At some point I remember thinking, "This must be what it feels like to freeze to death." Towards the end of our trip, the sun was almost up and the temp rose to zero.

We pull into the parking lot of the Flea Bag Motel in Wichita, KS. We unload all of our shit into the motel and Indestructo sadly disappears from sight on her way to the mechanic. The next morning comes within an hour...

Indestructo is dead. She is no more. Fortunately, through the modern miracles of auto mechanics, she could be revived with a whole new engine. The only problem is, she can't be revived until the following Thursday. Augh! We still have a whole week of dates to play. We are stuck in Wichita. What to do? After much debate, we decide to get a rental van. Indestruct-ette is her name and, man oh man, is she a beaut! (Shhh, don't tell Indestructo!) She is green and sleek and can hit ninety miles an hour like it ain't no thing! Just ask Young Lee!

We cancel the Dallas gig for that night and make a three hour trip back to Lawrence, MO. Luckily, we hooked up with a gig with the Dismemberment Plan at radio KJHK's twenty-fifth anniversary show. That was cool even though we played to about thirty people in a room that holds 1,500. But whatever, we got to play.

The next night we needed to be in Birmingham, AL. Indeed, a long drive. So, here we are... Lee is at the wheel. Indestruct-ette is cruising, easily, at ninety miles an hour through KY. We are an hour ahead of schedule, yet still four and a half hours from Birmingham. That's when our trip went from bad to worse. In our rearview, Young Lee sees the cop on our tail. We get pulled over. No big thing right? What's the worse thing that could happen? A ticket? A search of the van? A scene out of *Deliverance*? How about, Young Lee being arrested? Yep. It's true. I won't go into the details of the arrest, but I think it had something to do with a grease gun, a toaster, and gaggle of chickens. For the next two hours, we are in a police station while Young Lee gets booked and the band gets extorted for $250 in cash. Almost the entire earnings from our past six gigs! You heard it here folks... Rock'n'roll don't pay shit!

After we get Young Lee out of Sing Sing, we are back on the road, and according to our calculations, only one hour late. Of course, that is one hour late when driving at excessive speeds. We are not afraid. And we don't want to miss our gig opening for Sony recording artists, Bare Jr. Finally, a gig where there might actually be a big crowd! So, here we are speeding along trying to make the gig. By all calculations, we should pull into the club at 10:30pm and be ready to play at 11pm as scheduled. No problem. Well, turns out that we ended up having to make three pit stops on the way. One to eat, one to shit, and one to get gas. The strange thing is, each stop took about twenty to thirty minutes, but for some reason (like maybe the total disregard for traffic laws or human life) every time we get back on the road, we calculate that we will arrive at 10:30. Very strange, indeed.

10:29pm — We are one block away from the club. One left turn through a traffic light away. Literally one minute. This is crazy. As we come up to the traffic light, it turns yellow. Everyone starts yelling, "Go! Go! Go!" I am pumped! I hit the gas, we all fall back into our seats as the light changes red and I blow right though it. I cut the turn so hard, Indestruct-ette almost flips over, and I fail to see the two cop cars waiting at the light. As the cops start to head through the light, we almost take the front end off of car number one. Next thing we know, both cops are making U-turns as I put the pedal to the floor. We screech into the parking lot of the Nick and hit the brakes with both cop cars in tow. Everyone tries to hop out of the van before the cops can pull up. It was too late. The cops jump out with guns drawn screaming, "Get back in the van! Get back in the van!" I was sure at that instant that we were all going to jail. By this time, the entire crowd at the club has poured outside to see what was happening. Luckily, after all of the commotion settled and the guns were put away, the sound man at the club vouched for us and we were let off with a stern warning. It was amazing. I may be wrong, but I think it was the most rock'n'roll entrance ever recorded in history. It was five minutes later when we found out Bare Jr had broken up the night before and wouldn't be making the gig. We were an hour early again. Waiting to play to an empty room.

The next night in Chattanooga, TN, Bare Jr canceled again. Cropduster played two full sets to a nice size crowd. Many asses were blown away.

The following night, we found ourselves in Atlanta, GA where again, the supposed headliner, The VUE, barely made the gig. That wasn't so bad, at least some of their crowd stuck around.

The last night of the tour happened on Monday night in Nashville, TN. As you can imagine, the only people in attendance were the bartender and the other band on the bill. A depressing night indeed, since we had to cut the tour short by a few days.

On Tuesday, Marc and Tom headed back to Wichita to pick up Indestructo, while Young Lee and I headed home in a rental car. It was a sad end to an even sadder trip.

Luckily, in the end, everyone made it back home OK — a little wearier, a little wiser, and relatively unscathed. Unfortunately, the real hell is still yet to come when the bills start rolling in...

Scott Kopitskie, Cropduster (Hoboken)

Cleveland Blackout

I was at the bar. I asked the bartender if I could get a shot and a beer for the three I had on the bar. He shook his head yes. He poured me an overly generous shot and popped open a beer. "Three twenty-five." I reached into my pocket and pulled out a guitar pick, no go, then a bottle cap, whoops! Then lint, and finally sixty-five cents. A tall man in a hooded sweat-shirt gave me the TV eye. I smiled back at him. Some kid next to me told someone that Step Sister was playing. I corrected him, and told him my band was. "Do you suck?" he said. "Sometimes," I said. Then he proceeded to tell me about how wonderful his band was. Great, I came to Cleveland to hear about some stranger's band. And no, he wasn't in either band that we played with that night. It's hard enough to remember the people in the bands that you do play with, let alone... Everytime I needed a beer, the bartender asked me if I wanted another shot. Not yet! But I did another shot. I sorta remember the first band CD Truth, of Akron, Ohio. They were good, they had their own thing going, and they covered — appropriately — some Devo songs. (Devo's from Akron too.) I don't remember much after that. I am told that we played the Beatle's Birthday for Pat, because it was her birthday. About three songs in, some guy started to roll and thrash about on the floor, and I joined him. The tall man in the sweatshirt stood in front, and during one song I went over and called him sugar, or something. During the

whole set, as usual, I had a beer in one hand, and a mic in the other. I also sang a song in someone's lap. I am told that I made some friends that night. Some time after our set, the bartender told Stephanie, Doug's girlfriend, to take me outside. "She's gonna get sick and pass out and I don't want her to do that in here," he said. I vomited outside for what seemed like two hours. Stephanie got sick just from watching me. I yelled at the bartender for getting me drunk. Bloody Mess, who sang for the Vaynes, and had previously toured with G G Allin, broke some beer bottles and bled. I guess that's his thing. He also busted a microphone. Apparently, the band played well. They seemed nice enough to me. The doorman got a little freaked because he got blood on his hand. After we loaded up, some zine was interviewing Bloody Mess. I muscled my way into the interview. I don't know what I said, but I think I annoyed Bloody.

Gabrielle, Master Mechanic (Pittsburgh)

Ladies Room

We played in Minneapolis earlier this year, at some bar called the High Society Music Bar or something. It was an all-ages club with a bar. We were drinking and happy. The place smelled like body odor and Band-Aids. There was a huge amount of nerdy indie rock kids there to see this band called the Frenchies or something... some skinny dork wanted to interview us before the show for his little zine. We told him to ask us after the show when we were good and drunk. He was pushy and relentless, but agreed to leave us alone until then. This was the first show with our new bassist, Nigel. Nigel and our roadie Velcro Lewis are very protective of us. They usually don't let anyone talk to us before we play, cuz Strapbone and Boom Boom have a horrible problem with being sluts and have missed our sound check too many times because they were making out with some punk rock throw-backs, and I also hate people, so it works out fine. Well, Velcro and Nigel were off doing something stupid and trying to impress the local girls with their heavy metal cassette distro while we were getting ready to get made up and look pretty. That one dork with the zine asked us once more if we were ready for the interview. I said, "No! Get lost or I'll break your glasses!" and he ran away. We gathered our caboodle and wardrobe and strutted off to the ladies room to change. We were in there forever, dolling ourselves up, get-

ting naked, checking out each other's tits and tan lines, when Strapbone asks, "You guys hear some kinda clicky-clack?" "A what?" "A clicky-clack", she repeats. "We told you *not* to do whippets before a show ever again!" I scream at her. "No. It sounds like a camera... whatever, I hear that sound all the time, if you know what I mean..." She says. "Um, sure you do..." just then, there was a flash. Someone was taking perv pictures of us without the usual written consent! With my corset half on and Strapbone in just her skibbies, we kick open the stall door. It was the interviewer dork snapping pictures of his wet dreams! Boom Boom jumps in and grabs his camera and runs out of the bathroom. Strapbone and I push him into the open toilet. He couldn't get away. I cracked my knuckles. Boom Boom comes back in with Velcro and Nigel. She picks the kid outta the toilet, throws him against the sink. He doesn't even cry, shout, or try to get away. Boom Boom hands the camera to Nigel and Velcro holds the kid in a half-nelson. Boom Boom punches him in the gut while Nigel takes a picture. Then Strapbone takes a shot at him, right in the face. Nigel snaps another shot. Then I punched him in the nuts. "*Owwieeee!*" Another great photo opportunity! We took about six more pictures until the film ran out. We made him cry. That's what happens, after all, when a boy gets punched in the balls. We left him with the film, as a reminder that he got beat up by some girls... anyway the show went good and we got paid $15!

Jenna Talia, Apocalypstick (Detroit)

480 Studs

It all started when we were going on a European tour in March 2001. We rented a van, and since it was March and still was winter, there were snow tires on the van. Here in Sweden, we have a law that says that you have to have snow tires from November–April. There are two different kinds: studded tires and plain winter tires. The only thing is that you're not allowed to have them in Germany, and we didn't know that until we were on the ferry to Germany. We were kind of lucky because we made it through the customs and we never got stopped by the cops the first days on the tour. We did some shows in Germany, and then we went to Switzerland. On our way back from Switzerland we got stopped at the border. They were curious about the

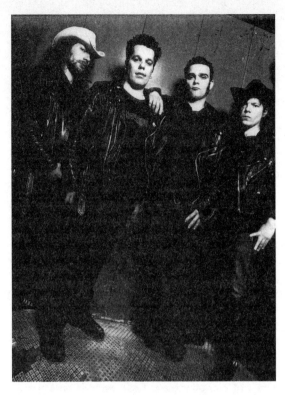

Photo: Ola Bergman

On our way back from
Switzerland we got
stopped at the border.
PSYCHOPUNCH

tires. They looked in some book and came up with this brilliant thing: "You are allowed to have them in Switzerland, except on the highway (autobahn), and you are not allowed to have them in Germany." Since the only road to the border was a highway, there was no way we could fool them with some crazy lie! Believe me we tried. So, we were "kind of late" for a show in Karlsruhe, Germany, and we didn't have time to stand there and argue with them.

So the decision was taken. "Take out the studs from the tires and pay the fine for driving with studded tires on the highway, and then you can go." That's something you don't want to hear after a couple of weeks on the road with a hangover from hell. It took us somewhere around four hours to take all the studs from the tires (around 480 studs). Now we were fucking pissed, broke and on our way to Karlsruhe.

A few hours later we finally got to the club... the next kick in the gut. The guy who had the club had a brilliant idea. "You guys are from Sweden and part of the Scandinavian scene. That's what people want, so I will charge more than usual at the door." We told him to go and fuck himself!

So there were about forty to fifty people in the club and a couple of hundred outside refusing to pay to get in.

We told them not to pay that much to get in, but some had traveled a long way to see us so... the gig went pretty OK, except for the fact that the skin on the bass drum broke after six or seven songs, and then the strings on the guitars started to break. So with a broken skin on the bass drum, broken strings, one microphone, a real shitty sound, and a fucking disaster stage, we managed to play the whole set.

There was only one thing to do to end that fucking disaster day, and that was to get as drunk as possible. I guess that was the only thing that went right that day.

JM, Psychpunch (Vasteras, Sweden)

Zombie Of Chocolate

Well... we (The Rockets) were goin' to do a gig in Helsingborg, south of Sweden. We were goin' to support the Danish band, D.A.D. Mike, the band's bassist couldn't come along because his girlfriend was pregnant, and was in the ninth month. We had asked a bass player from another band to stand in for this gig. (He hardly knew "Mr Brown"). Also a man from the local press asked if he could join us and write about the gig for the newspaper. "Sure," we said. Off

we went. Suddenly, after we had driven about twenty minutes, one of the guitarists started to sweat... and I mean sweat! It was drippin' all over! Then he started to mumble, but we couldn't hear a single word of what he was saying. Everybody got terrified and wondered what the hell was goin' on? The journalist looked at him with the biggest eyes you can imagine. The stand-in bassist got paralyzed, everybody in that van got really scared.

We pulled over the van to the side of the highway, the guitarist slowly raised from the seat. He was pale and sweaty... God! It started to smell... he had done it in his pants! Total diarrhea! He went out from the van and started to "walk" (ape-style) right out in the fields. He had turned into a fountain of brown "water"... a blast of shit was comin' right out from his pants and colored the jeans from blue to brown. What a mess! After a few more steps he felt to the ground and let the whole shit out. The journalist was shocked, the stand-in bassist was terrified... well, everybody was stunned! Now what? The poor guitarist sat in the grass, he had taken off his pants. He just sat there, in the middle of nowhere, with only a worn-out "Rockets" T-shirt on. Cars that passed, saw this misery and slowed down, wondering what was goin' on. We called his girlfriend to tell her the bad news and told her to buy a pair of jeans (she was already in Helsingborg, shopping). Now we had to wash him... he looked like a zombie of chocolate.

He had to sit on the grass while we were pouring beer over him. We washed him with about eight beers, a deluxe-shower! Now we had to drive. We were already late. We arrived at the club, with "Mr Brown" sitting in the van, totally naked. Luckily, "Mr Brown´s" girlfriend was waiting for us with a pair of jeans... thank God! He put them on and sneaked into the club's toilet (in a supersonic speed) and washed the resisting... Time for sound check...

The first thing that happens is that "Mr Brown's" amp breaks down. No one can imagine what we felt!

At the last minute we got a new amp... and the gig went superbly. Yep, this was a shorted story of a looooong trip.

There's still a trace in the backseat.

Warning! Don't eat an old egg and mayo sandwich at a lousy cheap café before gigging!

Mike, The Rockets (Sweden)

Sleep Is Shit

Tiny Elvis Tour April 2002 — ten days in. The moment I walk into the after-gig party, I know it's going to get ugly fast. During the last ten days of touring everybody has behaved. Now I can smell bad behaviour building up like poisonous gas in a swamp. For tonight and the next two nights, Chef has joined us on tour — an immoral guardian, if you like. A man who could make Keith Moon blush. This morning he woke me wearing a policeman's helmet and brandishing a samurai sword. The party is freaking me out, so I make my way back to the sanctuary of the van. I pull some filthy covers over my head and pray for dawn. Shortly before dawn, Ben and Liam wake me. Ben and Liam are somewhat anxious. Ben and Liam have decided not to go to sleep tonight — or tomorrow — or ever again, for that matter. "Sleep is shit," they say. "It's for other people." They then slither into the back of the van and proceed to have six-hundred-and-sixty-six conversations all at once. Sifting through the debris of the verbal assault, I deduce the following facts: Liam has had a fight with a record company goon. Reds' eyeballs have turned to chrome pinballs. Reds is screwing our esteemed hostess. Rob is dead, or in a coma. A cat is in a cage. Chef has kindly been invited to watch a young lady masturbate. I am tired, and for the first time all tour, neither drunk nor hung-over. I decide to walk into town to try and find some food for myself, and a method of losing my two comrades. Half a mile down the road a cop car passes, then returns and stops. The cop gets out and utterly ignores my offensively wasted band mates. He starts to quiz me about a robbery he believes I was involved in the night before. Ben, meanwhile, is wandering amongst traffic, Liam is bumping his head into his own reflection in shop windows. The cop does not bat an eyelid. I guess somebody must have stolen his helmet.

Jon Montague, Tiny Elvis (Bath, UK)

Meat And Whiskey

Portland, ME, especially in our early days, had been rather good to Roadsaw. Whenever we played there, we pulled great rambunctious crowds, mostly of the hard drinking bored redneck and biker variety. Our people, as Craig would say. Erin, the red haired Irish Viking princess who booked us into Zoots where she bartended, always made sure we had plenty to

drink when ever we played. In addition to building a following in Portland, we'd also built a reputation as drunks and drug fiends and we partied like mad men whenever we came. Erin in particular seemed to enjoy keeping up with the boys, and boy, did she. After the bar closed hordes of riled up fans, freaks and females made their way over to Erin's loft where the drinking and drugging would continue into the wee hours. Every gig was like this. It was an event when we played there and the crowds got bigger. Over the months we grew more demanding of Zoots. We now required two cases of beer and a fifth of Jack Daniel's every time we played. And Erin, ever the hostess, obliged without hesitation.

Once we arrived in Portland for one show much earlier than usual and decided to grab a bite to eat at an acquaintance of ours restaurant. Norm, who ran Norm's BBQ was at one time the loose cannon singer for a Boston band called Left Nut. He had since quit the rock biz, married and focused on his restaurant. It was a huge success and he had invited us to drop by anytime. He was more than happy to accommodate us. We walked in and were seated immediately. Before we ordered, pitchers of beer arrived. As we ate, more heapings of meat were piled onto our plates. It was delicious. We ate and drank until we neared bursting. "On the house," Norm waved when we offered to pay. Because we were such poor bastards on tour, we left no act of generosity pass without fully taking advantage of it. This time we drank and ate more than our fill.

By the time we had to play, we were groaning and moaning backstage, holding our straining guts and burping up the foul stench of a painful digestion process. We knew better about eating so much right before a gig. This is what Roadsaw referred to as a *brown out* similar to a black out, except it's an overload of meat in the system, not booze. It bogged us down while we played. It made us slow. Worse, it didn't leave much room for the beer we so desperately needed to pound down prior to the gig in order to play right. That night the set was OK, a little sluggish. But some one had the grand idea to bring the bottle of Jack Daniel's with us onstage and drink it as the set whizzed by. By the time we finished, we had polished off the whole fifth. Now we were fully bloated and stumbling. And as usual, once the gear was loaded, the party moved to Erin's place. Darryl, our guitarist at the time, declined and remained in the van, laying down on the futon in the back, hold-

ing his stomach and sweating profusely. "I think I'm just gonna stay here for a while. I don't feel too good." Fine, we left him and went inside to commence to drinking.

When morning came, we pulled ourselves up off the floor and went outside to fetch toothbrushes and clean T-shirts from the van. With blinding hangovers, we stumbled outside toward where it was parked. As we approached, we squinted ahead, confused by what we saw. It like some one had dumped something on the windows. They appeared from a distance, to be smeared with mud or garbage. That's when we saw Darryl's head pop up into view, frantic and desperate. Shit, we had forgotten about him. As we got closer we could see that it wasn't mud smeared onto the van's exterior, but vomit splattered on the windows from the inside. In his sick and drunken state, Darryl had laid down and gotten the spins. All the meat and whiskey that had been consumed too quickly and in such large amounts apparently disagreed with D's stomach. We could hear Darryl screaming through the glass. "The alarm, the alarm!" Craig pulled the keys from his pocket and pressed the beeper button. The alarm chirped off and Darryl threw open the side door, his hair and clothes plastered with chunks of vomit. "I got sick and couldn't open any of the doors because I didn't want to set off the alarm! I didn't have the keys!" he gasped. "I went from window to window looking for an opening to throw up out of!" Craig and I looked inside. Sure enough, every square inch of the van's interior was sprayed with meat and whiskey. It looked like someone had thrown a lit stick of dynamite into a butcher's bag of leftover guts. Everything, seats, ceiling floor, windows... all smeared in vomit. I could see long finger streaks on the back window, as if he had been trying to claw his way out of a sinking ship. In his drunken panic, he must have run to every corner of the van, a brown spray leaping from his lips at every turn.

The morning heat boiled the air into the van into a putrefying gas while Darryl lay huddled in a ball waiting for someone to rescue him. On the sidewalk, he stood there arms stretched out, red eyed and shaking not knowing what to do, unable to touch anything, looking up and down the front of his clothes, striped with half-dried swipes. His eyes were wild, searching for a way, an answer. With raging hangovers, we nearly puked ourselves just from the sight and stench. "Why didn't you just roll down

a window?" I asked. "I thought they were power windows!" D confessed. "I was drunk, man. I didn't know!" He hobbled inside, cleaned up best he could in Erin's kitchen sink and gathered a bucket and soap in an attempt to make the van drivable so we could get home. But it never really ever got clean again. Not really. Every once in a while, on our way to yet another show, someone would discover a mysterious brown chunk of something stuck somewhere under a seat or near a window. And we never really got the smell out either, especially on those long, hot summer tours through the South West. The heat brought it back to a steaming reminder of meat and whiskey and Portland, Maine.

Tim Catz, Roadsaw (Boston)

Bad Night In The Big City

When you come from a place like Pittsburgh, it's a cool thing to play in New York City and even cooler to play at a club like The Continental that people have actually heard of.

We left Pittsburgh in two vehicles and ours arrived in New York in good time. Upon hitting Manhattan, our directions went awry of course, and we were circling the financial district for way too long. Finally we figured things out, and were hot on the trail of our destination, when in the blink of an eye, we were forced over some bridge into God knows where (which turned out to be a forgotten corner of Brooklyn). Frustration mounted as we gaped at the bumper-to-bumper traffic heading into Manhattan on the other side of the bridge.

Flash to an hour later (after a lovely tour of Nowheresville) and we're finally heading back in the right direction and pulling into St Marks after our band counterparts have enjoyed an early arrival and a pleasant lunch.

The club has forced us to choose between playing at 7pm or 1am because we are stupid out-of-towners and those in the know have agreed that both slots suck, but that the 7pm is better than the 1Am. We opt for 7pm because we're told that things will most likely run late (there are nine bands) and that should we choose 1am, we'll be playing at 2:30am to no one. It made sense on paper.

They let us stall until 7:20pm (oh boy) and we played to about four people. We were tight and the sound was superb, but if a really good band plays in the forest and no one's there to hear it, did they really make a noise?

We didn't make any money, because supposedly we only brought in six people and we needed to bring in a minimum of ten to cash in. I wonder if this had anything to do with the fact that the uninformed doorman was telling people that we'd canceled?

Halfway home, of course, the truck dies (who knew it had 216,000 miles on it?) and it takes an hour and seven cell phone calls to get AAA to agree to send a tow truck, citing that they don't know where we are, even though we've been very clear providing information about intersecting highways, streets, and directions.

We call our band counterparts who are at least an hour ahead of us and of course they can do nothing but provide emotional support.

My cousin lives near Harrisburg and she rescues us from the garage we were towed to, while we watch the entire staff fuck around there the whole day, insisting that they won't be able to check out the truck until tomorrow.

My cousin takes Dennis, the drummer and proud owner of the truck, to a nearby hotel because he in no way wants to go home and then have to return later to claim his truck, and she takes me, Rachel the singer, and my boyfriend Peter to the Harrisburg airport to rent a car. About three hours after the truck dies, we are on our way home again, and within about five minutes we're lost in some dark suburb. At this point, it's actually funny and we question whether playing outside of Pittsburgh is healthy for people like us — the traveling impaired.

Dennis arrived home twenty-four hours after he should have and $300 poorer than he should be, but with a brand-new, spanking clean fuel pump.

All told, we did meet some really cool people, saw some great bands, I got to see my cousin, and we rocked our balls off to the lucky four people. Oh, and most important of all, we made a new band rule about staying together when we travel.

Pam Simmons, Motorpsychos (Pittsburgh)

From Coast To Coast To Jail

The year was 1988. The band was the Wooden Soldiers. We hailed from the fertile music scene of New Brunswick, NJ. Our debut EP, *Hippies, Punks, and Rubbermen* on Absolute A-Go-Go Records (1987), was a local hit and also turned the ears of more than a few nationwide. A tour was the perfect follow-up…

Besides the regular shows around the Metropolitan area with an occasional jaunt beyond that, the Wooden Soldiers embarked on their first and only cross country soirée. Equipped with a modified work van that contained us, a loft, half a couch, and a compulsive liar for a road manager, we played shows starting in Nashville and ending in Tucson. At that point it was us, a loft, half a couch, and a nearly

West Coast hang it was time to drive back. Our plans were to meet up with Rt 80 and drive straight east to the Garden State. We hit a snag in the eastern part of California. *Needles* to be exact. A suitable name.

After draining ourselves of urine and other things at a rest stop, we traveled on. Our bass player, the other Matt, had slept through this crucial stop off.

©2002 HEDGEHOG (with apologies to Godfried Schalcken)

forgotten road manager. The poor kid never made it past the first week. He is another story entirely...

The ecstasy, though, made it all the way to our final gig in Tucson at the Hotel Congress. And so did some mushrooms and marijuana. Believe it or not, I can't remember certain details like who ingested the ecstasy on that final gig, but I do know that our drummer, Matt, did not. No, he did not. He definitely didn't. After leaving Tucson and driving all night under the influence of fungus, the other songwriter, Paul, and myself got the vehicle to the Pacific Ocean. We arrived sometime around dawn. The sky was awesome. The future was uncertain. Los Angeles was a reality.

At this point we had no gigs and a couple of friends in LA. So after a leisurely week of doing the

Within a quarter mile of our re-entry onto the highway he awoke and announced his need to pee. We pulled over to the side of this desert highway. With the lack of trees, visibility was high. With a black bass player, visibility was even higher. From across the road we heard on a loudspeaker, "Put that thang away!" Yes, this was the voice of a county sheriff. They were doing a U-turn. We resumed driving with yours truly behind the wheel. We'd been had. They pulled us over. A county sheriff and his two rookie lackeys. One was surfer-like and the other was fat. First we were verbally educated on the ethics of a publicly displayed penis and the fact that women and children could have seen "it". Drummer Matt owned the van so they asked him if they could search it (the toothpick in his mouth and reply of, "I don't

care what you do" didn't help). We were removed and searched in classic style against the van. It was so *Starsky and Hutch*, but not as cool. Telling drummer Matt to empty his pockets he threw down their contents. To our dismay and the cops' victory there was a film canister with... ugh... a hit of ecstasy! We were not ecstatic. Matt was led away in handcuffs and they continued searching the van and ripping apart our equipment and stuff. They somehow missed the reefer in the coffee holder up front. Dummies, both them and us. Somehow I was the spokesperson in this situation since I had been the one driving. The sheriff took me to the back of the van and had me open my briefcase. It contained contracts and money as well as other things. There was an Irish whistle first visible once opened. Also visible beneath that was a bag of mushrooms obtained in Texas. He asked me while pointing at the contents, "What's that?" I answered, "Eh, an Irish whistle?" I guess I answered correctly. He told me to shut the briefcase.

Matt was taken to the station and booked. He was to wait ten days until the case could be heard by the circuit judge. Those days were spent in San Bernardino County Prison. Ah, the Wild West! We spent the next few hours on the phone with our label, on the phone with Jim Morrison's lawyer (I kid not), and onto the idea that with 200 bucks and no gigs we would have to leave. This really sucked. Our bandmate and good friend was in a county prison. We were on a lonely ride back home in a van that was lighter and definitely quieter. This was probably the beginning of the end for the Wooden Soldiers. We continued maybe another year. Matt got out of jail and some good friends brought him back to LA where he caught a flight home. He has jail stories that go good with beer. What's funny is that before the tour began I remember Brad from the label saying, "Just don't get arrested!" Irony also goes good with beer.

Greg Di Gesu,
Speedsters and Dopers (NYC**)**

Anti-Rock

We were on tour with Meatjack from Baltimore. I was playing drums for both bands. Chris couldn't go on the tour because of work. So Brian from Meatjack filled in for him on the tour. It was pretty incestuous.

Anyway, the show was in Houston. I forgot the name of the place. It was a coffeehouse. We were driving around downtown Houston, which looks pretty nice these days, looking for the club. We found it. The shittiest looking building you could see in any direction. Outside, hanging out, were all these homeless people, sitting at the tables of the place. Inside it was pretty typical, but there was no stage-type area. We were like, "Uh, where do we play?" the answer was "upstairs." So we went upstairs. Yikes. I can't describe it and do it justice.

The "stage" area was this smallish place surrounded on three sides by stacks of shoeboxes on shelves like eight feet high. On the fourth side were about thirty couches. Anyone who tours knows *exactly* what this means. Couches = anti-rock.

Then there's the club owner. He had been exhibiting a variety of disturbing behaviors, most notably talking to himself *very loudly* and walking around *crying*. We were instantly on edge.

We got fed well. That was all good. Thank you.

We went upstairs to set up. The floor was like a relief map of Colorado. The only place I could find to put the drums was right in the middle of the "stage". Dixie Tavern, NOLA, anyone? Aaron plugged his amp in, and it immediately started smoking. Upon closer inspection, it appeared that *all* of the power coming into this place was distributed through *one* power strip and the most insane spaghetti dinner of extension cords you've ever dreamed of, all going to every corner of the building.

So Aaron goes over to the owner, and says that his shady electricity just fried his bass amp. The guy tells Aaron to get away from him. Two hours later, the guy walks up to Aaron, says he's sorry, and hands him $200.

Showtime: I don't remember which band went first. But I *do* remember that the power cut out about ten times. Each band played for about fifteen minutes. It's all we could do. No power! And of course, when you have couches, the kids are gonna use 'em. So we played for about fifty kids, all lounging in couches somewhere off to our left. Rock. I think we sold one CD that night.

Meatjack has a projectionist. His name is Petey. At the end of the night, he was talking to this girl named Amber who had drunk *way* too much coffee. He was filming her while he talked. Then all of a sudden, he fell off the rack he was standing on. Kept filming the whole time. It's pretty funny to watch.

So the gig's over, and we're loading out. Suddenly, we're swarmed by homeless guys who insist on washing our windows. While we're trying to load the gear. It was an impossible scene.

Then we were off to our friend Wayne Wilden's retarded Houston oasis to do laundry and sleep. Good night.

Will Scharf, Keelhaul (Cleveland)

Hell On Wheels

...is what we should have called this tour.

The New All Age Club in San Jose, which turned out to be a yoga studio, is a good place to begin. We were suppose to borrow equipment which fell apart, snare fell off, and so on. We ultimately rocked and made it through such adversities (like the dressing room being a peepshow room for the fifteen-year-

old groupies). We continued to our next destination San Francisco. Yay, the big city! Nay, we're booked with a polka band? Oh boy, Punk Rock and Polka? Just as we were getting over the shock of the last two shows we continued up North towards Canada, in the summer, in the heat, lots of heat... over heat... turn on heater... oh shit... there goes our tour bus...

Piss Ant finally made it to Portland, Oregon on time. Rough start for this tour. I guess what I mean is, no start. I mean it, *no start* for our tour bus. The fucking bus wouldn't start. Hell! Time to push... No gas!

Seattle was a smashing hit. The rest is a piece of cake. Right? Wrong. One word: Canada. Ever try to sneak a band into Canada? Forget it. Four hours of interrogation in the immigration office and they almost took Jeff our drummer away. Ultimately, they wanted to extort money from us to get into their country with what they call an overpriced "day pass". Did I mention the interrogation and near arrest because of our CD cover being considered pornography?

After a few more times running out of gas the rest is all down hill... with the exception of the last seven hours of driving home in the dark. The entire electrical system on tour bus had blown out, so basically, we were driving in the pitch black with our left blinker flashing the entire time, because it was the only light that worked.

The sick thing is... we would do it all over again.

Josi, Pissant (Encino, CA)

Oh boy, Punk
Rock and Polka?
PISSANT

Shit Faced And Toothless

Just got back from a very weird tour, now officially called "Shit Faced and Toothless", 2002, on account of all the 'colorful' denizens of Missoula, MT.(Bum fight capital of the world! Everyone was feuding — they even wanted a piece of us!) We live in Tucson, AZ. On the way to our first show in Las Vegas, we lost our drummer. There is a checkpoint just before crossing the Hoover Dam (in case folks are smuggling plastic explosives to blow up the dam). Bass player Hank Topless was toking up, and then realized we were going to be pulled over and searched.

Art: Dee Rimbaud

The drummer Noel was sleeping. He woke up in time to see Hank's panicked expression, and the trooper about to rifle through our bags. Being half asleep, she kinda freaked out and lunged at the trooper, kicking him in the dick. I'm sure you can figure out what happened after that. They cuffed her and put her in the back of a patrol car, then took about an hour and a half searching our van in the blazing sun. At least we didn't get busted for dope, but we had to play our first four shows as a country duo (bass player on guitar/singing, myself on drums). This didn't go over so great at the punk rock clubs. Noel's mom bonded her out, and she flew out to Seattle where we met up with her to continue the tour. She has to go back next month for sentencing, so cross your fingers for her. This probably is not a wild rock'n'roll story by other band's standards, but I sort of see myself as a middle-aged house frau, with my wildest days behind me, so it was all quite an adventure!

Julia, Solid Donkey (Tucson)

Piss Party

To be kicked from a support tour with a big band is no fun and The Scarecrows absolutely have bad luck and experience with that shit. We played a show in a pretty big Swedish town in '99, when the headlining band just had released their hit single. We had ten or fifteen cool Swedish gigs to look forward to, and after that, a trip around Europe. But what can I say? We didn't behave. Both bands had played a successful gig and the party at the Hotel afterward got a little wild. I remember it started with both bands peeing in a big juice pitcher cuz we wanted to play a joke, putting it outside the tour manager's door and writing "apple juice" on it. But the guy who carried it kinda dropped the whole thing in the lobby. The pitcher was pretty big, and the floor was covered with a very nice carpet which was not so very nice any more. The best thing about the hotel was that there was no security awake, so the bar stood open for two already fucked-up bands. I remember we drank a lot of wine from the taps, but we wanted some stronger stuff, so me and the guitarist from the other band made a break-in on the cocktail cabinet and stole lots of vodka and whisky bottles and hid it in their drum cases. We thought we were smart and the hotel personnel would never notice anything was gone. The morning after, our room was strangely filled with water, and all the booze was in the other band's cases. But they had left, and we were still there to take the blame. Some days after, we got a call from their manager, kicking us off the tour, telling us we were too bad to have around. And the hotel sent us a pretty heavy invoice. Shit happens, but it was a hell-lotta fun!

Manx, Scarecrows (Sweden)

Part 2

HOMETOWN ZERO

Basking in local shame

I'm gonna rock this city
with everything I've got Thor

Dedication

I don't know why but it always happens in Yorkshire. Maybe it's the climate, maybe it's something in the water, maybe it's just us... the most accursed rock'n'roll band in the UK. The Divine Brown were preaching to Yorkshire's great unwashed, it was the usual sonic sermon of epic proportions. We'd preached in the town before, but usually propping up some fly by night, flash in the pan nu(mb) metal shit, but this time we were headlining (oooh). All was going well, good crowd, the kids were alright, etc, etc.

Three quarters of the way through the set some kid comes up to the stage in between songs, "Can you play a song for Davey, he was a regular in the club, and very well thought of by a lot of the people here tonight. He died in a motorcycle accident last night. Please play a song for Davey." I just said, "Yeah, no problem" without thinking to glance at the set list. I mean, it wasn't a request or anything, just a dedication, no problem. Unfortunately, unbeknown to me the next song in the set was a Ramones cover we'd had in the set for some time. I proudly announced "This is a song for Davey, God bless him, this is called," (looks down at the set list) "I Wanna Live". We got about two chords into the intro before a shower of bottles, glasses and chairs hit the stage. At first I thought this was a sign of respect, then I saw a hundred angry Yorkshiremen goose stepping towards the stage. They must have found the song unsuitable and possibly slightly sarcastic. Oh dear, wrong place, wrong time, wrong song.

I've never seen four drug-addled alcoholics move so fast, but before I knew it, we were in the van, and it was a-rocking. They finally gave up after half an hour (realizing they might miss last call), so we high-tailed it out of there as quick as we could. The ride was bumpy, as we were riding on the rims. They'd slashed our tires. God bless Joey and the boys.

Lloyd, The Divine Brown (London, UK)

No Smoking

As an old friend of theatrical rock'n'roll shows I decided that we need a proper smoke show on stage. We were booked for a gig at the Students House in Helsinki, Finland on a Saturday night, so on Friday morning I drove to a company that sells chemical ice. You know, that stuff you put in water to get it smoking like hell. "Two kilograms should be enough," someone had told me. OK, in the shop they told me the stuff would evaporate before the gig unless kept in a special freezer. And you have to wear gloves to handle the ice cubes. I was told the ice is so cold that it might break your normal fridge. Ten kilograms might do the trick. Well I was short of cash, so I settled for seven kilograms and drove home. I put half of it in my fridge and the rest in a dark closet, wrapped in paper.

On Saturday afternoon we had a sound check and our drummer Leo brought a small fan in case there would be so much smoke that he'd have problems playing drums. By the evening I fetched the ice but half of it had evaporated. When it was time to start the gig we placed a bowl with water onstage and put the ice in it when we entered the stage. We now had about third left of it. We started off with the first song and a small trickle of smoke appeared from the bowl. During the first song I lifted up the bowl so the audience would see our spectacular smoke show. You could hardly see any smoke at all. I put the bowl down again and continued singing. Then Pepe, our bass player, accidentally stepped in the bowl and we had water all over the stage. No smoke and the stage got slippery. The fan was slowly humming on the amplifier behind the drums. Afterwards our guitarist AG said a lit cigarette would have caused better smoke on stage.

Lasse Grönroos, The Dogshit Boys (Helsinki)

Grabbing The Girls

The first time we played with Rockbitch, it was just shock to be there with them. We didn't have a gig from hell, we just thought, "Fucking hell — this is ridiculous." But they were funny, because there were no rules... But then the next gig we had with them, we got the drummer's girlfriend and my girlfriend into silver bikinis to dance for us. We did about two songs, and no-one gave a shit about us, as always, and there were a fair few people at the venue but they were all at the back. Then, two or so songs in, we brought the girls out, and of course that brought a massive rush of guys to the front. They must have been thinking that Rockbitch were getting their tits out, so these girls would do it too. Blokes were leer-

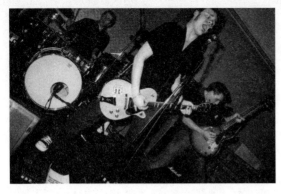

This is a song for
Davey, God bless him.
THE DIVINE BROWN

ing at them, and I was thinking "Fucking go away, you dirty bastards, that's my girlfriend". And you could see them, totally oversexed and totally drooling at the mouth. So we did our gig and that was all fine, then Rockbitch came on and invited our girls up to dance with them! I swear I was so angry. We were on the side of the stage and could see all these people jumping on stage and grabbing the girls. My girlfriend and Darren's girlfriend were just surrounded by all these blokes. For me, that was a gig from hell for definite. I didn't mind them being stared at if it was under control, but this... And they grabbed one bloke up, and strapped a big black dildo to his head, and he did one of them up the arse — this is not one of our girlfriends, I mean one of Rockbitch.

We played such small venues. We played this one place — upstairs at the Boundary in Birmingham. There's no room on stage, so our old lead guitarist played behind the bar!

Andy, Sally (Birmingham, UK)

Menstruating Rice

Demolition Girl's been on the road now for ten years and things kept happening all the time — here are some of our strange encounters:

EXPERIENCES IN OUTER SPACE
BETEIGEUZE, ULM
We were invited to play together with German veteran punk band Phantastix from Hamburg. The same event was to be our bass girl Frauke's last gig with us and Fresh-Fruity Frank's debut — an important affair. The location was the Beteigeuze in Ulm, an old, independent cult club. Arriving "just in time", the club already packed with people, we were offered "delicious" catering consisting of either half-

warmed noodles with an almost dried cheese-sauce and something looking like menstruating rice. We decided on cold beer instead (luckily cool and loads of it). It was our first gig with the Phantastix, and due to some little misunderstandings none of us brought a drum kit along — big problem. The promoter, a good-hearted and somehow sleepy old punk was in a cold sweat, but after a while he said he could organize an old friend's kit. Half an hour later, he came along with an ugly-something-supposed-to-be-drums. Schwabe, the Phantastix' drummer, stood there, not trusting his eyes "I'll have to take a photo or no one will believe me — this bloody thing hasn't been used for at least ten years!" and as if to prove that, a mummified mouse cadaver fell out of the bass drum as we tried to put the sad remains up. Luckily, another kit was organized and the gig went down quite well — but this was not the end yet. Backstage after the gig, tired, sweaty'n'drunk, we asked for the sleeping place... a moment of stunned silence as the promoter realized he'd just forgotten to organize that for us. Along came a girl, "No problem — you can all come to my place, but we have to go in a zodiac, as the whole area is flooded." Needless to mention that the Phantastix and us are the best of friends from that day.

SHIT HAPPENS
PRINZENBAR, HAMBURG/ST PAULI, CHRISTMAS '99
Due to large amounts of booze the way up was a "stop'n'go/need to leak" affair. When we arrived at the Prinzenbar, it turned out to be a former burlesque bar kind of place full of noble cloth and furniture and an amazing turn-of-the-century ornamental ceiling. Chris Duracell (our drummer then), who never had stepped out of the little suburb in his hometown of Velbert except for our gigs, just stood there very, very silent, and obviously deeply moved.

Sometime later, when it was our turn to go, I gathered my guys around me — except for Chris, who was nowhere to be found. I calmed down the promoter and searched all around the club. After a while I discovered him in the farthest, darkest edge of the backstage area, whispering "I just don't dare to go out there — everything's so beautiful…" Luckily, he changed his mind after a few charming words and one, two, three, four, the show started, with one of our guitarists shouting "Hello, Berlin!" We really enjoyed ourselves, and rocked the place — but unfortunately, there was only a small supply of backstage beer afterwards, disintegrating almost immediately. I had gone out to see the next band when suddenly I noticed JR Ambulance (one of my guitarists with the body of Jesus on the cross) creeping onstage, grabbing the microphone and saying "We want more backstage beer — or we're going to smash the whole backstage area!" Only seconds later the club owner (a guy well used to heavy geezers in the red-light district) came up to me, and quite shy and very silently asked, "Hey, what's going on? Your guys

he had quite a few beers too much and after some 100 meters he stumbled, landing with one knee in a pile of dog shit, but like a miracle, leaving the precious bottle unharmed at the same time. Not much later, Chris noticed a huge lump of something clinging to his trousers "What the hell is this?" He took a sample with his finger, licked and tasted it and said, "Tastes strange — this is… *shit!*" This is how Chris Duracell became a living legend in Hamburg, with people there still asking "How is Chris doing?" even after several years. Last but not least a big thank you goes out to the nice woman who washed Chris' trousers — and spared us the experience of driving back home in a car smelling like a public toilet.

THE BIRTH OF THE GLITTERCOCKS
Honestly, do you know the Demolition Doll Rods, the topless, pussy bonus girlband? OK, OK they're alright, but Demolition Girl has got two nude male Go Go Boys, The Glittercocks, and this is how we found them:

I was lovesick, it was my birthday — what do you

```
I was lovesick, it was my
birthday - what do you do
     in this situation?
  DEMOLITION GIRL AND
  THE STRAWBERRY BOYS
```

want to smash the place up!" I know my boys well and I said. "Really, why?"

"Because they want more beer."

"Oh, no problem, just give them some."

Within minutes there was so much beer we could even supply some of our fans. On went the evening at the Radau, a small bar nearby where we love to spend our after-show time. As we left there, we noticed Chris sitting bare naked on a pile of trash mumbling. "Just didn't play good enough — this is the place where I belong." It took all my angelic persuasion skills to get him to dress up again.

Shortly afterwards, on our way back to our sleeping place, he went into a gas station and nicked a magnum sized bottle of champagne. Unfortunately,

do in this situation? You go to a Rocket From The Crypt concert a do some heavy flirting — that's it. Some good friends from Hamburg donated me the ticket. This turned out to be a golden investment, because in front of the stage, I met two diehard fans from Kassel. We all celebrated RFTC (and my birthday of course), and spent the whole evening just dancing and kissing — I was more than just happy!

After the gig they "kidnapped" me, put me in their car, and straight off to Kassel we went — into the Mother, our all-time favorite club there — and partied on and on. When the club closed, "AC/DC" — Stefan and Neffe — took me to their place, and showed me a film called *Lighthouse Of Passion*, which I first thought was a porno, but turned out to be a

collection of ultra-funny-trash short films. Then *boom*, the table was emptied, and the two guys jumped onto it — bare naked — waving their cocks and Go Go dancing chanted, "Happy birthday, dear Hedwig"! I just couldn't believe it — out of my head from that amount of "Manpower"; I carefully asked them, "Do you do that a lot of times?"

"Yeah!" the two answered.

"Then try to cultivate this — why don't you just become Demolition Girl's Go Go dancers?"

This was the birth of The Glittercocks.

They made their debut in Münster at the Gleis 22. Were they prepared? Did they have any choreography? Of course not! They just painted their bodies with marker pens, put on S&M masks and one, two, three, four, they exploded. Münster is known for its Catholic background and the audience went berserk — some people got hurt, including one of my Go Go dancers — the evening becoming the talk of the town. Later he (AC/DC Stefan) went to the toilet to piss on his bleeding hand to disinfect it — but he just couldn't leak. In came another guy, and AC/DC just asked him "Hey, could you please piss on my hand?" *That's real punk rock!*

So the boys' debut was a full success and I love them and enjoy every gig we do with them.

Hedwig, Demolition Girl and The Strawberry Boys (Wuppertal, Germany)

Unlucky Dog

We played Sir Morgan's Cove, which is now the Lucky Dog in Worcester, with a bunch of hair metal bands. It went over very badly. Most of our worst shows were in Worcester. I got beat up there once. That was at the hair metal show. My band had pretty much ditched me; they went to find a strip club or something. The bartender loved us, so he had just been giving me free drinks all night. So finally I stumbled out of the place looking for the band. I found my guitar player, and I was yelling, "Worcester sucks!" and it just so happened that the LL Cool J concert just got out at the Centrum. I guess some guy wanted to display some civic pride, so he decided to kick my ass for saying that his city sucked. I don't blame him. So he got in a couple of punches, and I fell in the street, and as soon as I fell, our van pulled up and I jumped in.

Dave Unger, Random Road Mother (Boston)

Hillbilly Heroin

Back in 1999, although we had a decent number of out-of-town gigs under our belt, we were still game for playing fucked-up rural areas of Western Pennsylvania, specifically in Fayette County where we all were born'n'bred. Sure, there are some local tax-dodgers who landed good paying jobs in other counties and bought up rural plots of land only to clear the trees, build modular homes, and drive taxes back up by demanding water and sewage lines; but Fayette-Nam — as it's lovingly called by local law enforcement as well as some bitter locals — is still a strange combination of sub-poverty level "white trash" (and I can use the term, fucker, because technically I'm white trash by default) and rural blacks crowded into the same housing projects and Section 8 (HUD) neighborhoods. Drugs are easily bought and sold, and in some respects Fayette county is at the cutting edge when it comes to getting Fucked Up: for example, it was one of the first places Oxycontin ("hillbilly heroin") took a strong foothold. Crack, Cocaine, Dope, OC's...you name it, you can probably find it. This is what happened in postindustrial Appalachia — decent jobs are few and far between, education is lacking, teenage pregnancy is high, and booze and drugs are the only "relaxation" methods for the people there who have seen the American dream smashed by Reaganomics and union-busting during the seventies and eighties. For all its warts and scars, I still love the place and hang out there often, because it has a hell of a lot more character than the typical big city (shitty), with little to no rich kid cultural pretentiousness. That kind of shit takes time and money; in Fayette, we have the former, but not the latter. So when a friend of mine I hadn't heard from in five years got in touch with me about setting up a show in Connellsville, PA with his band in the opening slot, I said "What the hell... a good excuse to jump in the van and get drunk in the old stomping grounds."

On the day of the show, we all got out of work and went through the usual trip preparations of icing down the red cooler full of Yuengling Lager, taking inventory of consumables (guitar strings, pills, etc) and hit the road. After picking up a close friend who lived in Fayette County, we took the back roads to Connellsville, PA to avoid the local police and their random DUI checkpoints, blasting the van's nearly non-existent stereo system, swilling Yuengling,

and enjoying the mountain scenery along the way. The show was set up at the Hotel Riviera. The Riviera looked like a pre-WWII hotel alright, but the darkened upper floors with broken and boarded up windows hinted that only the ground floor level was in use. I had never been there, but assumed it was the usual dive-bar setup: stale cigarette stink, dusty linoleum flooring, fifties chrome tables and barstools, yellowed "25cent Wing Night" signs, with the band room separate from a dingy bar. Usually in these kinds of places, the band brings and works the PA as well as the door. Assumptions correct on all fronts, with one added bonus: the clientele at the Riviera was about ninety-nine percent "African American". Being city-wise fuckers, we've done our share of peaceful boozing elbow to elbow with just about every race on the planet, but the barflies in the Rivera just stared at us like a bunch of lily-white fuckers who were better off hanging out "with their own kind", while the bartender refused to even look our way when we went up for beers. "Hmm… wonder where the 'white' and 'black' drinking fountains are in this place?" was what we were all probably thinking. Eventually I had to walk behind the bar to get the bartender's attention, and judging by the look on his face when I did this, I expected him to reach under the bar for a baseball bat or a black market revolver. Instead, we got cold stares to go with our cold beer, and went back to the main band room.

At this point, I noticed that the guy who set up the show — who had said that he would take care of working the door and all the other shit work — was wandering around the room in some kind of pill daze. Yep, turns out he was fucked up on Xanax, Percoset, or some other kind of half-assed prescription medication. He hadn't collected a cent from the twenty-five or thirty punk-rock youths who actually showed up at this dump, so I had to go around and try to weasel two or three bucks from everyone in the place — except from the black guys at the bar — the old quote "I may be dumb, but I ain't stupid!" applies here. To the punk rockers' credit, they didn't pull the usual poverty-punk scam (you know, they claim "I don't have any money, dude" while you look at the hundreds of dollars spent on spikes, patches, T-shirts and bondage pants). Eventually, Percoset Boy's band started playing a drawn out, druggy kind of set that just irritated the bar's regular drinkers, and I'm pretty sure that after about forty-five or fifty minutes, someone in our drinking entourage told

them it was time to wrap it up. I just wanted to get the fuck up there, play a short set, and head back into the woods of Fayette for some relaxing beers, not babysit an ill-attended punk show, wired out of my head on trucker pills and cheap beer, while a group of surly, drunk'n'stoned black guys gave off evil vibes.

Finally, we got to set up, and plowed through about two or three songs while the local punkers formed a circa 1982 hardcore mosh pit. A near-fistfight almost started when some fucked up friend of Percoset Boy wandered up onstage in the middle of one of the first songs and took a couple of our beers. We weren't having any of that shit, so after we retrieved the stolen goods which took nearly ten minutes and a lotta heated exchanges, we went back into the set. Immediately after that song, we couldn't help but notice a huge — and I mean *huge*… maybe 350 pounds! — black woman standing about ten feet from the stage, screaming her pumpkin-sized head off, ordering us to stop, that our set was "Over", and it was time for the DJ — obviously the skinny, crack-ravaged guy at her side clutching a turntable case. "How great is this!?" I was thinking… it's not everyday you get heckled and bully-boyed by a gargantuan woman like this, so I took the opportunity to string her along with the usual veiled insults and half-assed pleas of "Come on… one more song!" over and over. Eventually I took off my Gibson SG and left the losing contestants with the parting gift of "This is why I love Fayette County!" The Wall of Flesh still wanted a fight, so she stood around muttering shit to and about us while we were packing up our stuff, trying her damndest to get us to start insulting her back, but I probably had too much of a shit-eating grin on my face the whole time to play along and my girlfriend just wanted us to get out of there before things got really ugly — the whole fucking thing was just too surreal. Percoset Boy, however, was more than glad to argue with her, which was even funnier considering what would have happened if she decided to stomp the shit out of his somewhat short and skinny frame.

After we got everything loaded out and stacked next to the van in the parking lot, my friend and I crawled into the back of the van to smoke a joint or two. As we were crawling back out, the local police rolled into the lot with their lights spinning. I started grabbing everyone's beers, throwing them into the cooler, into jacket pockets, anywhere just to hide

the fucking things. The police approached the van, and I turned on all the charm I could, given my fucked up mental state, and before they could start shit with us I told them that we were just loading our van and would be out of town in no time. "Everything under control here occifer, no nightsticks up my anus, please." The cops were actually decent to us, and told us that it was the bartender who had called the police to get rid of *us*. Apparently the whole altercation wasn't too funny to the bartender, but it left us with a lot of laughs for the ride back to our usual Fayette County drinking holes. All in all, I wouldn't necessarily call this a gig from hell because it was just such a strange and unintentionally funny night… but then again, it takes a certain sense of humor to understand Fayette County. Can't wait until the next time we play back there…

Ted, Mud City Manglers (Pittsburgh)

Green Snow

I usually take homegrown Cubensis before I play live, so one night we played at a local pizza pub with our own PA. They had this beer that was sixteen percent alcohol, and it was about 110 degrees in that bitch. Anyway, toward the end of my set, I started hallucinating, threw down my guitar, picked up my spare, smashed it, opened the back door, ralphed in the snow, came back in, and finished the outro. Burien rocks true, boy.

Horsehedd (Seattle)

The Rise And Near Demise

OK, our first gig from hell was, appropriately enough, our first ever under The Medicine Bow name. See, we'd played two before this one under a *really* shit name. Two pretty well-populated affairs they were, too. This resulted in us being warmly welcomed back by the promoter guy of this certain venue where we'd first hit the stage in the January. And so it got to this one, March 13 (-ish), 2000, if memory serves, and things don't quite go to plan (maybe 'cos there's never been one).

We sit around waiting hours to check, as always in this place. Yawn, yawn. Now, this fucking hip clip joint place doesn't sell draught beers, only bottles (for a continental feel, whilst in the middle of one of the most polluted cities in Europe, hey now *that's* cool), so we load up on cheap shit cider and the

like, being skint, but still having healthy thirsts. So far so good, maybe, but bring in the added fuel to the fire of our second bassist, (having gladly lost our first after the second gig), and a spectacularly vodka-fueled drummer, who from the sound check to being onstage, was, according to the engineer, like he'd all of a sudden become retarded… and things go haywire.

So, there I was getting more drunk and less bothered about trying to conceal the huge three liter bottles of cider (the kind that I'm sure are from secret government agencies as part of some chemical testing on dregheads) that littered the table, and someone comes rushing out from the back of the room where the toilets are, telling me to come sort something out. So, I wander off and find the drummer, from now on known as "Mr Wigley", screeching at this stand-in bassist guy, and him screaming back, and this bassist's missus squawking away too, about fuck knows what. All right in each other's faces, phlegm flying everywhere from faces about to explode… and you know what it later transpired to be about? Who had taken more of the equipment down the stairs from Wigley's flat into the cellar for rehearsals.

And then we went on stage, to a not considerable amount of people. Instantly, through me own cider haze, comes a knock on the door.

"Stu…"

"Yeah?"

"Something's going very, very wrong."

"I know, mate, it's that fucking drummer… what's the stupid cunt doing?"

"What's he doing, Stu, old boy? Why, he's playing at half speed."

"Well, it'll be all right next song…"

Who was I kidding? Well, me. The stupid fucking prick played the whole set at somewhere approaching half-speed, with the erratic maneuverability of a car driving with a puncture, didn't make any amends even with us screaming at him that we're gonna kill him, towards the end of the last song (which we never finished as the engineer pulled the plug) he shouted into his mic about how shit the place was (well, I can't fault him on that score) and how it's all stupid, etc. Then after knocking all the mics over (which the engineer loved him for, but anyway, he fucking reeked), he fell off his drum stool… and thereby off the back of the stage.

And so ended our first gig as The Bow. We were

threatened with being blacklisted from everywhere in town (damn...) and the bassist then had more fuel to scream at the drummer with afterwards. Bouncers were flocking like vultures, waiting for a sniff of a fight, so we left, and had some disgusting bottles of white wine that the drummer had half-inched from the strange Conservative Club were he worked. He doesn't drink before gigs anymore.

But he still plays with the erratic maneuverability of a car driving with a puncture.

**Stu Gibson, The Medicine Bow
(Manchester, UK)**

Rotterdamned

I woke up one beautiful Saturday morning. Sunshine on my face. I was happy, 'cause tonight the Lulabelles would have a great, totally crowded, well paid, rock'n'roll show — according to our new booker. The last five shows we played were a little shitty, but who cares? Tonight was supposed to be the night of all nights. It was a pretty long drive, about five hours. I met the other girls: Liz Lulabelle, Mary-Ann and Killin' Mama, around 13:00. We loaded the van, and off we went.

As soon as we reached the highway, it started to rain really, really bad. But so bad that in five minutes, water was everywhere. Of course our too-old van also let some water through. Our back-line was in danger, leaking water on our amps. So we stopped on the side of the road and took our jackets and some other clothes off to put over our amps. I must add to this that the amp I brought was not even mine, but it was from that very cool guy that refers to the amp as his "baby", and I don't wanna be the kind of girl who kills a baby...

It didn't stop raining and everything got wet, but the amps were okay.

We we're driving and driving, and after five hours, it seemed like every meter we drove got us further from human civilization. We didn't see a gas station for an hour and we all had to pee really bad, and if I say really bad, I mean really *bad!*

So we stopped on the side of the road. It was some kind of parking place. While I was peeing, I heard Killin' Mama scream... And it turned out that she was standing, with her very expensive shoes, in human shit. The smell was so unbelievably bad, I never smelled anything like that. So now we were driving in a totally wet van that smells like some

truck-driver's dirty shit.

Of course, the directions we got were totally wrong, and nobody answered at the number we tried to call. But thank God, we met someone on the street who could tell us where the club was. So, two hours too late, we arrived. Because we were too late, there was no time for a sound check, and we had to hurry like crazy. We we're still totally wet by the way, and totally hungry. After putting the stuff on stage, we had to run to the backstage, where they had a meal for us. We started to eat some totally dirty old Chinese food and after four minutes, some weird looking dude told us that we had five minutes before we had to go on stage. So we went on stage totally stuffed with dirty food and totally wet from the rain. But I still didn't care... everything for the cause of rock'n'roll right?

The first thing I heard when I entered the stage was, "Take your pants off, show your tits!" This was coming from the three farmers standing in front of the stage, and the other five visitors who where drinking at the bar. The sound was totally shitty, and when my intestines started to feel like they were exploding because of the bad food, I really had it with this whole fucked up day.

Of course we got like twenty-five bucks for the show, and we had to drive back in the rain again because some one fucked it up with the sleeping places. But the good thing is that I guess many other people stood in our diarrhea at some parking place

next to that high-way, thanks to the Chinese food.

Ann Alcoholic, Lulabelles (Rotterdam)

Crazy Love

So, as usual, we got to the club way early to load in. I was kind of surprised to see some people already there and ready to rock... okay well, there was a thirty-something creepy guy staring at me over his beer and his mother, knitting an afghan on the stool next to him. They stayed all night and didn't draw too much attention to themselves so I kind of just smiled to myself about the whole thing and shrugged it off. The next day the band got together to watch the videotape of the show. We noticed that when in fast forward, my creepy friend remains completely stationary in the middle of the screen while the world goes on around him... three hours... as the afghan grew and grew, "Bobby" never moved.

I eventually got a phone call from my new fan. Over the sound of really big dogs barking, I recognized my voice in the background. He was talking about how great my CD was and how he wanted guitar lessons. Anyhow, we ended up playing our next show at the same club and Bobby was there early like before, his mother with her many bundles of yarn. He gave me some pink slippers that she made for me. They fit like a glove.

Time passed and I got a few more calls, but I never saw the odd couple again... Well, I got a letter in the mail about a week ago. The return address was that of our local mental health complex. It explained how my little friend had been kidnapped and tortured by the police. They shot his dog. He was locked up. He wanted me to come visit, and he wrote me a song. "The sea gulls chased the dove away during the sunrise we made love all night," was one of the lines that struck me. It was disturbing in a cute sorta way... sorta. So last Friday night I stopped by County Psych and left him a band T-shirt and letter to refresh his strange attraction to me, 'cause everybody knows you need a creepy, stalker-guy fan in order to be any kind of legitimate rockstar chick. Right?

Binky Tunny (Milwaukee)

Free Thong

I was sixteen-years-old and playing (it had to be my third gig ever) at one of the premier joints in Balti-more, opening up for a dear friend who knew how to bring out the masses.

At the time, I was still solo acoustic and not very good. The butterflies (or moths in this case) starting flapping their wings in my stomach from the moment I woke up that day. I felt like a walking clusterfuck — man, I didn't know what to do with myself, or what I was going to do onstage to be truly entertaining. So to ease my mind and guts, I decided to clean my room. While cleaning out my closet, I found a ratty, old, chewed-by-the-dryer thong. This could be useful... Fast forward to the gig. I was onstage, playing my little heart out, not giving a damn about how awful my sense of dynamics were, not paying attention to the rash that had broken out minutes before due to nervousness — (the same nervous hives that happened to appear all over my chest when I first stepped foot into my gynecologist's office...); just trying to stay focused. Then the moment came — "Who wants a free shirt?" I yell from stage. Of course everyone wants something free, so I gladly throw out a Val Yumm shirt to the wolves. The shirt landed on a beam overhead. Ah, Fuck. OK, then — "Who wants a Val Yumm thong instead?" A wave of drunk forty-year-old men rushed to the front. That threw me off. But I wasn't going to disappoint them. I reached under my skirt and virginly awkwardness, pulled down the rawest shit thong in the land and threw it out into the audience. Can you believe people dove for the thing? It made someone pretty happy too, and at the end of the show, he had me autograph it (I made sure it was a red sharpie signature in the crotch).

I didn't really gain anything from throwing out my underwear into the audience (except the fact I really needed a band so I didn't feel the need to do anything besides play music to be entertaining onstage.)

The crowd loved it, I didn't know what to think and I'll tell ya, my dad (who was by the sound board the entire time) was so horrified that he doesn't attend any solo acoustic shows of mine anymore.

And to end the story, someone was kind enough to get a photograph of me, spread eagle with hives on my legs and chest, armed with a guitar and antique undies. That picture ended up above a urinal at a gas station in Central, PA with www.valyumm.com written on it.

(Just for the record, I wore two pairs of underwear — I have no desire to be the next Courtney Love)

Val Yumm (Baltimore)

White Stallion

Being in a band can be a wonderful experience. There is kinship with your fellow band members, creating something together that the world has never seen before, or even just somebody to have a pint with after rehearsals. It can also be a pain in the ass.

As an eighteen-year-old I had these grand visions of composing epic songs that would enthrall the world and lead to me living a comfortable life in a huge house with a different bedroom for each day of the week. Beautifully constructed musical compositions of sparkling beauty containing enlightening words for the benefit of all mankind. Then I joined a cover band.

It was comprised of a guitarist who was going out with the drummer's sister and was a cousin to the lead singer. I felt like an unwanted foster child but they needed a bass player and I needed a band so we put up with each other.

I ended up sat in my bedroom learning Bad Company's Feel Like Making Love and Boston's More Than A Feeling whilst constantly wondering what the hell it was I was doing. None of this stuff appeared anywhere in my own record collection. Blue Oyster Cult's Don't Fear The Reaper for goodness sake! I tuned my bass to the same key as the records and played along time and time again until I could do it in my sleep. It was boring so I would slack off and work on my magnum opus.

Anton, the guitarist, was eighty percent deaf and didn't lip read so it was necessary to shout anything that you wanted to say to him. If he had had decent hearing he would have been a great guitarist but as it was there were more bum notes than you could shake a very large stick at. I don't think he really heard them as when I mentioned it he would look at me as though it was my hearing that was at fault and not his.

The one thing we didn't have was a name. Referring to ourselves as "the band" was OK but we couldn't actually call ourselves that as it had been done more than once before. It was decreed that we would all write band names down on a piece of paper and then vote on the one we thought best. My suggestions didn't receive any votes at all except from me. To be fair, they were a little combative towards my fellow band members. I don't think they wanted to be in something called Purgatory or The Dante Family. I did hold out some hope for The

Opposite Of Heaven but to no avail. Eventually they settled for the somewhat pathetic White Stallion. It didn't get my vote, which was superfluous anyway.

Eventually we arranged a gig in the function room of a local pub called The Bulldog. It was nothing special but it was as good a place as any. I had turned up at rehearsals the previous week with a wad of papers containing several original compositions and asked that they pick at least one just to have a go at in readiness for the gig. I wanted us all to mess about with it a bit and see if we could make something of it. To present at least one original thing and not just poor copies of other peoples songs. "We have to practice The Chain," said Anton. "What, the Fleetwood Mac thing?" I replied to a nod of Anton's head. It was yet another nail in the coffin of my writing aspirations.

The band arrived at The Bulldog in the early afternoon and set everything up for a run through of the set before the night's gig. I was using an old Marshall top and a Fender cabinet that I was rather proud of owning, they really produced a great bass sound together. They also looked pretty impressive. Wandering over to them and doing a bit of knob twiddling made it look as though I actually knew what I was doing, when in reality I would be moving the knobs about but returning them to their original settings.

The bar was open so I had a pint whilst we tuned up and ran through a warm up song (Santana's version of She's Not There). Then we started the set, and between each song or couple of songs I would get another pint. By the end of the run through I had probably downed some eight or nine pints and was on the verge of falling over on the inside but looked composed on the outside. Plenty of time to sober up before the gig. No worries. Everybody went home to prepare themselves for the evening. Foolishly I decided to finish my last pint and waved them on their way. I was alone, in a bar, for at least four hours with nothing to do but help myself to beers and watch the telly in the corner. So that's exactly what I did, until I fell asleep.

I awoke a few hours later with a fuzzy head and dried spittle on my cheek just as the others returned form getting on their stage clothes. I didn't really see any difference between the jeans they had been wearing and the ones they wore now but they must have meant something to them. The worst thing I could have done was have another pint, so that's

what I did. I immediately felt better, a bit woozy but definitely better, the fuzziness subsided to be replaced with a feeling of not actually quite being there. It was an improvement.

I was leaning against the bar contemplating nothing in particular when the doors opened and people began filing in. My God, people had actually turned up. I was only expecting about ten but there was almost a hundred all coming in at once and heading for the bar. Oh bugger. My mum was there, my sister, my best friend, people from work. Oh double bugger. I smiled confidently — or what I thought was confidently; due to my alcohol intake it may well have been a manic leer.

When everybody had drinks and had found places to stand or sit the lights went down. I turned around

Between songs a friend of mine was fetching me pints that I placed on my Marshall top. It was combination of the drink, boredom, the drink, my internal idiot control malfunctioning and the drink that caused me to begin dancing. I jumped around, struck guitar hero poses, lay on my back and continued playing whilst flailing my legs about, played the guitar behind my head and generally made a fool of myself like some mad air guitarist who suddenly finds that he has a real one to pretend to play on. My fellow musicians threw me withering glances. They wanted a hole to open up and swallow me. I didn't care, I was pissed and having a jolly nice time thank you very much.

All the jumping around and foolish behavior had put my guitar out of tune. I hadn't noticed but Anton

I immediately felt better, a bit woozy but definitely better.
WHITE STALLION

Art: Martin Trafford

and leaned with my back against the bar to watch the show. The other three walked on and readied themselves, then all three turned to look at me, as did the crowd. I smiled back at them. Anton motioned me over to him and it was then that I remembered that I was supposed to be up there with them. I headed quickly for my guitar, picked it up and strapped it on. Turned on my amp, played a note to make sure it was all OK and suddenly we where playing the opening bars of Led Zeppelin's Whole Lotta Love.

was making frantic gestures at me in the middle of Don't Fear The Reaper and I finally got the message. When the song ended I tried to tune up but had somehow managed to completely lose the ability to do so. The hall was filled with bass notes going up and then down, then up and then down again. It was hopeless. I just couldn't do it. Anton came over and did it for me in a jiffy, making me feel like the completely useless fool that I was turning out to be.

At last we came to the final song, Freebird. I hated this song, or rather, I hated this song being played

by a three-piece band. It had to have at least one other guitar to not sound like utter shit. Of course when I expressed this opinion to the others they pretty much told me to shut up as it was the guitar solo that Anton played best or to put it another way, it was the guitar solo in which Anton played the least bum notes.

We played it, I continued to cavort around the stage area until I got caught up in my lead and fell backwards into my amplifier and speaker knocking several empty glasses and a couple of full ones over my amp but miraculously, not myself. The amp shorted and went dead. No more bass. Thank God for that. I unplugged the lead from the bass and walked out the fire exit door to the sounds of a not very full sounding Freebird.

I walked home holding the bass by the head and dragging the body along the pavement. It didn't do it a lot of good aesthetically but it would still play OK afterwards.

The next day I was sacked. It was about bloody time.

Verian Thomas (UK)

Sex Rock

I just found out that at our July show, there was this couple standing directly in front of me, and while we were playing, this dude was totally fingering this chick!

Here I was singing to them, thinking they were really enjoying the show. I guess they were in their own way…

Karen Neal, Queen Bee (Detroit)

Everyone's Drunk

Where, dear reader, does one begin to state the depravity, the horror, and the violence that is a No Means Yes show? I don't know, but I do know this — somehow in the process of becoming the coolest rock band this side of hell, we've spent a lot of time right there — hell. I guess I'll let you in on a couple of sad stories about us being beaten up, ripped off, broken down, etc.

Let's see. There was this one show we played — it was a benefit for a friend, a skate godfather of the northeast — Sid Abbruzzi. I personally set the whole show up. I got city permits, I went before the city council, I hired a sound guy, rented a stage, rented a

huge venue, put up a million flyers, and got six bands to play, including my own. I purposely gave No Means Yes the best time slot. Before we even get to play, our bass player, Buzznardo Brocaprio, gets kicked out. So, he's like, "No, you don't understand, I'm playing in fifteen minutes!" They didn't care, they kicked him out. So he's sitting in the car guzzling Southern Comfort, while we're setting up his stuff. Right at show time, we open the side door for him, and he gets onstage. No big deal. So we take the stage, there's 300 kids ready to rock. We rip into the first song and literally ten seconds into it, the place fills with cops. They tell us to stop playing. Bottles start flying. Everyone's drunk. We decide to fuck it, and start playing again. They pull the plug. Kids jump on stage and start chanting "Fuck the police! Fuck the police!" A bad scene, I tell ya. Every on-duty police officer in the city shows up. After so many hours and hours of hard work put into this show, I get to play ten seconds. And as a reward, the next day we spent the whole day in internal affairs being questioned over and over. Then we made the papers — "Party turns into riot, police say" — was the headline. That show sucked, I tell ya.

This other time, we were doing another benefit. This time for shake-a-leg or something. This was another very large venue. The only problem was that we played first, and there were literally four people in the room. Not that we haven't played for four people before, but since it was such a big place, it was really lame. But the funny part is that since it was for shake-a-leg, three of the four people were retards in wheelchairs! So the only logical thing to do was for me to start yelling the dirtiest words I could think of. It was the funniest thing I've ever seen, watching the caretakers of these people quickly scurry their crippled friends out of the room. So we finished the show for one person. That was the first show I dove into the drum set. What a great time.

The first live appearance we ever played was with Murphy's Law. They let us come up during their set and rock. So we count it off with the drum sticks, "One, two, three, four… bang!" The drum sticks fell on the ground in the first second of the song, and were never recovered. I said fuck it and dove off the stage. The only problem was that no one caught me, and my face met the floor. Our drummer takes off, runs outside because he's embarrassed, and finds a case of beer lying on the sidewalk. He picks it up and starts running to the van, the only problem was

that the beers inside were empty, and everyone standing outside the club was yelling "They're empty, moron!" Yep, that sucked too.

I could go on for awhile about having bad shows, but I'm not going to. I'll just leave you with these three examples. Hopefully we'll get some goddam respect one of these days.

Mike, No Means Yes (Newport, RI)

Feliz Quincenera

Here in Los Angeles, punk status must be earned. Playing in shitty conditions for drunken, hostile fans is our way of life. On a night in September 2001, we arrived at a gig only to find balloons and a banner stretched across the stage saying "Feliz Quincenera". To our surprise, the sleazy bar owner had double booked that night. Confused and frustrated, we still went on with our show. During our first song, Bleeding Away, Dora, lead guitarist, noticed the jukebox was playing. She shouted, "Turn that fucking off!" A bar girl quickly pulled the plug. Through the next couple songs, people were drinking and talking amongst each other. It wasn't until our punk song, MIA, that the drunken crowd started to mosh on the linoleum floor. Lisa, lead singer, threw out some Sugarpuss G-string underwear. A pair landed in the birthday girl's lap. Lisa coaxed her to slip them on. Then, she and her boyfriend high school freak danced to our next song, Hold On. Then a fat guy started to sway to our music. He was cool at first, but then he proceeded to pester the singer and the audience. A fan got so pissed off that she attacked him by jumping on his back. The security guards then kicked him out of the club. Sure enough, he came back. This time he was more obedient. A little later, another intoxicated moron started to slam dance as we played Fuck You! This joker was more intimidating with his shirtless, Zorro-like antics. He jeered at our drummer, Pat, saying, "Girls can't play." Pat proved him in our next song, Going Down, by playing harder and faster. As she sang, Lisa spotted a girl ridiculing her every move further pissing her off. Lisa taunted her throughout the song by screaming the lyrics to her face. To Lisa, there were only two people in that room at that point. Mano y mano, Lisa wanted revenge. The last song we played is our most hardcore song, Red Letter. As the ending neared, Lisa tilted her head like the mad woman she is and went in for the kill but was quickly blocked by the rude audience member's fist. With one wink of an eye, our bass player leapt over the tables and landed on the girl. Our buddies from the band Nothing Yet, who played with us that night, jumped in the brawl and took care of the rowdy crowd. Punches were thrown, the PA was dropped, and bottles were chucked; but all in all it was one hell of a nightmare of a show!

Lisa, Sugarpuss (LA)

Keep It Real

Our recent gig at the Metal Factory's Local Music Showcase: We're trying to establish ourselves with a local promoter. She calls out drummer Ray Fang and tells him that she has a cancellation at the Factory and wants us to play. The Factory is a stuck-in-the-past (and not in a good way) clueless metalhead joint — both Cinderella and an Ozzy tribute band played there that week. We want to do the promoter a favor so that she'll hopefully get us some better shows opening for a national act. We get there and they gave us a bar tab. The acts leading up to our set are hippy crunchy granola fags or carbon copies of mainstream radio alterna-metal. The second band combined new age music with hip hop, if you can believe that. They set up little candles on the tables in front of the stage. The singer, a young Morrison wannabe, starts blowing into a didgeridoo that he claimed he traded his VW van for, while a kid with baggy pants and backwards baseball cap keeps rapping "Keep it real!" into his microphone. It was a pointless waste of the club's excellent PA system. Tom remarked that if we were asked to describe ourselves, we should say that we're "budget rock." Ray starts doing tequila shots and I start doing rum shots. We're all in the corner; Tom, Tom's girlfriend Summer, Ray's wife Brenda and friends Tom and Rena, looking bored and ominous. One of the bar wenches, a tall, blond Hooter's reject, chucks a half-full bottle of beer at the trash can, missing and splattering Tom, the organist. The band continues to wait and drink. The drunker I get the more I want to urinate on the earth fag band's candles to put them out. They get off the stage and all of their dancing dirty hippie friends leave. The club has people around the sides but the crowd is thinner. We get on stage and start to play. Everything's sounding really good and then I thought that I'd do the twist or something on one of the tables near the front of the stage. It falls over

before I can stand on it. I decided to kick over the rest of the tables. I yell something about a shot of Vodka and some guy brings it to me. I really didn't need it but I downed it anyway. I get a little more floaty. We blast through the rest of the set and at the end I take off my guitar, pull down my pants of slide down the fronts of the PA floor monitors. Ray starts yelling shit into the microphone like "Thanks for the fucking clean-up slot, motherfuckers!" Ray called me the next day and told me that I was insulting people all through our set. He's not sure if we're banned from the Factory forever and hasn't heard back from the promoter yet. I just wanted to burn down any sick, sappy traces left by the other bands and I know that we did. I'm proud of our set, fuck 'em if they can't take a joke.

Derek Hyde, Creepy T's (Ft Lauderdale)

Cherrywood Outlaws

We played this shitty scumfuk bar in South Jersey named the Cherrywood. This is in 2001 when nobody gives a shit about rock'n'roll. It's a Friday night gig, and we have some guy playing acoustic covers open for us. Most of the crowd is his. Finally this fuck is done, and we hit the stage, ready to kick some major ass. We rip into the first song, "Outlaw", and the pricks ask us to turn it down. Anyway, about two songs in, most of the crowd is gone. By the last tune we are playing to three fucking people. Even the regulars at the bar split. The highlight of the night came when some dude hit on Mick (our guitarist) in the men's room after the show. Mick kicked this motherfucker's ass and we left. Anyway, this was a shitty gig and the others aren't getting better.

Tommy Krash, Sinn (NJ)

Quaker Breaker

We were booked to play the Tazza Cafe at Earlham College in Richmond, Indiana on Friday, September 2, 1995, and brought our pals AxPx to open. Earlham, as it turns out, is a rather strict Quaker college and I had signed something that said we promised not to curse, drink, use drugs, or have any other sort of fun while visiting their fair campus. The girl who booked the show told me it was just official school paperwork and not to worry about it. Since anyone even glancing at the Pizzle promo kit should

know exactly what to expect when booking us, I did not think anything of it. We did, however, think it would probably be better not to bring alcohol with us so we drank on the way. Pizzle arrived (with little or no fanfare, I'd like to note) and loaded in, saying "Hi" to AxPx and checking in with whomever was in charge. We'd been drinking cider all day, and decided to hit the local bars for some gin and tonics. Here's where it starts to get fuzzy. I remember one place with the worst gin we've ever had where the locals scowled and made unkind comments under the assumption that we were college kids; and one that was way too respectable complete with ferns and brass railings. I've been told that we drank at three other places but that's hearsay as far as I'm concerned. We stumbled back to the club, which was virtually empty due to a cross-dressing party at some frat house. Those Earlhamites sure know how to have a good time. AxPx rocked, and we got ready to do the same. For reasons that seem unclear now, I was only wearing trousers and a spiked collar. I always perform onstage fully-clothed, and it wasn't hot (being September and all) so I have no explanation for that. Making it onstage without my boots seems especially strange. We set up on the stage, which was covered with a plethora of cables and cords, and our singer Tom grabbed the mic yelling, "Where are the fuckin' Quakers? I wanna see some fuckin' Quakers!" We then kicked into a song called "Fuck, Shit, Piss, Satan." I was doing my usual punk-rock-hop routine and found it very difficult to remain vertical due to the obstacle course of electrical octopi on the floor. Well, that and the lack of sobriety. Anyway, the mics were shut off by the second chorus of "Fuck, Shit, Piss, Satan", leaving Tom with no choice but to run into the audience screaming lyrics into people's faces. Moments into our second song (the one glorifying the use of LSD) some very official folks charged the stage waving their arms and making it clear that we were done for the night. Tom went into a rage while our guitarist Lumpy and our drummer Chris quickly started gathering our equipment. I did my part by holding up the wall in the hallway. The security guy was trying in vain to get Tom to stop swearing and inanely accusing him of being drunk to which Tom replied, "Of course I'm fuckin' drunk!" Security Guy turned to me and told me that my buddy was "this close" to going to jail.

"What the fuck do you want me to do about it?" I slurred. "Watch yer mouth!" he snapped. I shrugged

wondering why he thought the mohawked, nearly-naked drunk was the voice of reason to which he should appeal.

Lumpy and Chris had our stuff nearly loaded and I was magically reclothed, tagging cars in the parking lot with our ever-popular "Pizzle Slept With Mom's Chopped Up Corpse" stickers. Meanwhile, Security Guy had told Tom that it had been his prerogative to shut us down and Tom was inches from his face repeating the word "prerogative" tauntingly. Tom had finally exited from the building at which point Lumpy said, "Gee, Tom, you did everything to get arrested but drop yer pants." Of course, Tom proceeded back inside with his pants down prompting a stream of frantic "Sir! Pull up yer pants sir!"'s. We were then informed that the police had been called, so we left.

AxPx captured the whole spectacle on video and it became a great pastime of theirs to drink beer and watch one of Pizzle's worst moments. The video has since mysteriously disappeared.

Jason, Pizzle (Indianapolis)

Faking It

In 1986, Hades were becoming huge in NJ, and fast becoming the house band at Lamour (*not* Lamours) in Brooklyn. We were opening up for bands like Megadeth, Overkill, Nuclear Assault, and Metal Church, to name a few. Right before we recorded our first album "Resisting Success", we got a gig there, opening for Anthrax. Lamour was sold out. As always, we opened up with "The Leaders?" and the crowd went bonkers. Any nervousness we might of felt before the curtain went up was quickly evaporating. I started the second song and about a minute in, something horrible happened. There was no sound coming out of my amp! With a road crew of two and no spare equipment, I was in trouble. Please God, let it just be somebody just accidentally pulled a wire out of my amp. Nope. Time was a wasting. The rest of the band were looking at me in horror. Was I "losing it" or what? After the next song I gave up trying to figure out what was going wrong, and asked the roadies to run downstairs and get me our practice amp. While they did that, I was pretending to be playing along with the band. Sweating, cringing inside, because we sounded like shit (I assumed), and it was all my fault. I plugged into the practice amp and we started another song. Holy shit, I couldn't hear a note I was playing! I had the roadie's throw

the amp on top of my Fender twin that I used as a head. I *think* I could decipher a couple notes I was playing. Pure shit. I think I only recently got over the embarrassment of that show.

Dan Lorenzo, Hades (Clifton, NJ)

Angels of Death

The reason for forming a band was the same as hundreds of teenagers before us. Access to girls and drugs mostly. Stuck in a small Welsh town we longed for the bright lights. Cardiff would have done.

We proved that the cliché of drug dealers hanging around school gates was a myth. We were gagging to get royally stoned but couldn't find any gear for love nor money. We assumed that would change if we dipped our toes into the local music scene.

I forget whose idea it was to form the band, but I remember we made up the name first. That was it for a year — the name. We talked bullshit to anyone who'd listen. How good we were, how great the songs were; all this before we even had a single instrument to our name. After a while people started to take the piss, they guessed we were all tat and wanted to see proof. The stage was set and forced into a corner. It looked like The Angels of Death would have to perform before an audience.

Instruments came from the Kay's Catalogue; after repeated requests my folks finally gave in and put down the deposit for a cheap electric guitar and amp. A joint Christmas and birthday present sort of thing. The only criteria to join the band was access to an instrument of some kind, so at our first band meeting every geek with a Casio keyboard showed up. We were ruthless in choosing band members, they had to have the right look and attitude. Failing that at least two amp inputs. The work done we were left with six of us, a kitty of £10 for rehearsal space and not one member who could play a chord.

First rehearsal and the pattern was set. Make up a song title, argue the case then sit around smoking fags discussing what female schoolmates had blown us out. What we didn't do was attempt to play anything in a conventional style. Looking back you could say we were fifteen-year-old Charlie Parkers, throwing away the rule book and going free-form. In truth though we were just Shite. Lazy mostly, with an idea that everything would fall into place before the gig!

We had five guitarists at this stage. A drummer

ten years older had been picked up from the pub cabaret scene. I think he was going through a second childhood, why else would he be hanging round with a bunch of kids. His face when we showed our stuff the first time was amazing! I get the idea he hung around purely to attract the hundreds of schoolgirls we talked about constantly. Our magnum opus was a three minute track I'd called Smell

fifteen years. We'd lied so much that the headmaster even mentioned the gig at school assembly. Three hundred fellow pupils buzzed to fuck over a pub gig by a band that couldn't play a note. We came to the conclusion that the best approach to take was to put on a show and blag it.

The day of the gig. The venue was an alternative pub/disco popular with Goths, punks and for some

By the time we got to
Smackfuck you could tell
the bar staff were
looking worried.
ANGELS OF DEATH

My Finger. The bass player would finish after a minute because he claimed his fingers hurt if he played any longer. This was our level of commitment.

The date of the gig was set. We'd managed to blag a venue slap bang in the centre of town. The place was as cool as fuck. I still haven't sussed how we managed it. They wouldn't have served us if we'd attempted to get a beer. They promised us £20 if we drew a big crowd and as much booze as we could drink.

The real fear came in the week before. You have to remember the trail of hype we were laying all over the school. Man we were claiming there would be A&R reps there, strobe lights, back projections all sorts of bullshit. The reality was we had five song titles, two amps and a singer who wasn't allowed into the venue because he didn't look a day over his

reason middle-aged gay men. We drank like fish as soon as we arrived. As an added bonus they sold Amyl Nitrate behind the bar. This meant the sound check dissolved into much red faced giggling, we knew we'd blow it so we intended to get through it whichever way we could.

By show time the place was banging. The bar staff were made up by the turn out, offering us as many gigs in the future as we wanted. There was no in-house PA. We solved this problem by plugging in at least three guitars into every amp input. We'd bought these double adapters the same day. To a pro it would look like a major fire risk, to us it was rock'n'roll. We kicked off.

At first the mix of amyl soaked fags and diamond white blocked out the feedback. The sober element in the crowd instantly retreated backwards; I just

Art: Richard J Smith

thought the sheer volume was blowing their minds, not causing pain. Each song stopped when we all got bored, in the mad rush to get the set finished the longest probably dragged on for no more than seventy seconds. By the time we got to Smackfuck you could tell the bar staff were looking worried. The head guy was trying to approach the stage, but the dense crowd weren't parting. Some folk were leaving almost in tears; we'd picked up on the poor sound quality but played on regardless. Two songs in and the drummer fucked off — just upped and left. He'd been a bit off all day, watching teens get monged and refuse to tune up! Think the idea that someone he knew from the pub rock scene would see him was the final straw. No problem, Johnny a hanger on jumped onto his stool and banged shit into his kit whilst ex-sticksman made a B-line for the bar.

Johnny you've got to realize, had never set foot near a drum kit, none of us had: the guy was obsessed with his kit. He'd go nuts if any of us tried to have a go.

The weird thing was although the majority were headed towards the door, some people were really digging It. AOD V The Son Of Godzilla was the straw that broke the camel's back. By now I'd realized that my guitar had become unplugged during the first seconds of the gig. So what! It just meant I could be more mobile, work that stage more.

What happened over the next ten minutes was less of a gig and more of a performance-art showcase. People dropped off, sat down and lit fags. Members of the audience came up and beat shit into the instruments. This lead to fights breaking out all over the stage. Even when the manager pulled the plug he had to physically remove us from the stage. All the time feedback squealed and beer spilled over electrical equipment. I fell out with my best mate and told him to go fuck himself over the mic, he kicked my amp and stormed off. The lowest came when an audience member wrestled the mic away and started shouting "Bollocks!" over and over again. By now most people were joining in the spirit of the thing by throwing ashtrays and drinks at the stage. We were improvising songs, letting loose — nothing audible over the primal scream of overloaded amplification. Suffice to say the offer to return was quickly withdrawn.

Aftermath: The bar owner threatened to call the police unless we paid for some damage. We guessed correctly that there is nothing illegal in playing in a shite band, and took off leaving the drum kit behind.

None of us got a shag as far as I remember, and large scale drug abuse would have to wait. We were cool within our school peer group, mostly because of the fighting. For some reason a muso-type ended up offering to pay for studio time, and we ended up recording a demo weeks later. The results were so awful that I destroyed the only copy years ago. By a strange twist of fate, the band booked to play the week after was the Manic Street Preachers.

AOD split shortly afterwards. To this day we still talk of reforming.

Bruce Barnard, Angels of Death (Newport, UK)

Rock'n'Roll Is Dead

There are myriad of truly hellish gigs The Necro Tonz have endured — from gigs where the uninitiated to the death lounge crowds have left in droves (and in disgust), to shows where the promoters and/ or club owners have not paid us what we were promised, to Battles of the Bands in which we weren't allowed to use weapons (what kind of battle is that?). However, in our thirty years of bringing the ghoul jazz to the masses, two stand out in mind as true nightmares.

The first was New Year's Eve, 1997. Our first drummer, Cliff Bundy (RIP), had booked us to play a huge party in the bowels of the Grand Prairie, TX, warehouse district. Much beer, liquor, cocaine and amphetamines were in evidence, and free for the taking. Our scheduled show time was midnight, and since we were all pretty high/drunk (and since the dead don't pay much attention to time), no one was paying attention to much of anything except the truly horrible bands that were playing before us! The place was slowly but surely clearing out, and suddenly we realized it was almost 3am! Despite efforts to find the party's host, who was nowhere to be found, we were left unsure as to what to do. The band before us had ensured that the crowd lost whatever rest of their hearing ability was left at this late hour, and it seemed as if the whole gig was falling apart. The bodies left didn't seem to have much volition to control themselves, passing out or peeing on themselves in corners. Due to the fact that The Nero Tonz are corpses of our word, we decided to

go on and play to the twenty or so people that were still there. But now, there was no sound man! Our good fiend, Rob "DJ Stereotype" Spray attempted to figure out the back-asswards soundboard, but the first note was nothing more than sheer feedback! DJ Stereotype made every attempt to figure out the source of said noise, but to no avail. We played three songs, looked at each other, wished for the dives of Las Vegas, and split.

We have experienced unexplained sounds from beyond the grave more than once. Nightmare number two took place in Sa(ta)n Tonio, TX in 1999. We were hired by the big rock station, KISS FM, to play their annual Halloween Ball at Sunset Station. The venue is a huge covered pavilion surrounded by clubs and restaurants. We received the royal treatment-rooms at the ritzy Adam's Mark Hotel, free dinner, drinks, the works. When we arrived at the venue for load-in and sound check, we were much dismayed to discover the smallest of PAs. It seems the radio station had forgotten that we needed a sound system for the event, and at the last minute the day prior, had called some guy from some band and asked him to bring his little six channel set up to accommodate. To make a long story short, sound check took an excruciating two hours before we thought we had it right. (It should be noted: all The Necro Tonz need in the monitors are vocals and sax — simple, right?)

Showtime arrived, and the place was packed. Everyone was dressed to kill in their Halloween costumes, looking freakily fabulous. The show was running late due to a huge amount of fucked-upness due to the radio staff, but when we finally hit the stage, there were hundreds of bodies on the floor. We hit the first note to "Last Wish," and it turned out to be nothing but screeching demonic noise! Our patrons (or should I say victims) turned heel, hands covered ears as blood began to drip from their heads, and everyone ran as fast and as far as they could to escape the aural pain.

Three songs later, after not one iota of improvement in the sound, I ended the suffering, shouted, "We're The Necro Tonz, goodnight!" found the office, got our check for $1,000, and we all got good and toasted.

Nekkie, Necro Tonz (An unmarked grave, somewhere in Texas)

Devil In The Details

On our second gig ever we had planned I would start off the gig from the bar opposite to the stage by reciting a text from the law book with a megaphone while the band accompanies me on stage with guitar and bass, and the drummer throws flyers and fake money on the audience. There was quite a crowd in the small venue so I couldn't see the stage from the bar but when they'd start playing I was going to start reading my text in the megaphone. I changed to my stage clothes and put my makeup on in the bar and I was ready to rock. I introduced the band in the megaphone: "We are The Dogshit Boys and we are going to rock your ass!"

But the band didn't start playing. I couldn't even see them because of all the people between the bar and the stage. I was standing on a table with the megaphone, feeling and looking like a fool. And there was no music. I stepped down and sat down on the floor, waiting. This was our second gig ever and it took us twenty minutes to realize that we hadn't turned the stage electricity on...

Lasse Grönroos,
The Dogshit Boys (Helsinki)

Too Loud for the Crowd

It all takes place in Malmö, in southern Sweden. An Englishman by the name Peter Briggs had started a club, called Kickstart, in a local pub. The club made the chance for several unsigned bands or artists to expose their music to the public for the first time. Sometimes a few important persons with connections to the music industry could show up. So you can imagine that a lot of bands wanted to play at that very club. And that became reality for the band Sugarpaved Honeys. Everything felt just right. The band had several new songs and a new self-reissued image that took the best out of the seventies glam rock mixed with a bit of grunge clothing. And really... I don't know what happened. It was their first concert in months and maybe they were feeling a bit nervous.

The time had come. The band started with a promise. Two beers, tops, before a gig and that's it. Not this evening, though. They started with a pre-party that lasted five hours and by that time they were totally drunk, pissed, whacked so to speak. We

called a cab, it seemed glamorous just to show up in a car together... well the nearest we got to a limo anyway, and the band must have been a sight for the spectators when they got out of the cab just in front of the pub, Estrad. With fake furs and sunglasses, V-jeans and eyeliner makeup they literally stumbled into the club.

I remember seeing Peter Briggs smiling and expecting the coolest show on earth. Yeah, I must admit they looked very cool. A band played before them. It was a very gentle pop band which did an acoustic set which was much appreciated by the audience. Around seventy to a hundred people had shown up. Sugarpaved Honeys went on at 22:00.

Oh dear... The first chord went through the air and I thought that the building would collapse. The volume was absolutely way too *loud*. I remember seeing people holding their hands to their ears with an expression of pain on their faces. Half of the crowd left after only three songs into the ten song set, and by the time it was three songs left of the show only fifteen persons remained. I must admit, despite the fact that the band were way too drunk, they played rather well, at least in the beginning. At the end, things got even worse The singer jumped of the stage to do a rock'n'roll pose and to throw up his guitar in the air. But the guy was too drunk, and he couldn't catch it.

It went straight down to hit a concrete floor. He picked it up and went on playing. The guitar was, of course, out of tune. The singer stopped to sing and tried to tune the guitar instead. It sounded terrible. The head on the guitar was broken. It was off, but none of the band members noticed anything. They finished the gig with a cover version of Nirvana's "Been A Son". It was over. I never felt so ashamed in my entire life. On the way home the sadness continued. We ran into some drunken guys who tried to beat us up (honestly, this is true). We had to run for our lives. Fortunately, with only with a couple of bruises, we got home safely.

Mike, Superpaved Honeys (Malmo)

Marysville Swine

It started out with the current band I'm in going to Marysville, WA for a show. It was a show at a grange hall up there that we had never played at, or heard of, really. Once we got there we noticed that some of the kids of that town were a little bit phoney. We saw a group of four kids get out of a Mercedes M-Class SUV that their mom was driving. Not a cheap ride, obviously. As soon as she rounded the corner when she was leaving, the kids start stumbling in an act to prove that they were intoxicated. At the time, we had enough reasonable assumption to believe these kids were definitely not drunk, and it was more of a venture to show they were so very "punk rock". Other than small things like this, there was one thing that made us certain that the people from there are a little goofy. Two guys came running in during the last band playing with a bloody pig's head, which they were throwing around, like it was something that was totally normal. They acted so nonchalantly about it, it was like they were playing a child's game. It seemed to me more like some modern, gothic version of Hot Potato, as the head of this animal was being passed around. At this point, I was reminded too much of freakish performers such as Marilyn Manson or Ozzy Osbourne, so we left the show and headed back south to home.

Chance, Low Rollers (Vancouver, WA)

Not Big, Hard, Or Clever

Back in 1988, in recession-hit Coventry, a couple of mates of mine — one known as Billy "Fat Boy" Bell and the other one, Pete "Number Two" Lyle; one on short-time, one out of work — used to do a bit of a turn round the pubs. Comedy singing, that kind of thing. Bit of a double act. "Number Two" Pete was the straight man. They had quite a good rep, and were quite well known. One night, a Sunday, I was on nights, and I'd finished. Billy shut the door and asked if I'd fancy a pint — just a pint, that's all. He'd done a gig on the Saturday the night before, had got a few bob and fancied a drink. It was about 9pm on a winter's night, so off we went for a pint. I live in the inner city of Coventry. Not far from me is a little back street pub called The Curve, in Ursell Street. Bit of a rough house, but a decent enough pub as it was. Anyway, we gets in there, just having a drink, and about half an hour later, the gaffer came over. He wanted to do a surprise birthday thing for his head barman after hours. He knew Billy and asked him if he was up for it. Billy said OK, and asked me if I would do the "Number Two" bit. Just do the odd one liner, and throw in a silly answer and be the straight man. I'd done it before so I said, yeah, no problem.

So time ticked on, and the gaffer said he'd pay us in drink. That was cool. So we were having a good drink. Anyway, the gig starts. Now, Billy's favorite piece was a big piss-take on the *This is Your Life* bit. He had this old red folder — fuck all in it, he used to make it up as he went along — he hadn't got it with him that night, but the gaffer got some red paper from somewhere, stuck a red ledger inside it and that was it — we was off. It was going quite well. The pub was very full, as all pubs in the inner cities are, even though no-one seems to have any money.

Then it started. There's always one, only this night there was a family of them. Sat in the corner — an Addams family. Low life white trash. Pissed up and intent on ruining everyone's fun. Now Billy Boy, he's

Now it was getting really heavy. The pub was loving it, and Billy was cooking on gas, but I was getting a bit worried, and so was the gaffer, because we were getting through some drink. And then Billy said, "Start the car". "Start the car?" I said. I could hardly fucking walk. This was about two in the morning. Luckily enough, some of these old pubs have an alley out the back. Outside shit-houses, the rest of it. I was sent away for a piss, jumped over the wall, found the car, got it running, and just left it running. Even if it had got nicked, he wouldn't have minded. What could he say? It wasn't fucking insured anyway. Probably not even his.

I came back in and Billy was firing some parting shots. The gaffer come over and said, "Listen lads, I

"Start the car?" I said. I
could hardly fucking walk.
 JOHN CARTER

a Belfast man. Don't take no shit; he's got a razor sharp tongue, and he can be mean. So he kicked in at them, and verbally destroyed them. Half of the stuff he said was over their heads, but the pub was loving it... They were getting more and more uptight. We were getting more and more pissed. We'd walked there, but I couldn't see us walking home. We couldn't get away to phone a taxi — the classic line, "Start the car", was going round the pub. Fortunately enough, Billy spotted one of his old mates in the corner — one of Thatcher's newly created underclass — unemployed and unemployable. He'd got a car. No tax, no MOT, no insurance. Pissed out of his head, he would lend his key to anybody. Billy had a word with him, came back, had a few more drinks, and carried on with the gig.

know I said I'd give you the drink, but you're pushing it a bit." "We'll have one for the road," we said. And we'd got the Addams family in the corner, they kept looking over, pointing and talking, and making menacing signs. So Billy said we had to get out of there. So we had another drink — the gaffer was not a happy man — we'd drunk him well dry, like someone out of *The Blues Brothers*, and then we slipped. Slipped down this back alley and over this wall. And as we were getting out, I saw the Addams family getting up. "Here we go again," I thought, *Deliverance*. Let's get out of here. Should have seen us — it's not big, hard or clever. Driving up the road, all over the shop, both of us pissed as parrots. Billy with his hands clutching the steering wheel, and me trying to change the gears for him. How we

86

ever got home I'll never know. I can look back at it now and laugh, but I was fucking frightened at the time. And that was a gig from hell.

John Carter (Coventry)

this was to be our only meeting ever. Needless to say he was very impressed and so was the other band.

Susanne Gibboney, Lust (Atlanta)
Nowhere (Newport)

Acrobatic Wino

We had a show booked for three months with several other bands at a new art warehouse. The other bands pulled off the bill at the last minute, because they were dubious that the space would be any good. We felt like if we commit to a show we should play it, even if the venue is a little weird. We get there and there is only a bum outside who is trying to get money from us for crack. The warehouse is open, so we load our stuff in, but don't want to leave because the equipment would no doubt, just disappear. After a few hours, a drug dealer shows up. He assures us that someone who knows something about a PA will show up sometime later, although he is unaware that there is a show. No one ever shows up who knows how to run the PA. We turn it on, but it is feeding back loudly and horribly all night. In addition to the constant hideously loud drone, there are also periods of high-pitched squeals from the PA. The mics shocked you every time you went to sing. We were doing a workout themed show and our drummer was dressed as Richard Simmons and had a prepared speech about his deal-a-meal that had been a big hit at our last show. We also had two trampolines for Barb and me to jump on during the set, but they were dangerously uneven since the stage was not totally solid. The drummer got wasted on cocaine and rot gut whiskey. Needless to say we played terribly, which would have been noticeable if you could get past the horrible screech of the PA. When he was supposed to give his speech, he had lost his deal-a-meal cards and speech and tried to wing it, but he just babbled for about fifteen minutes and wouldn't shut up. Finally, we decided to just end the set and invited the audience to jump on our trampolines for the last song. A wino who had wandered in agreed to come up, which seemed like it would at least be funny, but as he was jumping on the tramp (with another audience member stabilizing him) he shit his pants. There was a horrible odor and awful site. Unluckily the only people in attendance that I knew was a band that I wanted to try out for and asked them to come see me play, and my boyfriend's father who was moving to Italy and

Thunderstruck

We needed a show out of town to break in our new bass player, Kate. We'd never played Worcester before, so I figured I'd invite our label mates Rock City Crimewave (Kate's sister Meg was RCCW's bassist at the time) to do the show with us. I get the guy from Ralph's on the phone, and I learn they have a Saturday night open with an AC/DC tribute band, Thunderstruck, so I'm thinking, everybody in Worcester must love the AC/DC, right?

We start loading out for the show, and everybody is late as hell as usual. As we're loading out, Kate's brand new boyfriend Marc decides he'd like to go. No problem.

Everything is fine and dandy on our way to the show, laughin' and a' jokin'.

We get to the club, and we see that Thunderstruck is there with their tour bus (this is an eighty seat club tops, folks). So now I'm thinking that we've gotten ourselves on one heckuva show. We load in and start drinking.

On first is Rock City Crimewave. They sound awesome, and the only people watching them is us. The droves of AC/DC fans have not shown up yet. We play our set to RCCW & Marc. They loved us!

After we play our set, a few stragglers come in, maybe four or five, and I start to realize that nobody gives a shit about Thunderstruck, and I find out why when they hit the stage (up to this point, they've been hiding out in their dressing room). I think Thunderstruck thought being old and fat with toupees was the thing to be. They had that down. Angus was a lot older than Angus (the species of cow, that is), the singer kept making out with his overweight girlfriend in between songs, and the other guys looked like golfers. So, the gig really sucked big time, but it gets worse.

As I'm hanging out that night, I notice that Kate has disappeared. No one, not even Marc knows where she is. So we load out, with no trace of Kate. Everyone is smashed. Finally, Kate shows up. It turns out she was in the bathroom swapping shirts with some girl. A massive argument ensues between Marc and Kate. The argument continues in the van. The argu-

Basking In Local Shame

87

ment continues on the ride home. Kate's sister Meg decides to slurredly bring her drunken enlightenment into the argument. It almost gets into fisticuffs at this point, when Kate stomps a fucking monster sized dent in *my* dash board, and in a childish temper tantrum, throws her Frito's, cigarettes, and beer can out the fuckin' window (while we're doing sixty-five down I–90). Next to the van is a fucking *state trooper*. How that cop didn't see that shit practically roll over the hood of his car, I'll never know. That was Kate's last show with Lamont.

Pete Knifling, Lamont (Boston)

Hissy Fits

Cobalt Lounge. January 15, 2000.

We got called on this a couple of days prior to the show and agreed to play it cause (a) none of us had anything to do that Saturday, (b) we hadn't played the Cobalt yet and wanted to get in there, and (c) free beer in the form of drink tickets for band members. This show epitomized the enormous amount of band bullshit that goes on in this town. The plot line went something like this:

BAND NO 1 Throwing a hissy fit about the line-up. Don't want to headline (on a Saturday night?).

BAND NO 2 Participating in the hissy fit about the line-up. Don't want to headline either (on a Saturday night?).

BETTY ALREADY Whatever. We will headline for fucks sake! It's a Saturday night!

BAND NO 1 Second hissy fit about other bands' equipment storage.

BAND NO 2 Again, got dragged into the hissy fit.

BETTY ALREADY Moved our equipment in placating fashion for Band No 1 before they began crying and beating their breasts in frustration.

BAND NO 1 Third hissy fit regarding placement of Band No 2's decorations near stage.

BAND NO 2 Pretty livid by this time.

BETTY ALREADY Sat and watched verbal blow-out over a pitcher of beer waiting for someone, anyone, to throw a punch. Never happened.

BAND NO 1 Ran around the room prior to their set telling all their fans to leave as soon as they were done playing. Repeated this appeal during final song of their set.

BAND NO 2 Furious.

BETTY ALREADY Reaching a state of intoxication that made the whole thing wildly hilarious.

SUMMATION Although Band No 1 had run almost all of their people out the door after their set (some most unwillingly, it's a really cool club), Betty Already eventually hit the stage and kicked ass for those who stayed. Despite all the crap that went on before, and maybe because of it, we had a great show and had those die-hard rock'n'roll fans sweating and shaking along with us.

KITTY'S ADVICE FOR BAND NO 1 When babysitting her nephew, she always puts him down for a nice long nap in the afternoon to avoid childish ravings later in the evening.

Kitty, Betty Already (Portland, OR)

Someplace Else

Last Saturday night, eight o'clock. Just an hour before, we had visited the most luxurious music club in town, the one everyone wants to play, had a drink with the sound man, and talked about openings for future shows… Needless to say, we were in a good mood, feeling blissful with our independent status, thinking "This is life". I was already thinking about my tour bus, how it would have a king size bed, maybe a hot tub in the back. I would, of course, be staying in the best hotels across the country, inviting all my new-found friends back to my penthouse for long hard party frenzies. Upon leaving the club, with visions of playing stadiums in mind, with Guns N'Roses in the air, our big black trailer made its way around the corner to the dive that would be our home for the night. High fives all around, drummer shouting "Let's go kick ass", our rebellious egos roamed free. We knew this was part of the journey, the long hard road to stardom; lugging our own equipment and staying in cheap motels, drinking beer and being exhausted. "I remembered them when…" When we arrived, however, the mystique and "Fuck 'em all, we kick ass!" attitude turned into a deep, sinking, nauseous feeling in my stomach that made me regret the decision to accept the invitation to play. This particular venue — called Someplace Else — we quickly realized it was called Someplace Else because when you're there you wish you were someplace else. The sign was dark and skanky, reminiscent of a place long since shut down. There was one solitary car in the very narrow parking lot, and the stoners wandering in and out of the 7–11 next door didn't seem to remotely care that the place was supposed to rock that night. There was a chain

link fence around the back with a barking Doberman attached, and a sign that said "No noise permitted". The familiar scent of beer and smoke wasn't a friendly one when it met with the empty sound of the place — no TV or music, or anything remotely alive, except for the muddled grunts of the bartender and his one friend. When we asked if they had a house set, the dirty one at the end of the bar offered us the opportunity to play "butt-bongo fiesta" on his ass if we happened not to bring our own kit. We kindly declined, and made our way outside to reconsider the night. The people we invited we no longer wanted to attend, and we seriously thought about canceling the show. My earlier fantasies of rock greatness were gone, demolished into a whimper that said "Why me?" I thought I would puke. I thought I would be embarrassed. I thought the world would come crash-

ing down around me, and all that would be left would be that dirty man at the end of the bar, smiling, with his pants pulled down, saying "You want to smack my ass?" This thought, thank God, came followed by a moment of uncontrollable laughter. What the fuck? What the fuck am I supposed to do here? This place sucks... the people suck, the stage sucks, the sound sucks... Furthermore, I'm tired, we played three shows this week so far, so fuck 'em all. Pressing on — at least with an atmosphere of rebellious laughter — we were first accosted for our out-of-state licenses, then for moving a table in order to fit our PA through the skinny hallway, and finally for attempting to turn on the jukebox (heaven forbid there be music in this rock joint!) A man cornered my drummer in the bathroom, called him a hippie, put his fist to his neck, and told him he hated hippies (my drummer is not a hippie). Whatever. After putting on a great show despite the circumstances and winning everyone over, the sound man and license lady

got into a fight with our bassist because he wanted to keep the gear inside the club, so that we could stay and watch the other bands. They insisted we take it all outside, to which our bassist commented that if we packed our gear back into the trailer it would all get looted if left unattended, as the neighborhood was "shitty" at best. Our pyro didn't go over very well with the management, and they pulled the plug on a fellow band when their singer hung from the rafters on the ceiling. At least by that point we were all drunk and didn't care... The party starting spilling into the parking lot, which I guess they didn't like, the lady kept coming outside and yelling at us for having bottles of beer on the street, the 7–11 man was telling us to keep it down, and the sound man said the drummer needed to dampen his drums next time. Why have a rock club that you

After a few hours, a drug dealer shows up. He assures us that someone who knows something about a PA will show up sometime later. LUST

don't want to rock? Why own a rock club if you think music's too loud? Although the crowd was into it, the show felt like a teenage party busted by parents who returned too early.

Courtney, Pretty Suicide (NYC)

Smashed By Black Death

So there I was in the tiny upstairs bar of some college town pizza joint with the promoter Jesse, eight feet tall, three feet wide, a good-hearted, well-meaning Native American who loved punk rock, watching a bunch of local kids set up their tiny, novice, first cover band PA.

No idea what happened to the real PA or if one was ever really on it's way to begin with.

These local kids hammered out some Dinosaur Jr covers and then it was Bloody Discharge — obviously, an angry all girl band from Cincinnati. Martin McMartin really loved those chicks and supposedly

he wanted to (wink, wink) *interview* them back at the hotel for *Flipside* magazine. Then I hit the stage, er, that part of the room with a band I'd thrown together the previous weekend after my prior group, Eleganza, had ended when the guitar player met a coy little tweeker who loved sex and knew every lyric to *Exile On Main St* did a Nancy Spungen number on his ego. Hadda be something like, "You don't wanna be in a garage band version of Guns N' Roses and drink whiskey 'til you pass out in the street when you can be in a math-metal-turned-Jon-Spencer-Speedball-Baby-rip-off and do pills and junk." That guy showed up completely shit-faced drunk already with his meth nymph in her white short shorts at his side to heckle us.

Eleganza, in it's second incarnation, consisted of me all in silver from my silver top hat and string tie to my mirrored shades and silver spray painted antique platform shoes from Trivets in downtown Cincinnati; Nasty Bastard, my then faithful guitar slingin' (literally — one went straight outta window once and pierced the ground like a javelin, no shit) evil henchman, all dudded up in black leather, lookin' like the hairier older brother of Kid Chaos, that cat who got himself kicked out of The Cult, Zodiac Mindwarp and Four Horseman. Nasty tends to dress head to toe in leather, hair to his waist, black, iron crosses, big Nazi skull belt. We had this ratty little shit heel suburbanite metal kid on bass we called the Kid who wore this black sweatshirt everyday, on which he just "drew some shit" in the words of Kentucky Mike, the ex-guitar player. A schizophrenic metal shredder Randy Rhoades guitar prodigy who could easily have played for Ozzy were it not for his schizophrenia. Poor guy heard voices and honestly believed he had been "smashed by black death", which sort of became his nickname: Smashedbyblackdeath.

On this night, Smashedbyblackdeath had attempted to dress like the rest of us and he showed up in those suede elf boots from Chess King in the eighties that mostly girls wore, that folded over, and a white billowy lace-up pirate shirt he explained he'd saved from his high school's production of *Pirates Of Penzance* for an occasion like this. Boogie Jack The Bad Joker must have been in jail, so we were using the drummer from the much exalted indie-rock girlband, Lazy, who couldn't really play yet.

I never understood why every musician of note in town had taken their turns squiring her around until I saw her shimmering while playing drums in a sweaty tank top. Only she couldn't really rock. For my kinda rock music to work the drummer is the most important element. The music was a buncha two-minute buzz bomb punk riffs/pop choruses turned into four-minute songs courtesy of Smashedbyblackdeath's flash metal suicide guitar solos. The ex-guitar player got thrown out for trying to steal beer, the Cincinnati in-crowd who came to see the drummer could not understand why me and the drunken black leather crew seemed to do OK with the ladies and that eventually frustrated them to the point where they got us blacklisted from working at any desirable local jobs... on this very night, in fact, before the big rock show, my girlfriend of seven years had announced that she was in love with her *90210*-lookalike bass player, the token rich-kid-educated-junk-oriented-less-than-zero-type bad boy. Impeccable timing these chicks always have, eh? Right when you're in your vanity mirror trying to psych yourself into believing you're a leper messiah for an hour and not just an alcoholic who can't get a job at the record store — *shazzam* — that's when they say they're leaving you for the bassist with the $400 a day dope habit. I just kinda ended up sneering then sulking when we couldn't whip the crowd into any kinda frenzy. Then those venomous old men, The Humpers, came out and set the goddamn place on fire no sweat. It's still a thorn in my side.

Dimitri Monroe (Cincinnati)

Fire Woman

I had a gig with Caged Heat one night at this club. The owner was a real piece of work. He had this office with all these dolls in it. I was in there talking to him about something and he was molesting these dolls as I was talking to him. Not consciously or anything, just kind of caressing, and stuff. He had this one real pretty one in particular that he seemed obsessed on. When we were about to play I snuck into his office and grabbed that favorite doll to bring on stage with me. I don't even know what possessed me to do that. Just on a whim I guess, when I got up I barely even got the doll out when this guy totally loses it. He screams like a girl and comes racing towards me. I didn't really know what to do. I kind of panicked and threw it out into the crowd. It landed on some burning cigarette in an ashtray and burst

into flames. This person dumped their drink on it but it was already too late it was spreading to the table. The fire extinguisher put it out before the whole club burnt down. If that man hadn't been in total shock over the loss of his beloved doll, we probably would never have escaped with our equipment and lives. I don't think we are welcome back there.

Jill Kurtz, Caged Heat (Boston)

Tongue In Asshole

As four religiously practicing alcoholics, Soiler, banned from at least six places that we know about, has to scour its skid-marked soul for *the* single gig from hell. One could make a case for the time when we couldn't wake up Petewurst (who was filling in for our drummer, Under Indictment). Speaking of Under Indictment, it also could have been one of the fight shows. Or, it could have been the night the cops parked the paddy wagon in front of the door of the 31st Street Pub, and then preceded to harass the small pre-show crowd (the first band hadn't even set up yet.) Picture a boy-cop, too young to shave himself, checking ID's where the men have beards, and the ladies have tattoos, older than the boy wonder himself. This, under the pretense that his dog smelled weed on a car around the corner. Or was it the three flights of stairs, whopping fifty cents off the six dollar beers for the band, "Oh by the way, that other band I insisted on, he's not gonna come tonight, so I hope you have a PA" show. Yeah, that would be the one. Chin Ho (guitar) takes Under through the hellacious Saturday nite Southside traffic back to our secret location to bring back the old Bogan. Hellvis (from Cleveland) arrives and starts setting up. I explain the situation, and hey, we're fucking rockers, we'll deal with it. We polish off most of the Iron Citys they have before the show even starts. As soon as the Bogan arrives, Hellvis starts plugging shit in, and trying to get some fucking sound, the rest of us continue to drink. There is a small curious crowd until a bunch of our rock star buddies come with their collective entourages, The Motorpsychos, Delian Leauge and Plastic Jesus. I don't just have something in my pocket, I really *am* happy to see them. This is way more our crowd. Hellvis takes stage and rocks through the technical difficulties as we polish off the rest of the Iron Citys and domestics before we had to start drinking the imports. What are we gonna do, not drink? The crowd

is getting into it and Hellvis does a great finale even limiting the fireworks. (Fireworks Laws Suck.) After promising not to blow anything up, Soiler goes on, and the crowd moves back. With little beer left the staff has to go down to get more beer so I guess no one noticed when the "green room," an unworking, shit-filled toilet, went fragrant with a more pleasant scent. We tore through our first three songs before a flash of sick blue light and a loud pop, and half of the lights go out, right as we're starting "She had a big ol' Butt, but a tiny little Butthole". Well, nothing's gonna stop us now. Some of the lights come on and we just plug everything into one socket. The show goes on. It's getting rowdy. And I'm singing and kicking over tables in the dark and lying in a pool of beer slamming my fist into floor (which I re-injured.) As I'm face down pounding the floor and screaming into the mic, this guy sticks a joint in face. I discreetly take a few big hits spring up and start singing the rest of the song. Right off, I notice I can sing really good. I mean I've got real good range. We finished the set and sat at the bar drinking glasses of whiskey and other shots. The lady who booked us was all tonguing our assholes, telling us how great we were, and we were, both bands. There were like three beers left in the cooler. I'd call that a nice job. Yet to this day Ms Tongue-In-Our-Assholes continues to bad mouth us (yes, this is one of the places we're banned from). They say from time to time you'll have that. It wasn't until about 5am when Soiler and Hellvis were barbequing back at our secret location, that I found out that the joint was laced with opium. I look back every so often and thank that kind stranger.

Chip Hamm, Soiler (Pittsburgh)

Minus One Hot Chick

Monsterpuss, Flaco and The Lucky Bastards, Metro Café, Washington DC July 23, 2002. It was to be a night filled with friends, siblings and music. It was to be the first show Monsterpuss, Flaco and The Lucky Bastards played together. The drummer from Monsterpuss (Kiki) and the bassist from Flaco (Johnny) are siblings. It was going to be a great evening. Three hot chicks and five skinny guys rocking the night away. Kiki unexpectedly received a call at 9am from Ashley (bassist). Ashley was hysterical, she had just got into a car crash and totaled her car, and she was not sure if her arm was broken or not.

Kiki's worst fears had become reality. Her rock'n'roll dreams of a sibling united evening were crushed. She decided to call her brother Johnny. "Johnny, can you play bass with us tonight?" "Umm, I can try." Pretty soon, 10pm rolls around. Ashley shows up with her arm in a sling. She will not be playing bass tonight. Flaco goes on, their set is excellent. Johnny is getting nervous about playing with Monsterpuss. The crowd is expecting three hot chicks. The band is doomed. Ingrid (guitar) and Kiki get up on stage and Johnny hops up there with them. They rip into their first song and Johnny does not know what to do (he is also very tired from Flaco's set). The set begins to fall apart; Monsterpuss will have to continue with just drums and guitar. Suddenly, Laris from The Lucky Bastards jumps up on stage and grabs the bass. He is able to follow most of the songs and does so with unprecedented zeal. The night is saved, the car crash is now in the back of their minds, Monsterpuss has been redeemed. They will never falter again, pending on Ashley's driving skills.

Kiki, Monsterpuss (DC**)**

Mr Speed Freak

I guess it happens to all of us... there are *those* events which are so disastrous that one part of your mind would like to erase them forever while at the same time another part of your mind, probably in the opposite hemisphere (you know, that theory about one side of your brain being "emotional" and the other part being "rational"... I wonder how these two guys can live in the same home!) wants to keep them well alive in your memory to prevent you from doing the same mistakes again... Anyway, I'm going to tell you about the night which, at the start, seemed like being just a quiet hometown gig for the Rockets, but it ended up like one of those rocks falling down from the top of a mountain and causing an unexpected avalanche which will change the aspect of the mountain forever.

For more than obvious reasons there is *one* person I do not want to call by his name... let's say he will be referred to as "D" from now on. He is one of the countless lead vocalists who have stopped at The Pocket Rockets' motel for a few nights in the past... you know, almost every band has a problem with one "position"... for some bands finding a decent and steady drummer is a nightmare, some others crave for a lead trumpet player whom they just

can't find, our problem has always been (in the past, luckily) finding a singer who would fit right enough with the things we do.

That night everything had started in a very relaxed, laid back way... we had decided to fit in the bill of one of the very few places in our hometown where you can find, sometimes, bands playing various styles of rock music, just for the sake of playing a gig at the end of a normal working day (guess you know we all have day jobs, don't you?) without having to take half a day off for the transfer, and being also able to drive back home and sleep like an angel with our families/partners/pets as if (almost) nothing had happened...

We got at the club quite early, we knew other bands would have been playing that night but we were unsure about the correct order of appearance on stage, so we thought that having a few pints while eventually waiting wouldn't have hurt anyway. The first surprise was that the number of bands booked for the night was no less than *five*, and we were supposed to be the third ones. Considering the substantial amount of "buffer time" that we had already allowed ourselves to be there on time, that meant a *lot* of time to spend before getting on stage, so upon guidance of D we chose to go to another club quite close to that place...

The place was nice, very intimate, with a selection of good beers and a little stage with acoustic instruments. As no one was booked for the night, we decided to offer the bartender, as a goodwill gesture for the free beers awarded as soon as we got there, a short acoustic set. After all we had never played our live set unplugged, so we were also pretty curious to give it a go. I had noticed that D kept going back and forth all the time from all the various hideouts in the club, but as every time he came back with free beers for someone, I did not pay that much attention. Also because *my* little drama (well... *quite* little, to say it all...) was about to start!

A few days earlier we had had a massive booze at the end of rehearsals, I lost count after the third Negroni actually, and the morning after I woke with the face the size of a melon on my right side... Quite horrified both for the sleepless night *and* the fact that the only stage I could have been showing up with a face like that was probably in a theatre with *The Elephant Man* on the bill, I rushed to the dentist who prescripted me antibiotic tablets more or less the size of a surf table and *one* simple command-

ment: no drinks.

These tablets immediately proved very effective, so my concerns for showing up more a freak than I am on stage a few days later disappeared, but other paranoias came to my mind… the very first time I had taken one of these was before falling asleep (better say, "trying to…") the day I went to the dentist's. Whilst managing to swallow the surf table at the first attempt, I found this placing itself at the end of my throat, and sitting comfortably there for a *very* long time. I spent a very long time sitting in the bed waiting for something to happen, as dying suffocated in my sleep for an antibiotic tablet was not my ideal for the Final Journey… From this episode onwards my relationship with those tablets grew more and more difficult, because I was absolutely sure that those little (well, not *that* little) bastards would have tried to kill me somehow…

So, the night of the gig I took with me a plastic bottle of mineral water and a tablet broken in two pieces (this way I would have had the feeling of swallowing two table tennis bats instead of a surf board)… when in the first club beers started to circulate in quantities to our table and up on the stage where we were going all acoustic I had to start playing the sensitive guy and swallow those fucking things — *that* was the moment my nightmare started… being the antibiotics or being the fact I was the only one in the band not lubricated with pints of beer and shots of various spirits, I suddenly started to see things in at a perspective different from the others…

Anyway at the end of the acoustic set some of us, including me in full paranoid set-up, decided it was time to walk back to the *other* club, where we were supposed to play the electric gig in a short while. D said it was still early and he would have stayed a bit more there, having a couple of drinks more and a further chat with the people there. As he was looking already a bit "strange" we decided to leave with him the new member of the band, the guitarist (The Dude) with him, so that he could keep an eye on him. The rest of the band, me included, walked back to the other club where we still found the first band of the bill boring people to tears with their poppy new wave influenced rock by numbers… we thought that, after all, D was right but we suddenly changed our opinion when the second band started their set and he wasn't showing up yet. A few minutes before the end of the set of the second band, he (and the

accompanying junior band member) arrived, straight from the club entrance almost directly onto stage for the sound check…

What we had started to fear as an embarrassing night was probably setting itself right, at last… or not? Let's see what we had at that stage… A lead vocalist who had gone MIA for the last hour or so, and had arrived with a strange frenzy on stage directly from outside the club. A lead guitarist and a drummer not too concerned about the whole thing, but certainly a bit pissed (off, too…). A bass player still fighting with the devil inside him in the shape of two edgy halves of a surf board going up and down his throat with no apparent will to take the right path downwards. A new member of the band, the rhythm guitarist, with an undecipherable expression, halfway between the amazed and the worried… to which no one paid attention, that being the first gig with us. Maybe the guy simply had that expression every time before playing in public, and anyway time was tight enough not to waste it with that…

So, we finally found ourselves — somehow — on stage, and the fun begun.

D took away his leather biker jacket and we found out he was wearing a Spice Girls T-shirt under that. Considering his favorite way of renewing his wardrobe was to dig into the bags full of dismissed clothing for charity organizations left at the doorstep of the place he lives I did *not* feel surprised… a touch of humor and his sense of recycling were doing a good job, visually speaking, after all… problems started when the club sound engineer started to assist (?) us for the three-minutes-three sound check…

You know, I *do* hate going on stage after another band played and having to use exactly the same gear… this guy was trying to help us minimize the problems, but D was already in full blast gig mode, shouting in the mic gems such as "Come on you goddamn motherfuckers, time to rock now!!", "Are you ready to rock? *Yeaaahhhh!!!*" which, considering we were still attempting to do the sound check started to sound pretty strange to me…

The poor sound techie would have probably done a *bad* job anyway, but when — not nearly halfway through the thing — D told him (this is difficult to express in writing… I bet he wanted to "tell" him, but what he did was actually scream it in the open mic…), "Hey you motherfucker, you are fuckin' wastin' our time here, get your ass outta here!!!!!!"

with a grin I had only seen on Jack Nicholson's face in *The Shining*, the guy decided it was time to get away irrespective of the portion of the job to be done yet.

Of course the missing portion was bass... so I found myself not sound checked and, even worse yet, unplugged from every amp present on stage. I tried to catch the attention of the feeling sound techie but he did not see me, or probably pretended not to see me while running back at the other side of the club behind his mixer. In the meantime, D's cries of war had started to be really unbearable for everyone there, so we decided to start anyway. As there was a Trace Elliot bass amp on stage I though the most viable option for me was to plug in there, so I gave it a try. All we wanted was to start playing and get that guy on the front stage start screaming something more senseful in the mic than blasphemous curses, personal insults at the audience being "too fucking quiet" (they were not quiet... they were staring at him as you'd probably do if you found yourself at the zoo facing a gorilla armed with a knife and finding out he's pissed at you...) and at the sound tech for "having wasted our fuckin' time"...

As soon as we started playing, another giant ball of shit came rolling to us down from the hill...and we were down in the valley waiting for it... for a reason which goes far beyond my understanding, the whole drum kit had been amplified through that Trace Elliot amp I had been pluggin' in directly, with the result that we could hardly hear the drums playing unplugged below the wall of sound produced by guitars set at standard levels, a gorilla on speed on the microphone and an overpowered bass... I managed to regulate the level of my bass with the knobs on the guitar, but all we could hear of the drums on stage was the hi-pitched "tchit-tchit" of the hi hat.

So, *at last*, everything had turned finally to crap. The musical part of the songs was being played literally by heart by each one of us because we couldn't hear drums and the vocals were being handled by a person completely out of his head, so that we had to try and follow him in the new, improvised, structure of the songs...

Apart from singing constantly out of tune and out of tempo and stopping a few times because he could not remember the words, which is "just" pathetic when you see it, and even worse when you hear it, the guy also risked his health because due

to his speed- and alcohol-fuelled energetic jumping and kicking and rolling, the stage had started to split in two halves... for some reason this tiny stage, onto which fitting the five of us was already very difficult, had been built by putting together (without securing them with any bolts or whatever) two smaller stages... if I hadn't been in full tragedy "let-me-dig-a-hole-and-hide-in-it" mode I would have cracked into laughter when seeing the gap under the feet of D getting wider and wider, with him standing with one feet on one half of the stage and the other one on the other cursing in the middle of a song at the two giant-sized security men of the club putting the stage back together.

Luckily it was almost over... when the guy at the mixer threw us signs that the next song would have been the last, D replied in his style (shouting on the mic, that is...) "Whaasssshhhhhdafukkkkk r u sssshhhhhaaaayyyyng maaaaaannnnn?????" plus the usual various death threats we started our then final number, the cover of I Wanna Be Your Dog and at last the senseless stage behavior seemed to be less senseless thinking back at the same type of comic tragedy represented by Iggy in his worst period...

Three minutes after and it was finally over. When we got off the stage most of the audience was still staring at us with a blank expression (they were probably already longing to be sedated again by the two utterly boring bands following), but part of them was looking amazed... I really don't think they enjoyed the music that night, but the performance in itself must have been something to watch. I bet many of them still wonder whether some of those things were just theatrical tricks we had thrown in to make them live in person the drama and tragedy of true rock'n'roll decadence... some actually did because we witnessed a number of people rushing to D and patting him in the back to congratulate for the gig and offering (more?) free beer at the bar.

I agree that rock'n'roll is a sort of big circus where you can see almost everything but we could not tolerate to become the accompanying backing band of Mr Speed Freak like that night. That's what we tried to discuss a few days later in a pub. The problem was that he could not remember almost anything of the things occurred before, during and after that gig. What I want to say is... let's keep into account that things *can* actually go downhill for unexpected technical problems, or for "structural" problems due to bad acoustics, bad setups, tiny clubs,

etc. but I think there *is* a limit that alcohol, substances and bad taste in general should not exceed when you are trying to deliver some good rock'n'roll to people who are paying to see you. That's, basically, the last thing we said to the guy before sacking him…

Jo, Pocket Rockets (Genove, Italy)

Connemara Hookers

Remember the late seventies? Everybody who could beg, borrow or steal an instrument joined a band. Punk rock was king. Bands actually looked down on people who could play an instrument. The Connemara Hookers (named after a type of boat, actually) were no different than a thousand other Dublin bands. No innate talent, just an urge to get on stage and perform — or make noise, depending on your perspective.

The band evolved into a five piece over a year of intense practicing. I don't know if we would ever have decided we were ready for the public except that an old friend of the bass player offered us a gig opening for his band. It took all of a half a second to accept. Despite the drawback — we were in Dublin, the gig was in Kenmare. If you've ever been to the asshole of nowhere, Kenmare is another two hours further along the coast.

So we packed our gear and girlfriends into two cars and set out for Ireland's Wild West. Kenmare had, and still has, a large enclave of New Age Hippie blow-ins. The bass guitarist's friend was one of these. To say the whole endeavor was disorganized was like calling WWII a bit of a disturbance. We weren't even sure all the members of the headlining (that's a laugh) act knew about the gig, never mind the potential audience.

But we'd driven a long way and the prevailing attitude was "It'll happen if it's meant to happen, maaan." Undaunted (slightly), we found the (bloody enormous) hotel ballroom where we were to play, set up our equipment and, with nothing better to do, engaged in endless sound checks. By ten o'clock about twenty punters had showed and several guys with long hair, beads and flares had wandered in and plugged various pieces of equipment into the spaghetti junction of electrical cables and extensions that littered the back of the stage. By eleven there were thirty punters and we were worried. Everyone, except us, was beaded and braided and wore hair down to their backsides. Now, we weren't a mohican haircut and razorblades type band, but we did favor straight legged jeans, narrow ties and white shirts with tiny collars. Our sneakers fit in at least.

At eleven thirty the bassist's mate wandered in and suggested we start as they'd be going on in about fifteen or twenty. What about our set? What about an audience? He shrugged and went back out to finish his pint. We got up on stage, cranked up the amplification and belted into A Song From Under The Floorboards by Magazine, followed it with The Big Country by Talking Heads and banged straight on into Respectable Street by XTC. The least we could do was warm them up with something familiar before we went into our own material.

The thirty-odd punters stared at us in silence from the gloomy depths of a ballroom big enough to dry dock the Titanic, drank their drinks and chatted to their friends. Nobody danced, nobody clapped. We did our best to fill the vacuum. Not that these music-hating culchies deserved our unstinting efforts. We realized Kenmare was a cultural void, as far as music was concerned anyway, but motored through our set, note-perfect, in spite of the so-called audience. After ten numbers the bass player's mate saved us from further embarrassment, chucked our drummer out of his seat and began to bash the shit out of the kit. A distant relative of the Yeti borrowed my guitar and began to doodle a few riffs and fills. Three guys who might well have been ZZ Top on sabbatical mooched onto the stage and supplanted us. It took us five minutes to realize the real gig had begun. Another five minutes of ragged jamming and the ballroom was full. Heads were shaking in time to the heavy sounds, maaan, trippy hippie chicks were freaking out to the non-rhythms, smiling heads clapped in semi-time to the ramblings of their heroes.

Shoulders slumped, we headed for the bar. As I pushed my way through the crowded doorway a skinny guy with long blond hair, vaguely reminiscent of Duane Allman, patted me on the shoulder. "Tight as a duck's ass, man," he said, smiling. I smiled back. Tight as a duck's ass. That was good, right?

Bob Neilson (Dublin)

Midnight Rambling

It was about 1996, and this was the second gig I'd played with my first band. We were all about sixteen

at the time, and played sixties and seventies covers like Cream and The Kinks. Easy shit. The first gig was a school rock concert. We were the second band, and played three songs. It went great. Audience of about 500, and none of us were nervous. A friend was having a birthday party above a pub, and she asked us to play at it, just in front of friends. We practiced in the lead guitarist's dad's barn. We kept asking him when we could practice, and he kept saying "We'll do it later. We don't need practice." We turn up at his house the morning of the gig and we try to put a set list together. After listing about five three-minute songs, we're in trouble. We start going through his music books to find songs we all know, and start learning some quick Stones songs. We finally get about ten together, but there is no sign of the bassist! We phone his house, but there's no reply. How could things get worse? We get to the pub at about 7pm and have well given up on the bassist. I play rhythm, so I had to combine the bass lines with my regular parts. We get into the pub and set up our gear. The place is filled with about fifty people we've never seen before. It is damn intimidating. There is no PA, so the singer has to plug his mic into my guitar amp, which halves the volume. The other guitarist just totally overpowered us both. The first few songs go OK, but the beer is starting to take effect, and we're all getting more and more nervous. The set comes on to the new songs, and we just totally lose it. Halfway through "The Midnight Rambler", we all simultaneously forget what the next riff is, and we all play different things. Then we stop, and start again. And fall apart even more. We give up, and start the next song. Same thing happens. I've had it, and put my guitar down and head for the bar. I spend the next two hours grumbling into my beer, and somehow the other guys think it went OK. The birthday girl comes over, gives us a fiver each, and says nothing. Some of her mates ask us if they could play, and I'm too pissed off to care. It's the most humiliating time of my life, and I never played with those guys again.

Graeme Hayburn (Belfast)

Rock'n'Roll Zoo Animals

Hey guys, you ever seen movies like *Rock Star* or *Still Crazy*? Or any other rock'n'roll kickass movie showing how cool and fun life on the road is? Well... if you live in Italy, forget it! It's bullshit! Club manag-

ers rip you off, the equipment sucks, you only get one (maximum two) beers and a microwave pre-cooked dish of pasta which tastes like cardboard and horseshit. Forget about hot teenagers with big tits eager to show you how much they enjoyed the show (ninety percent of the underground club audience is males in their early twenties with pimples and T-shirts). We could tell you about hundreds of gigs where we played for a ridiculous budget in shitty places with no more than ten people watching us playing. Last time we played, it was in Viterbo, a small medieval town a couple of hours away from Rome. The place was called Delerium Club. When we got there (it was Friday), we found another band from the north of Italy. It turns out that the manager had made a mistake in the scheduling of the gig, and we

were supposed to play the day after. He said he was sorry and all... that after all it was only two hours away from where we lived and in a few words asked us to please come back the day after.

And so we did. Saturday: we arrive there. The guy is late. When he finally turns up, there is no stage, no mixer, a drum set which is good for the

junkyard. Fine! In the end we solve every problem (with not much help from the club manager who is too busy doing other things like smoking spliffs and harassing the bar girl.) We play. The gig is not too bad, although we had people walking right in and out the area in which we were playing, looking at us and our amps and guitars like we were animals at the zoo. At the end, we ask the bloke for the money he owed us (we only asked for 100 euros) and he starts complaining about the fact that the night hasn't been very good, and he expected more people to come (this would have surely happened if he had taken care of putting a couple of ads around). He gives us seventy euros. We complain and start to shout and threaten to burn the place down, in the end we agree on ninety euros with mutual dissatisfaction. We leave the place hoping the hand of God (any God would do) will take care to crush it down mercilessly on Judgement Day.

Rock'n'roll forever.

Skywise (Rome)

White Trash Pyro

Youngstown is the armpit of Ohio. Broken homes line the streets, porn stores remain the city's only thriving industry, and murder reigns supreme. Nevertheless, for Hellvis, it's the perfect setting. Recently, we played a show in Youngstown at a club called the Nyabinghi. With the neon Pabst Blue Ribbon sign, the overflowing urinal, and the moosehead on the wall, this bar has rock'n'roll written all over it.

Seeing as how Youngstown is my home town, we tend to go as over the top as we can for our stage show when we roll through. There was a great turnout and the whole vibe as one friend put was, "We all know something's gonna go down ,but we just don't know what." We saved all the drama for the set's finale as we had a scantily-clad fire eater throw balls of flame and then douse them in her mouth. I prefer strapping explosives to my bass guitar, which I did at the beginning of the following song, sending out a five foot high flame that nearly torched our guitarist and a few photographers. Not wanting to be out done our drummer shot off an 1841 Indian gun at the end of our closing song, that shattered the tubes in our guitarist's amp head and caused some severe whiplash in a few patrons sitting at the bar. We don't typically tell bar owners what were going to do when we bring our white trash pyro to

the show, but luckily The Nyabinghi's policy is, if it rocks, and you don't break the state of the art PA system, it's cool.

Besides, *USA Today* voted Youngstown the murder city capitol of the country. I'm sure our pyro is the least of this broken down town's worries.

BJ, Hellvis (Youngstown, Ohio)

Iggy Digs Me

The Creepy T's were booked to play in the Miami Rocks festival. This was a great opportunity because the band was extremely dysfunctional at this point, due to the influence of hard drugs. It was also the last gig before Eddie and I packed up and moved to New York, effectively putting an end to the band for almost two years. Jonny 5, from the now defunct avant-rock outfit We Got The Missiles, was filling in on second guitar because our guitarist William Trev bailed because of the excessive drug use. Jonny sounded good though. The day of the gig comes and of course Eddie and I are postponing leaving my apartment until the last second so that we could keep doing up our stash. Mark, the bassist, comes over and I ride with him. Eddie takes my car so that he can meet the drug dealer one last time before going to the club. He secures our stash for after the show and Mark and I arrive at the club. We soon realize that we're on the main stage and are headlining this fucking thing for a midnight show. My cell phone rings and it's Eddie. The car died on the I-95 overpass. He can't get the piece of junk started. My friend Chad is with us also and he's as high as a kite. He has my phone and Eddie calls again. Chad can't string together a sentence and Eddie yells at him, getting madder. "Give Derek the phone!" Chad gives me the phone and Eddie tells me that the car still won't start. Derek: "Fuck man, we're headlining this goddamn thing" Eddie: "*It won't start.*" Derek: "Do something, fuck, get here". Click. It's now 11:15pm or so, and I'm nervous, thinking that we're not gonna be able to play this gig. The phone rings again. Eddie somehow got the car started. He shows up drained and pissed off. We have to load in the equipment up a murderously steep flight of steps at Tobacco Road, Miami's oldest bar (the Sheriff was killed here in a Prohibition-era shootout once). We get everything inside and start setting up. The soundman sticks us with this attitude that he was the sound man at CBGB's for years and we had better listen to him no

97

matter what. That was all it took. Eddie opened up on him, "Why are you here then if you're so good, motherfucker? You don't know what the hell you're doing" etc. Now, Soundguy hates us. We get ready to play and my foot pedals don't work. The guitar is dead. I start slugging off my flask of Jack. Local music guru Rat Bastard sees my dilemma and comes to the rescue. As he's reconnecting my shit, he says "Play it better than Mr Osterberg". I knew he was referring to Iggy, but I wasn't quite sure why he said it. We start the set and the sound fucker is sabotaging the PA system for the first few songs. I start drinking more Jack and start baptizing the audience with it. Jonny five starts doing an obnoxious China man imitation for the rest of the show, punctuating our between-song banter with statements like "pork flied lice". Mark is solid, Eddie is solid and our friend Andy guests on a harmonica spot. The Heckler starts in on us because after one of the songs Jonny and I French-kissed on stage. "You disgusting faggots", to which I reply "You can kiss me too, you filthy hick," and "Go home and practice on your mother." Back and forth the rest of the set. I drink more Jack. When we get off stage I find out from several people that Iggy Pop was in the audience, and stayed to watch us for the whole set. I freaked out upon being notified of this. I meandered through the bar to see if I could spot him but he had already left. I'm glad that I didn't know he was there while we were doing our set. These days the band has the best lineup it has ever had, with the addition of Thomas "Mr Suave" Rotten on the Farfisa organ and the lovely deranged Ray Fang on drums. There's no more dysfunctional drug use, but oh, the memories. Nowadays, we rely upon gags like showing up at clubs in a hearse, dressing up in black leather and 3D glasses, pulling our pants down, and drinking from a plastic jug of juice with a radiator fluid label slapped on it.

Derek Hyde, Creepy T's (Ft Lauderdale)

Another Day In The Life

For the Vampire Horses to choose a bad experience shouldn't be a difficult task, since they haven't had any good experiences. Unfortunately, the black storm clouds of bad luck that follow these grim reapers of rock have also left their beer-drenched memories circling the drain. Lies, deceit, bad press, cheesy soap opera -like shenanigans, should have secured their infamy in the rock'n'roll history books. Instead, they have left the VH's on the outside looking in.

For example, Saturday, Sept 7 (last show before writing this). A last minute showcase for a local indie band website. Already the Vampire Horses are a little leery, but it's a Saturday night gig downtown Toronto. That alone should tip the scales for good, rather than disaster. First off we are suckered into the headlining spot. Then, they're told the first band is using the second band's drum kit. Our Death Mobile (van) is in the shop, and the War Machine (cube van) is just too big to park in TO. We had a funeral procession motorcade of black sedans crammed with coffins, mummies and equipment that had to be carried down a near-impassible garbage-littered, urine-stanched alley to a ramshackle narrow steel staircase up three flights. The sound guy's freaking because he thinks we are late (the info he received was that the VH's were on first and the rest of the bands were using their kit). He is promptly put in his place. Everyone loves free beer tickets, but the bar's tickets that only allow a dollar's savings make you want to smash things. Pretty fucking chintzy. On top of this, the club owner charges an alarming cover charge. Most of these things are usually sadly organized, poorly executed, and lack any real vision, not to mention the mismatching of bands. The VH's are high-energy beer-fueled horror rock like the devil intended. The other bands on this bill were smiley-faced poppy soft rock (you know the kind of music that makes you *kill and kill again*). The Vampire Horses diligently endured the opening bands' mindless dribble, only for these peace freak granola eating tree huggers to leave right after their uninspiring sets. With a near empty bar, the VH's rocked 'em out while the staff mopped the floors and cursed the day they ever heard the VH's. These events were by no means the worst, but more like the average day in the life. The band is not complaining. They are not bitter. That's rock'n'roll (so many people to kill so little time!). Even beer bottles thrown in hatred of the VH's is heart-warming, in comparison to lack of interest!

Rob Munster, Vampire Horses (Toronto)

Lotsa Poppa

I would like to tell you about one night at the old punk rock dive the Tip Top Inn (RIP) in San Francisco. I believe it was in February of 1998. We were scheduled to headline a show at the club with a

couple other bands. I can't remember who. First off, in club land, headlining sucks. Headlining *sounds* cool, but in the real world it means going on last. And if it's not a weekend, that *blows*; 1am on a Tuesday is a lonely place to be. This was a Saturday night, so we knew it wouldn't be too bad. It was a typical rainy night in SF. Loading gear in the rain is nothing new to SF bands. We get to the club, and as always at the Tip Top, there is no fucking room to put your gear — and the promoter wasn't helping anyone out. We actually were lucky to be playing there because we were banned from the club the year before because of a bullshit misunderstanding the promoter had with us (I won't get into that here). Let's just say we

reeking havoc at their shows. *Loved them*). His name is Ray (aka Lotsa Poppa). He decides to start fucking with us, just for the hell of it. He unzips his pants and whips out his dick. We are playing the Psychedelic Furs song Pretty In Pink and Lotsa Poppa starts pulling on his dick saying, "I want some pink! Come on, gimmie some pink!" We just laugh it off, and keep playing. Meanwhile I start to feel the bottom of my pant leg getting wet. I look down and Lotsa Poppa is pissing on me! I try to move from left to right on this tiny ass stage to avoid the piss, and he just follows my feet with his dick spraying like a fire hose. The front of the stage and my feet are now covered in piss. Security comes rushing in and takes

Security comes
rushing in and takes
Lotsa Poppa away.
ROMEO'S DEAD

like to talk a lot of shit, or really, Jay (our bassist) likes to talk shit. And his mouth gets us in trouble from time to time. Anyway, the club is packed! Not hard to do when the room only holds fifty people, max. But it looks cool, no matter what. The first two bands play and the room is still amped up (i.e drunk). We start our set on the tiny stage they had at this place (if you moved you would knock over an amp or something). It's a hometown crowd, so most of the audience is familiar with us and our songs, so the mood is good, but getting out of hand. Beer is being sprayed all over us from the crowd. My fault really, as I used to spray the crowd with booze at the beginning of every show. So the crowd usually would retaliate with full glasses of some cheap Pabst Blue Ribbon, or something. How no one in the band was ever electrocuted is a miracle. Well, we are about half way through the set when some extremely drunk guy comes rushing towards the front of stage. I recognize him as the bass player for another SF band, SisterKissers (RIP — a notorious band known for

Lotsa Poppa away. Not to my urging, other than the ruined shoes, I thought it was pretty funny. Must have bothered some girl up front, or something. We finish our set and the promoter is not pleased with the urine covered stage and is really irritated with us, cause we don't offer to clean it up. I don't think we were invited back to the Tip Top for over a year again. I ran into Lotsa Poppa a couple weeks later at the Lucky 13 club and he had no recollection of the incident, but apologized anyway. We ordered another round of drinks and talked about how fucked the scene is. Piss on it all!

Zane, Romeo's Dead (SF)

Bombay Fireball

I'll do my best to throw down some shit from memory... let's see what fizzles in. Never mind the fractured sentencing and fucked grammar... it's rock'n'roll, right? The Pretty Uglys took about five months to tear a new asshole into Ventura. Bakersfield

by the sea, as some call it. When we came up, we knew this disco-cover-band-loving town needed some real rock'n'roll. The two big yuppie crops around here, Nicholbys and Bombay Bar and Grill, were gonna get it first. Nicholbys is a weird joint. Nice looking, run by good guys, but infested with bad music and people. Definitely the hot bar for the college-educated moron. Long story short, our first show there, we show up in full makeup and bad clothes (as usual), and at the end of the set, I decided to invoke Gene and spit some fire. The roof caught fire, we got blasted with the extinguishers, and I was told, basically, that I needed to "Leave and live". Naturally, because we're the best thing this town has seen, they called back. We played again. I dressed like a fireman.

We'd made a big impression via the image, setting shit on fire (accidentally), and of course, loud rock'n'roll music. No big shorts or jerseys here... we're the real shit. Therefore, we were relentless about letting everyone know. Testifying. Despite this reputation, someone didn't notice. Bombay Bar and Grill wouldn't book us. We wanted their head so bad. This place is the worst. It's the breeding ground of the lame. Twelve dollar drinks, bouncers in monkey suits, middle-aged teenagers dancing to reggae. We wanted in there. A guy named Michael Kohli didn't notice either. He headed the biggest music promoting machine in his own mind, "Kohli rocks entertainment". I assure you nothing about this guy rocks, except maybe his ass every couple nights. All I saw him ever do music-wise was DJ in the lunch area on the community college. He'd play Poison and Whitesnake at lunch. He was getting bands together for shows he was gonna start booking. I told him to call me when he had it all worked out. One idea was a rock'n'roll zoo. He'd get us (we used to be Dogmatic) and this band Kitty Kat Stew... and some other "animal bands". He'd get real animals, too. I told him to shut up. No.

A week or so later he said he got us a show if we wanted it. No animals. Sure enough, at Bombay. They were awesome on the phone, promising a bar tab, guest list, the full deal. When we showed up at the front door, it was a different story. No guest list, no bar tab, short set, no pay. I guess they didn't want our friends in there, they didn't want to fuel us with more alcohol, and they wanted us out as soon as possible. So, we go to sound check. Seems the sound guy is gonna need a ninety decibel sound limit be-

cause the ska band is still playing in front. He also would appreciate it if we tried to not get the mics all wet with spit and stuff. We cranked the stacks to full (we had brought full stacks to play a 400 person venue) and ripped into the first three songs. Kicking around store-bought talls and flipping the bird at every suit in the place — we were rocking the shit out of that place. Then I saw Kohli, white as a ghost. They pulled the plug on us and about eight or nine of the tuxedo clad security lined up, arms folded on the other side of the wood dance floor. So, naturally, after we destroyed every microphone we saw... I spit a few good fireballs over the dance floor to the security. Blowing kisses. They all rushed the stage. When they hit that floor, they were sliding on that kerosene like the fucking three stooges. Funny shit. We were "escorted" out, and the rest is rumors.

Bobby Ramone, The Pretty Uglys
(Ventura)

Just Play Your Top Twenty Songs Tonight, Boys

OK, I know ya said "gig" but lookin' back I got enough to fill a book or two, and then some! So here goes!

Tellingly my first gig from hell was the very first gig by my very first band... Guess someone was tryin' to tell me sumthin', huh? Aged all of fifteen I'd run off to the Isle Of Man with my best buddies to catch our hero Marc Bolan and the wunnerful T Rex in concert. As fate would have it we got to meet Marc and the band and — unlike most any rock star I've met since — he was cool, witty and charming. Better still, even faced with a gang of scruffy Belfast delinquent teens he was real down to earth and went out of his way to make us all welcome. He gave me a signed T Rex music book and like in all the corniest dime novels I came home star struck, determined to buy a guitar and follow in his footsteps.

A few months later and I'd begged, borrowed and stolen (mostly the latter) enough for a third hand 'Satellite' guitar. I'd even gotten together a group of sorts with a couple of the guys who had been to the IOM and other teenage reprobate chums... And even though we could barely strum a chord between us and could only stumble ham fistedly through about three songs, we positively leapt at the chance to play a birthday party that a girl we hung around with was havin'.

First up we roped in a pal who drummed in a local flute band and persuaded him to buy a battered spangly drum kit on hire purchase. We could only rustle up a couple of worn out amplifiers, but what the heck… they had enough inputs for our three guitars, a bass and two mics as well! (Musta sounded good huh?) PAs? Never heard of 'em! So far so good, huh? So for weeks before we practiced furiously and finally we had a handful of three-chord rock'n'roll classics and stomp-a-long glam hits off pat (well, only after leaving out the hard bits). We were no slouches and were determined to make our mark! I'd hacked away merrily at my barnet resulting in what I optimistically reckoned was a dead ringer for a 'Ziggy' spike top and even sawed off a double breasted jacket in another nod to the thin white duke. (I'll draw a discrete veil over an earlier episode that involved pulling out all my eyebrows with pliers *a la* Aladdin Sane, not realizing that my plucked brows would swell up so that I looked like Rondo Hatton's bastard spawn.) Bassist, Grimmy had bleached his floppy fringe blonde (again) and borrowed a lime green jacket and long white scarf in a thrift store homage to the Dolls' Arthur Kane. Drummer Drew and fellow guitar plucker Ronnie were a bit less daring and stuck resolutely with their standard daywear of parallels and college jumpers — leaving token long hair Leigh stuck firmly with his Quo denims as befitted the only one of us who actually knew what a barre chord was (and he had his own amp and fuzzbox too)!

Still, we were quietly confident, sure that this was the first step of our meteoric rise to undreamt of riches and fame — just like in *Stardust*. Until the day before the big night — when word reached us that a top local heavy and his psycho biker mates had been invited, too. They were older and harder than us, had done real jail time and were legendary for beating the crap outta anyone and everyone who had the misfortune to be in their vicinity. Worse still they had well known paramilitary links… Sheesh… Still, we couldn't simply bottle out. And so we turned up, set up and waited, soothing our frayed nerves with the help of Olde English cider and our favorite tipple: Mundies celebrated wine. We probably supposed that a kicking wouldn't hurt as much if we were pole axed! By the time we started to play to our undying relief the bad guys still hadn't turned up. Even though we were rough as fuck — and scared shitless — everyone else was even more pissed than

we were and some brave souls even managed to recognize the songs and started dancing, i.e. staggering about paralytic in time to the racket we were churning out. Shit, we even started enjoying ourselves! And then, just like in a cheap western, *they* arrived, lining up along the wall facing us and clearing the dance floor in seconds with their menacing glares. We were bricking it, but reckoned we were safer playing on… And then Drew stepped out from behind his drum kit and headed straight for the top hood… What the fuck was he up to? I mean he could handle himself, but these odds were suicidal. To our undying amazement he chatted a bit and turned round beaming… "He wants to know if we can play House Of The Rising Sun," Drew said. Luckily we could stumble through it and our erstwhile nemesis ambled over and, grabbing the mic in his huge bear-like paw, started singing along! We were bowled over… weirdest thing of all, he could actually sing. By the time the song finished we knew we'd scraped through in one piece. And so, pissing adrenalin, we played on for ages, knocking out progressively more ragged drunken three-chord slop, while every so often our newfound vocalist would amble over and we'd stop what we were playing to launch once again into House Of The Rising Sun. We musta played it about six times that night. But it was well worth it to get out in one piece. Other times we'd not be so lucky…

Despite those shambolic beginnings some of us were well and truly bitten by the rock'n'roll bug. A couple of line-up changes later — after nicking our moniker "RUDI" from an old 45 by seminal proto punks The Jook — we found ourselves in on the ground floor as the first ever punk band in Belfast. Still all only sixteen or seventeen, we hired beat-up function rooms in run-down hotels and put on our own gigs, packing places out with our mates. Nobody else much had heard of punk over here and we had a ball! Marathon two-hour sets honed our chops and soon we were knocking out our own stuff as well as the tried and trusted faves. These gigs were great… pure teenage testosterone thunder and underage sin, sex and savagery. And even though we played real dives there was no trouble — so long as we packed the places with (underage) drinkers, the proprietors were more than happy to have us back.

But that all changed once the tabloids seized on punk and whipped up a frenzy of copy cat punk

101

bashing.

The Sex Pistols' God Save The Queen debacle mighta been an amusing jape in sunny suburban merrye Englande, but here where loyalty — or not — to the crown carried a whole different set of baggage, things could get real scary at times. Tellingly at one of our haunts — the notorious Glenmachan, a real fun place where I once saw a guy get his eye put out with a steel shovel — the DJs used to play all the punk 45s but were sure to always take Anarchy In The UK off the turntable before the verse which mentioned the UDA/IRA, so as not to offend certain gentlemen who were present...

We escaped trouble mainly because we were on pretty good terms with the local thugs (some folks said *we* were the local thugs), and also we knew who to look out for. Weirdest of all, our erstwhile singing buddy had caused so much trouble and put so many people in intensive care that one venue made him and his pals bouncers to try and stop them beating up all the paying customers! Others weren't as fortunate. Punks who came to see us from outside our area often went home beaten and bloodied and venues started banning anything "punk", even though it was rarely the punks who started any trouble.

So we had to get our pals to hire venues under the pretext of having birthday parties, and then we'd turn up to play unannounced — only to get banned again after the gig (never before the gigs, as the venue wouldn't turn away paying and drinking customers).

A lot of the folks who ran about with us weren't averse to standing up for themselves. I remember fondly loading my amp and stuff into the back of my dad's car after playing the Trident in Bangor, and noticing about thirty guys heading over to attack us — until a couple of our pals spotted 'em and ran at them. Such was our reputation that all thirty turned and ran!

And all of a sudden punk got real popular too, and everybody rushed to jump on the bandwagon. Even local no-hoper heavy rock hippies Highway Star, reluctantly clipped their flowing locks and, ditching their beloved flares, became cartoon punk combo Stiff Little Fingers — switching overnight from Deep Purple and Rory Gallagher songs to similarly uninspired K-Tel punk-by-numbers covers...

Earlier local show band Candy had tried the same trick, only they hit on the brainwave of still playing top ten hits as Candy half the week and playing punk hits the rest of the week as Pretty Boy Floyd And The Gems. Sadly, this enterprising attempt to get the best of both worlds met with disaster in the country towns they played most of their gigs in. One infamous night in Newry their van was turned over and wrecked and they only just made it out alive!

Now that punk was big business, the venues that had turned us away and labeled us as "spike topped troublemakers who couldn't play to save their lives", suddenly welcomed us with open arms. Local hippy hang out, The Pound, finally allowed RUDI and the Outcasts to darken their door and play one "try out" gig — promptly banning both bands after a few glasses were broken. Sheesh! Pussies! At one Glenmachan gig we were handed a bill for breakages that was higher than the money we lifted on the door...and we always packed the place out! Natch we didn't pay and got barred again (until the next time they needed a crowd).

One gig at the Strathearn hotel in Holywood outside Belfast (later blown to bits by a bomb), was memorable as a rumor went round that the Holywood UDA were coming down en masse to "kill the punks". Thankfully they musta had something better to do that night as they never turned up. At Hunters Bar in Bangor the band and entire audience had to get escorted out for its own protection when the venue was surrounded by off-duty soldiers, intent on causing mayhem and partaking in a little punk bashing.

But it wasn't all doom and gloom. Thankfully the aforementioned Gems did do one good deed in their time: kicking off live music in a run down ex-strip joint called the Harp Bar, which was to became Belfast's major punk mecca — where nobody cared what religion you were or where you were from, as long as you liked the music. (Tell that to The Tearjerkers — another combo of hapless bandwagon jumpers whose one and only gig in the Harp saw them get bottled off and shepherded out by the police for their own safety. Their crime? Sporting the wrong haircuts, wrong trousers and, worse still, copious facial hair!)

As punk started to break big, the lame ass hippy dippy promoters who had turned their noses up at it finally relented. Money talks? The Clash's October '77 gig was a watershed. They didn't actually get to play as the city fathers pulled the insurance hours before the gig was due to start. Outside the intended venue, The Ulster Hall, a huge crowd of angry punks

refused to disperse. Displaying their customary tact and diplomacy the cops raced up and beat the crap out of anyone who got in their way. We wrote a song about it called Cops, with the catchy singalonga chorus of "We hate the cops" and adapting the well known Ulster street chant of S.S.R.U.C. as an intro. This was the single most popular punk anthem here at the time. Cleverly we elected not to release it as our first 45 as we would save it for the major deal that was surely about to follow. (Yeah, what fat cat establishment suck-up major record company was gonna release *that* as a possible *TOTP* pick-to-click! Boy, were we naïve!) We did get to meet our erstwhile heroes who were holed up in The Europa, the most luxurious hotel Belfast had to offer. They did hang around just long enough to get dozens of press shots taken alongside the barbed wire and barricades... all good copy, huh? At least they were nice folks and did keep their promise to come back and play as soon as they could. A truly great band — but they talked absolute shit.

Early in 1978, The Buzzcocks asked us to play with them for their first Irish gig. Sadly their van broke down in Wales — a story no one believed at the time but which was true; everybody thought they'd chickened out! The promoter asked us to play for free to the punky waver hordes to avoid a repeat of the Ulster Hall riot. So we raced home and dragged out our tiny PA and played a blinder... We hadda play Cops twice! As a reward we snagged the support slot with The Adverts the following week. Interestingly, newly shorn Stiff Little Fingers were bottom of the bill. (Jake finally got his hair cut, but still sported his natty huge flares and polo neck.) Both bands arrived to set up while The Adverts sound checked interminably. Even though I'm caustic about some of the bands mentioned here, we were all pals and shared gear and arranged gigs together. The Adverts were my first sighting of the breed "rockstarus arrogantus".

They ignored us all and after the longest sound check in history, traipsed off to the bar to watch themselves on *TOTP*, taking their roadies with them! We stood around for hours until they finally came back, just as the doors opened. Both support bands hadda play without a sound check — the oldest trick in the book used by shitty top of the bill bands to make the better bands lower down the bill look rubbish. Really pissed off we had something to prove and tore the place apart — crappy sound notwith-

standing! Once word of The Adverts' childish ploy got round, our pals in the audience greeted the *TOTP*-sters with a hail of abuse. Despite their better sound, the headliners died on their feet. Besides they were shit live at the best of times. So much for punk solidarity, huh? Still they weren't alone amongst their peers...most every UK punksters we finally did get to play with or meet turned out to be little more than clichéd, record company bankrolled, limo riding ,drug snorting, egotistical rock star wannabes... Hypocritical wankers!

In contrast, reggae act The Cimarrons actually insisted we got to use their PA and arranged a proper sound check when we played with them at Coleraine University and Queens University Belfast. Mind you, when the student promoter tried to stitch us up over our fee in Colerain, some of our pals wrecked the place... and we were banned for life from ever playing there again (as I found when I went back to play there years later — the ban still stood). They moaned that our stroppiness was "worse than the Stranglers", who had played there the week before.

An ironic postscript: In 1980 we were to be filmed with our erstwhile chums Stiff Little Fingers by the BBC here. Jake Burns (an immodest man who would sell his Granny to get on, and has gotten rid of every original SLF member by hook and by crook over the years) tried the old "no sound check" trick on us. So we fucked off home, after making sure he knew exactly what we thought of him! Tellingly when we toured with The Jam — a bigger and better live band than *any* mentioned so far — they went out of their way to ensure that we got proper sound checks and their roadies and crew couldn't do enough for us throughout the tour (if perchance you are reading this — thanks again guys).

But back in mid 1978 and on the back of the roaring success of our first 45, Big Time — also the first release on the soon-to-be legendary Good Vibrations label — we headed for London with all our gear in a battered van. Driving down from Stranraer by night ,we solved our "no cash for petrol" crisis by pulling up in lay-bys alongside parked dormobiles and siphoning petrol out of their tanks whilst the unsuspecting occupants slept peacefully inside. The hardest part was stifling our laughter as we drove away! This practice continued until one night Grimmy and a pal got caught and were charged with "going equipped to steal". I guess it was kinda hard explaining why they were out in the middle of

A few weeks later
another car suffered
the same sort of attack
and was forced off the
road and some of the
passengers were killed.
RUDI

the night skulking round parked cars with a length of rubber hose and a petrol can. This was the first of several run-ins with Her Majesty's constabulary! Still, London was great! We slept in the van until we lined up squats in Clapham. Once settled in, gigs came thick and fast. Frank Murray gave us great support slots at the Electric Ballroom in Camden — including one memorable show with The Doomed (the Damned's first reform gig with Lemmy on bass!), which woulda been a real gig From hell if we hadn't insisted that our drum kit and back line got miced up properly. Imagine playing a venue the size of an aircraft hangar without your tiny amps miced up through the PA! Ridiculous! Thankfully Captain Sensible (a longtime buddy of our English roadie/squat mate Griswald) had a quiet word with them and we even got a sound check too. Motto: Never trust a lazy roadie!

Many shows were set up by our newfound chums in The Raped (a much maligned and under rated combo), who we met through one of our pals — the improbably named Mr Puke, who they had rescued when he ran away to London. At fifteen he was too young to get dole and they had fed and housed him until he reached the magic age of sixteen!

Folks were kinda scared of us as we came from war torn Belfast. This came in real handy when our newfound pals got hassled time after time and we hadda come to their aid. Yup, even at the height of the punk explosion, the sight of grown men in full make up and a Japanese drummer (called Paddy Field, of course) in shiny PVC hot pants still provoked a violent reaction!

In London we did have some narrow escapes… One gig in the Crypt with Shane Magowan's pre Pogue combo the Nipple Erectors was great — until afterwards when one of our pals over from Belfast on holiday, mouthed off at the local biker gang. We all only just escaped a hammering after some sweet talk from one of our newfound London chums.

Scarier still was a gig in Manchester, where we found ourselves supporting the newly shaven headed Skrewdriver. The place was so grim that even my erstwhile buddy and soon-to-be local legend, Steven Morrissey, failed to show — only telling me afterwards just how dangerous a place it was! Thankfully most of the audience had come to see us and left after we played. Taking heed of the number of hostile glares we were getting from the folically challenged headliners and their entourage we decided to follow suit…

Christmas 1978 saw us back in Belfast after Ronnie and Grimmy had ended up in jail and were faced with the choice of going straight back to Belfast, or going straight to jail for six months each — but that's another story. Our first shows back were jam-packed. We invited our chums The Raped over to play guest slots. Sadly Belfast wasn't quite ready for The Raped's sartorial elegance, and Sean and Paddy had to be escorted out of a party in Rathcoole

Gigs From Hell

by the police for their own protection.

But overall things were much better. Dozens of bands had sprung up. There was still sporadic "punk bashing", but now the punks outnumbered their detractors — though we still all walked round to the city hall to get the last bus home together, as stragglers would get jumped by roaming "spidermen" (local slang for marauding boot boys).

But venturing outside Belfast was always dicey. Without fail, some carefree local would surreptitiously slip into the conversation: "And what part of Belfast did you say you were from?" The wrong answer in the wrong place guaranteed a kicking, or worse — and we got real good at keeping schtum.

We did play one weird gig in a bar in Castlederg, a tiny town miles from Belfast. The set went down fine — even though punk rock had yet to reach that far, and the enterprising wideboy who had booked us was still charging people in after we had finished. We hung around until the bar closed and started loading up the van — only to find ourselves in the middle of a pitched battle between the folk coming out of the bar we had just played in, and the crowd streaming out of the bar across the road opposite. Unfortunately no one had seen fit to mention to us the quaint local ritual that took place every weekend, when the punters from both bars would kick seven shades of shit out of each other before they made their way home. (One bar was Protestant, the other Catholic.) Luckily we were well used to this sort of thing and, keeping our heads down, just about managed to make it out in one piece. Weeks later in a town not far away the Outcasts weren't so lucky and had their van overturned.

We played a lot all over Ireland and went down a storm most everywhere. Better still we managed to keep out of any major trouble, even in Dublin, which had a real bad reputation in the early eighties — although we did have one big gig pulled due to a stabbing outside the venue, and a two-night headlining stint at the Project Arts Centre was interrupted by random violence. However most of this was down to local gang rivalries and we always managed to escape unscathed. Unlike U2 who were tormented by a (Catholic) skinhead gang called The Black Cats, who used to wreck their gigs with monotonous regularity.

Our fortunes continued to rise and we returned to play England for prestige bill topping shows. We did have our own run-in with Dublin skins at one Hope And Anchor gig, when a huge mob of them arrived mid set and started shouting and singing. Amazingly, after finding out that we were from Belfast they assumed that we were from their side (so to speak) and we had a great night. Tactfully we opted not to let 'em know that we actually came from the other side… shucks!

Back home, we had our narrowest escape, and a gig from hell I'd never want to repeat… Fuck the funny stuff, this still scares me rigid! By the early eighties, punk had spread to even the smallest country towns and we were asked to play many gigs in out of the ways spots. Usually these shows were arranged by local punks — which guaranteed safe passage. Besides, for all of us, punk was the religion that mattered and nobody cared much what side you came from.

But being Northern Ireland in the trigger happy eighties you still had to be real careful. Out of the blue a promoter rang up and asked us to play Castlebellingham — a small town outside Dundalk, just over the border into the Republic. The money was OK, too. We saw no problem and agreed to play.

As usual we took a few pals with us to help shift the gear. When we got there we started to get kinda worried. The venue was a large run-down ballroom and the guy who had booked us looked strangely worried by our appearance; as we set up and sound checked, he started to look decidedly panic stricken. We were kinda bewildered at the lack of local punks, but when he shuffled over and asked us to "Just play your top twenty songs tonight, boys," the penny began to drop. Turns out he'd never heard of us but had been told we pulled a huge crowd up North and had just assumed we were a popular show band! He looked positively mortified when we told him we didn't do chart cover versions: just our own songs. Still he had booked us and we had turned up, so there was nothing he could do about it. We thought it was pretty funny, but the joke wore off real fast when the crowd started to filter in: This place only opened after the pubs closed and so the locals were all blocked outta their skulls. Worse still, there wasn't a single punk — or even anyone remotely resembling one — amongst them.

We reckoned that we could mebbe pull it off, and started to play. But as utter bewilderment began to turn to thinly disguised hostility, the promoter pulled us off stage apologetically. He'd actually liked us and even paid us, but realized that if the

105

locals didn't get the DJ back on with his MOR disco hits, things might get real nasty. We packed up to go, downhearted but not worse off for the experience — yet. Meantime, one of our roadies had gotten real paralytic and had not exactly endeared himself to a couple of the locals as his drunken attempts at good natured banter had fallen on decidedly unsympathetic ears. His broad Belfast accent had alerted them to the fact that we were outsiders. Not only were we horrible, nasty, filthy punk rockers — not only were we from Belfast — worse of all we were from the wrong side of Belfast. (Uh Oh!) So we hurriedly loaded up, made a hasty exit and hit the road home with the pedal down. A few minutes later though, out the back windows of the van, we noticed this car coming faster and faster and closer and closer to us. We slowed down to let it past and it drove straight into the rear bumper. At first we hoped they were just driving home blind drunk — but when they did it again and again, we realized to our horror that they were trying to knock us off the road. Our driver put his foot down and we thought we'd managed to lose them by the time we reached Dundalk. Mightily relieved we slowed to stop at red traffic lights — and they came hurtling out of a side street and ploughed right into the side of the transit, almost turning us over and tearing a hole in the side of the van. Fuck the red light — pedal to the metal we raced for the border. I don't think I've ever been as petrified in my life (not even when we were chased off Baker Street Tube one night by dozens of screaming, psychotic skinheads baying for blood). Nobody even dared to breathe as we sped along. The minutes dragged by as we waited for them to reappear behind us. I dunno if they had wrecked their car or what, but we finally made it back over the border in one piece and limped home safe and sound — though really badly shaken and scared..

Sadly this tale has an even more frightening post-script: A few weeks later another car suffered the same sort of attack and was forced off the road and some of the passengers were killed. The papers said at the time that local thugs would apparently steal cars and try to scare folks returning home who had the distinctive yellow Northern Ireland license plates, as part of a deadly, drunken game.

Whether the gig and the ramming were connected I don't honestly know, but I do know that I've never since played any gigs in towns I don't know real well.

On a lighter note, the first night of our support slot with the aforementioned Paul Weller and co. looked like going badly wrong. First night of the Transglobal Express' Jam Tour in 1981 and we came out to face a massed, partisan crowd of mods only intent on seeing the headliners. As we plugged in, the pennies started to fly and the chanting started: "We are the mods, we are the mods." Hardly a morale boosting welcome for a scruffy punk combo from Belfast, already pretty apprehensive at kicking off our first major tour support. The odds looked bad — four punks in front of thousands of howling mods. Cheekily, Ronnie walked over to the mic and started chanting along with em! Gobsmacked by this gesture the crowd were won over and gave us the benefit of the doubt. Needing no second chance we tore the place apart. A feat we repeated every single night of the tour — even getting encores most nights! (Most bands who played with The Jam had to vacate the stage early.) Rewardingly, when we headlined our own tour shortly afterwards a lot of the Jam audience came along to see us.

Phew! Guess that's enough for now... don't wanna hog the limelight! Gigs from hell, mebbe. But apart from that one real nightmare scenario I loved every goddam minute, and I wouldn't have missed 'em for the world! Aw shucks!

Brian Young, RUDI (Belfast)

Part 3

WHACK, TANGLE AND JIVE

Hassles, hustles, victories and defeats (mostly defeats)

I just faked my death, don't expect me to
fake yours, too The Ruiners

No Blood, No Fire, No Peeing

It was a huge opportunity for any band. An opening slot for Thelonious Monster and The Butthole Surfers at The Viper Room in Hollywood. Bob, from TM is a friend and a fan and was able to convince the Viper Room to give us a break. He warned me that the club may need me to tone down my act a bit to agree to the show.

This is not necessarily a problem. Though I've developed a reputation for stripping naked, throwing shit, pissing on stage and shoving microphones up my ass, I am capable of doing lighter and less outrageous shows. The chance to play with the infamous Buttholes at the very club that River Phoenix dropped dead in, was just too great to pass up. I would have to make some compromises. This would be a legendary show.

Unfortunately, my excitement for playing this gig was never matched by the Viper Room's owner and management. From the beginning, I was told that I would be limited to a thirty minute slot, starting promptly at 8:30, that I would not be paid (despite a $15 cover) and would have to sell merch on the sidewalk after the show (booths were reserved for important celebrities, like movie star owner Johnny Depp.) Me and my band would be driving eight hours each way, during the work week to play a thirty minute slot for no pay. And we couldn't even sell merch in the club to put gas in the van.

That was fine. We're a punk rock band. We're used to playing short sets for no pay. And we don't mind losing some income from our day gigs to head out of town for a gig. And despite the fact that many of our friends and fans plunked down $15 to go see us, we were smart enough to know that the draw for the show was the two headliners.

But then, just one day before the gig, came the proverbial straw that broke the camel's back. Dayle, the Viper's manager, who had been perfectly sweet to me in our previous chats on the phone, informed me that we would be limited to a twenty minute set. She also said that the owner, Sal (Depp's business partner) wanted to set certain conditions on our performance. I had thought this might be coming. But then she hit me with the big news. Sal wanted us to sign a contract with a list of rules I had to agree to. If I didn't sign the contract, we wouldn't be allowed to play. I realized it was too late to cancel the show. We'd all taken the time off of work, promoted the gig and our friends and fans had already bought tickets. We couldn't back out.

Dayle faxed me the contract. It read…

This is a contract for you to sign regarding your show with the Butthole Surfers. Here is the list of things you *cannot* do…

NO POOPING ON STAGE
NO PEEING ON STAGE OR INTO AUDIENCE
NO NUDITY MALE (BUT WE HAVE AGREED TO FEMALE NUDITY!)
NO SPITTING INTO AUDIENCE
NO VIOLENCE OF ANY KIND
NO THROWING OF ANYTHING INTO THE AUDIENCE
NO BLOOD
NO FIRE
NO PEEING ON STAGE, INTO MONITORS OR AUDIENCE AS WELL

Please sign and fax back. Thank you very much and have a great show!

I was floored. I wasn't necessarily surprised that they were imposing these rules (Bob had warned me they might) but that they seemed so arbitrary and hastily written (note the caps lock and the repetition of the "no peeing" rule). I had just packed my bags to leave for LA and here's a contract forbidding me from doing almost everything that I do in my act! And to top it off, Sal had revealed his true colors. He wasn't worried about lawsuits or getting busted for indecency. He explicitly agreed to female nudity (T&A was just fine with him.) What he didn't want to see was my fat ass naked. It was classic Hollywood industry bullshit: Give us safe rock & roll with plenty of naked chicks. I have a reputation for throwing shit and here they were asking me to eat shit. To do the show *they* wanted to see and not the show my audience comes to see.

I called Dayle to confirm what I had read. "I guess he doesn't mind seeing women naked. Just not men" she said. Then I signed the contract and faxed it back to the Viper Room. I went to the copy shop after work and made 100 copies of the contract. Then I headed out to rehearsal to consult with the band on what to do with this eleventh hour censorship.

The next afternoon, we arrived in Los Angeles. VH1 was shooting a segment on me and we shot an inter-

C'mon this is
Hollywood, not Omaha!
EXTREME ELVIS

view and some guerilla performance footage on Sunset outside of the Viper Room. After the shoot, we arrived at the Viper Room and all of my impressions were confirmed. We were treated like shit. The sound guy was rude and abrupt. He made fun of my $200 wireless mic, saying it was a piece of shit (The Viper Room normally insists that you play on their expensive gear.) Sal himself was busy telling a couple of our fans that we "weren't really a part of the show," but were "just the opener." The Viper Room was acting as they had all along: like they were doing some shitty unknown band a huge favor.

At 8:30, a good fifty people were still lined up outside as the mountainous security guards frisked each one methodically. There were maybe sixty or seventy people in the club and no one was in those precious VIP booths. VH1's crew set up at the foot of the stage ready to catch everything on video. Despite the fact that half the audience was still on the sidewalk, the club rushed us on stage. I was totally sober and completely aware of the adversarial dynamic between me and the club, a dynamic which was about to get worse.

We did Blue Suede Shoes, CC Rider and It's Now Or Never first. I kept my clothes on. My backup singer Ann (who is usually naked or near-naked) was covered head to toe in a Muslim robe that concealed her gorgeous body from the audience. At one point, I convinced a couple of friends to grab a seat in the empty "reserved" booths, since there didn't seem to be anyone rich, famous or important in the room. Other than that, the set was relatively tame. I stole people's drinks, rubbed my belly against audience members and made veiled references to the restrictions I was being forced to perform under.

Within fifteen minutes, I had shed my white studded Elvis jumpsuit and was down to a form-fitting tiger print spandex bodysuit. It wasn't "male nudity" but it was somehow disturbing enough. At the beginning of Suspicious Minds, I asked a friend to circulate the copies of the contract I'd made and then went into a long rant on the last minute nature of the contract. I read the contract aloud as the audience followed along on their own copies. No nudity? No piss? C'mon this is Hollywood, not Omaha! We're opening for the Buttholes. How did *they* make a name for themselves? I asked the audience, "Is this the show you want to see? The one with no nudity and no piss? The one with lots of T&A, but no P&A?" There was a small and vocal group of fans up front who yelled "No!" A young crusty punk ripped up his copy of the contract and flipped the bird to the Viper Room in general.

That was the moment. I knew it was time. I launched into the first verse of Suspicious Minds and began to let the bodysuit slip off of my shoulders. We made it through the second verse and into the break. I picked up the contract, letting my suit fall to the stage, revealing me in all of my naked splendor. I again read through the rules and looked up at the audience and said "Well, fuck Hollywood and fuck contracts!" I was about to piss on the contract when the sound to my mic was cut. Then the curtain dropped and all of the stage lights turned off. I jumped to the floor in front of the stage and yelled "Here's what I think of your contract!" and began to piss all over it.

One of the beefy security guards gently pushed me out the side door and onto Sunset. I pieced together

Hassles, Hustles, Victories and Defeats (mostly defeats)

109

my jumpsuit and tried to gather together my friends. Just then, a security guard gave me the evil eye. I started walking very quickly up Sunset Blvd with the security guy in hot pursuit. He was on his cell phone to someone, maybe Sal. He wasn't slowing down. I ducked into the Hustler magazine store and plopped down in a cushy chair, sticking my nose in a magazine so that I could get my head together for what would come next.

The Viper Room had called the cops on me. They wanted me arrested for public urination and indecency. It was a total circus. Bob, my band, the fans, various friends and fans (kicked out for cheering me on) and the two tough security dudes were all gathered around. Sal was foaming at the mouth, openly threatening violence to me in front of the half dozen cops assembled outside. I was frisked and then made to stand outside Def Jam records (of all places!) while the cops took statements and made their "investigation."

The cops ultimately pressured VH1 into rolling back their footage from the show in an effort to determine if I'd broken any laws. Meanwhile, they moved me to the end of the block where I was asked to do a couple of a cappella songs for them.

After another hour, the cops had reached a compromise with Sal. They brought him over and he told me I was not allowed to set foot in the Viper Room ever again. "No problem", I said. He asked me why I hadn't refused the contract before the show. I asked if he would still have let us play and he said "No." I told him that was unacceptable. Our friends had bought tickets and we had already put the money and effort into coming down for the show. If his rules were really reasonable, he wouldn't have denied male nudity in the show. After a couple more veiled threats, he began to yell at me. I asked the cops if I could go and they said yes. And I did.

The next day we made the long drive back to San Francisco, escaping the evil tractor beam of the LA rock scene. Unfortunately, this may have queered my friendship with Bob, who got me the gig. But it sent a message that we were ready to literally piss on any opportunity that asked us to compromise so much for so little.

Extreme Elvis (San Francisco)

Fantastic Snatch

Rock'n'roll is a big, sexy, nasty, evil animal. She will make you drink, smoke, crave, fuck and desire things that you can't even begin to understand. Bitch that she is,

she also has the power to save your soul. And that's why the biggest masochists (or maybe sadists, to the listeners) are musicians.

I, Miss Amy, have played drums in about ten bands over the last seven years. Several of them simultaneously. Primarily in New York City, the place (too) many people go to trying to make their dreams come true. It's given me some of the best experiences of my life thus far and something I will never be able to stop doing. But it ain't all diamonds in my jewelry box. You just don't get through it without a few big bites of the proverbial shit sandwich. But as we all know, when you are starving, you'll munch on whatever is shoved under your nose. Eat up:

THE WORST CROWD

I used to think that the worst shows were always the ones where no one showed up. Where the sound of one hand clapping was actually a wish. I was in a five-piece, all-girl, whacked-out, surfy, garagey band called The Amulets. We were asked to play a birthday party. Sure, why not, right? Parties are always fun. Yeah, well, they tend to be a little better when the crowd appreciates sounds that are a little beyond Yanni and Barney, the ambiguously-defined Dinosaur. That's fucking A right. It was a birthday party for a *one-year-old* child. Yes, we actually set up *and* played a full set for Team Pampers. Humbling? Mind-numbing? Surreal? All of those plus a cherry of embarrassment right on top. The only hope is that we somehow got in and warped their little minds.

THE WORST PAY

Either no money or enough money to get some gas and maybe some beer. There really is no reason for the in-between. In Philly, trashed out rock'n'roll band, The Blackbators and I don't even remember the name of the club. The minimal crowd was bearable. Watching our singer fall through a hole on the stage that was covered in carpet, mid-song, was bearable. Having the power go out a couple of times during the set due to the horrific wiring job was bearable. Being handed *seven dollars* as we were on our way to the next city, that's just a sad state of affairs. Here's my advice to club owners: I don't care *who* you are. Have the courtesy to put aside a freakin' $20 for bands you bringing from out of town. If you are open and running a bar with shows every night of the week, you can throw the bands a twenty each. Period. It divides much better than *seven dollars* and might get each person at least a pack of smokes.

THE STALKER

I made the mistake of inviting this guy to our show. Along with everyone else in the free world. Only the rest of the free world didn't show up thinking that because I asked them and happened to touch their arm while doing so, that I was inviting them not only to the show, but to pursue a deep personal relationship with me.

After the show, as our band was loading to leave, the guy asks me where we're going next. Uh, I'm going *home*, to sleep. *Alone*. So, I bust outta there thinking that I'm safe, go home with a minor amount of the creeps and crash out. 9am, my phone rings and it's freako wanting to know what we're going to be doing when we *spend the day together*. Ummmm. I hang up on the guy and go back to sleep only to wake up to my roommate telling me that the guy has called several times and is now *mad* that I'm not talking to him as he's waiting to *spend the day* with me. Had to give him a few harsh words which didn't prevent him from calling periodically for a few months. Some other poor girl out there is probably having to deal with this loser. Get a life pal, just because the band was called Fantastic Snatch didn't mean you was getting' you any!

THE WORST PROMOTER

Due to damages done in the true spirit of revenge upon this bottom feeding slime, no names. Washington DC. We'll call the place uh, The *Velour* Lounge. Can't remember the name of this asswipe, but I've heard he's long gone. Hopefully he got run out of town by a group of pissed-off, torch-wielding rockers. This guy promised my touring band a monetary guarantee, good treatment, and pre-show promotion and he didn't live up to *one* of those things. We were treated like complete shit by the guy, who was such a weasel that he was trying to hide out all night in the club's basement. While we were playing our rental van was broken into and *everything* stolen. Luckily we did find our clothes down the block. Nothing like pulling your panties out of a crap-covered stairwell at 2am. We got *no* assistance, no support whatsoever from this prick. Well, he did lend us some *masking tape* to cover our shattered window and then asked for the *money* for it. I don't know about you, but last time I checked, that stuff isn't exactly made out of gold. Adding insult to injury, the spineless scumbucket tried paying us about $60 less than what we were guaranteed. Then he has the nerve to ask us if we can *pay* the bar tab left by the band we were touring with. Uh, yeah, right pal, and tomorrow we'll call all their parents and tell on them for being bad boys and leaving your slimy ass with a bar tab for a few beers that should have been *free* for being treated so badly!

Miss Amy (Pheonix)

The Eddie Money Story

When I was working on our first CD *Backstreet Anthems*, someone suggested we should use a producer named Kurt Cuomo. Well, I had to call his manager first, who thought that since Kurt co-wrote the song Psycho Circus by KISS, he would be the biggest producer in America, and I should be happy that he was willing too work with me. To be honest, I wasn't impressed, but I've heard that he has a good studio. After I had to sign contracts through his manager, I was allowed to talk to him directly. He said everything would be perfect, and that we would start recordings the January 4, 1999. Five days before I left for LA, I called Kurt, to make sure he got all the stuff I asked for. A guy called "Eddie Money" (yes, *that* one) picked up the phone and told me that Kurt wouldn't have time to talk to me, and that *his* recordings would take longer, so my recordings are canceled. I told him that I had my flight already booked, but he only said, "Listen, I'm Eddy Money, one of the biggest rock stars on Earth, and I should be happy that he even talks to me. He said, "Good luck with your career", and hung up the phone. I never even heard an excuse from Kurt Cuomo.

Alexx, Shameless (Munich)

Women in Chains

Once years ago, there was this girl who hung out at practices all the time. I told her that if she kept showing up we were gonna just chain her in the practice place and leave her there all the time. She got all excited, and said she wanted me to chain her up! It was really ridiculous, but she kept at it. So I told her I was broke, and she would have to buy the chains. We went to Home Depot, the big warehouse place, where our old guitar player Tom worked. Anyway, we got there and I told Tom, "I need some good chains to chain this girl up", and he couldn't believe it. And she was like, "Yeah, yeah!" and she picked out these hefty chains and a lock to go on it. So I said, "Yeah you better buy those, those look sturdy" and I'm laughing. She took 'em up to the counter and bought them. I was all, "OK! If that's what you want to do, I'm your man!" Tom was just

> People were ninety-five percent certain it was Guns N'Roses.
> ROCKSTACY

laughing, like we were a couple of crazy people. We were probably all high and drunk or just stupid because we were young and crazy. So we went back to the practice place, I chained her up and we had a crazy fourth of July that I better not talk about...then she disappeared, and I never saw her again. Years later I heard she was telling people I was this evil guy who chained her up and shit like that.

Gideon Smith, The Dixie Damned (Charlotte, NC)

The Net Made Us Stars

Every band gets fucked. Sooner or later, a booker screws you around, rips you off or dishes you a useless slot. Another band lets in a hundred people, then demands their "fair cut" of the door. Vans break down. You get lost. You wonder why the hell you wanted to do this in the first place. Where is that damn glory, the fame, the adoration, the easy sex and booze and drugs and money piled high on the mattress in that penthouse suite overlooking the skyline of the city that shut down just to hear you play? Two measly beer tickets just doesn't cut it. But fun wacky shit happens, too. The weirdest thing (so far) that happened to Rockstasy happened on the net, in the summer of 2000. We were called Mountain Mama then, working with a different singer but cranking out the beatbox rock with the same over-the-top intensity. I was promoting our music like mad on the net, hitting all the different music sites I could unearth. One place we were listed was at IUMA.com, and a lot of people heard us there. A deranged Texan going by the handle Octagon checked out our track Free Spirit Rising and really dug it. Some people had already been on about how our singer Gary Fletcher sounded like Axl Rose on the track. Octagon decided to take the idea waaaaay further. He deleted the vocals from the verse but left the chorus vocals in, sped the song up slightly, and uploaded it to a bunch of Guns N' Roses fan sites. He renamed the song Keep On Rising (Demo),

and before you could say "Chinese Democracy", the gunners fans were going mental over the authenticity of the new track. Debates broke out all over their message boards. People were ninety-five percent certain it was Guns N'Roses. Maybe it was that collaboration between Axl and Moby that was making the rumor mill. Axl and Moby. Yeah. Not a bad description of our music, but we had no idea it was even going on. Two months later a guy in Spain clued us in. I tried to set the record straight, but even bone-headed facts have a way of perpetuating themselves. I'd tell people to check out the original song, and they still wouldn't believe me. No reasoning with a fanatic desperate for new material, I guess. Keep On Rising didn't die down until Axl showed up playing live at New Year's, putting on his best fat Morrison imitation. The tune wasn't performed, and Octagon fessed up to his switcheroo online. The fans had been had. Of course, they were pissed off with us! A lot of them dissed our material — the very track they'd been raving about a few months before — and then they went away. We got a ton of play, it evaporated, and we never had anything to do with it. We're back out there rocking hard, but mullet lightning hasn't struck twice. Who knows? Maybe Axl needs a little collaboration after all. Rockstasy could probably squeeze him in, but we'd have to talk bout that pile of money in the penthouse first...

Luke, Rockstasy (Toronto)

...To Pieces!

When I played the drums in the Vendettas I went on my first tour. It was the second night of the tour and already I had the heady experience of accolades for our performance and blatant sexual advances. I was giddy with excitement and couldn't wait for the next show. That night we spent the night with a friend at a converted gas station that he was living in. He had a teenaged cat that kept coming over and meowing for affection and strokes. Throughout the night he kept

coming over to my sleeping bag and purring and me-owing and waking me up. I would stroke him a few times and then move him to the bottom of my sleeping bag. In the morning when I woke up I felt something wet on my face, which I assumed was drool — but no. I reached up and peeled off a mouse that I had slept on all night. The weight of my face had squished all the innards out of the mouse and mashed the thing flat. The innards and outer carcass were stuck to my face and even after I had peeled it off there was a mouse and blob shape still indented in my flesh. Clearly the cat had been trying to retrieve his catch from me all night. The guy did not have a shower, or soap, only a hose. We did not have a show that night and couldn't take showers that night either. At the first rest stop I did was my face, but it didn't feel clean. If all those guys that had been clamoring for my affection could have seen me that morning.

Susanne Gibboney, Lust (Atlanta)

American Greetings

I remember when good friends Candlemass of Sweden came over to join us for their first big US tour, they didn't speak a word of English. Absolutely nothing! Soon after finishing up with us, they were to head over to meet the people at Metal Blade Records for the first time in person. So you know how whenever you try to teach someone a new language, you always show them the curse words first? That's what I did. I told them that when they got into Brian Slagel's office (head of Metal Blade) to call me up and place me on speaker phone, and when he walks in and I say "Go", that I want the whole band to give him a huge US compliment by reciting a little saying together. After the tour finished, a few days went by, and I received a call from Messiah (singer of Candlemass) from the California office. I said "Are you ready?" and he says, (with a thick accent) "Yes, Paul," and sure enough when the heads of the company walked in, I yelled "Go" and the whole band chanted, "White trash piece of *shit*." I'm not sure, but I heard that this visit was regarding the signing of their new record deal?

Paul Nelson, Leige Lord (Stamford, CT)

Gay Roadie

On the Bloodhound Gang Boobies tour we did two gigs in a row at The Electric Factory in Philadelphia. This was during the Bad Touch reign on MTV's *TRL*, and

both shows were packed. Our boys in BHG had a running gag where they'd challenge some idiot in the crowd to drink a warm twelve pack of Dr Pepper without spilling, pissing, or puking on the stage. The prize was 100 bucks and nobody ever pulled it off. Since some of the two thousand in attendance had seen this the night before we figured this was the best time to rib The BH Gang. As we paused before our last song I wiped the blood and beer from my eyes (my mic stand was wrapped in barbwire for the tour) so I could address the crowd. Unlike most of places on the tour, we actually had fans in Pennsylvania, and the crowd was hoss. "Which one of you assholes wants twenty bucks and a T-shirt?" I asked the crowd. For starters, we weren't about to give away 100 bucks, and by the positive roar of the crowd, they must have thought it was gonna be a Bloodhound shirt, not one of ours. "Alright, here's the rules," I continued, "You've got to make out with our roadie, Billy." I could tell the young chicks were drunk and willing by the high squeals and the gay-ass friendship bracelets (or whatever the fuck they call those things) waving in the air. "We'll hook one of you up under these conditions: Number one. You must kiss Billy on the mouth until this next song is over." They screamed louder. I could see Billy smiling over on the side of the stage. "Number two. You must not spit, piss, or throw up on our precious Billy." Even louder. These girls were loose. "And number three, you must be a guy." The next roar only came after a brief silence ending with a drunken fan doing his best to climb the five-foot high barricades to make his way to the unusually even-higher stage. He stumbled around behind me, pumping his hands in the air in a way usually reserved only for a Foghat cover-band's encore. As he grabbed a beer and began to throw it down, "Billy The Gay Roadie" skipped onto the stage smiling, and I asked what the crowd was surely thinking. "Dude, do you know why you're up here?" Still pumping his hands and spitting beer, he screamed, "No!" And with that he let out a "Whooohooo!" (That must be the Northern equivalent of our beloved Yeeehaaaw!). "You've gotta make out with Billy, or get the fuck off the stage." At that very moment, the band kicked into Talk Dirty To Me, the fan paused, and began to make out with our flaming crewmember. After a moment of hesitation, the guy pulled back. Billy grabbed him and shoved his tongue in his mouth. So there we were, covered in blood and spewed beer, playing a shitty Poison cover song, as two grown men rubbed their tongues together (And I assume at least one of them got a boner). At this point, a

very homophobic Evil Jared ran onto the stage, and ripped the two dudes apart from one another in a way that would have made Jesse Helms proud. Jared stared at the drunken sportsman, shaking him, and yelled, "What the fuck are you doing?!" I could see it in his eyes. I'm not really sure what "it" was, but I'm sure it had to do with Jack Daniels and some sort of pills that he wasn't fucking sharing with us. Whatever it was, as he realized that he'd just made out with a guy in front of a couple thousand *TRL* fans as he turned and ran toward the crowd. I've got no idea why, but the guy paused right before he got to the edge of the stage, then jumped, sort of. Both of his shins hit the barricade with full force and spun him over twice, clearing about twelve people in the front rows. I saw the guy later that night (The club's security informed me his old lady was pissed at him and was going to leave him. I went out to smooth things over) and he had knots poking out both of his shins the size of softballs. Refusing medical assistance. No shit. Bloodhound Gang forwarded us letters and emails for months with threats of lawsuits, complaints about us, demands for free shit and the like. Then they toured the UK and stole the gimmick.

Chris Sutton, Isabelle's Gift
(Columbia, sc)

Jailhouse Rock

Sometimes having friends of friends can be a godsend, get you a record deal, get you to play with that band you've always looked up to, and generally get one of your size ten's in the door. Now don't get me wrong, I hate nepotism, it is at the core of all that's wrong in this business we call music, but it's there. But it can bite you in the ass.

A friend of the drummer was an art teacher at the local maximum security establishment, and I mean *maximum*. This place was home to mass murderers and the worst IRA bombers the UK had known, very very naughty boys, indeed. We got offered a gig and without thinking about it, we wholeheartedly accepted. I mean, they were paying us, and think of the press we would receive. We contacted the local paper and they did a full page interview with photo, etc (even though they did a dumbass 'here's some of the songs they might be playing... Jailbreak/Thin Lizzy, Jailhouse Rock/Elvis etc. Ha ha ha. Fuck off.)

The day of the gig came and we drove up to the massive gates in the van. We all had to sign numerous forms, which probably exonerated them if we got ass raped. A guy climbed into the van to show us where to go. We must have gone through five sets of twenty-foot gates, all with armed guys on. We began to shit. It was one in the afternoon. Our chaperone informed us that the razor wire on the walls was illegal under the Geneva convention, but they paid the massive fine every year just to "keep the fuckers in". We shit some more. We parked up in a massive open courtyard with all the cellblocks surrounding us. That's when it hit home, four long haired rock'n'rollers playing in front of dangerous sex starved psychopaths. Hands reached out of the cell windows and the shouting started, similar to the scene when Agent Starling goes to meet Hannibal Lecter for the first time and endures abuse from the other inmates — though whether anyone said "I can smell your cunt is" debatable.

We unloaded the gear and set up in what can only be described as a classroom. Fifty or so chairs set up ominously, about two ft in front of where I would be singing. The guys were marched in by numerous guards who stood at the back and told everyone to "shut the fuck up". Now these guys didn't so much look mean, they just looked pissed off and unpredictable, pretty much like any other audience. I hear you saying, "But these guys weren't going to be standing at the bar, going home after the gig and generally passing Go and collecting £200." What is more, it's daylight and we're all stone cold sober, which is a first (and a last).

We go onto autopilot and do the gig, which is the most uncomfortable forty minutes of my life. Phew, got through that, can we go home now. Oh no, it's question and answer time. "Why are you so shit?"

"We had a country band here last week, they were shit, but you're worse."

"Can we take your guitarist into the toilet and fuck him?" Er, now I'm scared.

We get through that and are told to have a break. "What d'ya mean, break?" I enquire. "Before your second set," he says. "But that's all the songs we have!" I say, distraught.

So we do the same set again, none of them notice, the only thing on their minds is parole, not rock'n'roll, or maybe the showers. We earned every penny that day in fear and dry cleaning.

Whoever complains that a crowd was tough should maybe do a few prison gigs to put it into perspective. Jailhouse Rock? That film is very misleading indeed.

Brother Lloyd Loud (ass intact)
The Divine Brown (London)

Gigs From Hell

Malcolm McCracken

If you were to take Hitler, Jeffrey Dahmer and an over-weight hamster zonked out on Quaaludes and forced them at gunpoint to conceive a child you would have our first manager Malcolm McCracken. At first having a manager sounded like a great idea, you know someone to book shows, do press, take care of business, and well, then we met him. Malcolm talked a great game about his vast experience in the music industry working with punk bands. He would spend hours talking about all his connections and telling stories about our punk rock gods that he had worked with over the years. Yes the stories changed every time he told them but I dismissed it as a result of the multiple strokes he suffered. The strokes were a common excuse for everything from why he couldn't clean his apartment to his constant pill popping. It seemed too perfect from the get go for this forgotten genius of the music business to be living in exile in a suburban basement somewhere between Boston and Providence and sure enough it was.

The first sign we knew something wasn't quite right with Malcolm was when he mentioned in passing that he had spent all the band's money on kiddie porn. Now to understand this you really have to visualize someone who's outwardly appearance was so disgusting you couldn't help but take pity on him. He was a five-foot-two hunchback with limited motor functions, an omni present ass crack who had a face even the skankiest hooker would turn down no matter how many benjamins he was waving. It wasn't like there was much chance for Malcolm to get lucky any other way. Yes, I was really disturbed that he would spend all our money on this but at the same time it wasn't like we had any money to pay him and we believed he was going to do all these great things for us. Plus at this point band was starting to take off but as I would soon learn, with Malcolm McCracken things only seemed to get better at getting worse.

Malcolm's was never all that sane, it wasn't uncommon for him to start screaming at the littlest things and break down crying like a two year old screaming for his pacifier but downward spiral began one Monday night at show in Lawrence, MA. On this occasion he started to hit the sauce and the oxy contins as soon as we got to the club and within fifteen minutes he had somehow managed to sexually harass every prepubescent girl in the club, make death threats to the bartender, the doorman, the owner, and yours truly all the while offending every other band on the bill. This was a rare example one of the very few occasions Malcolm was ever efficient in doing anything. I was sitting at the bar trying my hardest to get enough of a buzz to melt away the demon child of my own that had been brewing in my belly since the beginning of the week when I heard the bellowing whine of the bitch baby. Wincing and turning my stool around I was met with the most horrifying sight I have ever laid my eyes upon. Malcolm was standing in the center of a circle of kids with his pants around his ankles, face beet red brimming with anger and embarrassment as his fat hairy knees pressed tight together to hide his wee wee. The room was dead silent scattered with dropping jaws and looks of frightening disgust and horror. It only took a second to realize that he had been pantsed by the leader of the juvenile delinquents, my new hero. Looking less than satisfied with his clever plan, my hero failed to calculate the baggy shit stained underwear that slipped off along with his pants, no doubt in hope to make a get away. Then as if in slow motion the mouth of the mighty beast opened and the most ungodly noise shook the earth as he groped for his clothing and chased our newly found hero in circles screaming for gasoline and a match waving a short stubby finger to the sky. "I am not an object of ridicule!" No I thought to myself as I turned to my drink again with a smile spreading across my face like a satisfying rash, but you are an object of pathetic comic relief. Everyone in the band by now had more than enough of Malcolm and we had a private chuckle and did our best to block him out the rest of the night which was no easy task since he whined incessantly like a dying donkey the whole ride home.

The next weekend we had a couple days booked in the studio and a show in between. After spending all of the day Saturday in the studio and playing a show in Worcester that night I was completely exhausted and had to be in the studio again at 10am to finish my vocal tracks. When we got to Malcolm's apartment to drop him off he insisted we stay at his house and refused to leave the car because he was "lonely". Now at this point we were all fed up with Malcolm and knew he was capable of some pretty sadistic things but I never actually expected to be kidnapped by this dwarf. He stayed in the car banging back and forth like the little girl in *The Exorcist* screaming hysterically that he would kill himself if we didn't stay over in his dungeon for what seemed like decades. While not the best approach I've encountered to try to get a girl to spend the night it was definitely the most unique. This lasted for a good

hour till somehow we managed to get the lunatic and his ass crack out of the car where my fists terminated him and we left him rolling around in the leaves.

To all the bands out there looking for some one to help them out, stay away from the crack addicted trolls. It's just not worth it kids.

<div align="right">

Hurricane Jenny, Midnight Creeps (Providence, RI)

</div>

Pin Cushion

Scene: Richmond, VA (Edgar Allen Poe's old neighborhood). Location/venue: Poe's Pub. Culprit: Mickeyblueyes, drummer for The Needles

So... it's a beautiful evening right... We get a great meal on the house and we're relaxing kicking back having some free "band beer" when this young girl shows up. She'd seen us play before in another town or something, and us being the suave young rockers we thought we were, we weren't surprised by this at all... The only thing is/was we didn't know we were going to have a temporary Nancy Spungen in our camp. Nor were we aware that our drummer had the inner makings, spitting image rivalry, of Sid Vicious.

We've often been asked "Does your band's name mean or promote drugs?" or "The Needles? That's not nice." Well, we've all at one time grown up, and most functioning bands are not drug addicts... Yes, we've a logo of a skull with syringes going through its head... imagery... We don't stick our fingers up our asses and lick 'em like M Manson though, and he sells tons of records right? Whatever.

We watched the gradual emergence of opposite sex chemistry evolve between our drummer and this out-of-town-chick at our table. We laughed and at times watched and eves dropped but mainly we were into a conversation or debate rather about "footage" vs "photage" and that's something else entirely. Well over the course of thirty minutes Mickey and the chick were gone. We didn't sweat it though. It wasn't even 7pm and we didn't go on until 10:45pm. We were fine.

Our drummer emerges from the bathroom and informs us he just finished receiving oral sex and did a little heroin. We're like, "Uh, OK?" He turns to me and says, "Hey, you know me, I'll be fine it was just a little bit and I feel great." But I'm thinking: "Yeah, but you just ate a half pound of ground beef smothered with cheese in the middle of two oversized, poppy seeded buns — note the "poppy" reference — and that's not going to stay down bro!)

Well it's 9pm and we're set up and sound checked. We've already been told we're too loud (the usual) and I've three blown speakers out of four. The input jack of our bassman's bass has mysteriously fallen out and our drummer's walking around sweating huge, milky gobs of smelly dope perspiration saying over and over, "Man, I'm never doing this shit again." And we're supposed to rock out in an hour and a half?

The show, for what it was, didn't really suck... to the audience that had never seen us before. We made merchandise money too. However, in the sober minds of three plus me, we had just played the worst show ever. I'd turn back and watch our poor dumb ass drummer holding in copious amounts regurgitation in his mouth and smoothly get it into his empty water pitcher, tucked into secrecy after every outburst, hidden by his floor tom. What was to come was worse and we were in no way prepared.

Now Mickey, he's Irish. He's got a good heart that's about twice the size of his brain but he's got the most rotten luck I've ever seen. If luck had any value at all he'd have a strong case and could get a nice settlement. As for judgment... you get the picture. Yeah, if you want to get high be courteous to your band, the venue and most importantly the patrons — do it after the show!

After the show we're trying to get over the bum performance and are talking with some people, all the while Mickey and the out-of-town-chick are nodding out and drooling about. We're like, "Who the hell is gonna put us up with this mess going on?" The headlining locals inform us that their place is huge and they're going to have a party. Lucky for us they thought Mickey was tired and drunk... maybe stoned (that's usually a bit more accepted than a hard, narcotic induced stupor).

We get to the local flavor's house and it's a small party in a really dirty and smelly house. Those of us who were brave enough to shower did so with our socks on. Clutter is one thing but clutter on top of dirty clutter on top of filthiness... The living room had van bench seats for us to sit and later sleep on (though the sleep thing really didn't happen). We were all out side on a large stoop in an old neighborhood where noise didn't seem to be an issue. Well, Mickey and the chick come walking up with a 7–11 bag.

"What's in the bag, Sid?" I said real pissy.

"I was hungry and got a foot long hotdog," said the Irishman.

"Brilliant." I exclaimed.

Within minutes the entire alleyway separating the

house we're hanging at and the neighbors who are on their porch partying is covered with drummer puke. His Eve for the evening said she'd told him it was a bad idea due to the dope. Now the other guys in the local band hear this, too. They come over and tell me, "Uh, we don't know if we want your drummer and the junkie chick hanging out here. We don't want an OD or any-

thing like that." And I'm like, "Look, nothing will happen. I'll look after them and be responsible if anything happens." And they're like, "Cool man, you wanna come upstairs and do some blow?"

The ride home was lame.

Midway through the dawn's early light we overheard the out-of-town-chick giving Mickey advice on everything imaginable as well as the following events: Mickey vomiting. Our bass player walking in on the chick shooting up in the bathroom. Us finding out that this chick was a bad junkie. Her cell phone constantly ringing and her not answering. And us thinking Mickey had banged up too, thinking our dear old drummer was going to be the "that guy" of this band. The thought that we'd have to kick him out so as not to have shit

like this happen again. (He later informed us that he had snorted which is at least safer and he did learn from his mistake and has been pounding out the skins quite rockingly and sober, until after the show. But hey that's fine, right?). Their front porch, early morning conversation was like that interview with you know who when Nancy wouldn't shut up and Sid would just snore,

```
If you want to get high be
courteous to your band,
the venue and most
importantly the patrons -
do it after the show!
THE NEEDLES
```

slur, forget what was just said and pass out again. Punk Rock right? Whatever… L.A.M.E. Yeah, lame! We've got a song about this girl on our first album called Pin Cushion. She sucks and there is no sweet tea in the "capital of the South" (aka Richmond, VA). What a drag.

CH, The Needles (Wilmington, NC)

Houston Hassles

HOUSTON #1

In two bands I've played Houston three times, and three times I've regretted it. You would think, since Houston is the biggest city in Texas, The fourth largest city in the US and only three hours from "The Live Music Capitol of Texas" that it would be a mandatory tour stop. Think

again. Bands be warned.

Our first trip to Houston was on The Valentine Killers first tour to Texas and SXSW. I got a contact for a club called Mary Jane's. I called and left a message, thinking we could play Houston around our SXSW show. I never heard from the club and figured they we're booked that night. A few weeks before we left on tour, I got a message from the club's booker. He said the night was now open and we could play. I called back and left a message saying we would be there, and he should call us back to confirm the show and give me an address to send promos and tour posters to. He never called back. I looked up the address online and sent the club posters for the show. We left on our three week tour to play the western US. A few days into the tour, we all came down with a pretty bad flu. I was hit the hardest. When we got to Austin, we stayed with good friend Toby Marsh, who put out our first seven-inch on Mortville Records. I told him that we had two days until our SXSW show, and that the next day we were gonna play in Houston, at Mary Jane's. He then told us, "Houston Sucks". He should know, he said, that's where he was from. He told us not to go, and instead we should stay in Austin and party. We took off on the three-hour drive to Houston and found the club. We got to the club and the doors were locked. I knocked, and no answer. We found a pizza place downtown and had some pizza and a few pitchers of beer. We looked in the local weekly to see what we were up against. The Murder City Devils were playing at Emo's Houston and there wasn't even a listing for our show. Shit, we knew it was gonna be a bust.

We go back to the club and the door is still locked. I pound on the door and a bartender answers. "Hey, you want a beer?" I reply "Yeah, and we're one of the bands tonight." He shot back, "There are no bands tonight". Instantly I get a sinking feeling in my stomach. He looks at the calendar and says, "Wait, are you guys the Valentine Killers? You're the only band tonight." Then he went out and put our name on the marquee. Everyone in the band was really bummed, we were all sick with the flu, thousands of miles away on tour, and knew this show was gonna suck. We load in, set up merchandise, and I start putting new strings on my guitar. The bartender and two of his friends sat at the bar, drinking beer and listening to The Eagles live CD. The band talks it over and we decide to split. The Bartender tells us "OK guys, go ahead and play." I say, "Look man, there's no one here, you guys are gonna hate us, we're going back to Austin." Defeated, we stopped at a gas station

and buy an eighteen-pack of Budweiser and start driving back to Austin in a horrible rainstorm while blasting Turbonegro and getting drunk. We get to our friend Toby's house and while an after-hours party is getting going, we walk in the door soaking wet, sick, and fairly loaded. He says, after taking a huge hit from a bong and in a Texas drawl, "you guys just drove through a tornado!"

HOUSTON #2

The Valentine Killers set off on a US tour in April 2001, which ended up being our last. We had a booking agent, Ralph Carrera, from Sweet Candy Booking doing the tour. So, no more bunk shows, with shoddy bookers in shitty clubs… until we get to Houston. On our itinerary, we all noticed that we were playing Mary Jane's in Houston again, and all joked about the prior incident and how much it sucked — but hell, we got a guarantee this time so it should be good. We show up to the club and noticed there wasn't a poster up in the club. Great, we spent time, money and effort making posters, labeling them for the club, sending them and they can't even put one up to promote the show. We go inside and it's the same bartender from our last "show" there. We tell him we're in The Valentine Killers and ask about our dinners and free beer in the contract. He said he knew nothing about free dinner and we get two beers each, even though we were supposed to get a case of beer. He asked the manager about the dinners and she said "Who the hell do they think they are, some kind of Rock Stars? We don't feed anyone." OK, fine. We all set off for food and come back. We're all beer drinkers and hellraisers in the band, so we were more worried about two beers a piece. After talking up the bartender for a while he decided to give us free draft beer. Perfect.

There was another touring band on the bill called The Chamber Strings, who were playing second, and a local opener. We talked to The Chamber Strings a bit and they were also upset about the lack of posters. The local opener takes the stage about 10pm and sound check. After they check, they all got off stage and started drinking beers and talking to friends. OK, well three bands — maybe we're starting at 11pm, that's cool. A little after 11pm, the first band starts playing some kind of Radiohead type bullshit and then proceeds to play for *over an hour!* We talk to The Chamber Strings asking how long they were gonna play, they assured us since time was short they would play thirty–forty minutes. Hey, right on, let's hear it for touring bands helping each other out! Yeah, right. By the time these jack-

asses get done and we get our gear on stage its 1:35am. The bar closes at 2am. So we have about twenty-five minutes to do our set.

The first thing I do is turn on my guitar louder than hell and let some feedback roll. This scares the hell out of the guys in the first band who are drinking at the bar, and the twenty-or-so rock'n'rollers who are left after the marathon of shit come up to the stage to watch us play.

One-two-three-four of the first song starts, I'm pissed and really loaded, and kick the shit out of a vocal mic, knocking it off the stage and onto the floor. We blaze through our twelve-song set ending right under 2am. Every band knows on the road that merchandise is really important, not only to leave something behind in that town so people will remember ya, but it helps pays for gas and food for the band. We go to our merch area where people want to buy shirts and CDs, LPs, or just grab a sticker. The employees at the club are yelling for them to get out. We try to sell merch and talk to people that came out to see us, while the employees of the club start kicking them out. I get pissed, and start yelling back. "We're trying to sell some merch here, give us a few minutes!" We start breaking down our stuff and the rude manager from before approaches us and says, "I want three shirts." There's no way in Hell I'm giving this bitch three free shits. Sure, we give out shirts to cool clubs and people that treat us well, but she can go fuck herself. I say "OK, that's $30 for three shirts. "No, give us three shirts, the bartender gave you free beer."

"So what, you screw us out of dinner, wouldn't give us beer at first, let the show run late as hell, kick out all the people that were buying stuff from us, and now you want us to give you free shirts?" We load out everything, say goodbye in the parking lot to all our new Houston friends, and go back in to get our pay. After getting paid, the employees are drinking beer at the bar and the bartender says "Hey, if you guys want to drink a few beers, c'mon back in." Our drummer pretty much tells them to fuck off, since five minutes ago they were almost kicking out. Fuckin' Houston.

The Valentine Killers broke up after that tour. Three of us started a new rock'n'roll band, Midnight Thunder Express. The guys who started the band love going on tour, so after getting going I booked us a three-week tour of the western US.

We have a rule in our bands, we give a city three shows before we say it sucks and avoid it like the plague. Houston has one more shot.

Booking a tour I tried to get our friends in Austin, Teen Cool to play with us in Houston. When they were on tour staying at my house in Seattle I told them the two Houston stories. Teen Cool is from Houston and they told me about playing at an All Ages pizza parlor called The Oven, and about the great shows they had there.

So when booking our tour, I asked them about playing Houston with them. They got us a show at The Oven but had just lost their drummer so we'd be playing with Alan from Teen Cool's little brother's band.

We find the Oven and load in. Meet Pat from Tremble Tremble, the band who helped us get the show. The Oven was closing in a few days. It was a pretty scummy little dive.

We're supposed to get some pizza, free beers, and a cut of the door. I asked the door guy/bartender guy about getting a beer. "$2.50," he says.

"Hey, I'm in the touring band."

"Sorry, no free beer."

We go down to the corner store buy an eighteen-pack of Budweiser and start drinking beers in the van. Setting up merch here was an ordeal because the door guy was a total moron, he didn't like where we set it up, and we all clowned on him because he was an idiot.

We played a pretty scarce show to about twenty–thirty kids and had a good time. After the show I talked to the door guy about pay. He says "Oh, there's no pay tonight, because we only got about $40 bucks here." Pat from Tremble Tremble told us that we'd make all the money from the show since we were on tour.

I tell the door guy, "OK, $40 great, give it to me."

"No, there isn't any pay tonight, because the bands got free pizza and beer."

"What? You didn't give us shit all night!"

The Idiot points to the beer taps and says, "What do you want?"

"I want the fucking money and I want to get the fuck outta here."

"Well, we gotta take out this amount for door and then split it three ways… that means you only get $13."

"Great. Give here."

"But it's only $13. You sure you want it?"

"Yes, we're on tour fucking thousands of miles from home gimme the fuckin' money."

By this point I'm about to fuckin' lose it; this guy is a total fucking retard. I go out to the van and tell the guys "Hey, here's our money, a whole $13!" Our singer Willie counts the money to put it away and says "Its only $12." *Fuck!* I'm about to have a fucking stroke at

this point. I go inside looking for something to steal. All I got was a stupid strip plug but it was a minor victory at this point. The guys got me in the van because they were sure I was gonna go nuts and kill the door guy. We leave Houston with $12, a strip plug and a cooler of beer. We drive back to Austin that night drinking beer. Houston: three strikes, you're out!

Stu, Midnight Thunder Express (Seattle)

Shock Rock

About four weeks ago, we were playing an outdoor gig in NJ, and as is often the case, there were any number of technical problems from the get-go. Each of us up front (Scott, Michelle, and I) kept getting low-level electrical zaps from our mics through sound check, so the tech supposedly fixed it. When we got up to do our set, all three of us went to sing into the center mic and got a strong enough shock that stuck us all together and to the microphone. It must have looked pretty funny, but it was fucking scary! The soundman realized what was happening after a million years (probably a few seconds) and cut the power. Luckily, no one was seriously injured or killed and we actually finished our set after a little more thorough grounding job was done.

The strange thing is: after that happened, we all seem to play tighter than ever before.

Chris, Tijuana Bibles (Toronto)

Hair Wars

Anyone who was bored enough to see the film *Rock Star* has an understanding of the rivalry that went on between local bands, and sometimes between bandmates, during the height of hair-metal in the late eighties. Well, I was in one of the high heeled, Aqua-Net bands. We were loud and proud. We boasted about our sexual conquests and bragged about our hair standing taller than any of our competitors. This was important because although there may always be room at the top, there was only room for one band to get the headlining slot on industry night at the Cat Club in NYC. So, after several years of clawing our way up to the middle, there we were. Even though we were experiencing some internal strife due to mounting studio expenses, drug use and sharing clothes, we hit the stage united for our big industry showcase! On or about our second song, it was obvious that the singer was losing his voice. He was experiencing severe nasal drips and assorted side effects associated with cocaine abuse.

This guy had been warned about pre-show partying before, but this time it was really getting the better of him. About halfway through the set, the guitar player got fed up with the poor vocal performance, put down his Ibanez Iceman and walked off stage. He was followed by our dizzy drummer. This left me standing there, in front of a packed house, holding my BC Rich Warlock bass, watching the singer climb off the stage, walk into the crowd and start cursing his own band through the PA for deserting him. It only took an instant for the guitar player to come running out, jump off the stage, tackle the singer and start to beat him. The singer broke free, grabbed a chair out from under a spandex clad beauty, lifted it high above his head and just as he was about to bring it crashing down on the guitar player, he was tackled again, this time by club security, who promptly escorted him out. That was the demise of our band. We self-destructed on stage at the Cat Club. Years later I met a CBS records rep who was there to check us out. He said, "I couldn't believe it! I thought it was part of the act!" I'll bet we were the best band he never signed!

Chris Pistol, currently appearing in the Scared Stiffs (NYC)

Acid Brats

When I was sixteen, my band, Acid Brats, entered a Battle of the Bands held at CBGB's, in New York's Greenwich Village. CB's is a landmark dive bar, a holdover from the glory days of punk, but it has for some time been kept alive only by the reputation it earned twenty-five years ago, when the Ramones and the Dead Boys were house bands.

The contest was "pay to play". Essentially, that meant we had to buy about fifty passes to the show (for about $400) and then try to unload them on friends and family. That the show's promoter apparently slept on a couch in her Lower East Side office (or that she was willing to book a band of stringy-haired kids who only knew about six songs and had a garage rehearsal tape for a demo) did not, to any of us, suggest that we had entered into a deeply suspect business relationship. Having been weaned on LA sleaze rock, like Guns N' Roses, the very squalor in which our agreement was sealed only fueled our belief that we were finally gaining access to the gritty underbelly of the rock world to which Headbanger's Ball was our only portal.

On the night of the show, we led half of the junior class of Hawthorne (NJ) High to the club's out-of-way

location on the Bowery (to this day, seemingly in a different universe than midtown, which was the only place in the city most of our friends had ever visited). While our friends searched for chairs they wouldn't stick to, we headed off to change into our stage clothes. This was right around Nirvana's heyday, but Acid Brats had consciously resisted the grunge revolution. While our girlfriends applied our eye makeup, we squeezed into tight pants we had bought at thrift shops.

From all the way down in the damp, graffiti-covered basement bathrooms where we changed, we noticed that whatever band was on stage was suffering from a *horrible* mix. The bass guitar overpowered all of the other instruments, and you could barely hear any singing. Sub-par mixing is a staple of venues like CBGB's. Some soundman "lifers" are driven partially deaf by their work; lots of others just can't be bothered to do their job properly. As band after band took the stage, though, it became apparent that whoever was working the faders was remarkably bad.

It wasn't until our slot came up that we got a chance to eyeball the man who had ruined the last four bands' sets. Though he couldn't have been much older than forty-five or fifty, years of hard living had made "Sonny" look like Wilford Brimley with a ponytail and two sleeves of tattoos. Through his glasses he squinted at us and groggily mumbled something about checking our levels.

Our drummer dutifully hit each of his drums. The snare was so loud and had so much reverb, it sounded like a gun being shot in a vat of Jello. The microphones on the toms did not seem as if they were even plugged in. Sonny held his thumb up to indicate he had gotten the set sounding the way he liked it.

Then Sonny ambled over to my guitar amp. I played my instrument while he manipulated the knobs, presumably in search of the exact tone he had gotten Johnny Ramone in 1977. After five minutes of aimless strumming however, I turned around to find Sonny *asleep on the drum riser.*

I used my microphone to summon the promoter to the stage. She was angry about having been bothered until she saw Sonny, now slumping into a heap. She was a small woman, and her shoves did even not molest the sleep of the narcoleptic engineer. She spoke quietly to someone off stage. The only words I made out were "horse tranquilizers." The promoter yelled at Sonny, who was beginning to show rudimentary signs of life. He finally managed to recover into a seated position, but it was obvious he would be on the DL for at least the rest of the night.

Our crowd started to become noisy and obnoxious. The captain of our high school's football team was a big David Bowie fan, and he had convinced some of the more enlightened meatheads on the squad to come to see us, so we were actually a pretty intimidating bunch. The promoter made a phone call, and then told us another soundman would arrive "within four hours". Wondering what sort of person had been reserved as the *backup* to a man who used barbiturates that were manufactured for another species, feeling the beers we had downed backstage coursing through our teenage veins, and also, I suppose, coming to the realization that no one would be hearing any of our songs like Suicide Nation and Mary Goes Down, my band started to trash the stage. Our drummer knocked over all of his symbols. I slammed my $200 starter guitar into the stage. I simultaneously felt the crotch burst in my silver patent leather pants, which were too tight to allow for underwear.

Staring the promoter down (and with an exposed testicle staring her down as well), amidst the riotous cheers of our friends, we demanded our $400 back. She actually threatened to sue us if we didn't play. In retrospect, I would have liked to have witnessed those proceedings, but she took another look at Sonny and relented. We collected our stuff, and led our crowd out *en masse*, like pied pipers, armed with ample money for forties and probably a better story than we have had if the show had come off.

Mike Tully (NYC)

Mother Russia

I was in this band called Mother Russia for two years. We had two shows booked in Phoenix, Arizona — Friday at Jugheads, and then Saturday at this band's house called Population Control. The Friday show went pretty smooth. I jumped in girls' laps and made out with a few, not much excitement. The Saturday show was better. There was a keg there, and about 100 people crammed into a living room. As usual, I take my show to the crowd… early that day, I stopped at Planned Parenthood for some condoms. I couldn't get them unless I told them how to use the condoms. I said, hell, I'll demonstrate how to use the condoms. So, when show time came, I pulled my panties down and tried to put one on. It looked like a Vienna sausage with a ski hat. The crowd seemed to like it. Even when I drenched a sexy young lady with beer, she continued to dance in her bra. All was good until after the show. While the

next band started playing, three of the band's girlfriends came into the room I was in, and I convinced them to show me nipples and boobies, and then make out, all while their boys were on stage. My band finds out about it, and gets pissed at me, saying I could fuck it up so that we have no place to stay. So, I'm being called an asshole, and I end up making out with one guy's girl, and later that night I hear them fighting about me. He's saying, "You wanna fuck that Dave guy!" and she's saying, "No I don't!" Yes, she did… so he fucks her, then makes her get out of the bed and sleep in the living room. I was gonna fuck her, but she had just fucked that guy, so I didn't. The band and I leave in the morning, and a week later, I get booted out the band.

Davit, Homeless Sexuals (San Diego)

Welcome to Weird City

Everyone has his or her horror stories. Everyone has some weird shit go down… and everyone has car trouble. Shit, our van has been on fire on the expressway — with us in it! But it's usually the weirdoes, that for some reason come out to shows, that make touring all worthwhile. Hence a few goodies for your enjoyment.

WHAT'S UP WITH UPSTATE…
"Albany is the rape capital of the world…"

Not a good way to start a show. Albany, NY. We pull up to a small neighborhood bar and we already knew this is going to be interesting. Just that feeling you get in the pit of your stomach. The stage was two-and-a-half feet wide and in the window… so you feel like a mannequin on parade. The bartender was the nicest guy and was willing to make the show worthwhile. He said, "I know you guys are used to larger venues, this is a small neighborhood bar and it's Sunday — instead of charging a cover I'll give you $100, a case of beer, and a bottle of any liquor." We were like, "Well, OK, I guess that's cool." (yeah right — we scored totally!) Then the townies started to pour in. Along with them the dudes that told us the beforehand mentioned statistic and some crazy kook who used his YMCA pass as an ID. He sat at the bar and talked about how he was from Venus and how he was going to slice Kevin's throat because rock music was not a valid form of music. The bartender told him to keep quiet and mentioned to me that he had just gotten out of jail. Great. There was also a chick who had been celebrating her birthday for a week and talked about the heyday of CBGB's in the late seventies and how all those bands used to come

up to Albany.

When we finally did play people got into it… I had to hold Todd's bass drum up with my foot so I stood in a super rock pose all through our set with one leg perched in front of his kit. The dudes from earlier had left, but another group of guys said to us as they walked out the door — " What are you doing in Albany? — leave while you can…"

WSUC (YEAH, W–SUC) COLLEGE RADIO
Cortland, NY… great little college town with a strange tension in the air. Great venue — an old railway station called the Third Rail. Should have known it was gonna be weird when we pulled up to unload and a group of people were sitting across the way on lawn chairs in their yard with their half rebuilt cars watching us — I was afraid to look for the shotgun. The "promoter" was a young guy from Rochester who was not very organized and was obviously having a bad time. He kept apologizing and talking to himself. His bands played and finally us. The show went well — not a great turn out, due to the fact that our buddy hadn't really done anything to promote it. But the fun was yet to start. We had loaded and Kevin walked in to get paid. We got $30. Mr Promo was jacked on something and screaming at the cashier at the door to open the register and pay him and she said that due to low turn out and all club costs — door, sound, etc — all he was getting was $30. He was yelling at her and waving his arms. Some guys tried to pry him away when all of the sudden promo dude pulls a knife and everyone backs off. Kevin is stuck between a wall and an ice machine… the guy is yelling " Stick! Stick! Slice! Slice! — I'll get you all, I'm going to pull some *Matrix* moves on you". Kevin ran out, hopped in the van, and yelled "Drive!" Then he told us what happened. At least we got the $30. Yeah but then we realized we had left one guitar. Shit. As soon as we turned around about five squad cars headed in the same direction. We waited a few minutes and followed. They hadn't even gone to the club but somewhere else… needless to say Kevin jumped out, ran in, grabbed his guitar and got the hell out of there!

OK, one more. And this time it's the Motor City…

DETROIT ROCK CITY
Typical biker couple into rock music offers us a place to stay. Dude is super-excited… old lady hesitant. She's seen it all before. All his buddies crashing at their place and drinking till wee hours. But we follow them any-

way. He's running red lights and we are trying to keep up when he pulls over to take a leak. OK... five minutes later we arrive. He couldn't wait?! Nice home. Very nice Native American art — dream catchers and velvet wolf paintings. To spark up conversation I ask her about her very nice fringe black leather jacket. "Oh yeah, ——— got it for me at the bar tonight for $30 from some crackhead. Yeah he owes me one. See he was sitting here listening to the stereo and the tape deck ate his tape, so he got up and shot the stereo with his shotgun. Yeah, well the son of a bitch bullet went through the wall and into the closet and into my new leather jacket. He was awful sorry and promised me a new one."

We kind of all sat in silence.

"You aren't gonna rip us off are you?" she said. We laughed. "No! We were just wondering the same thing!" We proceeded on a tour of the house and met their

pet python which had its own bedroom. Yeah. He was saving and drying the skin — had already made a lampshade — and was working on a G-string for her. We went to sleep. Next day as we were saying goodbye we asked where he was... "Oh he's out in back taking a leak — he just can't pee in the house."

Andrea Jablonski, The Drapes (Chicago)

Swallowed

We played Don Hill's — a club in Manhattan — and one groupie girl would not leave Noel alone, and kept following him, and plying him with alcohol, and various party favors. He got so loaded that he started to suck her toes in public — plain view of everyone in the club. He accidentally swallows her toe ring, and then sheepishly asks her if she wanted it back after he tries to find it. We were on the floor laughing. I thought that was a chestnut of a story.

Yana Chupenko, Shiny Mama (NYC)

No Potential Lesbian Fans

The Misses were looking forward to playing an ALL GIRLS, ALL AGES, ALL NIGHT show. We were asked to play with a band from California that were all girls, and punk. While no one had ever heard of this band, we were psyched. The opening band was a brand new local band from STL and were all lesbians, with a good following. The Misses were ready to make some new lesbian fans! Well, day of the show we find out that the local, lesbian band was canceling. We later found out that they canceled over four days in advance and had spread the word. Needless to say, no potential lesbian fans came to our show. Well, that's OK... the show must go on. We were told we didn't have to worry about getting to the venue early, since it was just the two bands now — although when we arrive, we are greeted by the staff with "Where have you been?"

I'm going to pull some
Matrix moves on you.
THE DRAPES

Hmmm... apparently the message from the owner was not translated to them. We meet the touring band from Cali. They replaced their female drummer with a guy, but that's OK, 'cause the girls look cool as hell. They decide to play first. Unfortunately, since it took longer for sound check, the doors didn't open until close until 10:30pm. This was an all ages show, and frankly, a few of the under twenty-one's got tired of waiting in their car and left. We also heard later that folks thought the whole show had canceled, so they didn't bother to show. The touring band hits the stage. Folks are eager to listen since no one knows anything about them. The band is dirty looking, with frayed clothes and hairy armpits. That's OK, we think, that'll make them rock even harder. The girls and I get close to the stage to support them. After much screaming and banging of instruments, we're not sure what to think. Is the song over? Is this a joke? Are they some kind of "art" band? Hmmm... well you could hear a pin drop after every song they performed, so we were sure to clap when we thought

123

appropriate. At one point the singer/bass player grabbed a frying pan and started banging it with a wooden spoon as she screamed intangible words! Were we on *Candid Camera*? No, I'm afraid not. Our loyal fans were troopers and sat through the whole set. Heads hung in shame for the poor band's train wreck of a performance (you couldn't help but watch!). Finally, we take the stage, feeling pretty darn confident after that monstrosity. Three verses into the first song and *!?&%!!* — my mic goes out. This proceeds to happen four other times throughout the night. During the fourth song, Misses Robinskin beater breaks on her drums. Luckily the touring band's drummer was able to help us out. Hmmm… we're beginning to feel like we'd been sabotaged. A friend of ours (and local rocker) brings all the Misses a shot of Jager to the stage. Now, my New Year's Resolution was No More Jager, but I was on the spot and caved into peer pressure. After the shot, we busted into a new song that sounded great. Whew, it's gonna be a good night after all. In the meantime, some local yahoo is starting a fight at the bar, so everyone was paying more attention to him! As he's getting thrown out, the ruckus knocks into our merch table. A few CDs were broken and stickers were soaked with beer. The set is finally over and the crowd (well there were about thirty people) begged for an encore. We were feeling pretty proud and did our best. The music is over so Misses T and I wanna load our crap up and get the hell out of there. Misses Robinskin always has other plans… *Keep drinking*! Well, I started loading, while Misses T watched the merch table, Misses Skin was drinking/socializing, and I wasn't sure at the time where Misses Mmmm was. I had on a cheerleading skirt and biker boots and started hauling everything down the stairs (yes, stairs!). I wiped out on the last three steps, but was luckily OK, just bruised a bit. By now it's 1am and I'm thinking I have to be at work in seven hours! Misses T closes down the merch booth, Misses Mmmm appears with help from a few friends and we load our cars up. The sound guy gives me $60 and I'm thinking that was the Misses amount. Nope, that was to be split between both bands! Ugh, we give the touring band $40 and we keep $20 (we spent more than that on flyers and "goodies" that we always have at our shows). On the way out, I back into someone's parked car. Our friend that helped us load said, "Oh, it's OK… don't worry about it." Thinking that it's his car, we leave. I later find out it wasn't his car! Yikes! So after unloading at Misses Robinskins' house, driving home, getting to be around 2:30am and waking up for work at 6am…we realize a

valuable lesson: Always know something about the band(s) you're going to play with and look out your rear view mirror!

Sikki Nixx, The Misses (St Louis)

More Soaking than Burning

We were playing The Burning Man Festival 2000. It's an anarchic arts festival in the Black Rock Desert, Nevada USA. If you've never been there, it's impossible to describe the place to you. Just envision pure anarchy actually working.

We got off to a bad start, leaving for the gig minus our guitar player. He opted to fly in and join us once we actually arrived at the festival. We have a bad feeling about this as he has begun to fuck up pretty bad and stiffed us a few shows already. His girlfriend of fifteen years hollers, "He's not going" into the phone as I make arrangements with him. She's screaming some shit that he will never be a rock star and needs to give up his childish dreams of rock'n'roll.

Much to our surprise, the limo delivers our guy from the airport at 6am on the day we're supposed to play. The limo was to have a dry bar as our guitarist is a wanna be recovering alcoholic (chug a fifth of vodka kinda alcoholic). The moment the limo door opens I smell the booze. Contrary to our request, the limo bar had been fully stocked. The driver informs me Lance Lucifer, our guitar guy, had been a one-man-happy-hour for the entire four-hour drive!

Ten hours pass and Lance is still too inebriated too function. We continue pumping him with fluids. With only a few hours left until we play he finally begins to sober. Just as we begin to see hope, the sky darkens and threatens rain. The temperature drops to the forties. We arrive at the stage where we are scheduled to play. (There are numerous stages throughout the event. You might have a hardcore band playing one stage while an opera singer performs at the same time on a stage half a mile away. People of similar taste congregate to what ever stage has what they like.)

We find a poppy, west coast reggae style band on stage and the place is packed full of dancing hippies. It's highly unlikely this crowd will appreciate our East Coast anger. Seems whoever booked the stage order was having a laugh at us.

We ready ourselves for the current crowd to leave when we play, which they do. Hundreds pour out of the place as if it's on fire. No biggy — we figure we'll attract our own element after a few songs and all will

be well. Just as we end our second song it begins to rain, cold rain. The place becomes a slippery mud pit in an instant. The rain eases during our second song and we begin attracting a few people. Before the third song ends the rain picks back up, sending people scurrying for shelter. I look over just in time to see 70s, my bass player, slip on some mud, and fall flat on his ass. The girls who dance with us cannot move, due to the slippery stage. The rain continues to increase and we're playing to about twenty people. The mic keeps shocking me. The covering over the stage has a leak and is dripping directly onto my drummer's head. I try to do my fire act, but it seems my torch has been heavily soaked by rain and will not light. The guitar player breaks a string. We call it quits after the fourth song.

I wish it ended here, but it doesn't. We sit with our equipment under tarps for two hours in the rain. People pass us by like we are invisible. We cannot find our ride to haul us and equipment back to our camp almost a mile away. The mud is more like clay. It clumps up on your shoes until you're walking on a five-inch platform that weighs twenty pounds. Finally our karma shifts, some cool folks in a pick-up drive us back to camp. Our equipment to this day, still bears traces of mud from that night.

Tom Waltemyer, El Destructo (Philadelphia)

Drunk in a Dress

What do you get when you cross a *drunken* middle-aged man in a dress with 100 people?

That is a question that was answered in the spring of 1997. I was part of a collective of artists, musicians and poets which gathered monthly for a spoken word event. This month it was my turn to host.

Prior to the event, in a fit of depression, I found myself in a local park drinking tequila and vodka straight up. A combination surely made in Hell. Drunk and depressed, I let my girlfriend talk me into wearing one of her dresses . Some lady friends decided to get into the act by painting my face. Thirty-eight-years-old, overweight, balding and wearing a dress. Who could ask for anything more?

I opened the show singing an a cappella version of Alice Cooper's Welcome To My Nightmare. When I finished the song I hiked up my dress and asked the crowd of somewhat wary onlookers, "Where do you put your testicles in a dress?" The games had begun. The first poet to read was a friend who, because of his womanizing, had put me into a fit of depression in the

first place. I introduced him as, "The only man I know whose ego has a foreskin." And so it went, from reader to reader. Each introduction was a lesson in fear for those about to read. While people were reading, I would crouch in the corner and stare demon-eyed at those who dared glance my way. Still, somehow, I was pulling it off. I was even cheered after singing a self-written song about serial killing. "Hey, I'm home free," I thought.

After two hours, I was ready to go home and sleep it off. That's when I heard the sound of broken glass. A confrontation was a brewing. A lady friend who had been taken advantage of had decided to get toasted herself, to the point of being fallen-down-drunk. So while I brought another reader up to the mic, I set about to calm the waters. I walked into the women's bathroom (as I had done oh-so-many times before) to find my friend looking in the mirror with her leopard mini skirt riding up in the back high enough to totally expose her buttocks. I managed to dry her tears, calm the waters and go back out and pick a fight with the man who put her this way. Luckily, he was smart enough to bid a hasty retreat. It was quite a night and I was quite a sight. A whirling dervish of insults and innuendo. A maniacal would-be messiah with heavy heart and devil eyes. From mooning the crowd to attacking everything sacred, I survived my own personal hell to the applause of those who dared to cross my path. It was the gig from hell for every reader forced to share the stage with me that night. For me it was a roller coaster ride of emotional turmoil and discontent. I survived and the crowd was treated to a memorable evening. I guess that's entertainment.

Michael Teal (Hamilton, Ontario)

Sloopy's Hot Stuff

It was 1984. Orwell's book didn't come true — for me, it was much worse. Flat broke, living off one bowl of rice a day, nothing else (I'm not kidding), I decided to call it quits for LA. The heavy metal band I was in that was trying to get signed fell apart, I was facing having nowhere to live, my car had been broken down for months (this means basically house arrest in Southern California), and my mom had died on my birthday (heartbroken at the time, eventually I realized what a good thing it was, as the woman made the lives of those around her miserable. What a final "fuck you"!). It was time to make some money. I joined a booking agency, and they got me a gig with a lounge/show band, Sloopy's Hot Stuff. Three hundred bucks a week, including a hotel

room and a meal, at that time it looked like great thing. I showed up across the country at a ski resort in Pennsylvania. That should have tipped me off; they were booked at a ski resort in summer!

Sloopy fronted Sloopy's Hot Stuff. In the sixties she used to be a dancer in Paul Revere and the Raiders. Allegedly Hang On Sloopy was written about her. Most of her career she was a show dancer in Las Vegas, but she was getting pretty old, so she got plastic boobs, a face lift, and started this show band. We played the top-forty shit of the time: Journey, Huey Lewis and the News — crap I really hated. One of the sets every evening was the "show" set, where we did classics like New York, New York, and she'd do comedy skits with her husband, Walt, the keyboard player. That was actually kind of funny, but what was really embarrassing was Thriller, by Michael Jackson. In the middle of the song, Walter's keyboard would go on automatic, playing the tune, while the band put on Halloween masks and tried to "spook" the audience! One time during this, his synthesizer freaked out and started playing all kinds of sounds. Very avant-garde!

More humiliating than the music were the outfits we were forced to wear. They were this purple and silver leatherette shit, the one I wore was an Indian get up; the bass player, Zinneman, a heavy set black guy from Philly, had to wear a court jester-style outfit that was way too tight on him. Off stage he was an impeccable dresser, it made it all the more difficult for him. He was also a great musician. In my experience, anyone who can play well is usually doing those kinds of gigs because financially they have their back up against the wall. It was real money compared to working at Tower Records for minimum wage. But basically I sold my soul for peanuts. Worse to come were the new outfits Sloopy had lovingly tailored for the band. Shiny turquoise leotards! Mine had a tank top that was cut so low my nipples stuck out.

I developed a drinking problem immediately. Me and the drummer (who stayed on for a week so I could learn the parts), after spending the whole night drinking on the gig, would get a fifth of Old Grand Dad and split it, drinking well into the morning. This went on daily. One time I awoke to find that my head, from the neck up, had fallen asleep! I was yelling, crying, and slapping my head! Eventually the feeling came back.

Sloopy's room was above mine in the hotel. One night there was a party going on up there, which eventually turned into the sounds of the whole room fucking, in unison! OK, in theory this sounds exciting. Heck, I

like to watch porno sometimes, but the next morning I saw this group-sex crew hanging out by the pool; ugly, peanut-shaped, cellulite ridden middle-aged couples! One guy had such a big, pitted, red nose that you could have sliced it down and sold it for lunchmeat!

I was sending a lot of money home so I could move to New York eventually. With the help of booze I had been able to deal with the situation, but soon I had to face the facts. We were in Bismarck, North Dakota. During our outings there, people would stare at us and point. They didn't act prejudiced or unfriendly; I just think that many of them had never seen a black person before. Actually there was one Chinese restaurant in town, and it had amazing food. Anyway, one afternoon Zinneman and I started our binge at happy hour, 4pm sharp, with gin and tonics. Many of them. I had a bottle of Beefeater in my room. Zin prudently took a nap, I continued imbibing. During the show, I'd drink at the bar, go upstairs to hit the bottle, come back down and play the set. By the end of the night I could barely play, and after the last number I stumbled up to Walt, slurring, apologizing, and saying I had to quit, I couldn't take it anymore. So the next night I talked with them, I gave them sufficient notice, they were good about it and we were all happy. After all, they were decent people, I actually liked them.

Well, decent to a certain extent. The next scene was pretty indecent. My last show with them was at the Holiday Inn in Greensburg, PA. Somehow while driving cross-country, Walt picked up this teenage girl. They put her up in a trailer with Zin and me. Not bad looking, she was definitely do-able. Especially as during my tenure, the band only attracted fat middle-aged married women. This girl wasn't very smart, but it didn't matter. I hadn't had any action for longer than I care to say. I was basically straightforward in my intention for casual sex. She wasn't into it; turned out her new boyfriend was Walt, Sloopy's husband.

The next morning I awoke to find that Sloopy's poodles had been bathed in my shower, dog hair being left everywhere. Again turning to alcohol, heedless of fines that would be imposed on me if I pulled another stunt like the one in Bismarck, I drowned my frustration and disgust with beer and a bottle of Mad Dog. Walt invited the band to have dinner with him before the gig. After dinner, Walt stepped outside with me as I attempted to walk back to the trailer. "Scott, you should have some coffee and sober up. I don't want to have to fine you, man." I didn't know what he was talking about, I was so wasted I thought we had already played! I

crashed for a couple hours, sobered up well enough to get through the gig, but I wound up puking on my drum set! Luckily it escaped Walt's scrutiny; I wasn't fined.

Their next show was in Cheyenne, Wyoming, and they basically had to drive straight through, set up, and play. Fortunately no one was hurt, but Sloopy fell asleep at the wheel and crashed the motorhome into a tollbooth, totaling it. Good timing on my part!

Scott Byrne (LA)

She's Electric

As I sit here and think of tales to tell, tales of sex, drugs, and rock'n'roll, it occurs to me that you have probably heard it all before and more. I doubt any story I tell could rival the story of the guys from Zeppelin inserting fish into places unknown. Well, bearing that in mind, I have a different story about playing music to relay to you. It is a story involving electricity. Something one doesn't give a lot of thought to unless we are paying for it or lacking it.

I have the privilege of playing harmonica through an ungrounded vintage amp. Simply put, this leaves me completely vulnerable to every venue's unique electri-

see them coming. By the end of the set I was waiting for and craving them. I couldn't get enough. I guess you might say there are other ways to get strung out or see colors.

The worst shock I ever received. I can't even remember where it occurred. It wiped out all memories, twenty-four hours in either direction. I do remember a brilliant blast of white, somewhat akin to staring straight into the noonday sun. I am told I was attached to the mic until my observant guitarist had the sense to give me a kick, which served to dislodge me and possibly save my life. I heard it was a great performance. All I can say is that the event left me permanently paranoid.

One more thing: did you know the guy from the band Stone The Crows, Les Harvey, died after being electrocuted on stage at a gig in Swansea? Not the most glamorous demise. John Rostill of the Shadows met an untimely death after being electrocuted in a recording studio and Keith Relf of the Yardbirds met his maker after being shocked to death by his improperly grounded guitar. I bet you never knew being a musician could be so dangerous.

Jill Kurtz, Caged Heat (Boston)

Lucky for us we were not trampled.
SPIDER ROCKES

cal wiring. From club to club I have no idea what sort of shocking circumstances await me. A little known fact to which I have become aware, electricity delivers its shocks in many shapes, colors, and doses. One special case that sticks out in my mind was a tiny little club in Troy, NY. It was there that I saw the most beautiful electric blue lightning bolts lined up in rows one on top of the other; it was breathtaking in more ways than one.

I have seen green and violet on occasion. Once I was playing during an electrical storm and the shocks came in waves. Little pinpoints of light reaching up out of the microphone to greet me. I could feel and almost

Cow Tipping

We were driving to a show in upstate New York. Stressed and running a little late, after hitting deadstop traffic in NJ (damn NJ traffic). We made a pit stop at a crucial junction, and our singer examined the map. We made the turn our singer instructed and started driving. We drove for over an hour, up and down mountainous hills. We started worrying after seeing nothing but farm country, so we stopped near a farm to take a closer look at the map. At this point, our drummer, who grew up in New York State, tried to show us how to "Cow Tip" by demonstrating on a nearby cow. It

didn't work, since the cow was awake (cows who are awake don't take kindly to someone trying to knock 'em over), and we were chased through the field by the cow until we safely reached the other side of the wooden rail near our vehicle. Lucky for us we were not trampled. In the truck, we looked at the map and found out we had gone forty minutes in the *wrong* direction. Singer girl was properly chewed out, and club was called. Fortunately, the club was very cool and understanding, and we made it there in the nick of time, before we were scheduled to go on. Singer girl is not allowed to be the official map reader anymore. And, we won't be trying to knock over any more cows. Stupid idea, anyway.

Helena, Spider Rockets (NJ)

Dead Dog Blues

It was at Scappy's in Phoenix, I think. It was hot as a crack pipe on Sixth and Mission. The crew was hung-dog shitty from a month-and-a-half of cheap beer chortling and relentless whiskey inhalation. We pulled up to the back door and looked in. The other bands had already loaded in their shiny new gear, and were tuning their guitars on stage. They were young enough to be our great grand kids. We gave a brief hello and threw our haggard, old shit on the stage as fast as possible. Hungry and desperate for cold beer, we asked the Mom-promoter what she had in the way of libations. After a long typical lecture about respecting the all-age scene, we hurried off to stalk Debbie (the cooler). Since we were broke and hungry, we decided on a three case meal of Old Milwaukee with Tequila and beef jerky for desert. "There's a pork chop in every can," we said, as we quickly turned the hangover into a nice warm buzz. Assisted by the sloppy intoxication of the forty-five nights, the buzz came quite easily. That evening we thought we were lucky to be the middle band, and were quite happy when we were told we would start rocking at nine-thirty. The kids started to show up pretty early, and we were beginning to get saucy when the first band started playing. They proudly showed their big black Xs and started their set. They began by praising the righteous way of veganism, then busted into a set of bumpin' Rap-Rock. Most of their songs were dedicated to their parents and teachers. The kids ate it up like Crunchberrys on a Sunday morning. The band was actually pretty damn good for a gaggle of youngsters. After two songs, we knew that we were doomed. We set up quickly, to try to play before the crowd left the room. Right when we were about to play, a young girl ran in from outside proclaiming that she needed some water for a dog that had just been run over by a car. Everyone went to look. It was still alive and whimpering in the street. The sober and somber children gathered around and shook their heads. They denounced the devilish driver, who didn't even stop. It was time for us to play. The room was empty by now and to pump up the crowd outside, Trey (the F-man) Bundy took the mic and yelled ,"Fuck that stupid dog, goddam it, let's get fucked up and party!" The three kids in the room turned pale, exchanged glances and sat on the floor. In between our furiously fast and drunk songs, you could hear the cars going by on the street outside the club. Even the stage lights seemed to buzz at us with disapproval. The paint on the walls was loud, compared to the non-existent crowd. We continued praising Alcohol the Almighty, and proclaimed that God was dead. By that time the dog really was. We ended the set by singing the extremely unappreciated Beer Song (Somebody Give Me A Beer Please!) because by that time we just didn't give a rat's ass. The next band was a Christian Rap-Metal band so everybody came inside and went ape shit... I guess the moral of this story is: If you don't plan on getting shit-face-plastered, worshipping Satan and sodomizing dead dogs, don't go see Bar Feeders.

Cecil Ebeneezer Hurbuttopolous Jr, Bar Feeders (San Francisco)

Rock and Roll Swindle

The Phoenix Festival London 1996. The Sex Pistols reformed! Pillbox was lucky enough to be put on the same bill as this legendary awesome band. I was so nervous that I planned everything from the time we would drive up to the venue, to the time we would leave. My tour manager Shep had no problem with this, as he was super responsible. My girlfriend Joe also came along in the van to support us, and of course, to get in free to the Pistols. Pillbox played, our show was amazing, everything was perfect. I now had a chance to relax, and watch my favorite band on stage, knowing full well that we had to miss half of their performance, or otherwise we would be stuck in a parking lot jam for two hours (since it was the last day of the festival) — and that is not my bag. So, my boyfriend and I made it to the van in the middle of Pretty Vacant, and needless to say no other Pillbox dudes were there to meet us as planned. That wasn't too surprising, because Sean

Joe had been
puking all over
our sleeping bags
in the van.
PILLBOX

the bass player was always a bit flaky, and Dov the drummer was consistently tripping on something. But when Shep got out of the van, slurring his words to the tune of "I'll be fine in an hour", I knew we were seriously fucked. Joe had been puking all over our sleeping bags in the van, that much I could make out. Apparently, the two of them decided to be Dead Heads for the afternoon and took some serious acid. I'm a rock chick, but not *that kind* of rock chick. I like things nice. So, we decided to find another band's van. We noticed that Jocasta's very plush van had everyone in it with the exception of Jocasta. My boyfriend and I got in and convinced their stoned tour manager to take us, instead, and that our guys would take Jocasta. Somehow, that seemed to work. I directed all the way back to London. Those Poor Jocasta guys, I heard Shep didn't make it back for another two days. Puke & everything — yuck!

Susan Hyatt, Pillbox (London, UK)

Dick Party

After a fairly uneventful, half-drunk, extremely low-attendance gig at the Spiral in NYC, we went back to an apartment I was sitting for in the fairly affluent Upper West Side. The apartment was owned by my boss at the time, Dick Buck (his real name). Dick Buck was a flamboyant sixty-five-year-old queen whose heyday was in the sixties. His apartment was covered in Christmas lights, original Peter Max artwork, original Beatles memorabilia, and naked pictures of himself. (I once found a huge butt plug in the sofa.) Behind the kitchen cabinets were cutout centerfolds from a dozen gay porno mags and the walls of the living room were covered in shelves holding videotapes, because he taped

everything compulsively. His ironing board dropped out of a kitchen cupboard and came complete with a large naked guy cut-out glued to the front and a folded-back ten-inch cock so that it could be unfolded and stick out the side of the ironing board. Why? I dunno.

His main bedroom had a $3,000 dollar stereo and racks of pristine seventies album vinyls. The other bedroom we called "the blue room" because everything was covered in blue chiffon and there were framed pictures of naked guys holding their dicks.

In New York, apartment space is at a premium and this was a two-bedroom in a door-manned building and in an affluent area. Easily two grand a month. So, of course, we had a party.

We invited about fifteen people who also invited people and before we know it we had thirty-or-so people in a two-bedroom apartment. Within two hours we had raided the closets and Satanicus was in a full length yak-fur "Chewbacca" coat (complete with cowboy hat) and I was in an orange dashiki and ten gallon Indian Stetson. Everyone was fully lit on booze, pills, coke, weed, and whippets. The places was being systematically wrecked: toilets clogged, fridges stocked with booze, the jar full of about 200 bucks of quarters emptied and spent on pizza, people fucking in the rooms.

I don't remember much else except that at different points: Satanicus and I had a fistfight, I was naked and turntable scratching on a pristine *Ziggy Stardust* record (by dragging the arm back and forth across the record), Satanicus was fucking with some guy's girl, and the next morning someone had stolen some of the Beatles memorabilia. When my boss got back to work I had to get a new fuckin' job and I never even found out who stole the yellow fuckin' submarine.

Vic, Super Deformed (NYC)

Hennesee Loogie

I suppose I should begin by explaining that the true "hellish gigs" are the ones not even worth mentioning — like the one when our drummer had a kidney stone and instead of canceling the show, we played it anyway with a last minute replacement. Knowing that the show was going to be lame, one of our guitar players didn't even bother to turn up, leaving the rest of us to fend for ourselves with a drummer who didn't know our songs… the club was packed, of course.

Hellish gigs not worth mentioning are shows when somehow you happen to drink a bottle of wine and some shots before going on, and two songs into the set, dressed like a complete wanker and wearing women's makeup, you fall off the stage, take out a row of skinheads with your my mic stand (on purpose), cut some girl's arm up (accidentally), all while a band member's eleven-year-old cousin looks on in horror.

When we formed The Beatings in 1997, the musical climate in Baltimore City was dismal at best. The legendary Memory Lane club had recently shut down. Bands like Jakkpot and The Reprobates had become a fading memory. There were a few clubs still catering to underground music, but on a local level most bands were either doing the rockabilly thing (Glenmont Popes/ Johnny Love and Speed), angry noise shit, art rock, power pop (The Put Outs) or punk-by-numbers. There were a few exceptions of course, like The Goons, The Sniff Shits (who eventually became National Razor,) The Fuses, and a handful more. These bands were all around the same age as us and were also the bands that we'd play with the most frequently, taking advantage of the newly opened Baltimore venue called the Ottobar.

When we first got the band together I was a fourth year art student working at a record store and as a DJ at strip clubs while having art shows of my clumsy rock'n'roll inspired paintings in places like the 9:30 Club in Washington, DC and The Akira, a cool punk rock sushi restaurant in Southwest Baltimore. I had been obsessed with rock'n'roll since I was born and was really bummed out by the lack of interest in trashy rock, classic punk, glam, and new wave in my home town, let alone everywhere else. But when you're just out of your teens you want something to do all the time — at least I did. I was running in circles going nowhere fast. I had no money at all. I was sick of school and realized I was only staying to get the student loan money so I could afford rent and records. I was also going through my obligatory Johnny Thunders emulation period, which I don't suggest doing if you haven't already. Sharing an apartment with the notoriously unstable Jason Reprobate probably didn't help my situation either.

I met The Beatings' bass player, Dave Dart, while bartending at Garfinkle's Pub in Fells Point. A spitting image of a young Adam Ant, Dave is a butcher from Hagerstown, Maryland (home of KIX!) who dresses like Nikki Sixx's girlfriend's closet exploded on him. I thought he was great and we hit it off immediately. We decided to start The Beatings along with my oldest friend Kevin (Dr Tookis), who plays drums, and a few other teenage friends who had a place we could practice in the suburbs, close to the record store where Tookis and I worked. We wanted to form a band that was like the Alice Cooper Band or The Stones if they were punk. Or maybe the New York Dolls on crack. I was also obsessed with Lou Reed and Bob Dylan, if that makes any difference. Obviously there wasn't going to be a band like this any time soon in Baltimore, so we decided to take it upon ourselves to start a little punk group/performance art project. It hasn't ended yet. Gene Simmons and various other cheeze heads have been quoted as saying the only reason people form a band is to get laid and to get money. Maybe if you're an ugly fuck like Gene Simmons that's the case. I never had a problem getting laid and I think that's the worst reason on earth to start a band. I couldn't relate to any of the art college wank I had to endure in school, I'm a rocker who's generally annoyed by most people. When the band started, I was a pissed off kid who wanted to rock and have fun… and I probably always will be. Our first public appearance was at the Ottobar coinciding with an art show I arranged to celebrate my twenty-third birthday.

Other early shows were held in Southwest Baltimore, a run-down ghetto area, which despite attempts by locals to turn it into a sort of haven for the Balto Bo-Homo sect, it remained merely a place for art fags to go and cop heroin, be pretentious and live in fear. It's also the location of Baltimore's annual SoWeBo festival and the former home of the now defunct restaurants The Akira and The Cultured Pearl. The Pearl was a grimy Mexican joint which hosted occasional indie bands, poetry readings, a great happy hour buffet and short order cooks who hustled dope. The Pearl became like a clubhouse for the few Baltimore City degenerates in the know. I feel the urge to vomit just thinking about the place, though it has nothing to do

with their food or the lovely clientele. It was only a matter of time before the Pearl was going to shut down and The Beatings had the privilege of being the last band to play there. It was our third gig.

After our first show we had positive reactions from our friends, the club staff, and other local yokels. But it wasn't until we met our lead guitarist AJ a few weeks later that the band really started to cook. A young guitar whiz from Baltimore County obsessed with Guns N'Roses, Alice Cooper, and Johnny Thunders, AJ blew us away the first practice we had together. We instantly recognized him as a kindred spirit, plus he lived only a few minutes from where we were rehearsing and had fantastic hair. He joined the band in time for our second gig with The Goons at Sud Suckers. When then nineteen-year-old AJ joined, the core of The Beatings was solidified.

We lost our rhythm guitarist after our second gig, but had already lined up the show at the Cultured Pearl. Luckily, on another night bartending at Garfinkle's Pub, I hooked up with Idzi Marion, the former bassist of Baltimore's favorite hard rock local legends Child's Play. Child's Play were like the little brothers of Kix. Signed to Chrysalis in the late eighties, they were hair rock personified and were also known to sell out the legendary Baltimore rock venue, Hammerjacks, at the drop of a hat.

That had been ten years earlier though, and Idzi had since been floundering in bar bands as a hired gun, with no musical direction to speak of. I gave him a tape of some demos we recorded and though rough by his standards, he heard something he liked and agreed to join The Beatings… at least for The Cultured Pearl gig. Idzi had never been exposed to punk rock like we intended to perform it, and he probably never quite "got" what we were doing, but he was fucking great at it! Idzi was excited to be doing something new and we were ecstatic to have him… especially playing straight-up punk rock'n'roll. Even though he was a little older then the rest of us, his lifestyle was probably more out of control than the rest of the band put together. Plus he was a rock'n'roll pro with great guitars and amazing stage presence.

When we arrived at the Cultured Pearl for our gig we were duded to the nines. I clearly remember walking in from the frigid ghetto streets with my girlfriend Melissa (now my wife), wearing a leopard fur coat, a black feather boa, and pink glitter in my angular haircut. There was no stage or lighting except from the ceiling fans that brightly lit up the garish paint job of the restaurant. The turn-out was great, due to the buzz after our first two gigs and the fact that everybody's friend Tim Put-Out was acting as guest bartender.

The restaurant failed to clear any tables from the floor surrounding the stage area and most everyone in attendance slouched over their dinners, sucking back margaritas and laughing at how we dressed. We cranked the Marshalls to ten and exploded through our drunken set in under thirty minutes. I punctuated the last number with my usual faux-cocky banter and leapfrogs from one table to the next, knocking over countless margarita glasses. Instead of being met with reactions of horror and disgust, the crowd loved us… fueling our desire to play wherever and whenever we could.

Inspired by the New York Dolls notorious residency at the Mercer Art Center in the early 1970s, I decided it would be cool to book a similar regular weekly gig for us during the bitter winter of 1998/99. The venue I chose was a cocaine-infested scum hole/heavy metal dive located in the Highlandtown section of East Baltimore called Hal Daddy's. I initially loved the place, primarily because they had seventies LP covers bordering the walls and the ceiling, including both Joe Perry Project albums. We had played there a few times before, once billed with some lame ass metal band who brought their own fog machine and printed their own "backstage" passes. Hal's bar was not known for high quality bands, so I thought it would be cool if we headlined every week for a month, bringing in some of our friends' bands from the scene. The first two weeks were a success. We brought in groups like The Fuses, Twin Sixx, and The Uniform and we had cool crowds that dressed up for the occasion. The jukebox rattled out Bowie and The Ramones in between sets. Our shows were getting wilder, interacting with the audience and whipping out weird cover tunes all the time, which was always fun. The third show into the residency was a truly hellish gig. Idzi invited Child Play's old manager to see us play, which in hindsight was no big fucking deal. Though having a coked out old man staring at his watch throughout the night cramped the vibe. There were a lot of people crammed into Hal Daddy's. The owner Hal wasn't there to control the place. The teenage doorman looked like the singer from Korn and was an aspiring pro wrestler. He was taken by the spirit of the music and was already drunk by the time the doors opened. Early in the evening after about fifteen people had come in, Korn decided he'd demonstrate his pro wrestling skills and stop collecting money at the door. He was smashing steel chairs against the stage as peo-

ple at the upstairs bar wondered what the "clanging" noise was. By leaving his post, of course sixty more people were able to come in the bar without paying, which pissed me off because I knew Hal was going to stiff us for the night. Meanwhile, Idzi, who was at the club earlier to set up, picked up a stripper from the titty joint across the street and disappeared to his house, which was a few blocks away. He must have had coke dick, because by the time he made it back to Hal Daddy's the rest of the band had been stalling on stage for fifteen minutes. It had been over an hour since the previous band had played, and the crowd was getting rowdy. Audience and band members heckled Idzi and gave him a serious ribbing upon his return. He was probably too gacked out of his mind to even know why.

At this point I was pretty annoyed and drunk as well. When the club's shitty new Peavey vocal PA began to short out about five songs in to the set, I got an idea.

Around this time Idzi was complaining about never making any money and he had a point. I had a habit of destroying mic stands and we'd always get charged more than necessary for pieces of shit stands held together with electrical tape, that I "broke". On top of our bar tabs, broken shit, and most of our friends getting in free, we'd usually be sent home with twenty to a hundred dollars if we were lucky. We also played a bunch of benefits for the sake of exposure in different places in front of different people. I had begun to really dig Idzi as a friend and was glad to have him in our band. I was also glad when he offered to book some "decent" paying gigs for us. Idzi first got us a gig with our friends Johnny Love and Speed that was hooked up about an hour before we played. Having just heard about the gig we barely had any time to tell anyone we were playing besides our girlfriends. This was no big deal since the show was at a "Hootie" bar (remember, this gig was during the fucking height of the "Hootie" invasion). The

```
Not my animals!
Not my animals!
THE BEATINGS
```

Inspired by Korn's earlier use of the steel chair, I thought I'd take a more scientific approach and began dropkicking the PA with the chutzpah of Jimmy Snuka on Valium. Hal Daddy had seen enough and rushed the stage football tackling me in front of the mic stand. He began yelling into the mic for everyone to get the fuck out and cleared the place in minutes. Strangely enough, Hal and Child's Play manager still poured me shots after the gig and offered me free cocaine, which I declined, wisely avoiding an endless and mindless conversation with two pathetic old men. The next week's performance was snowed out, thankfully, though Hal wanted us to play one more week to make it up. We needed to practice anyway so we wound up for our last night of the residency with no flyering or advertising at all. Our friend Tascha and a couple of underage squatter punks passed around booze in brown paper bags that they brought in themselves.

bar was called EJ Buggs on Broadway in Fells Point. Broadway is the main drag in Fells Point and on the weekend, every yahoo-frat-boy-meathead goes barhopping and hunts for some girl to date rape. The "Hooties" (along with a few members of Twin Sixx and some friends of Johnny Love) got a fine performance that night, with me adding some heat to the frigid air by tossing a few unoccupied bar stools into the fireplace as the band bashed out an MC5-esque freakout. AJ had to leave the club as soon as we were done since he was underage. His girlfriend, Megan, wasn't even allowed in to watch and had to sit outside. We loaded up and split as soon as possible. If we made any money we let Idzi keep it.

Our next gig, also set up by Idzi, was at a hard rock club in the redneck blue-collar area of Baltimore called Dundalk. The club was called the ZU (no umlauts unfortunately…) and none of us had ever heard of it. We

had to go through winding wooded areas and over railroad tracks to get there. Even if any of our fans had wanted to go to this show, I'm sure they would have never found the place. Upon our arrival we were shown our dressing room which was the size of a Pizza Hut with similar decor. We shared it with the two other bands on the bill, whom I had never heard of before. One of the wankers in the other bands remembered Idzi from his days in Child's Play, but I can't remember what their names were. As we got ready before the show, I remember Idzi pacing around nervously, fiending because he didn't have any drugs. His skin looked translucent gray, and he was sweating profusely, getting sicker as time went on.

We went down into the club and checked out this huge barn space with a sports bar ambience. Joe Lynn Turner blared through the PA and the barmaid in her mid forties was wearing spandex hot pants with a matching tank top in the dead of winter. To emphasize the name of the club, the walls had shelves with giant stuffed plush animals like the kind you'd win from a boardwalk game. We opened with the initial riff from the Scorpions' Rock You Like A Hurricane which had a positive response from the scattered audience. Unfortunately for them we swiftly burst into one of our most "punk" numbers, hitting the stage like a time bomb. The audience responded with the sound of dropping pins, a few odd coughs, and crickets chirping into the cold night. After earnestly trying to put on a "rock show" for these people and feeling like complete twats doing so, we ended the set with AJ slapshotting my pint of vodka and orange juice off the top of my vocal monitor with his Les Paul. I proceeded to gather a herd of plush animals onto the dance floor and sodomized a fuzzy tiger, much to the shock of the bartender who shrieked, "*Not my animals! Not my animals!*" Needless to say, we got the fuck out of dodge and again, if we made any money we let Idzi keep it.

Besides our regular appearances at the Ottobar and a few other successful paying gigs over the next few months at places like the 8 x 10 on Cross Street, our last gigs with Idzi were approaching and one of the best wound up being another freebie. This show took us back to the Sowebo area, for the first time since we had played the Cultured Pearl. The gig was at the free punk collective called The Laugh And Spit. The line-up featured National Razor and some hilarious degenerates called the Assmen. The Laugh And Spit was a run-down empty rowhome with lots of little rooms to go and fuck around in. The downstairs living area was where the bands played. Since it was not really a club, they could only ask for donations at the door, which meant no one ever donated shit. Homeless winos and crackheads would wander in off the streets and go crazy, digging on the energy of the young crazy white kids while keeping warm in the process. This was the gig where we really won over a big chunk of our fans in Baltimore. I remember Idzi pulling up in his coke buddy's white corvette in a camel's hair overcoat and black turtleneck, talking on his cell phone amongst all these dirty little squatter punk kids. I also remember the punk kids looking at Idzi like, "Who the fuck is this guy?"

By the suave manner of Idzi's attire, I'm sure he had better places to be, but he showed up in time and we rocked the little sweatbox like motherfuckers. I had help on backing vocals from some cracked out brutha, and we tumbled to the floor screaming into the mic as spiky haired kids pogoed in unison… pure heaven!

Idzi was obviously tired of spending so much time with us and not making any money at all. I can't blame him either. We were a lot younger and were happy to have something to do, where as Idzi probably could have easily put on a wool cap and played nineties style alternative rock with some lame college band, get a development deal and make some extra cash. The last I heard he was involved in something not too far off from that scenario.

The Beatings quickly found a replacement guitarist in our friend Fernando Evil of the late Baltimore shock-rock troupe The Rockstars. For the most part, he has been with us ever since. We continued to play with the same neck break scheduling as always, but after a while it became necessary to step back and evaluate the situation in which I was living.

In late 1999, after having started our own business, Melissa and I decided to fuck off to the sunny sands on the Gulf of Mexico and set up house as far from the ghetto of Baltimore as possible. The Beatings continue on though, with a little more thought than in the early days. Since I've moved from Baltimore, the band plays better gigs then we'd ever imagine, even sharing stages with legends like Sylvain Sylvain of the New York Dolls, Jeff Dahl, and Snatches of Pink, as well as peers that we admire like The Backyard Babies and The Briefs. We've also released two records and plan on recording a new full length for release in the winter of 2002. We seem to do a tour every year, and the hellish gigs still manage to occur regardless of how much fun we're having or how much further we may have come as a band.

Some gigs we were sandwiched in between eight unmemorable bands at a venue like The Continental in NYC. The Continental is one of those dives which has long lost its steady clientele, depending more on their location or reputation rather than their skillful booking, advertising, or appreciation of the music they're supposedly cultivating. There, our band got polite applause from a mild audience of bankers, students, and posers. Each band is allotted a strict twenty-five minutes to play, and our time slot happened to be in front of a left-over happy hour crowd with no interest in our shit-hot brand of rock'n'roll. We got no money, paid $20 to park the van, they didn't give us any free cocktails, and our drummer had to use a corpse of a drum kit worse-off then his usual road-beaten piece of shit. The handful of punk girls in the crowd sat at a table in the back and swarmed to us at the end of the set saying how great we were. I wondered: if that's true, why couldn't they be bothered to get off their fishnetted asses to shake a tail feather for a couple of tunes?

Maybe a gig like the one we recently had in Boston would qualify as hellish. We, The Beatings, were on tour with our friends, The Briefs from Seattle. We had played New York City the night before to a great crowd, raced to Boston the next day (pulling a gas station nozzle out of its tank during a pit stop along the way!) and were due back to NYC the following evening for another gig. Despite the drive and the extra cost for destroying a gas pump, it was a show we were looking forward to, especially since we got to play in front of the hometown crowd of a band that stole our name and even worse, play a lame hybrid of Pixie-esque bullshit done to death by alterna-wankers the world over.

Our show wound up being combined with some local favorites called The Explosion and a support band of their choice. This was cool because The Explosion draws big in their hometown and with a hot line-up like we had the gig quickly sold-out. We were stoked at first. We figured we'd make some dough, go back to NYC the next day, and get to live like kings upon our return to the city. Of course, when you have such expectations, the opposite always happens. The Explosion pocketed fifteen hundred dollars and we were paid fifty. Punk Rock. Of course, there was no reasoning with anyone involved. I wound up hocking a Hennesee loogie on the back of the club guy's greasy scalp and kicking a few things over in typical rock brat disgust. At least Kevin Mess from Boston's Dimestore Haloes was cool enough to put us up, saving us money on lodging,

and smoke us up and turn us on to a bunch of Replacements bootlegs we had never seen.

Those types of gigs are common when you're a virtually unknown band going to places you've barely played, doing the typically boring "rock circuit" thing. You find yourself having the same conversations every night with people dressed in the same clothes as the bizarro versions of the same person you met in a different town the night before. Of course, it's not always this way and when we first formed, our experience was quite different. But no matter what bullshit we've had to endure as a band, I can multiply it by ten and it wouldn't even equal a fraction of the good times we've had or take away from all the great friends we've made. In fact all the hellish moments, in retrospect, have been some of my most cherished memories and I wouldn't trade one of them for anything. And so they continue on, the good times, the insane gigs, Dave Dart's platform boots, the clumsy falls from stages, the late night shenanigans, blah, blah, blah. Rock'n'roll's not dead kids, it's what you make of it. Remember that and welcome to Hell… where else would you rather be?

Adam, The Beatings (Baltimore)

Velvet Lounge

Anyone who's been to the Velvet Lounge in Washington DC knows not to get there early and hang around. Well, we'd never been there before, so I suppose it was *our* fault we got mugged before the show. The owner laughed at us when we told him we'd been beaten up and robbed. He didn't even give us a discount on drinks. Once the show began, only one patron actually showed up. And he heckled us mercilessly. What's worse, we deserved it. We played terribly. After the show, I discovered someone had run off with my leather jacket (which I'd had for almost a decade). We had also invited several out-of-town bands to play with us, and had to pay them $100 out of our own pockets to cover their travel expenses.

Dan, The Overprivileged (Manassas, VA)

Super Groupie Meets Chud

Back in my professional groupie days I was on the road with the Misfits. It was the last night of their American Psycho tour with Anthrax and Cannibal Corpse in Portland, OR. I was nineteen at the time and, as always, came on board stocked with a beautiful bi-sexual girlfriend and enough drugs to keep the band and their crew

wired for two weeks. Anyway, Dr CHUD — the band's drummer — and my girlfriend and I had all become best buddies in the last couple weeks and were frolicking every chance we got. Saddened that it was the last night of the tour, we got a hotel room before the show and I gave Dr CHUD his first taste of crystal meth, followed by a few forty ouncers of fine malt beverage, and a threesome that seemed to last forever. Somehow, I came to about twenty minutes to show time and realized that he was about to miss his own gig! Both CHUD and my female sidekick were so fucked up that I had to dress them and convince him to get over to the venue. "I don't wanna play... I want to stay here with you," he said. "Fuck that! I'll be damned if I let you miss your last show. Besides, your manager will kill me." I answered. I phoned the front desk for a cab and somehow managed to drag the two of them through the lobby half dressed. A few minutes later we pulled up in front of the venue to find the Misfits manager pacing back and forth. We were quite a sight, completely inebriated, half dressed and five minutes to show time. "You really scared me this time, CHUD," the manager yelled. "We had Charlie from Anthrax learning your parts... and," he paused, "what the fuck are you on?!" CHUD could barely stand straight. "I'm just a little drunk," he replied. There was little time to argue so I dragged him inside and smeared the staple white and black misfit make-up on his face, which was a difficult task, because he kept trying to undress me. At the same time their singer, Michael Graves had lost his make-up and had about two minutes to put on a skull face and was completely freaking out. "Here," I tossed him my make-up bag and turned him onto MAC crème liner in black. I was showing him how to use it while CHUD was still trying to fornicate with me right there backstage! "Later, baby... after the show," I pleaded. "Oh, what happens then?" Michael chided. "Are you going to suck his dick?" "No," I replied. "You are. I'm just going to hold the video camera." Michael and I had been taking stabs at each other for most of the tour but I thought he was hot and talented anyway so it was all in good fun. "And you better shut your mouth 'cause that make-up I gave you looks a hell of a lot better than that Halloween shit you'd been using," I added as a chorus of laughter among band and crew broke out. A moment later we were all lined up ready to take the stage. CHUD kissed my girlfriend and I and said that tonight was for us. "Get ready guys, I'm gonna play faster than ever before," he warned the other Misfits. They went on and played a great set while I

watched like a proud mother from stage left getting interrupted only once when I turned around and saw my girlfriend passed out on the wing with the boys from Anthrax encompassing her like vultures, kicking and poking at her. I ran over. "Shoo, Anthrax!!" I yelled as I picked her up and dragged her closer to the amps. She came to and after the show we went back to our nest of debauchery with CHUD and continued our threesome until the tour bus came to pick him up and take him back to New Jersey. To this day, CHUD tells the story of how he almost missed the show and makes a ritual of getting fucked up and crazy every time the band is in Portland, OR. A tradition he credits me for. Dr CHUD and Michael Graves even wrote a song for their new project, Graves, called Ophelia.

Lexa Vonn, Ophelia Rising (LA)

300lb Ogre

The best advice I could ever give a band that has dedication to progress to the next level is, kick the guy who isn't pulling his weight the fuck out! If he isn't up to par with your standards, then why are you letting him hang around any longer than he has to? This is where you have to separate friendship from business. Unless you're gay, and intend to build an extremely intimate relationship with this person, kick him out. You'll actually be doing him a favor. Sooner or later the one that is not pulling their weight in a studio, will be the first one to go. Sometimes it will take a producer/ engineer to be blunt with you and say, "Look, you're a good drummer, but you need to practice. You're not playing as well as the rest of the band, and frankly, you are the weakest link, goodbye!" That's just the truth. So to avoid an even harsher road, it's better that a mate tells him to leave before the studio plays a part in it, because when that happens, you can forget about trying to put it nicely. The producer will tell him flat out, "You are potentially going to cost this band a lot of money in the studio. You're holding them back, so pack your bags." It's happened to us every time we've been in a studio in the early days. We had a drummer that was totally over the top in everything he did. Addictions were quickly killing him. We're only in our mid twenties now, so you could imagine we were just kids when all that was going on. What happens when the band shows no signs of mercy, and the battle of rock'n'roll rages on, but the drummer is lagging behind, missing practices, and just isn't good enough to hang with the hardcore anymore? That is our story.

When I first formed the band, my intentions were to attain a group of people that were willing to work and hit the stage hard as hell. I called up an old time friend of mine who played drums. I wasn't sure if he even still played. But he said he did, so we gave him a shot. Well, after two long and grueling years struggling with this guy to meet our requirements, we kicked him out. He was a 300lb ogre who didn't care whether he lived or died tomorrow. He took each day mindlessly, thinking he'd live forever, and drank booze no end. Don't get me wrong, the number one requirement for joining this band was to be able to get messed up together and trip out to Stoner/Southern Heavy Rock. But bottom line, he just sucked at drums. Couldn't handle the kit as well as others can. It was sort of like the whole Christopher Robin and Pooh Bear thing. At one time Chris needed Pooh to get by and help him grow. They became good friends, and wanted to be side by side forever. But when Christopher got older and grew up, he didn't need the lousy fucking bear no more. He had chicks to worry about, probably, and other more important stuff to attend to. Not some stupid bear. Christopher outgrew Pooh. The bear just stayed the same age. That is kind of what happened to us. We got better, older and needed to expand and start searching for our style, and he just stayed the same as when we started. Never got better. Never cared about getting better. So before this story continues, I think we should use an alias name for our ex-drummer, to avoid a suicide or humiliation. The story can't continue without this guy being named so we'll call him Dick Shitson.

The last gig Shitson ever played with Bones was Halloween night. We played a Devil's Night gig at St Clair College in Windsor the night before. A town called Amherstburg was his last show and the beginning of our future.

I was always the man in the band that was looked at as the leader, and it only made sense for "the leader" to do the dirty deed. So I did. That night after the show, we had moved all our gear out of his dirty crack house and moved all our shit up to the band's city rehearsal warehouse. Dick Shitson assumed he'd be coming with us, since the biggest show of our lives up to that date was less than a week away. Our biggest problem was that we weren't honest with him up-front. But how do you tell a guy that he sucks ass at the drums, when all he's doing is asking you numerous times if what he's doing is to our liking? We lied to him. I told him, "Yeah man, it's all good… Rock On!" Basically that was the good ol' *Fuck you!* What he didn't know was, we had

already hooked up with a buddy of mine who played bass and drums in other bands and wasn't doing anything at the time, so we asked him to come in to our camp and fill in as a temp until we found someone we could fully trust as one of us. This guy already knew all our tunes, so it was not a slow transition at all. But the biggest show of our lives was in two days and we still hadn't kicked Shitson out. He still thought he was in the band, and that he was going to play The Loop in Windsor with us.

Dick Shitson was not a stupid guy, he figured something was up and decided to drop by the rehearsal space. There we were jamming away, working on an entirely different set than what he was used to. (The moment we got our new drummer in the mix, we started writing new material instantly. It was the greatest breath of fresh air we'd felt in a long time.) Shitson barges in with all his buddies (our ex-roadies) and demands answers while completely and totally outraged by our actions. He clearly saw that he had been replaced. To make a long story short, the guy did not want to take no for an answer, and was bothering us everyday until the show. He was not letting us get any practice time in at all, and the guy was just being his ogre self. By the end of his run with Bones, none of us liked him at all. So you can imagine what it was like to have this guy around even after we kicked him out. He was in denial and was getting wasted all the time to cope with all of this.

The Night Of The Show: Five minutes before we go on, I get approached by some hoodlums in the washroom who claim they are there with Dick Shitson, "Powerhouse Crapper!" They had threatened me and said that we would be truly sorry if we went on stage without Shitson back in our corner. None of those idiots understood shit. They didn't care what was best for the band, they only cared what was in the best interest for their landlord/friend/whatever, Shitson. So I tell them straight up, "Look, you can either move out of my way, or I'll move you out of my way. Silence! Or be silenced…" So I fled the bathroom, and checked my guitar if it was in tune. It wasn't. Fuck it. We went on that moment. From start to finish, from opener to closing tune we were constantly harassed by our ex-buddies in complete and utter humiliating style. What was supposed to be our best show became a true nightmare. Shitson was up in our face all night long swearing and cursing, at me mostly. People in the crowd were trying to start fights with him, everyone in the whole place started to realize what was going on, and the rumor

spread through the crowd pretty quickly that he had been kicked out a few days ago, and that we went on without him. The plan was originally to do a live recording that night, everything had to be scrapped because you can hear Shitson's fat voice screaming and ruining over top of everything. Out of 250 people, nobody wanted him there. We tried to fight back by using the mic to our advantage and try to explain our actions. I started to say, "We bleed for our music, and we'd die for it too. Our ex-drummer had no love for music, and didn't know how to play!" Then he threw an ashtray up on stage, followed by a pitcher of beer. Things stopped right there. The show was over after five songs. (Not bad for a headliner… yeah right!) Security warned him and let him stay afterwards. We're at our table by the stage after the show drinking, and Shitson comes up to our table and begins to holler and yell at all of us, mainly me again. This time we had chicks with us, so that wasn't very cool of the loser so we all stood up to fight and the crowd started to chant and yell — everyone was watching apparently. But security stopped it before it went any further. He was banned from the bar permanently. For a little while after that show I saw him everywhere I went. It got to the point where we were the only local band to have hired security at our gigs.

I was disappointed that night. It was the gig from hell… But if I had to go back in time, I wouldn't have changed anything for the world. Although that was the worst show we ever played because of our heavy distractions, that was also the show that got us signed.

Alex Petrovitch, Mister Bones
(Windsor, Ontario)

Slightly Covered Titties

No 1 The Joint Sucks
OK, so we get a call, and are asked to play at a music showcase in Richmond, VA, *and*, the place we'll be playing is a strip club. Excellent, Jimmy and the Teasers in a strip club — should be perfect. Things are weird when we get there, though. For starters, in Virginia, the strippers *have* to wear pasties. That's right, a strip club with no nipples. Bad sign. And there doesn't seem to be anyone from this alleged "music conference" around. Just a bunch of balding middle-aged creeps who keep hittin' on the Teasers, 'cause they think they're strippers. Someone finally shows up and, I don't remember exactly what the deal was, but there was a local band playing, so we went on first. We had a lot of our slow grind

kinda songs set to play, somethin' these chicks could really dance to. Little did we know, these ladies weren't strippin' to *anything* that wasn't played at their high school prom. Without a Def Leppard cover to pull out of our ass, we were screwed. They swayed around a little during the first song or two, rolled their eyes a lot, and then finally just laid down on their stomachs in the middle of the dance floor and stared at us. Needless to say, all the middle-aged guys that didn't come here to see anything but slightly covered tits are startin' to get *pissed*. Teasers or no, ain't nobody getting nekkid. I think we played for fifteen minutes, drank our free beer, and got the hell out. As a consolation prize, the strippers hated the next band, too.

No 2 Nature Sucks
We're doin' a show in Boone, NC, and we hear there's a hurricane comin'. There were about ten people at the show. I guess everyone was out buying candles and canned food. We don't have much money, since the gig paid hamburgers and beer, so we set out driving back down the mountain in our '78 Ford Econoline. No problems the first half-hour and then, boom! We're screwed. There's a wall of rain, 70mph winds, tree branches in the road, and water *pouring* in the van from every rusty opening. I can't go more than 30mph or so without feeling like the van is gonna hydroplane outta control. So the only idiots driving in this shit are me, and eighteen-wheel transfer trucks. And those truckers aren't battin' a fuckin' eye at the weather. They're passin' me goin' seventy, throwin' a wake like a damn ski boat over the top of the van. While that's happening, the whole sky is lighting up like fireworks because of all the power lines getting blown down. It took four-and-a-half hours to make a two-hour drive, and three weeks for the carpet in the van to dry out.

No 3 I Suck
Kansas City, MO. And the show is lookin' pretty bleak. I had *begged* a friend to help me find a show for this particular night. It was a Sunday, and the bar was an odd place for a band like Jimmy and the Teasers. The band that opened up for us were *nice* guys, but it was prog rock, and the few people there were really digging it. Best case scenario: they were gonna hate us. So I meet a dude at the bar from NC. He's glad to hear my accent, and buys me a shot of Irish Whisky. OK, *three* shots of Irish Whisky. I don't recall whether we had eaten or not, but the shots, combined with the free draft, made for one very drunk Jimmy. Suddenly, more

Without a Def Leppard
cover to pull out of our
ass, we were screwed.
JIMMY AND THE TEASERS

people show up, and it's time for us to play. Normally, inebriation wouldn't bother me, but this was the night from hell. To my recollection, one cord, two batteries and a guitar input jack all quit working within the first four songs. I just couldn't deal with it in my state, and tuning without my tuner (dead battery) was a total impossibility. But still, I could take it, if it weren't for a guy in the back of the crowd going, "OK, come on, North Carolina, we wanna hear some rock! What's the matter with ya?" He just wouldn't shut up. So, I drop the guitar I'm wearing, and storm out after the guy. I get to him and he looks kinda shocked. I take the cigarette outta his mouth, take a drag, blow the smoke in his face, and hand it back to him. He never says a word. I walked back to the mic, said "Fuck it, just don't pay us," and went out to the van and passed out. I had to buy a guitar the next day in Oklahoma City to replace the one I dropped. And a pack of batteries.

**Jimmy Brad Ray, Jimmy and the Teasers
(Raleigh, NC)**

Drunk, Coked-Up, Enthusiastic

We were on a very long tour, thirty-four shows in thirty-eight days or something crazy like that. We were down in Chapel Hill, NC playing at the Local 506. Walking through town, Steve (drummer) disappeared for a few minutes. We find him talking to a drop dead gorgeous blond woman. I'll call her Jane. Classic hot chick in sexy business suit. Tells Jane to come to the show that night. That night Jane shows up… wearing tight blue jeans and black leather vest. She looks incredible. We play the show, play some pool, then end up back at someone's house, with Jane hanging in tow. Next couple of days she is traveling with us. She's got this poodle and a car full of stuff. We dunno what to make of her but she's taking care of Steve, so who cares? We end up playing at this warehouse-like club in Spartansburg, South Carolina, called Ground Zero. This is years before September 11. Who knew? Anyway, they got a couple of pool tables, a long bar, a huge stage and a cobblestone floor. Our girl Jane has been going outside a lot. We suspect she's a coke head but she isn't giving it up. She's wearing a black leather miniskirt tonight and high heels.

We start playing and she's drunk, coked up and very enthusiastic. She can't hold herself back. She loves the music. I look out onto the dance floor on this desolate Wednesday night out in the middle of fuckin' nowhere and all I see Jane start dancing in her high heels on the cobblestone floor, then — boom! She goes down. But in a few seconds she's right back up again. Starts danc-

138

ing then — boom! Down she goes. At first I was concerned but now I can't stop laughing. I don't think the other guys see her. They are just trying to get through the set. Now I'm cracking up, missing notes, not even singing. Jane must've had some really good coke cuz she was feeling no pain. She must've fallen down at least fifteen–twenty times during our set. After a while I got tired of laughing.

Pete Cassini, the Peasants (Boston)

Shooting Squirrels

Gigs from hell? I think we have one that wasn't, and it was cancelled. Every band has had their fair share of crap gigs… the out of town show where you'll play like gods and sell hundreds of CDs that takes place in a thirteen-year-old's backyard in front of both his friends for his birthday celebration. We won't get into these, it would take me a whole sycamore trees worth of paper to do so. How about our story instead? I'll map out how we made it nowhere.

Things started out nice — they really did — we had four songs and recording dates set, the sky was the limit. (I don't know who lowered that awful sky on us.) Two weeks before recording, a night made up of heavy drinking, the loss of a wallet, the entrance into an unlocked fire department, and the trying on of firemen's clothes (and hat) was all summed up in one final vision. That vision can be best described with our drummer drunkenly stumbling down some stairs in slow motion (imagine Europe's The Final Countdown in the background to make it more dramatic), bouncing off of walls and coming to a hasty stop at the bottom, where he would lay limp. Needless to say, his arm was broke, he would not record with us (nor play with us ever again), and our guitar player would perform drums on our first recordings.

Things were shaky, but heck, we were resilient and quickly sprung back with a new drummer, the kind of drummer that all bands who don't have a drummer dream of. We finally got our stuff together and found ourselves playing out again in no time. A couple of shows later, it was Mommy's Little Monster by Social Distortion that we were playing when I swung my bass — I have a neat little trick where I push my bass real hard and it goes all around me and comes back to its original place, but it never works because physics is wrong. I swung my bass and it stopped quick. Something went wrong again. I looked around and saw our singer holding his lip. He calmly made his way to the bathroom, to

clean a whole bunch of blood off while panicky thoughts raced through the rest of our heads. Thoughts like, "Should we stop playing this song?" (we didn't)… "This sounds kind of boring without a singer"… and "Where'd I put my beer?" Well, that show ended and now Mike (our singer) has a scar above his lip, and I recommend he grows a moustache.

We practice at a Polish club. We're not Polish. We usually practice on Wednesday's and Saturday's (which is not important to anyone reading this unless they are in our band). Usually Joe, Dave, and myself show up for practice and then Mike (our singer who should have a moustache) comes later. One Saturday's practice, only Dave and Joe showed up first, and were left to question my whereabouts. Where was I?…I was exactly where I should have been; I was crawling through the woods by myself, drinking water out of puddles filled with oil, with a bullet stuck in my leg. You see, I had been target shooting earlier and threatened to shoot a squirrel with my beloved .22 pistol. Instead of shooting the squirrel though, I opted to do my impression of Billy the Kid (who shares my initials, BTK) and spin the loaded gun with the safety off around my finger. I ended up in the hospital for a week since I lost nearly all my blood and again all shows had to be put on hold. I've done funner things.

Is there no band ethic? All bands should do whatever is necessary to help out other bands; it's a rough world out there. This is not the case in Erie. In Erie, it is survival of the turtlenecks. We shared a practice room with this crummy band, Rockets Red Glare. The room was signed over in their name so we had no say. They became uncomfortable with our side of the room. How bothersome we were to them, they would hold grudges over a cigarette butt being on the floor — how rock'n'roll is that? So after the second cigarette butt was found, stowed away under a couch cushion, the camel's back broke and they changed the locks on us. Fine and dandy, we broke the locks, entered the room, took back our things (and some of theirs) and left. They owed us money so we took their drum cases as ransom and sold them back to them. For a few weeks we practiced in a bedroom, and hopes of finding a new place to practice seemed slim. It took a while but we were finally able to get our own room — right across the hall from Rockets Red Glare — at the Polish club. Now they don't have anymore cigarette butts on their floor, but we see to it that they have a steady supply of after-practice-ball-sweat caked on their outside door handle.

And that brings us to where we are today. It is now time to part, we must go look for the 300 CDs we misplaced somewhere.

Klins, The Good Guys (Erie, PA)

Eight Years of Hell

Gig from hell? Is there any other kind? Hell, we've spent the last eight years traipsin' through Dixie, playin' in every backwoods, stab'em-and-slab'em, blood bucket juke joint that'd let us up on their stage for an hour. I reckon' I've seen it all: bad women, bad dope, and cheap whiskey; brave words, bloody knuckles and broken bones; fist fights, buck knives and Saturday night specials; band members too drunk to play, too mean to quit, and did I mention the not-so-welcome participation of various law enforcement agencies? In the early days of Hellstomper that was an honest-to-God typical night. And who even knows what the fuck happened on the nights none of us can remember? Wanna hit the highlights?

1994 Nobody knows how to bill four often ill-tempered, hairy-assed hillbillies who play country music at louder-than-God decibel levels. As a result, our first gigs are shared with food stamp punks, hippy jam bands, and absolutely horrible metal bands. Everyone hates us and we actually make a guy cry one night when we break out our version of the Freebird: a big, dead rooster.

1995 Our second gig with Antiseen. It's the first one in our hometown. Some people get mad at us because they think we're buddies with the half-assed, flea-market skinheads that are there. The skinheads get mad because I taunt them (let's face it, they stay mad all the time anyway). Halfway through our set the rather large crowd erupts into what most folks would call a full-fledged riot. While we're literally beating the hell out of everybody coming at us, my ol' lady gets cornered at knife point by a cranked-out mullet head in a side room. One of my good buddies from Carolina helps her out while exercising his right to bear arms. I'm confronted at the end of the night by a scenester who reads me the riot act as I'm holding an axe and losing my temper. Fisticuffs are avoided as he slowly realizes I can pretty easily kill him like ol' Paul Bunyan chopping down a tree. Our next gig with Antiseen follows the same pattern pretty closely. I wind up in a fight with some balding, low-rent piece of punk trash. Jeff Clayton forcibly holds me back like a mad pit bull on a leash. Why in the hell is the video camera never

running when it should be? Later on in the year, in a drunker stupor, I cover myself and half the crowd in watermelon and flour. What the hell was I thinking? Who knew that was how they made krazy glue?

1996 After our guitar player and myself almost come to blows in the parking lot of one of the worst beer-joints in the state, I decide enough is enough and put a halt to the whole damn thing. It's all getting on my goddam nerves.

1997 Hellstomper reunion of sorts in Lawrence, Kansas at the Confederacy of Scum Supershow. It's hot and miserable and I get about six hours sleep for the whole weekend. Did I mention it's hot and miserable? We go way, way deep into the hole to play this show. Musta been a sign of things to come. And goddam, it was hot and miserable!

1998 Revolving door consistently spins and we change at least one band member every six months. Sweet GA Brown shows up at a gig with an amp made of plywood and chicken wire — no shit. The sound is bad enough without the improvised amp and since me and our bass player have been in the cups, we write up our set list wrong and spend the whole night playing different songs than the drummer and guitarist. We don't even realize it until the set is almost over. Fisticuffs in the parking lot.

1999 Literally drive through a hurricane on the Carolina coast to play to fifteen people. Tornado touches down on the freeway about ten miles behind us. God hates us. We play at a local bush league wrestling card where we are billed as "A Rock Band". We are required to play inside the dilapidated ring so we have to tie our amps to the corner posts so they don't fall over. We are flipped off by twelve-year-olds who consistently holler "*You suck!*" while their sling-blader parents stuff tissues in their ears and sit with their arms crossed. We play an Elvis tune to try to win 'em over and are accused of "ruining one of the purtiest songs ever written". The management pulls the plug. Shocking sidebar to wrestling story: we are actually paid the full amount we were promised at the end of the night.

2000 Bar owner cowers in the corner behind his bar after ripping us off. His "bouncers" and a rent-a-cop threaten me with physical violence and arrest, respectively. I threaten back and it's dropped like the proverbial hot potato. The drugged-up bar owner (a misplaced yankee know-it-all, I might add) will *not* quit running his goddam mouth. It's not enough to merely rip us off, he has to continually harass us with taunts of "roughnecks" and "white trash". He finally presses the

panic button under the bar and soon half of the Hamilton Country Police Department are on the scene. We split while he's left to explain why he did something so retarded as to press the panic button and why he's serving beer to minors.

2001 We tour Texas with our pals in Cocknoose. Average pay is around $30 a night. One night we wind up in a fucking reggae bar that doesn't even have a working cooler. It's over a hundred degrees inside and we are charged $1 a pop for hot bottled water. We play a rousing set under red, yellow, and green pictures of Bob Marley. We be jammin'.

2002 Our first show of the year is in three weeks. Will it be a gig from hell? Like I said before… is there any other kind? And call me crazy, but I fucking love it.

The Goddamn King, Hellstomper
(East Ridge, TN)

The Relic Scores

I was on a tour of the western US with a power pop band out of Seattle. The road manager for the excursion was an antiquated old relic. We had to pick him up from the dry-out center on the morning of initial departure. As the tour rolled along, the aforementioned manager began to complain with a certain degree of regularity, about his consistent lack of feminine attention. Being in his middle forties, and touring with a band who played primarily college type venues, he was spending many nights alone in the tour bus. Then one night as we were casually sipping a few prior to a show somewhere in the magnificent state of Utah, there appears before our bedazzled eyes one of the most beautiful mature blonde women that I have ever had the pleasure to behold. She walks straight up to our table and says, "Hello, Joey." (That is the manager.) She leans over the table and plants a big kiss on him. Joey just looks at us with a crazy look in his eyes. "How good to see you," he says. "Sit down and visit a while." Getting the hint we left him alone there, and kept a casual watch on the two from across the room. There was a good deal of smiling, petting, and laughing going on over there. We did the show, and we all did double duty so Joey would have some time with his new friend. Shortly before we were to leave we returned to the table just to check on things. They were still getting along fantastically, when Joey spilled the beans. He looked this woman straight in the eyes and said, "I am so sorry, but I have to tell you, I have been playing along all night, but I can't figure out who you are, or how I might know

you." The woman just laughed and said, "Why Joey, you should remember me — we went to school together." Then she told him her name. Joey turned instantly pale, got up from the table, and left without saying a word… Later that night in the tour bus we began with the inquisition, "Who was that woman, and why did she make you mad?" So, Joey lets us in. "She did not make me mad. I just remembered who that was. *That* was a good friend of mine from high school. I mean like we were locker partners in PE. That Michelle, was a Mike. I almost went home with *that* tonight. We were good friends you know, when I realized who that was I felt somehow betrayed. I didn't know whether to hug him or punch her. I just didn't know what to say."

Jon Fosdick, Dog Leg Preacher (Seattle)

Hammer of the Clods

The worst gig of my life was as the guitar player in a San Francisco based punk rock'n'roll band, The Almighty Sons Of Rock'n'Roll.

Kimo's is a dive bar on Polk St at the edge of the Tenderloin section of San Francisco. This particular stretch of Polk St is best known for it's underage male prostitutes and transvestite hookers. Possibly for these reasons it's something of an SF tradition to play at Kimo's in drag.

Since we were already pretty ugly as guys we figured we'd mix it up a bit. Me and Matt (the other guitar player) would wear dresses, Mike (bass player) would do a Nikki Sixx/Glam thing. Nate, our singer, decided to start the set off with a black Elvis-style jumpsuit with lightning bolt lapels. During the "drum solo" he'd change into a white version of the same suit. Mick, the drummer, decided to play naked.

We were headlining and we had a small guarantee which we needed pretty badly, since we were broke as hell. Somehow it was decided to include some flashy stuff: lights, smoke machine, maybe some shit to blow up. Nate worked at a lighting company and managed to convince a co-worker he could borrow a lighting rig. A smoke machine was also procured for the evening. We rehearsed a KISS cover (She) and we were pretty stoked on it. Nate had just bought a new vocal preamp and some kind of reverb/delay thing. We got our outfits together, waxed our axes and polished our knobs. This was gonna be great. Get it on.

For some reason our van wasn't working that night, so Nate borrowed a very, very old pick-up truck from somebody. We loaded our gear in the back and set off

for the club. We looked like the fucking Beverly Hillbillies, driving through the city with our gear falling off the back. We got to the club and carried everything up a flight of stairs to the room where they do the Rock. Kimo's is a two-level joint with a bar and a karaoke machine downstairs and live band room/second bar upstairs. At the time, one particularly groovy feature of the club was that there were no windows or ventilation upstairs.

It became pretty obvious in a matter of minutes that the sound guy was tweaking on some kind of drug.

Then again it's the nature of the drum solo to seem a lot longer than it probably is.
BLACK FURIES

that Nate and Tweak-boy were having a hard time getting the PA to work. After a while it became apparent that Nate's new vocal effects/pre-amp thingee was not gonna work through the PA, but it was possible to get signal without it. I made the mistake of suggesting to Nate that he do the gig the way he'd done every gig for the last two years… without vocal effects. He didn't seem to like that idea. Around this time Mike made the same comment. Nate didn't like it any better coming from him. At this point we had been standing around for about ten minutes, doing nothing. We decided to

He got the PA up and running and then somehow couldn't keep it working (the *only* thing he had to do was get the PA up for vocals, nothing else got miced). He was talking awfully fast and he was spending a lot of time connecting and disconnecting wires and looking confused. One speaker would work, then another, then none. Not good.

The opening bands played. They were all good. The PA seemed to work well enough for them to get the job done. More people were showing up, the room was getting pretty crowded. We were ready to rock. Not being in any particular hurry to look like idiots, we set up the amps and drums in our street clothes. While the rest of the band were setting up, it seemed

change into our "outfits" and take it from there. By the time we got back to the stage there was still no progress with the PA. After another few minutes of standing around doing nothing (but now dressed like idiots) I finally said to Nate, "Hey man, let's just work with what we've got." He didn't like that at all. He was pissed now. At me, at the sound guy, at the whole fucking world apparently.

Finally even he'd had enough, gave up and changed into the first of his two jumpsuits. Someone started up the smoke machine, Mick walked through the crowd naked as the day he was born (and probably dropped on his head). We were off.

About twenty seconds into the first song I realized

that my microphone wasn't working. No backing vocals. When the song ended I pointed this out to Nate, thinking maybe he'd say something to the Sound Tweaker.

Instead he shot me a kind of deadpan look and said, "Hey man, let's just work with what we've got," and turned away. Ouch.

The sound at Kimo's is fucking horrible on a good night. A friend of mine who won't play there anymore says it's like playing in wind tunnel. Our sound that night was especially bad. Wall of mud bad. To make the whole thing worse we were loud as fuck.

Halfway through the second song I broke a string. I switched guitars and broke another one. Wow... a new record. Everything stopped while I changed the string. Nate seemed to be getting progressively more distressed as I tuned up.

Songs were started and aborted, nothing in particular was audible through the mud and it was kinda hard to breathe, but the crowd seemed to be having a good time. I guess they thought it was funny. Maybe they even thought some of it was on purpose. Somehow we made it through the first half of the set. The plan, at this point, was for Mick to start the drum solo while Nate changed into jumpsuit No 2. The Big Rock Lights were supposed to come up and I'm pretty sure there was also going to be some kind of explosion.

Mick started the drum solo. The smoke machine went off again, the fancy lights flickered for a second and... the fucking power blew.

Gotta hand it to Mick, he didn't miss a beat. He played his naked ass off until someone figured out how to get the power back up. Which seemed like a lot longer than it probably was. Then again it's the nature of the drum solo to seem a lot longer than it probably is.

The power came back on, the light show was retired (unused), and Nate returned to the stage in Jumpsuit No 2. We launched into our well-rehearsed KISS cover and everything went horribly, irretrievably wrong. Somehow all five of us were playing and/or singing different parts of the same song. We finally got together on the verse and then lost it again on the chorus. Nate walked off, throwing his microphone (the only one that worked) on the ground. I started trying to sing the lead, shouting over the band in the general direction of the audience. After about five seconds I realized I was screaming pathetically and inaudibly in front of the world's worst KISS cover band. Wearing a dress, fishnets and a blue sequined cowboy hat. Nate returned to the stage, we thought to finish the

set. He started packing up his stuff and wouldn't talk to anyone. We tried to point out that people genuinely seemed to want more — God knows why — and that we still had some rock left to give the people. Sure, the whole thing was embarrassing as hell, but funny as shit at the same time. I guess he didn't see it that way. He walked out of the club and quit the band.

AFTERMATH

The guy who had "borrowed" the lights was freaking out because he was gonna get fired if he couldn't get them back that night. He seemed like he was on the verge of tears. We had to finally give him cab fare. The pick-up wouldn't start. Only Nate had the owner's phone number and he was gone. We were stranded. At 4am the club closed and we had to leave our gear overnight and rent a U-haul the next day to get it out. Between the cab fare and the U-haul we spent all the money we made that night. We never played another gig together.

Cliff, Black Furies (San Francisco)

Big Disasters are Better

Bands are like cliff faces — they start out imposing and impressive, but the elements erode them every day, and once in a while a real jeezer of a storm comes along and strips off a whole layer of strata. You can see the most burnt-out ones, shuffling along by inertia alone, little craggy molehills that are just waiting for that one last rainstorm to flatten their asses for good.

None of us still harbor that childhood delusion of "making it big", but — call us optimists — we still like to view the rock'n'roll world as a big, smelly group group of camaraderie, rockers and club owners and sound guys and the people who put out underground records and zines; no one getting rich, but all in this together for the fun of it, and the greater good of the rock. When it's not like that, that cliff face gets smacked with a windstorm full of stinging sand, and you're one step closer to selling off the van and letting the ass fuse permanently to the couch (or, worse yet, the office chair at work).

It's the little things, too... driving to Cincinnati with your guitarist's girlfriend's band in tow, only to find an improv troupe double-booked at the bar you're playing, and then watching them skate with the door money at eleven, leaving you four dollars (the cover of the two dudes who walked in after the thespians flitted off

143

to karaoke)… pulling up to an empty bar in Chicago on a Friday night and, upon announcing your presence, hearing "there's a band tonight?" from the bartender… trading shows with a band who treat you like kings and put you up, then bringing them to town on the night when the bar across town has a bill so hip, even your bar's owners take off to go bathe in the cool rays, leaving you looking like dicks in an empty room…

Big disasters are almost better, because they become the stuff of road legend (remember that time we got a flat and the semi driver on ephedrine knocked the van into the ravine and the redneck cop cited us instead and ass-raped the bassist?). The little things just pile up, a constant murmur in the back of your mind,

> A girl staying with him
> had run his phone bill up
> into the hundreds spending
> hours on the phone with
> someone in San Francisco.
> WILMA

like the entire universe is quietly chanting "fuck off" at your band. Some succumb to it early and crawl back home, and spend the rest of their lives telling inflated stories of their rock'n'roll years to their buddies down at the sports bar on Ten Cent Wing night. Others start to feed on that murmur, though, and you can see the lines in their face and the bags under their eyes deepen as they strain to keep hearing it with ringing blasted ears. Going back out and rocking more shows is the only way they've ever learned to say "fuck off" back at the universe.

I'm not saying we're that old, jaded, crisped and haggard yet. But if you are, we're probably opening for you some time this summer.

Keith Bergman, PB Army (Toledo)

No Beer for the Drummer

My cute little wife was finishing her education at the University of Texas and we lived just off campus in a cute little yellow house. We decided to start a band together, so she took bass lessons and I took guitar lessons. After about six months, we placed an ad in the local paper seeking a drummer. Within days, we were auditioning a music student also attending UT (University of Texas), who lived less than a mile from our house. I had just finished an enlistment in the Air Force and he had just finished his enlistment in the Army. It was perfect. We loved him. He had a small Ford station wagon and I had a truck. He worked at a sandwich shop where

we visited him from time to time. Within weeks I knew his phone number by heart. We played our first gig and it was magical. Then another. And more followed. We had been a band for about two months when we hooked a gig down the road in Ft Worth. I loaded up the amps and guitars in my truck, and he loaded up his station wagon with his drums. Off we went. About half way there, his car threw a rod. We adapted and overcame, but hence forth, he would no longer have a car. I was now not only his guitarist, but also his driver. The next week his phone was cut off. A 300 pound junkie of a girl staying with him had run his phone bill up into the hundreds spending hours on the phone with someone in San Francisco. He couldn't pay. The stress must have been getting to him because within a week he got fired for drinking beer on the job. Within a week of

that he got thrown out of school. Things started to change in our little band. He'd show up at our doorstep at 10pm in the middle of the week demanding cash for beer. "No" was not the answer he wanted to hear. He then demanded I get my cash card and go to the convenience store with him. He'd need a ride to rehearsal, then afterwards to his girlfriend's house. The fact that he outweighed me by about a hundred pounds started to be a factor. I knew something was wrong

when it became my job to break down and load up his drums after shows. Ten drummers later I have come to the conclusion that being in a band can be over rated. Big time.

John Marshall, guitarist of Wilma (NYC)

French Sweethearts

Let's see… June 12, 1999. Undercover Slut show at La Péniche Blues Café — Paris, France. That Hare Krishna lover/sucker of a promoter along with those venue owners, aka Paris' notorious Jewish mobsters, cancelled our show fifteen minutes prior to being on stage. They obviously couldn't stand our use of Hitler's samples during our sound check… But also, don't forget that you can make way more cash from your insurance company canceling a show than actually selling tickets even if it's a sold-out one. Some people would do anything for money. Another one involved an Ohio redneck coming to Paris to be our drummer, circa March/April 1999. That loser obviously couldn't play at all… just a cheap trick to spend some inexpensive vacation in our beautiful city… Speaking of drummers, we have another story (Summer 2001) with another moron who left our band the day we were supposed to buy our plane tickets for our US of AmeriKKKa tour last year… The death threats are fun, too! From the Muslim freaks to the Torah fanatics, it is so funny to witness their stupidity and lack of information… If it was a movie it would be a cross between *Blair Witch* and *Hedwig and the Angry Inch*… Promises, lies, drug & alcohol abuse, violence, rape, white supremacy blame, blah blah blah… you'll discover the sordid truth in our forthcoming best seller whenever we'll have the time to write it

'O'/96/Dazzle/Vile
aka Undercover Slut (Paris)

Redneck Millionaires

He spent all his gig money on foot powder and ice cream, had $20 wired to him not aware that Western Union charged fees for this service that would leave him with only $9, and started a tour knowing twenty-five songs then after two months of solid shows remembering how to play only twelve of them.

Our bass player JR was both a constant amusement and a constant knuckle in the band's ass.

First practice illustrated this point perfectly… while packing up he tells us that his first tattoo was when he was thirteen years old and his buddy's mom attached a guitar string to her vibrator, dipped it in some ink and scrawled something that looks like a Aztec warrior stepping over a speed bump with an ice cream cone in his hand. While we're laughing at this, he then pulled out a Ziplock bag full of pennies with a few sprinkles of dimes and nickels to pay for his end of the practice rent (I think there were also some game tokens which he claimed were "still good").

With JR, you either said "What the fuck?!" in an amused or frustrated tone — always quick smiles followed by long frowns.

While there are hours of JR stories I could tell, here are some of the ones worth your time:

REDNECK MILLIONAIRES
Toured with this band called the Hookers, bunch of

What time the bands
go on is the least
of my worries!
THIRD GRADE TEACHER

good ol' boy rockers from Kentucky. He claimed that they were a bunch of poseurs who actually are trust fund babies with tons of money who are acting like struggling bluegrass folk. When pressed to explain himself, he looked at the drummer Buckshot and I, gave us a pity headshake and said, "Guys, they're from Kentucky. Kentucky is a commonwealth. *Commmon wealth.* That means everyone there is rich"

PER DIEM

In Philadelphia, the club we were playing at had a downstairs restaurant for which they graciously gave the band $10 credit to eat. We all sit down and order. JR asks for the "$2 salad and the rest in change". The waitress, as well as the rest of us, looks at him waiting for him to laugh… but it never came. He ended up getting five salads and asking for a take home bag.

ALIAS

Then there were his theories. He explained to us that he was going to "use one of his aliases" to secure some money. When pressed to explain (as you can see, this happened often), he told us that his friends claimed that as a US citizen, we were each afforded two aliases which we were at our disposal to use during our lifetime. He was going to use his to get a couple credit cards.

SCUMBAG WHORE

Also there was the whore he signed over a second party check made for $100 to, who would only do it if she kept the check plus $25. She then said she would buy a round of drinks on her credit card then at the end of night asked him for $30 for his end of drinking. She also made out with him for twenty minutes then jerked him off in the bathroom… for $20. So out of $100 bucks he was left with $25. He then threw a fit when we wouldn't give her a ride home, which was thirty miles in the other direction (actual exchange: ME: "Bitch could have got a cab with the money she scammed from you." JR: "Hey man, don't call Angel a bitch.")

ROAD LINGO

And in closing…we were driving in Tennessee where on the roads there are signs that read, "Slow down", "Falling Rocks" and other cautionary signage. We drive by this one sign, which I didn't see, and JR says, "I heard about those things coming in from Africa and attacking people in Florida but I didn't think they would make it up here." I asked him what he was talking about. He said, "I just saw a sign back there that said, 'Be Alert' and I thought it was weird that those killer bees made it all the way up here."

There are other stories that involved too much alcohol, masturbating in ramen cups but every band has a story like that. And I bet every band has their JR, someone who helps the band musically but takes it down in other areas. We got a new bass player after that tour, which was best for all parties considered. Last time I heard about JR, he was playing in a Led Zep cover band in Croatia… he claims they are as big there as the original band was in US.

Donnie Razor, Throttlefinger (SF)

Treestock

Gig from hell, eh? 3GT has been lucky with so many great shows that most bad memories have been overshadowed and forgotten. Any (barely) worth mentioning are of the ya-had-to-be-there-but-we're-glad-you-weren't variety: the skinhead riot and stabbing outside the now-defunct Natural Fudge Co; the shady and indifferent Mafiosi-style "dinner club" where a screaming, deranged security thug nearly beat up our guitar player David right before we played… And while it seems unfair to include benefits, usually "organized" by folks lacking both a clue and experience in putting rock shows together, special dispensation should be given for these (hint #1) unadvertised gems: "Treestock," a vague tribute to trees on a cold, wet, makeshift stage hours from home, and attended only by its beneficiaries; and the self-benefit for the meth-addled booker who graciously snapped at this "headliner": "What time

the bands go on is the *least* of my worries!" (Hey, just trying to help.) The tweaker psychodrama only went downhill from there… All. Day. Loooong. Couldn't save that sinking ship!

Laura, Third Grade Teacher (LA)

Bandmates Suck — A Primer

Gigs from hell. Had quite a few of those. I have been thinking about those moments when you know it's going sour. That split second between tomorrow, oblivion, and your last whiskey. You scream at the bartender to bring another round and mumble something into the microphone about murder in hopes of making the audience afraid of you. With us, the gigs from hell were gigs from hell from the get-go. The ones that turned out like fire in a hell party were hot from the opening scream of feedback. The only defining variable in direct relation with stardom and a nice warm welcome from the You Suck Club is, well, who we had recently hired as our rhythm section.

We changed rhythm sections every two weeks for about four months straight. Sometimes it was them and sometimes it was us. Either way it always ended up with two guys who didn't know the songs. But a wise man once said, "Shopping for shame with a dead man's taste is a little bit of lovin' and a lot more waste." With that avenue in need of extreme repair, we sought out a spot in the local musician section of the free paper in town. Whether we had musicians or not, we kept it in the paper 'cause we knew one of the assholes was going to quit sooner or later. So to let you in on what we did wrong, we have written an article entitled:

FINDING BAND MEMBERS AND
HOW THAT FUCKIN' SUX
I'm just gonna rant for a little and try to show you how bad it can be. You can look at it this way if it helps: marriage is a joining of two souls for better or worse until death does them part. Keeping a band together requires a similar style of attention. Be aware our brothers and sisters, the band's future is dependant on the people you take this death wish with. The simple difference between a marriage and a working band lies in the fact that one benefits from the ingestion of large amounts of bourbon and the snorting of speedy substances for inspiration and the other one doesn't. So when people come to audition you gotta keep your eyes open and avoid a few character traits. First and foremost, people's habits that are noticeable at the

beginning say a lot about that person. It means they do it a lot. From our experience, these are the habits that led to them leaving the band. Here are a few in no order of importance:

THE TALKER
He talks too much, all the fucking time, never shuts up about how he fucking saw Metallica seven times in one year. I don't give a shit. I fuckin' hate Metallica.

MR LET'S BE FRIENDS
The guy that gets in a band to make friends. If I only see you at practice and the show, that's cool with me. Just because we like rock doesn't mean I believe in all the shit you're talking about karma, so don't fuckin' bore me with it.

MR NEW SHIRT
If he shows up to the audition and doesn't have at least one hole in some article of his clothing, chances are, he's a cocksucker.

MR I DON'T DRINK UNTIL AFTER I PLAY
If he's not getting wasted by the third or fourth practice, you should tell him to fuck off cause rock'n'roll is about fuel. I only know one kind and it doesn't start with the word coffee.

MR HEAD FUCKED
If in all his music collection he doesn't have one copy of *Bloodrock 2*, then you should tell him to take the next fuckin' train to hell cause that's where the sorry bastard belongs.

MR MISGUIDED
If he doesn't think Urban Cowboy is fuckin badass, then tell him to go live in Pasadena for a year and tell me if wasn't a hell of lot better with a mechanical bull. This might not seem so critical but you're going to be arguing with him all the fuckin time…

"LEE — LIKE BRUCE LEE, LIKE LEE MAJORS"
If he uses this as his introduction and tells you he was born on the same day as Napoleon, then he is probably a fuckin' lunatic.

MR SEX STAR
If he thinks you want to hear the intimate details about what turns his fat wife on, then show him the door. And a rocker shouldn't have a wife in the first place.

THE DUMBASS

If he is so fuckin' stupid that he thinks people from New York can't understand people from Texas due to the differences in dialect, kick his ass out and throw his fuckin' shitty drum set at him.

MR USED TO BE LIKE YOU

If a guy shows up wearing loafers but starts talking about how he used to be a mechanic just because it looks like you were sleeping under a car, cut your losses and tell him it was nice laughing at him.

MR JACKASS

If he asks you at the audition to tune his instrument or if you have any drumsticks, please tell him to fuck off! This guy is gonna be a pain in the ass in more ways than one.

The ideal situation would be to place this information in a location where auditioners might read it. In sum, if they felt they were in one off these categories they would not waste your fuckin' time. A newspaper might be a little expensive, so you should condense the info and probably avoid anything like this:

> LOUD DRUMMER NEEDED
> To drink cheap beer and play at shitty clubs. Influences include Jim Beam, Old Crow, and PBR.
> Call ———

From the results of this ad, it would seem apparent that professionalism and musicianship are of oxymoronic maximums. However, from what I have seen in magazines and books there are those that strum and hit who take their passions seriously. I have illustrated what not to do, for a more affirmative approach for the search, I can only suggest your daily *Behind the Music* or your successfully gigging local guitar store clerk (if such a character exists).

Dale Bookout, Kent Hassinger, Sawtran (NYC)

Part 4

WAGE OF MAYHEM

Rock and roll
over the edge

**I want to make you
as sick as me Rock City Crimewave**

Blood and Guts

In almost twenty years I have spilled a lot of blood on a lot a stages all over the world. But sometimes the things that go on in the audiences simply astonish me. I'm not clear on dates but I do remember cities (for the most part) and here are a few of our "crazy kids" craziest moments:

GERMANY

A Sid Vicious look-alike was pogoing and smashing into folks who just didn't care to be bumped in to. In retaliation, a couple of skinhead "looking" types pulled a blade and cut him across the stomach from side to side. He was holding his guts in when the club owner asked us to leave the stage until the paramedics came to get the guy. About twenty minutes later we took the stage once again and picked up where we left off.

HOUSTON, TX

At The Emo's in Houston, we played to packed house. Most our shows in Texas are very well attended…They just like our kind of *shit* down there. Anyway, another skinhead "looking" type was being overly enthusiastic in the front and some kid who was trying to watch the show stuck him with a jagged beer bottle top and the guy was carted outside until paramedics could reach him.

HOUSTON, TX

The Axiom club. What a violent city. Some crusty, neo chicken looking modern primitive grabbed Tom O'Keefe's bass strings in mid song. All the poor sod got for his trouble was a kick and a smack in the mouth from Mr O'Keefe. About fifteen minutes later the crowd parted like the red sea and we saw Mr Modern Primitive getting kicked more times to the head by than I think I've ever seen in my life by about six or seven other patrons! Needless to say, he didn't walk away. Now the kids aren't always the ones who cause the shit. As we see from…

CLEVELAND, OHIO

During my wonderful washboard playing section of our set, a group of young punk rockin' types bumped into my mic stand sending the mic smashing into my teeth. In a moment of blind rage I picked up the mic stand and hurled it like a spear into the crowd. Instead of clobbering the little group of punks I was aiming for, I pegged an innocent bystander right in the face with

the base of the stand. He didn't have me arrested. Whew!

LAFAYETTE, LA

During our 1994 tour of the south and mid west with our pals Cocknoose, we played a club in Lafayette, LA. For some reason , we seemed to rub this crowd the wrong way. A happy loving married couple in particular. After my infamous "juicing" gimmick I jumped into the crowd. Dumb move. Mrs Married Woman decided that she would toss an entire pitcher of beer in my face. With the mixture of blood, sweat and beer I was temporarily blinded. Not knowing exactly where this was heading, I wrapped the mic chord around my hand and did my best Roger Daltry impersonation, and backed the entire audience into the back of the room. Mrs Married Woman, not being satisfied with the pitcher toss, decided to heave a beer bottle at me full force. Through sheer dumb luck, the bottle missed me, but beamed the guitarist from Cocknoose right in the head. He was nearly knocked out cold! I made my way back to the stage and managed to get my site when all of a sudden Mr Married Man came up to the stage making all these mock moves, shooting the bird and motioning for me to get back down into the crowd. I laughed in amusement at this bozo who looked like he was doing a mating dance for gorillas then our guitarist' Joe Young jumped off of the stage and grabbed the guy around the neck and started pounding him in the face. Jeff BBQ Young, Joe's brother and our merchandise man, was there in a flash and crashed into Joe and the guy falling into the PA columns nearly knocking the entire stack to the ground. As this was going on the power to the stage was cut and the soundman started gathering up microphones saying "shows over, shows over". The show I guess indeed *was* over, but the entertainment was just beginning. Widowmaker and Commander PP from Cocknoose jumped in to assist the Young Brothers and a few people jumped in to help Mr Married Man, including Mrs Married Woman. Commander PP swung a beer bottle her way and it smashed against her fist which had her wedding ring on it. Minimal damage was done to her hand but the wedding ring was destroyed. My brother Greg and I made our way of the stage and into the whirlwind of people that was heading towards the front door. The married couple made it out onto the street only to be chased by PP, Widowmaker and the Young Brothers. As Mrs Married

In a moment of blind rage I picked up the mic stand and hurled it like a spear into the crowd.
ANTISEEN

Woman cried and screamed about the damage to her wedding ring, Commander PP replied with the line of the evening "go to Kmart and buy another one , baby!!!" As we exchanged words with a few of their friends the club was soon empty . We figured we should maybe get packed up really fast in case they were to bring back reinforcements. Instead, a cop car pulled up. The two cops , both male, one black and one white, came in and shouted "Who is the lead singer of the band?" With my blood covered face and beer drenched hair I raised my hand. They demanded that I go outside. This was real soon after the Rodney King beatings, so I asked my band mates to please check on me after a few minutes! The first thing they asked was "What in the hell happened to you?" I had to explain how it was part of our act, no different than pro wrestling. They informed me that the couple had gone to the station and said they wanted to press charges. The woman claimed to have a broken finger and wanted someone to pay for her ring. I asked if I was under arrest, and they told me the complaint was not filed out yet, that they were there primarily to break up the fight. Well, I seemed to make a good impression on them, and before long we were laughing and joking about the whole thing. When asked If I would be getting a summons, they just suggested we get out of town and if charges were pressed I'd be obligated to appear in court. Well, we rode about a half-hour out of town and got hotel rooms. I did get my summons but I'd be damned if I was going all the

way down there. That was in 1994 and nothing has been done about it since. I wonder if we are welcome back in Lafayette?

Jeff Clayton, Antiseen (Brutalsville, USA)

Night Of The Groupie

In the early eighties I managed a hot band from Chicago. The Young Swingers were a guitar and vocal harmony driven post punk band with a hint of Stones. The Swingers played all the best shows, all the best clubs and that brought out the *best* groupies. One of those fine young ladies was the lovely and talented, with the emphasis on talented, Foxy Roxie. Long thick reddish brown hair, long muscular legs that would rise up and make a perfect ass of themselves, the package was a rock'n'roll dream.

Following one overly excessive night of rock'n'roll debauchery at famed Shytown night spot Exits the groupies were out in force for The Young Swingers. Due to large doses of the wonder drug MDA, guitarist Burn, singer Willie, Foxy Roxie, and I were not ready to give up. So off to Roxy's we went.

When we arrived at Roxy's the MDA was kickin' on high, with stars in our eyes, hallucinations in our heads and love in our pants. I was playing DJ and we were all dancing round the house. Willie, always the thinking man, was thinking with not one head but the other. Soon enough, Willie had scooped up our lovely Roxy

and carried her off to the bedroom. Burn and I continued dancing. Burn maybe not quite as quick as Willie was still on top of things. It was not long until Burn had taken his place with Willie and Roxie. I continued dancing.

Although I always considered myself fairly sharp the MDA was in control of what little brain matter I possessed at the time and still I danced, alone. Eventually though I do catch on, besides I was tired of dancing with myself. Hey managers need love too. Hell, animal lust works.

I entered the nether world of Roxy's room. I knew she had an oversized waterbed, and I knew Burn, Willie and Roxy were spread out on that bed but it sure was dark in there. Not one to miss the action I whipped off my clothes and dove on in.

Now the three men in our bunch are all raging heterosexuals, but with heads full of MDA sloppy seconds or thirds did not much matter. Now remember it was dark and all I could see were my hallucinations. So I did what any tripping maniac would do naked in the dark with three other people, I used reason and intelligence. It was my time and I wanted what I came for.

I began to feel around since I could not see. I felt one butt, it was OK kinda firm a little round not hairy. Then I went to the next butt then the last. Again I am a reasonable man I can tell the difference between butts. One butt in particular stood out from the crowd. The butt was soft yet firm perfectly round completely hairless. That must be the butt, the one connected to those great legs and that beautiful red bush I had pictured in my mind. I had picked the best I had picked Roxy. So I began to rub I began to caress and yet I was still not able to see through my hallucinations.

As I eventually began to part those perfect round cheeks with my gentle fingers. Heading for that mystical tabooed entrance that would lead me to drug induced ecstasy a voice boomed out of the darkness, "STICK THAT FINGER IN THERE AND I WILL BREAK IT OFF". That perfect beautiful butt was Burn's.

I did end that night with Roxy and very sloppy thirds. Roxy continued to be at our shows. But from that moment on Burn, Willie and I went our separate groupie ways, left with a memory that will last a lifetime.

Kipp Elbaum, The Drossels (NYC)

Healed by Porn

About a year ago we did a gig in a Swedish little redneck shit hole called Motala. It is just about 80km from our hometown, so not that far away. As a sort of road crew, we brought with us our friends the local tattoo artists Martin and Ricky. To keep us away from fights and help us with things during the gig, and of course, to drive us home after it. Well, the gig went great! Lots of people, lots of drinking and no fights! We threw a serious after-party and everything felt all right. Unfortunately, our so-called road crew also participated in the drinking bash. And after several severe Tequila races they were piss-drunk and unable to drive. We had to get home that night because of work and stuff the following day. So with two piss drunk "drivers" we had no choice but to draw straws of which one of us who was to be behind the wheel on the way home. Luckily, it turned out to be me, because I was the most sober one in the fellowship. Me and the two fucked up tattooers hopped in our Chevrolet Caprice station wagon (the others decided to go by bus) and begun the insecure journey towards our hometown. I managed to drive pretty safely although I was sort of drunk and really tired. Everything was OK except for the two in the back, who were in the mood for drunken games, screaming and shouting at people we passed, fighting like children and over and over again pulling the parking brake to collect things along the road. Traffic signs, cones, and stuff like that. I was really tired, so I didn't care. I just hoped for no cops to turn up. After reaching halfway home, they both pulled the break and shouted out loud — "We want to surf the roof of the car man!" *No way*, I thought to myself, and tried to convince them it was a bad idea. I was pretty fucking fed up with them acting like teens with their "double-dare you" stuff. But drunk and insane as they were, they talked me into it. And I have to admit that I thought it was a pretty fun thing to do at the moment. So we drove of the freeway and into a smaller road in an industrial area. There I found myself behind the wheel with the two drunks upon the car roof, and we started our unusual surf tour. Carefully, I held a steady pace of about 30kmh but they weren't satisfied, wanting me to go faster and faster. This is when I sort of lost it, thinking what the hell — "If you wanna ride, ride the wild horse!" So with total lack of care, I pushed the pedal to the floor speeded about 70–80 kmh while they kept on screaming for me to go faster! In the same moment as the speedometer reached 110kmh we went upon a little hill, and at the top of it I suddenly noticed that the road stopped to exist! I panicked, hit the brakes and turned left. In the same split second, I saw Ricky tumbling in front of the car, tearing his face and hands against the solid as-

phalt. *Oh shit*, I thought, *this is not good!* As quick as possible, I stopped the car, and ran out to find Ricky lying in a puddle of blood. The other guy, Martin, went into some sort of drunken shock, and ran around shouting, trying to stop a passing car. He succeeded, but bad luck for us, it turned out to be a patrolling security car. I, who started to get visions about my driver's license being ripped apart, rushed towards the security guy and tried to pull some story about a drug deal thing, claiming that a car forced us off the road to beat the shit out of Ricky. Luckily, the security guy seemed like a newcomer on this job, so he just stared at us frightened and asked if he was to contact the cops. I explained that it wouldn't be necessary so we gathered Ricky together and continued home. When we were just a couple of km from home, we had to stop at a gas station to get the surfer some paper and ice, to stop the blood pissing from his bruised face. Martin, the guy

with bicycles downwards a slalom hill. I don't think they bought it, but what the hell! When the trip was done, I found myself sitting in some state of shock outside the hospital's emergency center at 7am reading porn. Well, what can I say? Don't drink and drive. At least not on top of the roof.

Matt, The Nifters (Skarblacka, Sweden)

Goop Girl

Several days prior to our Saturday January 28 gig at the Coach and Horses in Windsor, Ontario, Canada (right across from Detroit), the Trailer Park Sex Cowboys wrote a new song. The music was dark and incredibly sexual. Johnny said it reminded him of "cum running down the inside of a girl's leg". He quickly wrote the words around a bondage/S&M girl and the song Sadie Masochistic was written. In the middle of the

An evil plan was hatched
to test the loyalty of
their fans.
TRAILER PARK SEX COWBOYS

that stayed on the roof, offered himself to go and get it, probably feeling a little compassion for his partner. When he came out from the gas station, he couldn't hold back his excitement, shouting: "Everything is going to be cool now!" With him he had one sixer of beer, a couple of candy bars, every single porno mag there is to get at a Swedish gas station, and of course, no paper and no ice. Ricky, with his torn face, wasn't too happy about neither the beer or the porn, because he couldn't drink or see at the moment. Well, when we finally got home, we had to get Ricky to the hospital to get him some stitches. And on the way there, we tried to figure out what to say to the staff. Let's just say he got beaten up, I suggested. "No way", Ricky answered thick, "I've never been beaten!" So once again, we had to pull a remarkable story of how we raced

song, the song tempo goes from an aggressive grind to a slow psychosexual driving bass line. It was decided to make this slow interlude into a platform for Johnny to talk to the audience. Now after their first few shows, the Sex Cowboys were beginning to build a rather loud and brave following of females so an evil plan was hatched to test the loyalty of their fans. Just prior to the gig, all four members of the band masturbated into a pint glass. Then, Johnny added half a shot of Bailey's Irish Cream and combined this DNA Juice into a ghastly syrup of sorts. He kept this glass on stage with him. During the debut of Sadie Masochistic the plan unfolded. When the slow part arrived, Johnny began his monologue. In it, he demanded absolute loyalty from the female contingent of fans. He said that to be of the TPSC faithful, you must take a part of the TPSC inside

153

you. He grabbed the glass, swirled it in the lights for all to see and announced that, "Within this glass is the complete DNA of the Trailer Park Sex Cowboys," and that he was looking for a volunteer to come up to the stage. Several women cheered and finally one brave girl approached the stage. She appeared nervous and excited, all at once. Johnny handed her the Love Potion and she held it in her hands. As the music swirled and the temp began to rise and fall with brutal sexuality, Johnny told her to drink it all down. And, after taking a deep breath, she did! The complete spunk of the band ran down her throat! And live, in front of over a hundred people! And so, the legend of the Goop Girl was born....

Johnny Ten Inch, Trailer Park Sex Cowboys (Windsor, Canada)

Battle of the bands, Indeed

It's always dodgy, Wolverhampton, at the best of times 'cause there's a lot of mullets in the heavy metal scene — a lot of mullets! We entered The Battle of the Bands, and the scoring gave points for the number of people you brought with you, quality of your song-writing abilities and everything... So, we did the gig and we brought no-one so we got no points for that. We came last. I'm not going to defend our ability, because we were shocking anyway. Afterwards, one of the other bands there started to take the piss out of us for some reason, shouting and saying that we deserved to be last. Our guitarist started pushing him. Some bloke came out of the pub — an innocent man — and said, "Come on, stop fighting, there's no need for any of this, lads — calm down", all in his best Wolverhampton voice. Because he grabbed our guitarist to stop him from fighting, our guitarist thought he was fighting him, so he punched him, everyone jumped in and the bloke went straight to the floor. I saw my friend boot him in the head, and this was all because we'd lost The Battle of the Bands. Then two of the other bands joined in against us because they saw what was happening, so there was a massive brawl in the streets (people were lying in bushes and everything). The man's on the floor and there were, I think, three riot vans coming up and a couple of ambulances. The guitarist's dad came up the road in his car, and the bloke was on the floor unconscious, and his dad says, "You're fucking dead!" So he grabs his son and puts him in the car. And everyone runs — there were police everywhere. And to top it off, the next day on the news it said that a man was

found beaten to death in a car park in Wolverhampton, so we all thought "Oh, my God", till we realised it was a different man.

Andy Parker, Sally (Birmingham, UK)

Meth Bonanza

We were in the middle of a month long tour with Zeke and the Hookers. At our show in NYC at the Knitting Factory, I met a guy named Steve Jackson. I told him that the following day was one of our days off, and we had nothing to occupy our time with. He said he had a friend who owned a record store in Buffalo NY that was sort of the punk rock "kingpin" up there, and he might be able to hook us up with something. He called his friend, and his friend said he would be able to hook us up with a warehouse show if we made it up there. Anyone who has been on tour knows that days off are torture, so we headed to buffalo with bad hangovers and low expectations. once we arrived at the record store in question, we met "Ratdick", or at least that's what he had us call him. He said he had set up a last minute word of mouth warehouse show featuring four bands with us headlining. He said if we bought a keg of beer, the outcome would be greater. We said "Fuck it", and bought three kegs of the cheapest beer money could buy. By this point, it was about 5pm, and the show was to start at 9pm. We went to eat at some shitty grease pit, and were overheard discussing the show by a guy named Dave who ran an independent radio show from six to nine every night. He was grabbing a bite to eat before he went to the radio station, and asked us if we wanted to go with him, and promote the show on the air. Since we're brilliant motherfuckers, we did so. At the station, we drank, drank, and drank. We also plugged the show every chance we got. At 8:30 we headed to the warehouse where the show was going on. The first band was loading in, so we set up the kegs, and drank more. At 9:15 they started, and from the get go, I could tell they weren't gonna do shit for me. Me and Wes Texas went out in the parking lot and struck up a conversation with two extremely attractive, young punker chicks who said they had an apartment right down the street, and if we wanted to, we could chill out there until it grew closer for us to play. Once there, it took Wes and myself a matter of about ten seconds each to begin getting down with the two girls. About two minutes after being there, me and one of them (Marissa) went to her bedroom, while Wes and the other punker (Adriana)

I have never witnessed so
much fucking violence in a
ten-minute time span.
THE BULEMICS

stayed in the living room. Me and Marissa went at it for about an hour and a half. When we went back into the living room, Wes was still giving it to Adriana, so we stepped out on their front porch to grab a smoke and drink a beer. About ten minutes later, the two of them came out, and Adriana asked if we wanted to do some speed. It didn't take much convincing for me and Wes to get a mirror and blade in front of us. After too many lines to count, and a couple beers, it was time to head back to the club. I don't know if it was the radio shit, or the word of mouth shit, but by the time we got to the warehouse, there was 300-plus kids there. They were also charging $5 a head to get in. The third band was playing, and we were next. We took the stage around 12:30 chemically fueled to perfection. During the very first song, some dipshit spit beer on me. I took the mic stand and hurled it into the crowd, but accidentally hit the wrong person and knocked him out cold. That was it. From that point on, I have *never* witnessed so much fucking violence in a ten-minute time span. The girls were even getting in on the action. Right in front of the stage, one girl ripped another girl's shirt and bra off, and just pounded her into oblivion. Neither of them could have been over eighteen. All we had to do was watch from the stage. That night, *we* were the ones being entertained. Like all good things, it had to come to an end. After our last song, the entire band went back to Marissa and Adriana's apartment. It was a meth bonanza. We all got so high our eyes were about to pop out. Marissa asked me (in different words) if I wanted to go for round two. I told her with all the speed I had done, there was no way I would be able to get a hard on, and with all the speed she had done, her twat must be as dry as the Arizona desert. Well, this must not have been the first time she's done this, because she went to one of her boxes of tricks and pulled out a bottle of Viagra, and a tube of lube. I was overwhelmed. I popped the Viagra, and waited for it to kick in. as soon as it did, it squirted half the tube of motion lotion into her beaver, and went to town. Fucking on speed's the best. It lasted almost four hours. During the course of our fuck frenzy, everyone came in wondering what the fuck was going on at least once. After the climactic moment, a smoke, and another line, I asked her how old she was. She said sixteen. I don't know if she was full of shit, because she looked at least twenty, but then again, you know what that lifestyle will do to you. Well, after another couple hours of partying, it was time to get into the van and head to Boston for the show later that night. It was around 9:30am at this point. As we drove there, we all agreed that the night before had been the best Bulemics experience ever, and under such strange circumstances. As we rolled into Boston, we knew it could never hold a candle to the madness and mayhem that went down in Buffalo New York the night before.

Gerry Atric, The Bulemics (Austin)

Girlfriend Episode

Our worst gig was when our saxophone player, Vinnie Valentine, was shot in the stomach, over some girlfriend episode. This chick, Julie something, I don't remember, shot him while we were on stage. The only reason that it was bad was because we had to stop the show. There's bands like the Beatles, let's say, with their *Dr Pepper*, which was a monumental record for them, right? Well, that's what I want to do on stage every night, the whole cream show. And with somebody getting shot on stage, I can't achieve that. I had CD 1 done. Where's CD 2? You open up the case and it's missing. People are yelling at you, going, "Where's the party, where's the party?" and I'm giving them paramedics...

Harlem Greenwood, Coke Dealer (Boston)

Punch Palace

One night in Wichita Kansas. My band had been out

on tour for two months on a shoestring budget. Peanut Butter, Generic cereal without milk, and many a whore's bath in gas station bathrooms. We were working our way back home to Cleveland from LA, hitting every town you could imagine in the meantime. We rolled into Wichita; Kansas about ten minutes before sound check and loaded out into this little dive bar filled with Native Americans and truck drivers. Immediately after sound check, we meet the band we're playing with. Basically, a high school Nirvana tribute band with a couple originals. Beautiful… I go to the bar to ask if we get free beer or at least a discount… The answer was a roaring "No!" followed by a cackling laugh, as the bartender walked to the other end of the bar. So then my dilemma set in. I've got fifteen bucks… Should I drink, or walk across the street to the gas station and get a proper road worthy supper of leather-skinned hot dogs and a slurpy? So, I drank….The first band limped its way onto the stage and went right into some blurred Nirvana… I drank more… Halfway into their second to last song, the manager of the bar informs me that the second band wasn't showing up due to the singer having a cold.. Their name slips my mind but I was told they were a local favorite. So, I find my drummer at the Golden Tee 98 video game and tell him and then I'm on the hunt to find my bass player who was outside on the curb drinking some $5 bottle of whiskey that he tracked down. As we're sitting on the curb, three cars fly in filled with the bar's softball team. We sat for a couple minutes and reminded ourselves that we had five more shows until we'd be home. We walked back in the bar as the first band were tearing down and talking to our drummer about how much of a punch palace this bar was. I went to grab my guitar to start tuning it when this old Native American guy asks me to sit down at his booth. I tell him I'll talk to him after we're done but he insists. His girlfriend comes back from the bar and tells me that he really needs to talk to me. So, I open my guitar case, pull my guitar out and sit at their booth to tune it. After I had sat there for about thirty seconds in silence while the two of them are arguing about something, I finally ask what's so important. He then proceeds to ask me how my parents are and how it's been a long time since he'd seen me. So, I play along. "They're fine," and "It's good to see you too," I reply. I get back to tuning my guitar while he proceeds to tell me that he'd always known that I'd make something of myself and how proud he was of me. I look up when he stops talking to see him tie off his arm and stick a needle in an open scab on his arm. It's almost to comical to walk away, but I've got to get on stage when he offers me what's left in this worn out rig covered in sweat and blood. I politely decline, and I tell him I'll talk to him tomorrow. He says OK. And I make my way to the stage. The voices around me are getting louder and louder as an argument over the softball game that day heats up. I introduce the band, try to push some T-shirts, stickers, and discs and start off the first song. Now, I'm known for having some massive stage volume but even in the middle of a scream I can still hear the argument and now that I'm on stage I've got a perfect view of the two, then three, then four, then five gentlemen arguing at the bar. The end of each song is greeted with screams of "You're a fucking pussy!" and "I'll fuck yer fuckin' mouth, son!" as the confrontation at the bar grows more and more physical. Now the entire bar, minus the junkies in the booth, are now involved in the argument, as a crowd is now formed around a large man in a number eleven softball jersey. Someone shouts something about a wife, and Mr Number Eleven picks up the guy in front of him and breaks a table with his back. Straight out of a Hollywood picture, or a bad police TV show. Another guy jumps on Number Eleven's back to pull him off the guy and Number Eleven throws him off his back and proceeds to smash his face repeatedly into the corner of the bar. One guy actually got a couple good punches to Number Eleven's face but he barely moved and kicked the guy's legs out from under him. While all of this is happening I keep playing. My band staggers a couple times but I turn and smile, and we keep going. I stop singing and we go into Happy Trails. If I'd known the theme from Dukes of Hazzard it would have better suited. Finally we stop. The entire bar is now climbing all over each other. There is barely a table standing and pool sticks, chairs and bottles are being broken left and right. My drummer freaks out and starts packing up his gear at a pace that would have made The Flash smile. I follow suit and start putting my shit away. My bassist pulls a bottle of whiskey from his amp and sits at the edge of the stage to watch the festivities. When I finish, I join him. As we're talking about how we can't believe this, I see another fight in the back of the bar by the pool table and I see tall, husky guy pick a pool ball from the table. Whether he was or not, I'll never know, but it looked as if he were looking directly at my bass player… Before I could say a word the pool ball was airborne, and I grabbed his head and pulled it down to hear the ball crack at the stage wall behind us. This gave my drunken bass player the initiative needed to

get his ass in gear and get his shit out of there. This guy came out of nowhere and offered us help getting our equipment to the van. We formed an assembly line and barreled everything into the back of our rusted Dodge. Now, I had to find the manager and get paid somehow. By this time the local police have covered the joint in blue uniforms. As I walk back in, I see badass Mr Number Eleven stomping on some guys head as three cops are climbing all over him and crack him with nightsticks. Finally a little pepper spray and nice little crack to the back of his legs take him down. The guy who helped us load out ended up being a friend of the owner's and got our 100 bucks for us and we're gone. As we pull out of the lot I see a sight that I couldn't pass up. Two ambulances and five cop cars at the side entrance of the bar, and around twelve to fifteen bloody faced bad asses in hand cuffs line the outside wall of the bar right under a sign that reads, "Appearing Tonight, From Cleveland Ohio, Danny Frye and The D-Dolls"… It made a nice photo….

Danny Frye, Devil Dolls (Cleveland)

Last Thrash

In 1989, we were scheduled to play a club in Ottawa, Ontario, Canada for a large estimated audience. We arrived at the gig, hungry, tired, totally broke and penniless, and fighting with each other to discover that there had been no promotion for the show whatsoever. Nobody knew about the show. There were two people in the "audience" and we were pissed off. I told the promoter to give us an advance on our money for the show and I went out and bought pizza and drink and showed up in front of the others, happily pigging out while they were still starving. I waited an hour and gave them their share of the money. Instead of food they bought booze! Before the show, Dave (guitarist), Brian (drummer) and Bobby (guitarist) got totally shit-faced in the back stage area and could barely stand. They smashed out a mirror in the dressing room, pissed all over the floor, vomited, ripped out the sink and the toilet from the wall and then went on stage to play for two people. We opened up with Fuck Of Death and changed most of the words to all curse words, slagging the bar and the owners for not promoting our show. Into the second song, they turned the power off on us and told us to pack up and get the fuck out. We had already got paid so we didn't care. I stole an expensive microphone. Dave had picked up this groupie from New York named Carla and fucked her in the back of a U-

haul, while Bobby slept a few inches away. After he screwed her he dumped her at the back of the club and drove away, leaving her stranded. I was mad at everybody and not speaking to them. Unknown to them I decided to quit the band, and hooked up with another Toronto thrash band (friends of ours) named Sacrifice. I was going to take off back to Toronto with them and leave the rest of my band behind.

Both our bands were scheduled to play a large festival in Quebec City the next night so I drove with Sacrifice to Quebec and decided to do one more show with them. I decided to play one more gig with Slaughter and then quit the band for good(when they read this they will be hearing about it for the first time!) We made up in Quebec and went on stage. Once again the whole band was totally drunk and stoned on coke except for myself, and within the first few songs it was clear that we couldn't play. Three of us were playing one song while Bobby our new second guitarist was playing a totally different song. The crowd was just staring at us in disbelief, and I threw my bass guitar in the air and walked off stage. I told Dave that I quit the band unless the new guitarist, Bobby, was kicked out, and we returned to our original three-piece line up and played our old, classic tunes from *Surrender or Die* and *Strappado* albums. We drove back to Toronto, not speaking and never played as Slaughter again.

Dave, Brian and Bobby formed the new band Strappado with a new bass player, and I quit the music biz.

Terry, Slaughter (Toronto)

Bitch Slap

There was one show where we were showcasing for some record people. Some idiot at the bar was flinging those cardboard coasters at us. He was really good at it. He winged Jenna in the head with them a couple times. Our rhythm guitarist, Charles, goes out into the crowd, and while he's still playing, bitch-slaps the guy. The guy jumps him, and they're rolling around. He's still playing. He comes back onstage and finishes the song. He's got the guy's hair in his tuning pegs…

Spyder, Detox Darlings (NYC)

No Lip

A few months ago we played in the little town of Frostburg, which is in the northwest corner of MD. Frostburg State University is there, and not much else.

The big debate in town when we were there was should/should not the municipal government set into action a plan to put fluoride in the drinking water. We played at a place that was half a hippy restaurant with microbrews (they though it unethical to sell much else), and half family game room. The show was with a rockabilly band from PA. The show itself was fairly uneventful, but things got much more exciting…

After the show, we ended up at a little bar called the Hurry Back Inn. You could buy a can of Bud and a shot of Beam for three dollars. Dangerous. After some college freshmen-like bingeing, vomiting and Karaoke to Sinatra, it was off to one of the promoter's homes for some sleep. We get to the house at about three or so. There were about twelve people in our group, and I was one of the first in the house out of us all. There were a handful of folks there already, and just as I walk in, I see this very big Rottweiler trot out of the kitchen and give me a "Why are you in my house?" look. I promptly strolled back out to the porch. Everyone else in the group except Tony (bass) went inside. No more than a minute later I hear some seriously aggressive dog sounds, followed by some very concerned human sounds. Mike (drums) walks out to the porch looking very pale and sober says, "We gotta get Abe (drummer for other band) to the hospital. That dog just fucked him up bad. His bottom lip is on the kitchen floor." Just

One girl tore off
Tommy's pants.
SWAMPASS

then I heard someone in the house say, "Pick that up and put it on ice and let's go." Ugh.

As some folks get together to take him to the hospital, Mike gets recruited into going, too. Speeding through downtown Frostburg at about eighty, they naturally get pulled over. Mike has quite a bit of contraband on his person, and the driver is hammered. The cop took one look into the back seat and sent them on their way.

By now it's late. Everyone is really flipped out. The bathroom looked like *Fangoria*. We (Tony, John [guitar] and myself) head to our rented short bus to get some shuteye. Mike of course has the keys, and is stuck at

the hospital, so Tony breaks in and I pass out. In the morning I wake up and look in the seat in front of me to see this poor guy's torn up face all stitched and swollen. I was hoping I had dreamt it all. Stitched from the middle of his bottom lip, down almost the whole way to his chin and back to the corner of his mouth. There was also a sponge sewn into his face where the doctor couldn't put any lip. It looked like it was done in the Middle Ages. He was in our van because his band left him there. We were playing in their hometown that night anyhow.

Easily in the top five most fucked up situations of which I have ever been a witness.

Matt Conner, RPG (Richmond, VA)

Crystal Meth and Razorblades

It seems every Ophelia Rising show we book is laden with problems, missing guitars, late band members, and performance time errors. But the show we had scheduled for February 12, 2002, at Club 66 tested our faith in survival like no other. It was a week before the show date and there had been some recent drug problems among the Ophelia girls. In particular, Satania heraManic, our lead guitarist, who had recently quit crystal meth, for the second time. Anyway, we picked her up for practice and she was acting kinda funny and paranoid. We

couldn't make sense of the gibberish, but we hoped she'd be okay by show time. After dropping her home that night, we hadn't heard from her in days, so we got a little worried. After a chain of calls that led us to Twin Towers Correctional Facility, we learned that Satania had had a scuffle with her father over the validation of Marilyn Manson's music that resulted in her bludgeoning him with a Fender Stratacaster and landing her four months in jail! She had apparently had some sort of nervous breakdown and there was no way they would let her free by the show date. Coincidentally, my publicist was dating a former member of Sinisstar, one of the many bands I used to party with, and we were able

to pull him in to learn our set in three days! The show didn't have quite the same vibe with a boy on board, but I carved Satania's name into my arm with one of the razor blades that hangs off my mike stand and ripped off my slip dress during a cover of Leslie Gore's You Don't Own Me, and managed to get a rave review in *Meanstreet* anyway.

Lexa Vonn, Ophelia Rising (LA)

Bruised Thighs

You don't expect a lot out of Indianapolis usually, I mean the rock'n'roll scene is pretty lame over there. But last time we played there, we walked in to a pretty rowdy crowd. I wear fishnets sometimes, I think Tommy was wearing striped tights at the time. These girls started shoving dollar bills in my fishnets. That was cool, but then things started getting rough. They were shoving money down the backs of our tights, and then they started pulling our tights off and tried shoving money up our asses. One girl tore off Tommy's pants and tried sticking her fingers in his ass; he just narrowly escaped that. They were ripping off our clothes. I had a dress on at the time, and she pulled it over my head, then kicked me square in the back. Then she started spanking me, basically with a closed fist. I had bruised thighs the next day. By this time, people were heckling us, so I started throwing bottles on stage. Then people started throwing bottles and wine glasses at us. There were a couple of tables set up, and people started climbing all over them, falling off and onto the floor. It was a pretty violent little episode we had going on there.

Ginchy, Swampass (Chicago)

Insult to (Head) Injury

I was playing an all ages show and things were going wild, I was down on my knees, bashing my head into the floor, when something cut open the top of my head. Blood starts gushing down my face, I thought, "Wow! this is cool!" Then I got really dizzy, managed to finish the whole show and asked my fill-in guitar player to drive me to the hospital, by this point I was completely covered in blood, dizzy and barely able to speak. The guitar player in question was a temp, he was an acquaintance who played awesome so he filled in and did the show. Being a pretty "hot chick", he totally hit on me all the time at practice and I was really sick of it and even told him to go fuck off a couple times and he still kept doing it. So, we are in the car, I am profusely

pouring blood by now and all the way to the hospital he is saying, "I really like you Charlie", "we should be together... etc" He is going on and on and on and I am laying back thinking, "What the fuck? I am *dying* here! This guy is fucked in the head!" So, I say to him, "I don't want to go to the hospital anymore, take me back to the show." So we drive back... I get out and get over to where my band is tearing down. They are all shocked that I am back. So, I decide to take advantage of my condition and get some sympathy and some jerk's ass kicked at the same time. I say this: "I wanted to go, but all he could do was hit on me and say all this crap when I am dying here!" That was enough they all started yelling at him, and a couple seconds later his guitar was thrown at him and they kicked his ass out of the hall. I did eventually end up at the hospital that night and I never saw that loser guitar player again.

Charlie Drown (Vancouver)

Defeats of Strength

I was told by the prop manager that the cables attached to my harness would hold up a ten ton truck. So in the middle of my show, I flew over the audience, singing a heavy tune, and then as I approached back to the stage from over the crowd, the cable snapped, dropping me twenty feet to the concert floor. I felt like every bone in my body was broken. I was truly THOR! One night I was singing on stage and the pyros went off. I leaped around and came back to my stance and held the mike, and unfortunately stepped on a live flash pod at the same time. I saw blue lights flash before me and collapsed. I did come around, as I must have dropped the mike to stop the electric flow as my foot also came off the pod during my fall. Yes, I was electrocuted! Then there was the time I was ripping a license plate in two, and almost severed my fingers. There was blood everywhere. Or the time I was to pick up the heaviest person in the audience up off a table with my neck and teeth, to the pulsating heavy metal. A 400-pound woman came on stage, and when I tried to pull the cable holding her with my teeth, the podium collapsed, so both her and I fell into the audience. I almost broke my neck and had to wear a cast for a month.

Thor (Vancouver)

The Backdoor Dwarf

Well, I remember a time we was playin' in a venue, town, and county that shall remain unnamed. I ain't

I was truly Thor!
THOR

even gonna tell you what country it was in, to protect the guilty. It was a blisterin' show, but a hard, hard crowd — they was distracted by all the knife fightin' goin' on, or something. Anyhow, Hollis had earlier on had his face in plateful of mystery powder, so he was getting a little twisted onstage. Playing like a motherfucker... but since I was standin' next to him onstage, I could tell something wasn't quite right. He just had this look in his eye, like... something was gonna get weird.

Now, things are usually kinda weird at our shows — S&M burlesque nudie reviews, wet T-shirt contests, blatant onstage drug usage, gunfights between fast food icons and giant chickens — that kinda thing. But I could tell this was gonna be special.

Now, I think whoever had got Hollis all jacked up on mystery dust had done the same thing to a lot of this venue's patrons. It was a provincial place, so maybe the illicit substances were getting cut with some questionable things. People were going ape shit by midnight, hanging off lighting rigs, fighting, chicks showing their tits an' bushes, beer flying everywhere.

So, the ten or twelve of us are rockin' up a storm — I can't remember how many people in the band had actually made it up onstage that night. There'd been some heavy whiskey drinking the night before and I think a few guys were actually getting some free lodging care of the last town's local authorities. Sorry, I'm digressin'.

Anyhow, me an' Hollis were in the middle of our Cincerro Blanco guitar dual, and suddenly we noticed this white trash-looking (our favorite kind) chick with a banana clip and Def Leppard shirt at the side of the stage, leaning over our guitar cases. She had this big ol'

smile on her face. Then I guess we both noticed the toothless midget standing on the kick drum case, behind her. Or should I say, fucking her from behind while standing on the kick drum case, behind her.

I just broke into hysterics and couldn't play no more, but like I said, Hollis was bit twisted at the time and he was seein' something completely different than me. He ripped off that big ol' double-neck guitar and started screamin', "Mama-Lou, Mama-Lou, I'm gonna kill you!"

Now, it ain't no big secret that Hollis was orphaned and raised by the transsexual Madame of the most famous whorehouse in Glen Spey, Oklahoma. But they had a fallin' out in 1979, and Hollis ain't talked to Mama-Lou since 1986.

Anyhow, Hollis musta been seein' crazy flashback shit cuz he just started swinging that double-neck guitar like a Conan-style scimitar. The young lady in question must crapped herself in fear, cuz the midget didn't look none too happy. They didn't move either—maybe they was frozen by fear, maybe they was frozen by some crazy muscular thing. But, nonetheless, there they stayed.

Hollis was movin' closer and closer with that swingin' rock weapon, so I knew something had to be done to prevent bloodshed. Hollis is like a puppy dog most of the time, but once in a while he goes Jacob's Ladder-style, if you know what I mean.

The Sarge had also noticed this shit too and stumbled over in his inebriation to help. He knows Hollis well, so the Sarge just started clubbing him with his microphone stand. Hollis is a big fella, ya see, so brute force is the only way to bring him down. I used this opportunity to try and tackle him. But I guess I was a little wasted too, so in my haste I knocked over some

160

candles, which in turn caught some curtain on fire pretty quick.

By this time, the band's stopped playin' and people are going ape shit cuz nothing's going on. There's this big ol' brawl on stage, and several more are breakin' out in the club. Meanwhile, the club's startin' to burn.

I guess somebody done put the fire out, cuz we're still alive. The promoter didn't wanna give us our money, though. So we brought in all the boys and threatened his ass before he gave it up. Hollis was unconscious, probably with a concussion, but later on he said he slept ok and couldn't remember much about the incident. Can't get mad at the boy then, can ya? I think the poor lady and the midget had to go to the hospital to be separated.

We won't be playing that town again.

Clem, White Cowbell (Oklahoma)

Emotional Breakfast

Originally I thought I'd write about some promoter that fucked us, or the time we all got crabs, or something like that (though maybe they were just little, delicious lobsters). Instead, I'm gonna tell y'all the tale about the first time Jumbo's Killcrane met Fargo, North Dakota.

It was the second to last day of an exhausting and soul-sucking six week tour. We rolled into town unusually thirsty that evening, and were desperately hoping for a cold beer at the club we were supposedly playing at. When we arrived, we found out that the show had been moved to an indoor archery range down the street. Needless to say, they don't serve any drinks at the archery range, so we moseyed on down the seemingly deserted main strip to a friendly looking tavern. We had a few beers, a few drinks, flirted with the bartender, and then went to the liquor store on the way back to the gig. This is where it gets kinda hazy, but I know there was at least a fifth of Canadian whiskey (don't ask…) that went down in less than an hour… I don't remember who the fuck drank how much of whatever, but I do know that we were all pretty drunk, and that I was extra-specially drunk. Next thing I know, we're on stage playing to like fifteen people, five of which were in the opening band.

I think we got through three songs OK. In the middle of the fourth song, I fell off the stage, got my legs caught in a bunch of cables and knocked over all the sound guy's equipment. I then proceeded to rip through the cables with my now bloody legs as I marched back to the stage, and then somehow I got back up there. Everyone was still playing the song, but by this time Adrian (our drummer), was fairly irritated with me, and started to mouth-off. So, I did the only logical thing, and threw my guitar (kinda on accident) at Paul, who was our bass man at the time. Adrian then started throwing parts of his drum kit at me, and after a while, the whole thing. With bass in hand, Paul had run outside the venue by this point and gotten back in the van. Adrian soon ran out too and joined him, as I stayed on stage alone to destroy the rest of Adrian's drum kit with my guitar. After slurringly demanding our guarantee from the abused and shocked promoter (and understandably only receiving half), I also ran outside, but with different intentions than the first two lads. I went outside and ran straight at the van, and kept ramming the sides with my shoulders and forearms, screaming, "You're both fired, you fucking pussies! I'm playing the rest of the shows by myself! Get the fuck out of the van and take a bus home!" They've got the windows cracked and the doors locked, saying something like, "We fucking quit before you even got out here! We helped pay for this van too you fucking fuck! Fuck you!" And, "We only have one show left, you stupid fuck!" I guess whatever I did shortly after that involved handling wood, because I had lots of big splinters in my hands and arms that I noticed the next day.

Anyhow, we left the town of Fargo that night and ended up at some truck-stop at four in the morning. Tears of idiocy were falling onto my chicken fried steak as I apologized and exclaimed my love for Adrian and Paul. It was an emotional breakfast. We eventually all made up and drove fourteen hours to Columbia, Missouri to play our last show of the tour, which also sucked, but that's a whole different story.

Ervis, Jumbo's Killcrane (Lawrence, Kansas)

Not Called the Nuges for Nothin'

Date: Friday, August 24
Venue: The Rainbow Inn in Hazel Park (Detroit area)

We played with a band called Killswitch. At the last minute we find out the opening band broke up, so they won't be showing up. Well, the singer (Eric Dahlstrom) in my other band (Negative Conductor) happened to be there to see the show as well as the singer for my old band (Bryan Adams, believe it or not). So we just throw a band (we called it The Nuges) together on the spot with Eric on guitar, Paul on bass, me on drums and Bryan singing. This is a smallish bar (I think they

used to be a divey sports bar that went under) with a fairly small stage, a pretty sucky PA and, oh yeah, we found out when we got there we had to work the door (which I didn't mind because that meant the bands actually got all the money) and do the sound ourselves. Well, another couple of friends at the show helped out and did the door and sound. The PA was a little six channel mixer on the side of the stage running out to two fairly large speakers sitting on stands on either side of the stage right out front. We (The Nuges) started playing to open the show. The guitar is so loud that five minutes into the set it blows one of the PA speakers (sitting right in front of the guitar amp) about five feet through the air… luckily there was no one near by or they would have been killed. The speaker comes crashing to the ground to the ecstatic cheers of the crowd but, to be honest, we were so fucked up we really didn't notice until the first song was over and we heard the guy that was doing sound freaking out "DUDE, DUDE, TURN IT DOWN, TURN IT DOWN!" We only played for about fifteen minutes then Killswitch went on and finally The DragStrippers. The crowd was electrified for the rest of the night and they even ventured up near the stage eventually. It was a great show. But even after The DragStrippers played people were still saying "Man, I've never seen anyone rock so hard they (Nuges) blew the PA speaker off the stand! That was the shit!"

Gram Larceny, The DragStrippers (Detroit)

Berlin, Boston, Wherever

Gigs from hell, eh? When you play in a band like the Dayglo Abortions you get to see a lot of what normal straight boring people would think of as hell. I've been playing punk rock since the seventies. Uncountable thousands of fucked up shows in hundreds of different cities. But they all have a common starting point. Doesn't matter if you're in Berlin or Boston or wherever, it's the same in every town. Keep driving past the nice part of town and head straight for the skids. When you're sure there's nothin' but winos and junkies on the streets start looking for a mohawk. He, she, or it will probably be able to give you directions to the club. Now I don't want you to think I'm complaining about this. I'm not generally welcome over on the nice side of town anyway. The Dayglo's played a big rich resort town called Jasper about a month ago, and we got dragged of the stage by the cops and ran right out of fucking town. We didn't get paid, and the fucking coppers charged our singer with criminal mischief and disturbing the peace to make sure we never come back. So fuck those rich cunts, let's get back to the skids. OK, so what I'm getting at is… take a van full of substance abusing freaks (that's us) and dump them off on skid row and chances are, shit will happen. Then there's our responsibilities as "professional entertainers". That's really the catch-22 for us. I know that a lotta folks think what I do is an annoying joke, but I take my job very seriously. Well, as seriously as a forty-two-year-old drug addled alcoholic punk rocker can anyway. I'm not trying to sell you my brand of politics, or change your life or anything. I just wanna change your night. What we offer to the audience is- the most over the top, balls to wall party they've ever been to. Because of this, it is each and every member of the Dayglo Abortion's solemn duty to be the hardest drinking, fat rail snortin', skirt chasin' motherfucker in the place, and still be able to crank out the riffs when it's our turn to rock. We're quite proud of the fact that we party every town that we play, right into the ground. It takes them days to recover. I've heard of people losing their jobs, getting divorced, and even dying, all because they had too much fun at the gig. (I guess in some way or another we actually do change peoples lives) That's great for them, but when we're on the road, we play every night. We have to pull off that level of insanity thirty or forty days in a row, and believe me when I tell you, that is one big league drinking binge. Add to that the most important thing for any entertainer. The audience. The guys wanna sing the vocals, dance around knocking shit over and stage dive, and the chicks wanna get naked so, of course, we make this all possible for them. It gets really out of hand sometimes, but it's what makes the show for a lot of people. Now we're not just some band that they saw. We're some band that they got up on stage and rocked with and that makes them happy, which is our job. Needless to say, the Dayglo's stage is a dangerous place. I've had my nose ripped off by the head stock of a guitar, my foot crushed by a bathtub full of beer, I've been lit on fire, and even stabbed (not everybody likes me). One time in Saskatoon Saskatchawan, of all places, there was so many naked chicks on stage we couldn't move. We actually had to stop playing for a minute and get the security dudes to thin them out a bit.

When I started writing this thing I quickly realized that we have never really had a gig from hell as such. It would be more accurate to say that we live and work in hell, and we're having one bloody hell of a good time doing it. We've been ripped off once or twice in the

past, but over the years we've picked up some serious motherfuckers that worship the Dayglo's and would do anything for us, so if your thinking of fucking us over, think again. We've played some really fucking scary crowds too. Back in the day we did a show in Greensboro North Carolina and the whole fucking place was full of Nazi Skinheads with a couple of genuine Klansmen running the show. These people were fucked right up. They hated absolutely everything and everybody and that's all they would talk about. They had tons of booze and PCP and were starting to look more like an angry mob than a bunch typical folks out to have a good old time. Now we're not pussies or anything, but there was no chance we could have fought our way out of that place, and we were thinking, we can forget about playing Kill The Nazis tonight but the real problem is that half our songs drop lines about racist groups, religion, governments (to me pretty well everything in a suit is on the other side), and our other guitar player, Mike Jak, is a native Indian. The full on whiskey drinkin', wagon burnin' kind, right down to the mohawk. We figured, we're fucked. It turned out though that Mike was a real hit with the KKK dude that was running the place. He didn't seem to notice the "Indian thing" Mike had going on, so he got out his handy KKK indoctrination kit and was trying to sign him up. Then, as luck would have it, most of the skinheads knew our shit, but they didn't really get the sarcasm in it. I'm saying when you get someone like that telling you they feel like our songs are written specifically about them, you politely answer, "They were, just not in the way you think". So it took nerves of steel, but, with tongues firmly planted in our cheeks (or in Mike's case, some skinhead dude's girlfriend's reeking snatch) I should watch what I say. That could be illegal humor. Is it OK to get sexist with a racist? Anyway I have a difficult time separating individual moments of Hellishness in my life. Maybe because it's so packed full of chaos and weirdness that things like that are common place. They happen every day. I'm just happy to be able to put a coherent sentence together after what I've drank/smoked/snorted/injected/huffed or stuffed up my ass over the years.

Cretin, Dayglo Abortions (Victoria, BC)

Something Cool

We get this offer from a friend to play this "party" in Kenosha WI, it is said to be huge, like tons of people are gonna be there, lots of drugs, beer etc. So it sounded cool.

Well, we get there, and let's just say there are plenty of places to park. So once inside, we were told that the party pretty much happened the night before, but people should still come out....

That never quite happened. Excluding bands, there were about five people and a dog or two at the final tally.

The Evolutions played first. Their singer starts by asking the crowd of five, "Are there any Jews in the

BAD GIG

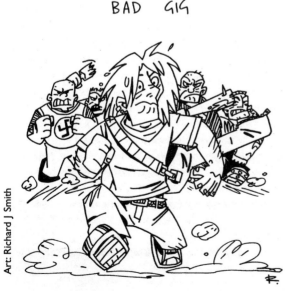

GOOD GIG

house tonight?" Then goes on about Jews for a couple sentences I can't fully remember. Then he gets a lighter, and starts lighting his shirt on fire. Then he realizes he *is* on fire, and starts beating himself senseless, because his fire thing got too out of hand. So, that was entertaining.

Then we play our set, everything goes smoothly until after we are done. I'm talking to Matt, one of the guys I came up with, and this guy comes up and asks Matt, "Hey, You wanna see something cool?" Matt says, "No." The guy asks him again. "You wanna see something cool?" Matt says, "Sure."

So the guy turns to his right and runs full speed head-first into a brick wall.

Falls straight back on the basement floor. Blood starts pouring out of his head like a river. He's out cold.

The bass player from the Evolutions runs up and picks up the back of his head off the floor, her hand instantly becomes red with blood. She's yelling, "Somebody get me a towel to stop the bleeding!" He starts mumbling he can't feel he can't feel anything. I'm trying to keep him awake telling him to move his arms and legs.

Somebody went and called 911.

We are all looking around the situation and figured there was nothing more we could do. The cops are coming, we got him under control until the ambulance gets here, so we are like, "Let's get the fuck out of here."

So, we are bringing out our equipment right next to this guy who is in a puddle of blood. We get loaded up, and I was talking to our friend who set us up with the show, thanks for setting us up. And we all agreed there was nothing we could do. So we left right as the ambulance lights were coming around the corner...

So long Kenosha.

Drew, The Leg Hounds (Sheboygan, WI)

Scooter Trash

I could tell you about the time we were set upon by off duty members of the Serb army in Belgrade, or about the time I spotted the clearly psychotic biker running his finger across his throat while mouthing "After the show you're DEAD!" at me. The time I broke my ankle at a show for the handing over of the Commonwealth Games from Kuala Lumpur to Manchester was a bit of a pisser, and as for embarrassing, there was the time I accidentally knocked over my entire Marshall

amp stack while facing the amassed crowd at the Finsbury Park Sex Pistols reunion. But for thrills, spills, danger and all out abject insanity I've just got to regale you with the events of the Bridlington on Sea Scooter Rally.

Scooter magazines have always loved Gold Blade, so sure, we took one of them up on an offer to headline a big seafront rally and off the Gold Blade rock'n'rollercoaster shot to the Yorkshire coast. After the sound check and the customary stride up the seafront (dilapidated, tatty and grim, one in three light bulbs missing, scowling locals etc...) we headed back to the venue which was rapidly filling with mods, skins, suede heads, scooter boys and girls all frantically moonstomping to a fine selection of northern soul, ska, rock steady and motown cuts. A good time was being had by all. And then we hit the stage.

As the beer glasses started to rain down, I remember thinking two things: that the promoter had said "We've kicked all the racism out of this scene" earlier in the day, and that we looked pretty much like Rockers, glam ones at that (and therefore obviously gay) and that one of us was black (just what the fuck did they think they'd been dancing to all evening?). We were pressing the three buttons your average dullard Skin doesn't want pressed, and we were pressing them hard. I can recall ducking a hurtling bottle that instead found a target with Brother Mike on keyboards and front man Brother John reaching out with a huge grin to shake hands with a big group of Skins who were screaming blue murder at the front ("Your gonna get your fucking head kicked in" etc...). One 'orrible lookin' character who earlier has told me, "You look like me fuckin' bird" flings another pot my way. Sure, a bunch of people were digging the show (we were playing harder and faster — our resolution even tighter due to the chaos down front) but as it started to look like there was impending full scale mayhem I realized that the odds didn't look too good. Roughly six Gold Blade Brothers vs 600 rampaging Skinheads.

Still we do a full set and climax with a full-on Punk Rockabilly number, a statement of intent and a FUCK YOU to the bigoted halfwit scum front of stage (which by now is a minefield of tossed cigarette dimps, broken glass and weak beer).

Suffice to say leaving by the front entrance was a big no-no, so out the back door we rolled, loaded up and sped outta town.

Jay Taylor, Gold Blade (Manchester, UK)

Seth is a Cunt

OK, here is the story of my gig from hell. The gig was actually with Upside Down Cross performing. I was not seeing Anal Cunt, but two members of that band, Seth (singer) and Josh (guitarist) were in attendance to see Upside Down Cross.

Here is how the trouble started…

At the beginning of the night I was standing by the men's room door. Seth, from Anal Cunt, was going into the men's room. Instead of saying excuse me to get into the men's room, he violently pushed me aside and my head slammed against the pay phone I was standing next to. I made a gesture as if I were going to kick him, but never making contact. A woman, who was later identified as his cousin, had told him that I tried to kick him. Believe me, if I were going to kick him, he would have felt it!

After this, Seth, Josh and this woman were making faces at my friends and me like they were going to kick our asses. Of course, I was not intimated and probably egged them on some by laughing at them. Through the course of this gesturing they were drinking many pints of beer and shots. After each shot was downed, they would take the glass and slam it on the floor breaking glass everywhere. I am surprised they did not get shut off or thrown out at this point. But no one did anything about their behavior.

When Upside Down Cross came on stage, all hell broke loose. It is not unusual for Upside Down Cross to bring props for the audience to destroy while the band destroys the club with raw meat, smashed items, etc. So the place went wild. The members of Anal Cunt were on the forefront of the mayhem and were tossing objects everywhere. I took this as an opportunity to throw a pitcher of beer all over Seth and his cousin. Sorry, for the alcohol abuse, but it seemed well worth the $3 it cost for the pitcher!

Bodies were flying, pieces of props were airborne and everything was out of control. The camera man was ducking quite often, but still catching the chaos from the band and audience on tape. During all this chaos, Seth decides to break off a piece of the clothesline and it poked my friend in the eye. She was hurt pretty badly at this point, so we decided to back off from the mess at the stage. Later, she found out she had a detached retina and has, to this day, had eight surgeries to keep from losing her eyesight.

After the bands had finished their sets and all the bands were packing up, Seth (Anal Cunt) decides to tantalize us again. My boyfriend's band had been playing that night as well. My boyfriend also grew up with Seth and earlier on in life, had parted ways. Seth and his friends were heckling his band the whole night. This began to carry on out on the street while everyone was packing up their equipment. I usually pack up my boyfriend's drums and was doing so when Seth came by and said something stupid to the both of us. I am not sure, at this point, if I remember what he said, but it was enough for me to start chasing him up the street with one of the drum stands. My boyfriend punched him in the face and all hell broke loose on the streets.

Seth punched one of our friends, who was yelling at him, and happens to be a woman. He punched her right in the head. When another one of our friend's saw this he freaked. In the meantime, I am hurling the drum stand around trying to block punches from Seth and Josh. Their cousin was on the sidewalk yelling all sorts of obscenities at me calling me a crack whore and a crack head. Mind you, I have never touched the shit in my life. So my mind cracked and I yelled I was going to crack her head. I left the battle on the street and proceeded to kick the living daylights out of her. Don't forget she was the one to mention that I had supposedly kicked Seth at the bathroom!

While I was kicking her ass all over the street, the friend who freaked at Seth hitting a woman, went across the street to a bar and called out a few friends. At this point, Seth's head had become a soccer ball! Everything subsided when Seth had his last blows to his head up against a van tire with many a foot pounding his head against it. He lay there unconscious and bleeding all over the street.

At this time I was already in front of the bar waiting to leave. I honestly did not know that Seth had been beaten down. A cop was walking the beat, was called to the scene, and saw Seth on the street. Traffic was backed up. People were all over the sidewalks watching and the cop called for back up.

In the meantime, this woman that was with Seth, his cousin, told the cop I was the one who had beaten Seth down with the drum stand. I was standing in front of the bar waiting for the car with a few friends and a guy in a leather jacket came up behind me and grabbed my arm. I only caught the image of a man in leather jacket behind me, while grabbing me, so, I struggled to get away, thinking it was one of Seth's friends I was struggling with. Next thing I know I am slammed like a meat slab to the ground with my arm tugged behind my back and pulled up around my neck being pinned

165

down.

I am screaming, "*Get off me you motherfucker! Who the fuck are you! You fucking motherfucker, get off of me!*" A friend that was with us came out of the bar and sees this guy on top of me and pulls him off and puts him in a full-nelson and is swinging him around. The back up police show and tackle my friend with the guy he is wrestling with and me as I was trying to get up off the sidewalk. I was picked up and slammed against the bar window with my face against the glass pane, arms behind my back again.

The other police got my friend down and put the handcuffs on him. In the meantime, they handcuff me and put me in the paddy wagon. My skirt was up around my chest by then, so I was screaming to the police to let me put it down. They did not care and threw me in the wagon.

After the street was cleaned up of all the chaos, mess and people, I was driven out of the area in the paddy wagon. After about a half-hour of driving, these cops get a call. The dispatcher wants to know when they are going to bring me in. Mind you, they stopped and got coffee and donuts and were hanging out in the donut shop parking lot drinking coffee and eating donuts when they got the call. I see the two cops look at each other in amazement and tell the dispatcher they did not even know I was in the back. I hear the dispatcher tell them to beware that I am dangerous and had just committed assault and battery on a police officer. I was as surprised at the accusation as much as they were surprised I was in the back of their wagon. They were not too kind to me after that call came in. They put on the siren and took every corner at top speed throwing me all over the wagon in the back while cuffed and shackled.

I was taken to the police station. I saw my friend, who took the policeman off of me was there as well. I was shoved into a cell and then was assaulted two more times in the cell, while the police told me they were going to teach me a lesson for assaulting a police officer. I had never even known the man that grabbed me at the bar was a police officer until I heard the radio call when I was in the wagon. Therefore, I was charged with five counts of assault and battery with a deadly weapon by means of a shod foot (in English: kicking a cop). I was also charged with two counts of assault and battery on Seth for splitting his head open and rendering him unconscious. What? I had not even known Seth was beaten up until this point.

My friends came from the club and bailed me out. I was released with a court date to answer to the charges. I was beat up very badly and had to go to the emergency room after my release from jail, whereupon I was X-rayed and photographed. I was given massive amounts of pain killers and sent on my way.

The next day I contacted The American Civil Liberties Union, an organization that protects American's Civil Rights. I was going to sue the police department for police brutality. I pursued this for two years with no success. So much for our justice system!

In the meantime, I went to court several times on these charges getting continuance after continuance. I was appointed a public defender, a lawyer appointed by the courts. You get one if you cannot afford a private attorney. Private attorneys charge about $150–200 per hour, therefore, I was stuck with the court appointed attorney.

Luckily, for me, during the case, we found out that the gig had been videotaped with some very incriminating footage of Seth/Anal Cunt. He was taped breaking up the props, acting out of control and the most incriminating footage was him screaming through the whole performance, "Kill niggers, kill Jews!" At the end of the performance he went right up to the camera, stuck his face in it and repeatedly shouted, "Kill niggers, kill Jews!" He had this very insane look on his face. My friends and I decided to also go to Anal Cunt's website. We downloaded all the pages to bring in as evidence of his behavior, as we did with the video tape. On the website are statements promoting sexual harassment on women in the workplace.

Lucky for me, the District Attorney that was prosecuting these charges on me was a Jewish woman. She dismissed all charges against me that were for assault and battery on Seth, but one charge of assault and battery on the police officer with a deadly weapon by means of a shod foot was kept. The best feeling was to see Seth leave the courtroom with his tail between his legs after having to watch him for days in a junkie, heroin stupor nodding off all over the courtroom. Also, to see his cousin embarrassed after she was told the charges were dropped because of the video tape was a treat as well. She was the ringleader of the whole circus. They told her that there was footage of her acting out of control at the club as well, when she had totally pretended to be this sweet, innocent person protecting her cousin. Ha!

My lawyer was no good. He felt that since I had some contact with the police officer, I was guilty and did not want to bring this case to trial. I kept trying to

166

And that's when the
drive-by happened.
SLASH CITY DAGGERS

tell him I was defending myself kicking all the cops off me after they had cuffed me and were beating on me in the cell. But he felt that if we took it to trial I would get found guilty and be put in jail for twenty years. He felt that if I just plead guilty, I would get probation, unsupervised for six months and not have to go to jail. What choice did I have? I thought none. I tried to get another lawyer, but they kept telling me I had to keep the one I had. I plead guilty to the charges of assault and battery on the police officer with great reluctance.

So much for the justice system in America! As I was pleading guilty, the judge asked me if I were telling the truth. Mind you, I am under oath. I swore on a bible to tell the whole truth and nothing but the truth, so help me God. I still plead guilty for fear of going to jail and knew I was lying to the judges face when I told her I was not. I was also asked by the judge if I were coerced in any way to plead guilty. I lied and said no. I wanted more than anything in the world to tell the judge that I was coerced and that I was lying. But who knows what would have happened. The fear of going to jail stopped me from speaking the truth.

And now, I have a criminal record. I am considered a *felon*! Thanks to Seth from Anal Cunt and his *cunt* cousin!

So that is the story of my gig from hell!

Susan Slater (Boston)

Bulletproof Blowjob

We were playing in a club in a club on Melrose in August. There were these three Mexican chicks we were talking to that had some drugs. So, of course we are gonna do the drugs. So we all get in the van and we are all doing drugs and we turn around and one of the Mexican girls is totally going down on Pickle. I mean, sucking his dick. The rest of us went in the club to tune up and that's when the drive-by happened. They were shooting back and forth at each other in on the corner of the club. Two people got hit. A bullet went through

our van's passenger side windshield, through the dash where the air bag is. Pickle got freaked out, but lived to tell about it none the less. Good thing we got the insurance on that rental van. We rocked, after the show cops were everywhere looking for shells. They checked our van and told us to go. We went and hung out with our friends in LA, and when we woke up in the morning we saw the bullet hole. It was pretty fucked up shit.

Abe Ruthless, Slash City Daggers (Phoenix)

Rock'n'Wrestling

I woke up on the floor of this chick's living room to the sounds of two people fighting outside. Shit, this sounded remotely familiar. Upon closer inspection I see that The Vulture and Pablo were cooked up on whiz and outside beating the hell out of each other in the spirit of "The Rock" and "Stone Cold Steve Austin". We were in Sydney to play a show and instead, these guys wanna wrestle on the streets and wake the neighbors up. The Vulture's up a tree at 7am screaming, "I'll get you Pablo Ramrodder!", while Pablo's running around with his beer in hand, trying not to spill even the slightest drop. The Vulture was told not to come back by some taxi driver after he helped himself to the cabby's cigarettes. This, we believe, is what set him off. The fight lasted for hours, and made its way into the hallway, the kitchen and living room, involving any poor soul that stood in its way, even poor ole Beaniehead. There was blood, and it wasn't a pretty sight. "Fuckin' hell guys! We got shows to play!" The Rocker and I were saying. Pablo and Vulture wouldn't stop, they just kept going at it. At this rate I was wondering if we'd ever play another show. Damage was done. Pablo had completely fucked up The Vulture's knee. No sorry, no nothing. Just a carton of beer. Yeah, get him drunk to numb the pain. Perfect! It worked. Well that was until we landed in Brisbane for the second leg of the tour. The Vulture was limping, he was not happy. He wanted out and to return back to his comfortable home in

Rock and roll over the edge

Adelaide. That wasn't an option. We had shows to play, money to make, and a swag of girlies to catch up with. Unfortunately, things started to fall apart and the future didn't look so bright after all, in fact, so dull that we had to take our shades off (yeah, crap joke but it *was* an overcast day). The Vulture ended up in hospital, while the rest of us went out and did important shit like drinking and buying records. The Vulture was not happy. He was fucking pissed. So we did what any person with a heart would do. We bought him more alcohol. Problem solved! The weekend came. We played, we rocked! We went home to spend the money.

Damo, Muscle Car (Adelaide, Australia)

Laughing and Bleeding

It was a Tuesday, sometime last July. Hot, hot, hot. Onstage, headlining at Sheffield's Casbah club. Last song, Sneak Preview, singer Denis jumping a round, knocking things over, falling down, causing trouble. Christoff the bass man, swings his bass tool around like a crazy man, and — *smash*! Christoff's bass machine head and Denis' ear collide. Blood everywhere. Denis' 1986 Maradonna yellow soccer shirt now red, ear lobe and other bits writhing on the stage floor. Sir Dickus Mintus, other singer, picks lobe up, hands it back to Denis, who is laughing and bleeding. Crowd thinks it's part of the show, as nobody really knows what will happen next at a gig. Doctors stitch lobe back on, plastic surgery is rumored. National coverage in UK. *NME* runs story, local papers run story and pictures, infamy complete. For our next trick, we will set ourselves on fire, live on CNN.

Al Machine, Less Than Zero (Sheffield, UK)

Assholes from Texas

A few years ago we drove several states away from our home in Texas to play at a private art college. I don't know how we got on the show other than it was set up through a band we drove up there with the now defunct Reverbarockets. So, apparently this private art school full of pseudo-intellectuals have a once a year party/fashion show. Somehow, we got on the bill. We were to go on right before the fashion show. As we loaded our equipment on stage (good-sized school auditorium) wannabe model types got dressed up by wannabe designer types and gave us looks of disdain. The stage was about four feet high and the art kids had constructed a big runway for the models to walk to down (sorta like an ugly Victora's Secret commercial). After we tested our equipment a "stage manager" who was a couple of steps away from "Hollywood" in those *Mannequin* movies, approached us, and told us that under no circumstances were we to set foot on the precious runway. That's like giving someone a new porn tape and telling them that "under no circumstances are they allowed to jerk off to it". Yeah, I'll just look at the tape for the acting... Anyway, we played and tore the black velvet covering the runway to shreds. "Hollywood" started hyperventilating and shrieking in that "Hollywood" way (I *know* you've all seen the damn movie). The crowd of about 250 art kids stared at us like we were from another planet, and remained silent when we berated them. After we played and the models went on everyone went out to the outside campus area for some type of art student circle jerk. We were informed by "Hollywood" that we had almost ruined the evening and we wouldn't be getting paid and that we were a blight on humanity. After I talked my band-mates out of murdering "Hollywood", a terror was unleashed upon the students final projects...sculptures were broken, tables were smashed, and clothing was doused in beer. Many minimalist abstract paintings were made all the more meaningful by now reading "I Love the Riverboat Gamblers". Etchings of wildlife now had "Texas" scrawled across them. One of the Reverbarockets shit in a teachers desk. It was beautiful. It more than made up for not getting paid. We may have destroyed the next Picasso's early work, but I think it's more likely we destroyed the next graphic artist for Vagisil's early work. They say that to this day the kids at that school still talk about "those assholes from Texas".

Teko, Riverboat Gamblers (Denton, TX)

Captain Panties

The numbers aligned for a countdown to destruction: four kegs of beer, three tons of dirt, two gallons of liquor, and a hundred people at a giant party. The reason? The final farewell show of the Penis Wolves. It was actually about the twelve time we'd said a show was to be our last (perhaps a rock'n'roll record percentage-wise, since we'd only played about fourteen times all told). The evening began with ecstatic nude mud brawling outside while inside a strange party brewed. Winos walked in off the streets. College girls wandered in. There we were. All of us. Dirtbags, rich girls, and homeless men all getting annihilated together. The true Ameri-

Gigs From Hell

can dream. The highlight of the show was surely the milk enema that Captain Panties shot out of his ass into the crowd. It was unbelievable, and quite simply defies description. The crowd basically rioted. Everything in sight got smashed or dismantled. Air conditioners took flight, fan blades were chucked like frisbees, the sewage main broke, a refrigerator got punched. Afterwards, we grappled in the mud. The Captain had me down and was waving his balls in my face. I grabbed as hard as I could, but he was so drunk that he didn't move at all; the sensation barely seemed to resonate. It wasn't until I dug my nails in deep that he howled and leapt off like a wounded animal. At the end, in a moment of surprising emotion, we hugged and everyone begged us not to break up. I kind of wish we didn't, but am probably glad we did. I don't know if I could take another one of those, and I'm sure the Captain's scrod couldn't.

Josh, Penis Wolves (Lancaster, PA)

Iggy Pose

We had this gig at this really small place in Stockholm, Sweden. It was back when Matte was still in the band. We were really piss drunk and it sure was a gig to remember. The drummer fell over the drums a couple of times and the guitarist and bass player had a really hard time trying to keep themselves up on their feet. A lot of beer drinking on stage led to a lot of broken glasses and bottles on the stage. When we got to the final song Matte laid down on the stage floor (pose a la Iggy) and laid there singing and crawling on his back for half of the song. When rising for the final chorus everyone noticed all the blood flowing down his back. He had cut all his back on all the pieces of broken glass on the stage floor, not that he or we cared, we were too wasted. Now that's r'n'r… Then later, backstage, we found a box with bottles of wine, which off course wasn't meant for us to drink. Well, we emptied some of them (into ourselves) and then filled the empty bottles with… yeah, we pissed in the empty bottles and put them back in to the box…

A lot happened at that gig, but this was probably the highlights. R'n'r is so much fun!

PM, Burnitude (Stockholm)

Frankensteined

We played this bar on the east side of Detroit. It's right on the edge of Grosse Point, which is this really wealthy neighborhood, but it's right next to the ghetto. It's really weird. I had a lot of wine. I drank a gallon of Carlo Rossi before the show. I was like Tony Clifton in drag. Anyway, apparently I got too close to some guy's girlfriend or some shit, and I didn't realize it until later, until I watched a videotape of the show, but these guys were throwing these big motherfucking thick beer glasses right at me, but the music was so loud, it was breaking off the walls. So that one dude, he came around to the corner of the stage, and he got in a good pitch right at my head. He got me, right in the eye. That busted my face open. But we kept going, you know. They shut the bar down, shut the power down, called the cops, and all these ambulances showed up. Because apparently — see, I didn't know why the ambulances showed up. But there was this other dude, I guess, who tried to stop the guy that threw the glass on his way out, you know, trying to play the hero. So the dude that broke the glass, he just grabbed a bottle, and broke it over this dude's head. So, he Frankensteined him, too. We got blamed for starting a riot, and after that, no one wanted to book us.

Johnny Flash, Lanternjack (Detroit)

Spiked

This happened on our second US tour in March 2002. We were driving down to Austin in our small mini-van from Oklahoma City. We had been touring the country for three weeks starting in San Francisco going from city to city to New York, then down to the south. A couple of nights before our only Marshall head had been blown by another band in New Orleans. Prior to that we had had some problems with the drums. The hi hat stand just bent mid tour, the tom stand unwired itself constantly and the bass drum pedal had broke the night before.

When we hit the stage at Emo's the bass head exploded during our first two minutes, and left a layer of smoke on the stage. It was burning. It took a couple of minutes to get the fire put out and the bass lined. There was a crowd of people on stage from The Dragons, Gaza Strippers and Immortal Lee County Killers helping out. During the next song our guitar player Stefan's fuzzbox stopped working for some reason, It kinda lost it's power even though the batteries were new. After a minute or so with a clean low volume rhythm guitar the sound was back to normal again. It has never happened before or since. Then we got going again and I got into this guitar solo and these girls upfront started

messing with my hair, pulling it, almost making me fall off the stage. We're playing our Radio Birdman medley. They started jumping and screaming, having a real good time. Then suddenly I realized that people were moving away from the stage. I was thinking, these Americans sure change their minds fast. But then I saw a big pool of blood on the floor. Like five feet wide... Apparently some guy knocked a bottle over. The top broke leaving the foot of the glass standing on the floor, upright with razor sharp spikes sticking right up. He jumped up and landed with his sneaker right on top of

> A knock came on the door, and I said, "Oops, there's my ride." I got pulled out, beat up, and thrown out of my favorite venue.
> WILD DOGS

it and it penetrated his foot. Being drunk out of his mind he continued to dance until the blood loss made him faint. So the ambulance came and took him away.

Later he wanted our autographs.

We continued playing of course, wondering who died. Then we realized the new pedal for the bass drum had broken into two pieces. The second one! So drummer Micke made a quick decision and left the stage running through the blood, the glass and the crowd backstage to borrow Immortal Lee County Killers' pedal. Then we played Search And Destroy and left...

Mathias, The Demons (Stockholm)

Deconstructing Winger

Well, there's the time when I got passes to Mr Big and Winger... well, after ripping out an entire section of seats in the balcony, groping various parts of various women, and going onstage with the band, I was tossed out three times. I re-entered with yet another pass, and I ended up in the dressing room remarking, "Wow, you guys don't eat much, do ya? You're so fuckin' skinny..." A knock came on the door, and I said, "Oops, there's my ride..." I got pulled out, beat up, and thrown

out of my favorite venue (the guy who did it is now in jail for murder, but that's another story). I bought $50 worth of heroin, ate it, and went back in... before I was pummeled again... and drove home. Oh, the horror in Portland.

Matt McCourt, Wild Dogs/
Dr Mastermind (Seattle)

Camp Blood

We were playing a show at Camp Verde Park in Camp Verde, AZ. It started off good, but after the second song, the neighbors who were really close to the park started

to bitch about the noise. Then, halfway through the show, one of them called the cops. The cops came and tried to shut down the show, and that pissed everyone off. We didn't wanna stop playing, so we didn't stop. The cops came up and bashed their clubs into all our amps. Then the riot broke out, 300 kids, including us, destroying this little park. There were cop cars on fire, trees on fire, people screaming- it was a concert gone riot. After it was all over, the park had to be closed. I don't know if anyone died or not, but I wouldn't be surprised. We lost a lot of equipment. The only good thing was we came out with a bad ass story to tell.

Ryan, The Pythons (Tucson)

Dee Dee and the Nazis

Once upon a time… no, fuck that, this really happened. So I am NIM, and I am the singer/guitarist in a three piece act with my two brothers called Mr Underhill. We are from Canada and we tour all over, and blah, blah, blah. So, last summer we got a chance to play with the late great Dee Dee Ramone at the Shackin Anahiem. This has to be my favorite show we've ever done, (a) because it was with Dee Dee and (b) Because it was fucking crazy. So anyway, we open the show and things go pretty cool, another act plays and then Dee Dee goes on and starts doing all the Ramones hits and the crowd is loving it. Before I get to the meat of this story, let me tell you that where we come from racism isn't really something that we see, and neo-Nazis are *not* a group we come across at shows very often. All that we really have to worry about is drunk people smashing glass (which is fun most of time) and getting too stoned on the greatest *weed* on earth. So, it came as a *huge* fucking surprise that half way through Dee Dee's set, shit goes down like this: I am standing to the side of the stage with my girl, dressed in a leopard skin full-length coat and black eyeliner feeling pretty fucking cool, watching Dee Dee rip it up, when I see these three huge fucking monster dudes push their way right to the front and throw this white rag into the center of the floor. Things are going through my mind at this point and I start to realize that something is comin'. So, their next move is to line up and proceed to beat everyone in the audience out of the circle as they claim the area immediately surrounding the white rag. They then go on to stomp around the white rag, straight SS Nazi style, with the whole "Heil Hitler" thing going on… you know, the outstretched arm with the flat hand. At this point, some people are getting pissed.

A couple of guys attempt to beat the Nazis out the circle, and are no match for these huge-ass Hitler lovers. After that, some more guys try and break up the circle and a *huge* fight starts. I'm talking straight out of an old spaghetti western style saloon brawl. All I saw was a stool lift up in the air, and the whole place moved backwards away from the stage. I grabbed my girl and tried my best to get us the fuck out of the way, and fast. I don't know if the bouncers were friends with the Nazis or just knew better, but they did nothing but stand back and try via osmosis to calm things down. Anyway, things did calm quickly, but a mass exodus began leaving. About half the concert go-ers left in the audience. The amazing thing is that through all this, Dee Dee kept playing. He either didn't notice, or just didn't bother with it, or maybe he didn't realize what was happening. I say he didn't notice, because he was ripping it up pretty hard. He just played right through it and left the stage after his last song which, for the life of me, I can't remember now. Then he actually even came back and did an encore, for those confused and stunned people who remained. I talked to him after and he seemed as though nothing had happened. I guess even if he *did* see what was happening, it wasn't something he hadn't come across before, because I'm sure if anyone has seen it all, it was him. I guess after a career in the Ramones, what the fuck else could there be for him to see? Anyway, Dee Dee rules, and the world will miss him, and he probably had no idea that a passing day for him was a really special one for me and our band. Gabba Gabba Hey, forever!

NIM, Mr Underhill (Vancouver)

Spiderland Acres

Here's the story — although some parts were pieced together after the fact (and over painkillers) with other bands that were there. It occurred at Spiderland Acres, a punk "festival" between Montreal and Toronto. Our manager had informed us that the show we had intended to play had been canceled and this was a way of, in his mind, keeping ourselves busy. Little did he know. Really.

Everything seemed pretty relaxed when we brought our truck through the woods down to the main stage. There was a punk band (Bunch of Fucking Goofs) from Toronto playing and we were assured that all types of bands were welcome, so we figured psychobilly would fit right in. It was an independent "festival" with two outdoor stages and we were playing at dusk. We set up

Rock and roll over the edge

After leaving the emergency ward at Mt Sinai Hospital we wound up at the Bovine Sex Club.
BIG JOHN BATES

and hit the stage playing our loudest, fastest songs which were kicking ass with the older punks. After the third song the sun went down and the shit hit the fan. Some idiot lost it on horse tranquilizers and cheap liquor and bottles began flying over the front of the stage. Security? Couldn't be found. With the stage lights on we didn't have time to get out of the way when the bottles came over the front of the stage (about four feet away) but we kept playing. Then the lights exploded in my head when I was hit in the mouth with a high-velocity beer bottle that broke my lower eye tooth in half. I was staggered as the blood gushed out but we kept playing. At the end of the song I asked the audience to stop this idiot (or at least point him out to me) but when we started the fourth number bottles began smashing against the wall behind the drums. Then an empty forty-pounder of tequila hit my fret board and broke two of my fingers. It hit so hard my finger bone pushed the low E-string a quarter-inch into the rosewood fret board of my hollow body. We finished the song and leapt off the stage looking for the loser. I heard the singer for the next band (Broadzilla) asking the audience to please stop. The idiot continued pelting her band with bottles.

As we left the second stage was being destroyed. There were ambulances at the road but they couldn't get through the throngs of people and many of them were wasted and walking into town a few miles away to vandalize whatever was there. After leaving the emergency ward at Mt Sinai Hospital we wound up at the Bovine Sex Club. We found out that there was a fair bit of damage done to the storefronts in the town and another eighteen or so kids had taken off into the woods (on the abundant horse tranquilizers) and that the OPP police helicopters were searching for them. I

understand that they were all found although one girl was found dead (after OD-ing in a ditch.) Lessons learned the hard way — hell, yeah. We don't play those kind of shows any more, we don't play festivals without security and a responsible promoter — and we now have excellent lawyers and dentists. And I left the tooth broken to remind me of what can happen when people get stupid . . .

Big John Bates (Vancouver)

Troubled Youth

So this gal appointed herself as our manager. Well cool, less work, besides playin' our asses off at shows. She got a website goin' for her "booking company" with links to us, and shit. Things are finally looking up for my band. Now, this gal also works with some "troubled youth" at a place called Gaderummet (The Street Room). Most consist of dopers and unemployed soccer hooligans/skinheads, who've been banned from most clubs. Would we do her this favor, and (of course) play for free? Well, as I said before, things were looking up, so why not? So, we arrive with our gear, everybody's doin' drugs, and are dressed up as pirates. So far, so good. We talk with the other bands, two metal bands with lots of tattoos but no real stage experience, and sat waiting around, drinkin' a few beers. More and more doped up people arrived in this four-room flat turned "youth crisis center", or whatever. We hit the stage around 10pm, and the crowd is pretty rowdy and mean looking. Forty seconds into our first song Cheap Booze Cheap Women, I knock out Thomas, my bass player's front teeth with my mic! Well, we carry on like nothing has happened, 'cept he's pissed as hell (huge dental bill coming his way — hey, it was an accident!). We end the

first song and introduce ourselves, but the crowd seems kinda sedated, and we play some more songs. I throw around some chairs and start calling these hooligans "faggots and losers" and all kinds of shit, after I find out that nobody knows who the hell Ann-Margret is! Now they just seem pissed, but somewhat scared of us? We end our forty-five minute set and starting drinking beer, but nobody's bothering us, ha ha. Some punk rock pals of ours, The Headfall Attitudes, then hit the stage, and people start getting psychical, and start beating each others up! Then the metal bands play, and the speed-crazed hooligans are beating *them* up while they play! The next two hours are the most chaotic bloodshed I've ever seen. I look around for some older authority figures at this place, but they're as drugged out as these "troubled youth". One ugly forty-five-year-old woman starts hitting on me for sex! It's like some weird violent seventies exploitation flick. Our new manager also beats up a friend of ours! Suddenly, somebody can't find our merchandise in the carnage. Well, we counted our losses and later we fired our manager, but these hooligans kept on coming to our gigs after this bizarre experience!

Jens Kofoed-Pihl, Hellroute 16 (Copenhagen)

LA Riots Revisited

Rebel Rebel gets banned from most clubs. We destroy stuff, Plasmatics style. We burn and break shit, and blow things up. It can get insane. Sometimes, people react to it in a violent way. We've had many nightmare gigs — no pay, getting screwed by the clubs, fights, violence, vehicles vandalized. The papers write about our raids, which is why we can't play anywhere, more than a couple of times. In Los Angeles, we're banned from the Whiskey, Roxy, Troubador, etc.

But one club would always invite us back and let us do what we want — the Garage. We could set stuff on fire, smash TV sets, throw stuff into the audience- anything goes. Our singer, Jet, has gotten used to taking the show out into the street. We tell the club we won't destroy anything inside, so that's our way of keeping our word while still being true to our "art".

We had played the Garage for months straight, and finally, at out New Year's show, Jet pulled out all the stops. He went into the street, lit a baby's playpen on fire, and the crew set off a shitload of fireworks. At the same time, Jet had a glitter cannon he was shooting off. It looked like the LA riots. Out in front of the club, cars were busting four-turns, there was smoke and fire eve-rywhere, and most of the club's crowd were out in the street. The channel and news crew finally called the cops when Jet jumped onto the back of their van.

Then we came back into the club, and did a couple more songs. Jet goes back outside, and crosses the street to tag a bus bench with the Rebel Rebel logo. A cop car comes screeching out of the adjoining alley. Jet was busted, red-handed. When the cops saw all the people outside the club, they called the riot squad. Cop cars, news vans, it was mayhem. Jet was busted by LA's notorious "Rampart Division" — the worst, most corrupt cops on the planet. They couldn't get Jet in the car with his shoulder pads, crotch piece, and all his other Road Warrior gear. It was a sight to see him take all that shit off. The cops couldn't believe it. Jet looked like an alien in the back of the cop car, as they drove him off to jail. The cops wouldn't tell us where they were driving him, so all we could do was wave bye-bye.

We finally found out that he was at Rampart jail, which scared the shit out of us. These cops kill people. They set people up with drugs, planting them on people. They beat them, all that shit. We went down anyway to bail him out. He was charged with vandalism, tagging, terrorist threats, and a bunch of other bullshit. Jet's cellmates thought he was the devil when they threw him in the cell with his fishnets, boots, two-foot spiked hair, and makeup. Anyway, we finally got him out, and the cops escorted us back to the freeway to make sure we left LA. They said they were going to bust any show that we did in Los Angeles, and that they were going to let all the clubs in LA know. Shit, punk rock clubs don't care about cops. We still play all over Los Angeles. Fuck 'em.

Teddy Heaven, Rebel Rebel (LA)

Melbourne Blackout

Our gig from hell is one we had at the 9th Ward in Melbourne. A very good venue. We'd finally stepped up a level when it came to crowd size and venues and we'd promoted this gig hardcore. It was a Friday the 13th, a good sign if you're in a hard rock band. I left home early and got fifty meters down the street to realize I had two flat tires. I remained positive and ran home to get my brother's car, I loaded it and headed for the gig. Three blocks from the venue our drummer called my mobile phone, he needed a lift too. Shit, I was already running late, now I had to go pick his late arse up halfway across the city. I picked him up and loaded the car and had a silent and awkward ride to the gig —

he'd just found out that I'd slept with his sister, this was part of his revenge. His sister was a little groupie who was courting a very popular Japanese Ramones-styled pop punk band, the same band who had also just found out about the affair and decided to blacklist my band from half of Melbourne's venues. We got to the 9ᵗʰ Ward and as luck would have it I found a park for my bro's car right out the front. I was stressed, nervous, panicky and late. But I was soon to find out that the venue's mixer and lighting guys had been in some kind of accident and were running late. We took the opportunity to play our favorite drinking game: "Circle of Death." An hour after we were supposed to be on the mixer

They couldn't get Jet in the
car with his shoulder pads,
crotch piece, and all his
other Road Warrior gear.
REBEL REBEL

the drummer showed up, the drummer was insisting he finish his pizza before playing so it wouldn't get cold. We went backstage and ripped the shit through him, this drummer had already sabotaged two of our previous gigs by canceling at the last minute (one gig we hadn't turned up to was at a venue ran by big-time dealers and junkie gangsters, word is they're still looking for us, and after a stream of abusive answering machine messages I'm pretty sure they mean business, thank God their venue has been shut down and most of them are in jail now). Anyway, a few of us had slept with the drummer's sister and maybe he had a right to be annoyed but there's a time and a place to argue and

turned up, he was still in deep shock from his undisclosed accident, and the lighting guy was in hospital. We were pissed. Snake (our front man) and The Doctor (who prescribes — on bass) had gone halves in a pill and also taken a trip each, leaving me to do all the stressing. The near-capacity crowd was getting rowdy. The show had to go on, unfortunately our drummer had gone for a pizza and hadn't returned. The Doctor had also disappeared "on a mission". Snake and I did a sound check and tried to buy time by playing a guitar duet. When I do the sound check into my mic I tend to make gratuitous moaning sounds, a punter at the front of the stage was yelling, "Fuck you ya dumb cunt, what are ya fucking the fucking mic?" I don't like coping shit, so I said, "Yeah and soon I'll be fucking you, too." The punter lunged at me, Snake came and broke it up before we could properly meet, and we just threatened each other. The Doctor was still missing, and the drummer was nowhere to be seen. I got on the drums and did the sound check for each drum, that same pissed punter yelled "I can hit the fucking drums like that too, you're shit, play something ya fuck!". I laughed it off this time and offered the pissed bastard to play. He declined. The venue was getting mighty pissed off when

this wasn't it. A documentary maker following and filming our band was having a field day at this stage, so we got some jugs of beer and walked the drummer on stage to make sure he played. The crowd cheered a sarcastic cheer. We knew full well that this would be the drummer's last stand. As I walked out from backstage, I tripped on some cables and fell forward scratching my guitar's immaculate paint job on a PA and spilt beer into the power point. The venue's lights blacked out immediately. Lucky no one saw what happened except for the documentary maker, but a reserve power source had the power on within seconds. The mixer was fuming, we'd trashed some of his priceless equipment, no one else in the band knew it was my fault so they were abusing the mixer. Another verbal fight ensued. The mixer did some electrical wizardry and we started our show, however the blackout had blown some of the speakers facing the band. Still, we were playing the best we ever had. Three songs into it our bass player showed up and got onstage half naked, and he had dry sex with his amp for the next two songs. Mid way into the set the rowdy punter up front punched out his girlfriend and the bouncers punched the living shit through him right at our feet. We kept playing. Snake

174

took a break and did his trademark burn-a-cigarette-out-on-his-chest to get the crowd going. Unfortunately he'd missed the wet patch that dampened the lit end and burnt a hole into his nipple. His scream still echoes in my head at my amusement, and the five-foot long snake tattooed on his body still bears the scar. He dropped the cigarette and it landed on his lead and burnt straight through. The Doctor walked offstage again. For the final two songs our drummer decided not to play anymore. Going into a guitar/vocal frenzied outro we received a standing ovation. We packed up our gear trying not to listen to the comforting words our friends were telling us, ate the drummers cold pizza, then went outside to see an empty parking space where I'd left my brother's car. To say the least that fucking sucked.

**Johnny, The Switchblades
(Melbourne, Australia)**

Shipwrecked

Bona Roba: Queens, NY. We got to Block Island, RI, early one Tuesday to play in a festival later that night. There wasn't much to the town — one supermarket, one bank, and one liquor store. We dropped our bags off at the hotel, picked up a thirty pack of Bud high-boys, and went to the beach to drop a few back. We weren't alone. There were three locals sitting there with the same plan. They introduced themselves to us. The first was the most normal and named Brian. The second guy had red leathery skin, a prosthetic leg, a hand brace, and a tattoo with a skull and swastika that read "Harley Fucking Davidson." his name was Shatter, and it was his *birth* name. The last guy appeared to be the leader of the three, and everyone called him F.U.N. He was Shatter's brother F.U.N spent the next two hours spouting bullshit about how every girl on the island wanted him, and that he had "Ripped about seventy-five per cent of the broads on the island." He would talk about drilling some broad, then laugh like a fucking psychopath. We stuck around for as long as we did only because they were rolling one joint after another and besides, what the fuck else was there to do on Block Island than listen to a couple of white trash drags reinvent themselves? By the time we went on that night (around midnight), we were more than half in the bag. We had dropped back about twelve Buds throughout the day, smoked four or five bones, and now we were onto Jack. We played our shit and everything sounded good. After the show, these two girls

come up to us and say, "You guys do blow?" We packed up our shit and took off with them. On the way to their place, we run into Shatter, Brian, and F.U.N. They're fucking tanked F.U.N is throwing beer bottles at people, and Shatter is mumbling old war stories, or some shit. We get to the front door of the girls' apartment and one of them says, "Your friends can come too, if you want." We thought about it for a second and decided to let F.U.N and his crew come along. First thing one of the girls does is throw on a red light, take out a bag of coke and throw on Guns N' Roses' Appetite. We all start doing bumps… one after another. Everyone's feeling great. These girls are giving us drinks and drugs and we don't even know their fucking names. By about the time My Michelle started playing, one girl says "Alright, let's get naked." All of us are fucking spaced out and feeling like ten thousand dollars, so we strip down. There we are, dicks hanging out, slugging back cans of bud, high fiving, and high as fucking kites. The girls start dancing and making out. After awhile they take off their shirts and we're thinking we're in it to win it. One of them pulls the other girl's dress down and hanging there is a seven-inch fucking cock! The girl drops to her knees and starts blowing the girl with the dick. It took about a minute to comprehend what was going on. On the right side of the room, F.U.N reacts by putting his pinkies behind his head and snorting like Satan himself. Shatter removes his prosthetic leg and starts playing it like a fucking guitar. At this point, we're all on another universe and unable to make sense of anything, other than the feeling that we're in a David Lynch movie. Somehow, we managed to put our clothes back on and head for the door. We never looked back and never saw those motherfuckers again.

Neal, Bona Roba (NYC)

Bird is the Word

Good evening, sinners! This is the Deacon speakin', organ player extraordinaire (that's definitely a matter of opinion) of The Brimstones. When asked to write about some of the strange, crazy, and stupid things that befall our little band, it really hit me. We've done, and been a party to many strange, crazy, and stupid things. On that note, I realize how hard it is to pick one freak occurrence out of a million. Do I talk about the time we managed to set the stage of a club on fire beneath our feet as we played (causing much damage, and fun!)? Or do I talk about how our bass player, Woolley "The Bully" Brimstone, managed to play his bass, engulfed in

a huge fireball, while hanging upside down from a flimsy gas pipe (the club owner was not amused and Woolley's eyebrows still haven't grown back)?

At this point I began to realize a pattern. Our shows seem to degenerate into chaos at the exact same moment at every show. This is the moment where we let the first chord ring off of our closing song. This is our cover of Surfin' Bird by The Trashmen (we are a surf and garage band after all). We all get the fever when we are playing, bangin' away, going completely nuts, but Surfin' Bird is something else entirely. At this point we know that we don't need our instruments for another song (we've managed to destroy enough instruments to fill a pawnshop), and even if we did, after this display of violence, the owner is sure to toss us out on our asses. We've really got nothing to lose at this point. It's been that way over five years and hundreds of shows (if you can actually call them shows), but one time in particular sticks out in my brain.

It was one of the first time we incorporated Surfin' Bird into our set. In fact, it was one of our first shows, period. We were invited to play a punk and hardcore show in Staten Island, a couple of years ago at some shitty little club in the slums. Right off the bat people were giving us shit because we were "some stupid surf band". This just goes to show you how excepting the punk scene is. The show was uneventful, the same shit over and over, where everyone just stands around and looks pissed off while they ignore all of the bands. We figured we would just rock out and get it over with, but the tables turned very quickly. We took the stage, and to our surprise, the place went fucking nuts. People were dancing, stripping, singing along and going completely crazy. All in all it was a great set, and then came Surfin' Bird. Nobody knew it was coming, but the second it kicked in and everyone recognized it, they went even crazier. Now, as any band will tell you, the crazier the crowd is, the more into it the band is, and this was to be no different. We were all jumping around, smashing shit all over the place while I'm screaming the words to The Bird. It was awesome, but the point of this story is about strange occurrences, so let's get to the heart of the issue.

Lord Skooch, our sax player, had a hankering to start smashing stuff against the wall during Bird, however, I don't think Mr Bouncer/soundman/owner of the club was really diggin' our demolition. Right at the break in the middle of Bird, this giant arm encircles Lord Skooch's neck, choking the living shit out of him, and yanks him off of the riser and out of the back door. We all stood

there kind of dumbstruck and then I devised a plan. I tossed the microphone, picked up the mic stand, and rushed the back door, ready to turn Mr Soundman's head into a fucking ashtray. I didn't say it was a great plan, but it seemed like a good idea at the time. The stage door was locked, so I started pounding the handle with the mic stand to get in. All of the sudden our sax player comes kicking back through the steel door, slamming me in the kisser, sending the mic stand flying, and stomping onto the stage with the soundman in tow, both of them screaming at each other. The soundman picks up the mic and starts yelling at the band and the audience (after all, we were being rude and inconsiderate). At that point the crowd just started throwing all kinds of shit at the soundman (bottles, garbage, etc...), all the while chanting "Let them play" and "Fuck you, you fat asshole". It was a Hallmark moment. Now there was only one thing left to do. We picked up our gear, and at the high of the riot, tore right back into "Surfin' Bird" while the crowd kept right on assaulting the sound guy. I think it was one of the best shows we ever played, and certainly on of the best versions of "Surfin' Bird". However, the sound wasn't very good. I don't think the soundman liked us.

So here we are, a million shows later. It's been a blast, and we have all of the broken bones, bleeding wounds, cracked teeth, blown knees, and smashed gear to prove it. If you don't believe me, maybe you should come out and see The Brimstones some time. Perhaps I'll tell you the story about how our bass player got his balls caught in a plastic beer cup while swinging from a live PA wire, all the while dressed as a voodoo witch doctor. Shit, I should have told that story, oh well there isn't enough space in this whole book for that one. Until next time.

Deacon, The Brimstones (Satan's Hollow, NJ)

Shit McMuffin

My old band the Ventilators get a gig in the Tahoe/ Truckee area of California with our friend's band, The New Strange. We rent a van and make the two-hour drive from Sacto without incident. Once we get there, we find out it's a birthday bash for a local pro snowboard guy, who is so fucked up he can barely speak. It's like, only 7pm. The guy is actually cool as shit, and tells us to find a door guy, and to take whatever money is paid and to split it however we see fit... cool with us... well, we find out there are no mics, and the PA is fucking puny. We hook up with the local sound guy who takes

us to his makeshift apartment/practice space which is located in the attic of a thrift store. He gets stoned and plays that fucking horrible "hit" song by that fucking horrible "hit" band Creed. We split soon thereafter. Things are really looking up. We get back and the local drunks are in full effect. The puny ass PA is set up, we plug in and play our set. During our set, one of the local snowboard kooks is fucked up and taking our

complete with a human shit McMuffin which someone brought into our room… fucking gross. We go home. The cleaning lady must've been bummed. Later, we find out that the guy getting his noggin thumped by our singer is on video and that the guy is a cousin of a high school student of mine. I could not wait to tell him.

Curtis, The Ventilators (CA)

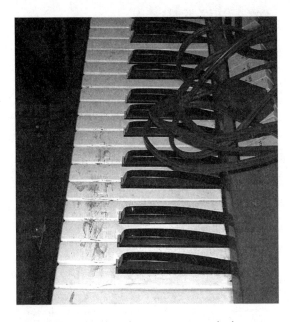

We all get the fever when we are playing, bangin' away, going completely nuts, but Surfin' Bird is something else entirely. At this point we know that we don't need our instruments for another song.
THE BRIMSTONES

beer of the stage, knocking our mic stands down, getting up on stage and slobbering all over the mics. Our singer, Jason, keeps pushing him away until finally, while the guy has his back turned to the band, he takes his tambourine and throws it over the guy's head and around his face and yanks him backwards off his feet and into the drum kit. The guy is bleeding from the head and is unconscious for a minute, then is finally dragged off the stage and outside… Yes, he even comes back into the club/pizza joint and starts licking the beer off the floor in front of the stage…

The New Strange play without incident and after their set some drunk ass chick comes up to the guitar player, Jesse, and is clearly annoying him. All I saw next was a half-filled pitcher of beer being thrown into her face and Jesse fighting the bouncer with their bass player, Ronnie. The place clears out and two guys off to the side pass a knife to someone else and we are gone… We end up staying in some hotel that offers a continental breakfast in the morning which is a good thing to see, until you open the door and our friends from another room have left the remains of their breakfast

Drag Queen Inferno

Our first gig was definitely a memorable one. Since it was our first show, I wanted to get a few low-key gigs in the Valley under our belt before we went out to gig in Hollywood. I figured it would be a good boot camp to tighten up our live act. I booked a gig at a coffee shop that I saw had a listing in the *Music Connection* magazine. I called the owner for the gig, and the owner was like, "Yeah, come on down this Saturday night, you can go on after our production of *Pippen* Let's say 2am". I was like, *Pippen*, huh? Sure, what the fuck, long live the theater. We get to the gig, and this drag queen dressed up like a security guard buzzes us in. This place is a coffee shop/drag bar/after hours club/musical dinner theater place. We load in, and there are three Valley kids playing pool, and about a dozen forty-something drag queens conversing. We walk in, and the whole place turns their head and there is a moment of silence, then everyone goes back to beauty tips. I go to load gear onto the stage, and the stage has the backdrop for the play *Pippen*, so I am loving it, feeling this

sixties *Brady Bunch/Family Affair* on acid vibe happening. So we set up, and the owner Debbie/David, I couldn't figure out which name to call her/him, tells us to go after a short acoustical performance buy this queen named Spanky. Spanky was this sixty-year-old drag queen with an acoustic guitar that does one song, called Scandalous. I never remember lyrics that well, but I will never forget Scandalous. "She used to work nine to five, then she's doing smack and now blowing guys, that girl is scandalous, she was daddy's girl, that went to far, now she works on Santa Monica Boulevard, she's scandalous, even Heidi Fleiss won't give her a job, she's scandalous." Spanky was dressed to a T, in ripped fishnets, and a wig half-falling off during his performance. Well we play, and the drag queens come into the room, and are ballroom dancing/mash potato-ing to our music. We play power poppy seventies glamish punk, and it was a trip. Not necessarily formal dancing material, but what the fuck, it's rock'n'roll. Well the second we were done, I am putting my bass down, and I look up at the disco ball, and it is shaking. I look around and the ground is moving. All the queens start screaming and running out of the room. Me and my singer start hi-fiving because the earth is shaking after our first performance. We eventually go outside, and a few of the drag queens are screaming, and the one dressed as a security guard runs by, trying to maintain crowd control. A tree fell over the power lines, and there were power bursts coming from the lines. After a few settling moments, I walk by into the room, and hear two people screaming at each other. I walk into the stage room, and on stage in front of my gear is a tall raven haired queen screaming at Spanky. I am like, "What the fuck now?" The raven haired queen yells, "Fuck you, if you don't want my Grade-A Puerto Rican ass you can go to hell. If I see you again with that bitch I will cut you both." I am like, "Holy shit." The raven haired aggressor slaps Spanky in the face, Spanky does not move. Then she slaps Spanky again. Spanky grabs her wig, and they start cat fighting in front of my gear. The security guard-dressed drag queen tries breaking it up, and Spanky is knocked into my amp, knocking down the cabinet, and knocking over my stand. I dive to catch my bass, and barely grab it by the neck. The next thing I know, I am huddled over my bass like flies on shit, while earrings are flying, wigs are coming off, and heels are breaking. A group of drag queens rush in and break it up. Meanwhile, my guitarist is sitting in the seats with his jaw open, the singer is making on some chick not noticing, and the drummer runs through the back of the *Pippen* stage set and hides.

Shortly after we load our gear out, and order is restored at the coffee shop/drag bar/after hours club/musical dinner theater place. I knew we were destined for rock and roll grandeur after the earth shook, and stood still after our first performance. Long live the theater!

Johnny 99, Silver Needle (Hollywood)

Creeps In Corby Hell

I'd found the gig in a list sent to me by a promoter in return for a handful of videos he was interested in. Working for the Visionary video label had its advantages. I'd sent a couple of dozen tapes out and managed to secure around a dozen gigs up and down the country — in places none of the band had ever heard of. Corby was one such unknown quantity — this was literary two weeks before the "schoolgirl kicked to death" incident. The promoter called me and sounded like a nice guy. Soft spoken and knowledgeable about music, he poured praise on our tape and booked us to play a Saturday nightspot.

We had got into the habit of setting off to gigs earlier than really necessary. The reasons were two-fold. Firstly, we could compensate for any delays, and secondly, if we arrived early we could get something to eat and chill with a few pints before the gig. We'd played several gigs over the past few weeks and were in good spirits; our mini tour had been fun so far and we'd had some cracking audiences. With the gear loaded and a trip to the off license out of the way, we set off towards the Midlands.

Our bass player, Ramjet, had procured some particularly nice and highly potent skunkweed. It mixed wonderfully with the red wine, cheese and crusty bread we'd taken along for the journey. By the time the van's engine blew up we were already gibbering idiots. We sat on the hard shoulder smoking weed and drinking claret whilst we waited in a mental-fuzz for the AA to arrive. After around twenty minutes we heard a van pull up next to us. "Excellent service!" was the cry from the back of the van. "Fuckin' shut up! It's the Bill!" replied Dunk from the driver seat, cramming extra strong mints into his mouth and praying for adrenalin to straighten him out. Give them their due the police were really helpful. Not only did they call up the AA and request an urgent response, as we were sat on a particularly notorious section of the hard shoulder, they also produced half a dozen traffic cones and positioned them around the van. On hearing that this was going

on, Ramjet went hysterical. "Quick, throw the cones in the back of the van!" he blurted out. "We'll melt them down and make them into spoons!" At this, I also lost it along with our guitarist Steve. Max the drummer and his wife began to swear at us through clenched teeth from the front of the van. This made us worse.

Fortunately the police had little time to spare and were quickly on their way. Shortly afterwards the AA arrived. After ten minutes of fumbling around under the bonnet, it became clear we'd killed the van. We were hauled onto the back of the truck and we asked the driver to take us to the gig (dedication or what?). The next hour drifted by in a haze of stupid comments and more wine. It's probably fortunate that we broke down, as the journey — courtesy of the "fourth emergency service" — allowed us to recover and the weed was given chance to wear off. We arrived at the gig with plenty of time to spare. The venue was located in the middle of a large imposing housing estate. The van was lowered onto the car park, much to the amusement of the bar staff, and we hastily unloaded and set up the gear. I spoke to the promoter for a while and he told me that he was expecting quite a few "old faces" to turn up. He was confident his promotion work would

Art: Dr Adolf Steg

pay off and we had a good night to look forward to. My instincts were right, he was a nice guy.

A few people were already in the room when we sound checked. There was a mixed response. Those who had obviously had a bit of a day of it threw casual insults our way, to which we responded with rapier like wit "Fuck me, it's a rubber man!"... "Don't worry, you'll be asleep by the time we play!"... and so on. After the sound check we made a nest at the side of the stage and continued drinking. By this time we'd all had some whiz and were once again feeling buoyant. By nine o'clock the place was respectfully filled out. We decided to go on earlier than usual as we were itching to play and realized we were in danger of getting too pissed to put on a good show (something we had vowed to stop doing after a couple of near-disasters). Dunk had recently got out of the nick and married his girlfriend, the tour was going really well and we nearly had the money we needed for the studio session we'd planned. In short it was a happy time and we played bloody well. The audience were kind and we even had a few moshers (whatever that means) on the floor.

After the gig we retired to the bar. The staff were extremely complimentary and fed us a few free beers. The promoter was more than happy and called me through to his office to rebook the band, claiming that word-of-mouth would more or less guarantee a full house next time. I wasn't convinced but he also offered more money, so I agreed that we would return in a month. When I got back to the bar Dunk was agitated.

"I think we've got some trouble!" he said. "Some bastard has nicked me Zippo! I wouldn't mind but it was a wedding present from Angie [his wife]. I think it was a bird. I caught her with me pint."

We were then approached by a youngish looking skinhead. He was taller than Dunk (which doesn't really count for much) and thick set.

"What you doing upsetting Tracy?" (Forgotten her real name to be honest.)

Dunk tried to protest: "She nicked me pint!"

"How do you know it was her?"

"I caught her and she owned up!"

Tracy came over in tears. "Bastard said I nicked his fuckin' lighter!"

"No I fuckin' didn't!" protested Dunk. "I said someone over there has nicked it. It was there when we went on stage. Then you lot came and sat in our places. What would you think?"

"You see the bastard is callin' me a fuckin' thief!"

"You are a fuckin' thief!" was the surprise retort from matey boy. Fair shout!

Then his pal arrived. Short cropped black hair. Pissed. Obviously a barm-pot looking for trouble.

"What the fuck's going on?" he growled. "These fuckin' shithead band blokes giving you shit."

"Not really!" chirped matey boy.

Cue Tracy's tears again: "That bastard called me a fuckin' thief... said I nicked his fuckin lighter and beer!"

"Fuck me!" moaned Dunk. "You did nick me fuckin' beer!"

That was enough to send captain aggressive over the top. It was all the excuse he needed. Dunk didn't even see it coming. The punch landed squarely on his right cheek. All hell erupted. People dived in from all over the room. We were flailing about wildly. Fortunately the security blokes were on our side. Max, who is six-foot-odd and built like a tank, had bodies hanging off his shoulders as he threw people around and occasionally stamped on them. I got whacked from behind and lost my footing (bloody brothel creepers). I had to crawl out of the mêlée suffering several halfhearted kicks to my side and arse I got to the edge of the dance floor and turned to rejoin but, as is often the case on these occasions, the rut had already subsided. That magic thirty seconds that lasts ten minutes. There was a short stand off before the bouncers managed to separate everyone. The police had been called and arrived pretty damn quick. (We later discovered the guy with the black hair was local public enemy number one, and they already knew his whereabouts.)

Ramjet was remarkably lucid. "I want him, him and him arrested!" he shouted pointing to three of the culprits involved, including matey boy and black hair. There were already fresh drinks on the bar for us. I passed a pint to Dunk and witnessed one of the freakiest things I've ever seen. His right cheek suddenly sprang a long, almost geometric shaped section of flesh, as if a section of broken bone was being forced out of his skull and through his face.

"Fuckin' hell Dunk, what's that?"

But Dunk heard nothing and collapsed unconscious onto the floor. As he lay there waiting for the ambulance — which fortunately wasn't far behind the police — a guy wandered over and handed me Dunk's lighter. "Is that what all this fuckin' mess is about?" he snarled and walked off in disgust.

Max and his wife went with Dunk in the ambulance — Max didn't drink and we decided it was better that someone who was sober went. The rest of us had to then play the waiting game. The plan was for Steve to use his RAC membership to get us towed back home. However, until we heard from the hospital we couldn't really call them. Fortunately the staff and promoter at the gig were all pretty embarrassed and upset by the incident. They really did want us to play there again. We promised them that we hadn't changed our mind and would still honor the arrangement. They plied us with free alcohol, bar snacks and games of pool for the next hour-and-a-half. In fact they let us serve ourselves, which was nice. When we got the call from the hospital they gladly sold us a carryout at cost price. The RAC turned up fairly promptly (I managed another large Jack Daniels and a pint of Stella just to make sure my boots were well and truly filled), and we set off to the hospital.

Images of Beirut spring to mind. The hospital was chock full of drunken blokes and birds. Screaming and moaning, bleeding all over the place, mainly from the head. There were eyes like damaged plums, swollen to the size of tennis balls, noses that would not have looked out of place on a Picasso, arms with the hands pointing the wrong way, toothless bloody mouths, bloody soaked T-shirts, ears hanging off... And some of these poor fuckers were still up for a scrap — with each other. In truth we didn't look out of place. Max was in bits. The place was freaking him out. We still had to wait for some discharge papers, so I went for a wander and managed to steal all the latex gloves, facemasks and paper hats we needed for the journey back. It was fairly low-key driving home (or rather riding home). The RAC guy was highly amused by our antics and let everyone drink and smoke... The skunkweed lifted our spirits and eventually knocked us all out. When we came to we were outside our rehearsal room with the van already unloaded onto the road. We gave the guy a fiver and thanked him. We then endured the horrendous ordeal of unloading the gear into the cellar before making tracks to our respective homes.

Several weeks later, myself, Dunk and Ramjet were called to Kettering Crown Court as witnesses to Dunk's assault. The trial was successful and the guy with black hair got three months. It turned out that he had in the past maimed several locals, leaving them scarred or crippled for life. No one in the town had the bottle to come forward as witnesses. None of us have been to Corby since.

**Richard King, The Phantom Creeps/
Razor Dog (Lytham-St-Annes, UK)**

Broken Boned

A few years ago the band were going to a town just north of our hometown Gothenburg to play at some kind of outdoor festival. It seemed to be a cool get-together and we pretty much looked forward to it.

We got to the place for the event, did the sound check and then felt that it was time for a late lunch. After a short while we found a Chinese restaurant that looked alright.

So there we sat, enjoying our chop sueys and our beers, when a bunch of guys, four or five of them, entered the place all dressed in similar orange overalls. Kinda weird looking crew, we thought, and redirected our attention to the food and beer.

It didn't take long before we heard these guys insulting the staff of the restaurant and making racist remarks in a quite ugly way. They kept going on so eventually we had to say something to the effect of "Shut the fuck up you stupid weirdoes!" Well, that might not have been the smartest thing to do, because in a sec we had the guys surrounding us and in another sec I heard the sound of crushing and shattering plates and glasses and was very surprised to realize that it was me causing that noise as I tumbled over the tables, being hit by one of the overalls. My compadres replied instantly by throwing their beer glasses at the bastards and tipping the tables over and trying to get at them in general. The scene was accompanied in a rather striking way by the screams of the Chinese staff and, after a while, by the police sirens. As the fight and the devastation of the restaurant went on, and even though our opponents seemed to be trained kick boxers, which meant, I have to admit, that we received a whole lot more thrashing then we were able to give, I found myself thinking that: "Fuck man, this is — ouch! — just like a proper — ouch! — saloon fight in a western movie or — ouch! — something!" Well, as I said, eventually the cops arrived, and somehow managed to calm the situation down. They were led to understand by the Chinese that we weren't really the bad guys in this case, and after talking to the local press — "Band in Bar Fight" — we were escorted by the police to the venue for the gig, which felt really, really funny.

We managed to drag our beaten bodies up onstage and the gig went well enough, with a little extra aggressiveness stirred down into it.

This could have been the happy ending had not a couple of our friends would have gotten drunk and spotted the overall weirdoes outside the fence behind the stage and of course had to provoke them to climb the fence and at that exact moment we came round the corner with our things and of course they had to hurl themselves onto us again and the fight we didn't really feel like anymore had to continue...

Goran Florstrom, Generous Maria (Gothenburg)

Sports Bar

I just got out of rehab, and I found out that my kid was diagnosed as schizophrenic. That was on a Thursday. Then on that Sunday, my dad had a stroke. So, things weren't going well. The next Tuesday, I'm sitting in a bar, and I'm telling my wife that we've got to get divorced. And my wife is fucking nuts, it's one of my favorite things about her. But it also makes me terrified of the chick. So, she started making fun of me, she was saying, "You know, you're kid's a fucking retard." So at that point, I slapped her, and I just left. I went to another bar. There was this asshole at this other bar, and he kept giving me shit, I don't know what was going on, it was a sports bar, I don't really hang around at those kind of places. So finally, I just stand up and I say, "Dude, you're a fucking asshole," and I walked out of the bar. Now, him and his bouncer, they run out into the parking lot and grab me. They hit me, and throw me against the car. And I just remember looking into their faces and thinking, "Dude, I'm going to drive my fucking car right through your bar." When they let me go, I got into my car, I put it in drive, and I smashed into the fucking bar. I'm glad no one got hurt. So I go home, and right as I'm pulling up to my house, there's like fourteen cops. I've never seen anything like it. They took me to jail. They said, "You're under arrest for domestic violence." I was like, what? Then they added malicious destruction of property, leaving the scene of an accident, operating under the influence of alcohol, all these charges. But I've got a feeling that they're going to let me go, although I'm not sure you should be able to drive your car through a bar and not do any jail time.

Cranford Nix, The Malakas (San Diego)

Rock and roll over the edge

Art: Dogger

Guilty Parties

VADGE MOORE is a drummer, a noise conductor, and an expert on the occult. He spent eleven years beatin' skins for the infamous punk band the Dwarves, ten years in the goth/satanic band Neither/Neither World and the last three years orchestrating noise for his decadent-hate band Chthonic Force. He's written for the esoteric/occult 'zine *Dagoberts Revenge* and interviewed numerous occult-underground friends for *Primal Chaos Online*. He is currently working on a book about his life-long hero Aleister Crowley.
[w] www.thedwarves.com

SLEAZEGRINDER was raised by wild spiders. He has been called "the greatest rock writer, ever" more than once. Mostly by himself, but occasionally by other people. He often disgraces the pages of many magazines and newspapers in the US and elsewhere, including *Hitlist*, *Carbon 14*, *Boston's Weekly Dig*, *The Noise*, *Maximum Rock'n'Roll*, *New York Waste*, *Stance*, *Mic Stand Monthly* and *Headpress*. Currently, he is working on an Urge Overkill biography, a Gigs From Hell DVD, and several compilation records, including a Zodiac Mindwarp tribute. He's big on the Zodiac, you see. When not busy building his half-assed empire, he enjoys listening to Guns N' Roses, hanging out with drunken rock stars, and making out with his wife, Stacey. Sleazegrinder does not believe in tears, and although he quit drinking years ago, he still walks into walls all the time.
[w] www.sleazegrinder.com

Band Contacts

When they limp into your town, buy them a drink, would you? They've been through a lot. (*Some contacts may have changed by the time this book reaches you.*)

Antiseen [w] www.antiseen.com
Authorities [w] www.authoritiesdevilmusic.com
Ballistics 13 [w] www.theballistics13.net
Bar Feeders [w] www.thebarfeeders.org
The Beatings [w] www.altamontrecords.com
Betty Already [w] www.bettyalready.com
Big John Bates [w] www.bigjohnbates.com
Binky Tunny [w] www.binkytunny.com
Black Furies [w] www.blackfuries.com
Bona Roba [w] www.bonaroba.net
Brimstones [w] www.brimstones.com
Bronco Billy [w] http://surf.to/bronco-billy
Bulemics [w] www.thebulemics.com
Burnitude [w] www.saari.net/burnitude
Buzzsawyer [w] www.angelfire.com/band/
 buzzsawyer/
Caged Heat [w] www.chillykurtz.com
Charlie Drown [w] www.charliedrown.com
Cheetah Chrome [w] www.cheetahchrome.net
Cowslingers [w] http://cowslingers.com/
Crash and Burn [w] www.crashandburn1.com
Craw [w] www.craw.com
Creepy T's [w] www.geocities.com/creepyts/
Cropduster [w] www.cropduster.net
Dayglo Abortions [w] www.godrecords.com/dayglos/

Dead 50's [w] www.dead50s.com
Demolition Girl and the Strawberry Boys
 [w] www.demolition-girl.de/
Demons [w] www.gearheadmagazine.com
Danny Frye and the Devil Dolls [w]
 www.dannyfrye.com
Greg Di Gesu [w] www.speedsteranddopers.com
The Divine Brown [w] http://thedivinebrown.com
Dogshit Boys [w] www.dogshitboys.com
Dozer [w] http://welcome.to/dozer
Dragstrippers [w] www.dragstrippers.com
The Drapes [w] www.thedrapes.com
The Drossells [w] www.thedrossells.com
El Destructo [w] www.eldestructo.com
Extreme Elvis [w] www.extremeelvis.com
Flour City Knuckleheads
 [w] www.flourcityknuckleheads.com
Gasolheads [w] www.chez.com/gasolheads/
Generous Maria [w] www.stonerrock.com/
 generousmaria
Girl Trouble [w] www.luth.org/girltrouble/
Gold Blade [w] www.goldblade.com
The Good Guys [w] www.geocities.com/bklins/
 the_good_guys.html
Hades [w] www.hadesusa.com
Hellroute 16 [w] http://listen.to/hellroute16
Hellside Stranglers [w] www.angelfire.com/de2/
 hellsidestranglers/
Hellstomper [w] www.hellstomper.8m.com
High School Hellcats
 [w] www.highschoolhellcats.com
Homeless Sexuals [w] www.homelesssexuals.com
Horsehedd [w] www.horsehedd.com
Isabelle's Gift [w] www.isabellesgift.com
Jackalopes [w] http://hop.to/thejackalopes
Jimmy and the Teasers
 [w] www.jimmyandtheteasers.com
Jumbos Killcrane [w] www.jumboskillcrane.com
Keelhaul [w] www.keelhaul.info/
Lake Pussy [w] www.lakepussy.de
Lamont [w] www.lamontband.com
Lanternjack [w] www.thelanternjack.com
Leg Hounds [w] www.angelfire.com/rock/
 theleghounds/
Less than Zero [w] www.pmella.freeserve.co.uk/
 sheffieldbands/lessthanzero.htm
Liege Lord [w] www.liegelord.com
Low Budget Screamers
 [w] www.lowbudgetscreamers.com
Low Rollers [w] www.geocities.com/lowrollerspunk

Lulabelles [w] http://kiss.to/lulabelles
Lust [w] www.lustrocks.com
Master Mechanic [w] www.mastermechanicusa.org
The Medicine Bow [w] www.themedicinebow.com
Mercury Pusher [w] www.users.muohio.edu/
 spencegm/mpusher.html
Method and Result [w] www.methodandresult.com
Midnight Creeps [w] www.midnightcreeps.com
Midnight Thunder Express
 [w] www.midnightthunderexpress.com
Miss Amy [w] www.candyforbadchildren.com
The Misses [w] www.stlvbug.org/misses/misses.html
Mister Bones [w] http://home.cogeco.ca/
 ~misterbones/
Mister Underhill [w] www.mister-underhill.com
Dimitri Monroe [w] http://mypeoplepc.com/mem-
 bers/povereem/index.htm
Monsterpuss [w] www.monsterpuss.com
Motorpsychos [w] www.motorpsychosrock.com
Mud City Manglers [w] www.mudcitymanglers.com
Musclecar [w] www.longgoneloser.com
Necro Tonz [w] www.geocities.com/SunsetStrip/
 Birdland/4275/
Needles [w] www.moonrockneedles.com
New Fangled Black [w] www.geocities.com/
 newfangledblack/
The Nifters [w] www.thenifters.com
Cranford Nix [w] www.themalakas.com
No Means Yes [w] www.nomeansyesrocks.com
Ophelia Rising [w] www.opheliarising.net
Overprivileged [w] www.theoverprivileged.com
PB Army [w] www.pbarmy.com
The Peasants [w] www.thepeasants.net
The Phantom Creeps/Razor Dog
 [w] www.razordog.co.uk
Pillbox (UK) [w] www.pillbox.co.uk
Pissant [w] www.piss-ant.com
Pizzle [w] www.pizzle.net
Pocket Rockets [w] www.thepocketrockets.com
Porn Rock [w] www.pornrock.net
Pretty Suicide [w] www.prettysuicide.com
Pretty Uglys [e] yourmother666@hotmail.com
Psychopunch [w] www.psychopunch.com
The Pythons [w] www.geocities.com/
 pythonspunkrock/
Queen Bee [w] www.queenbeedetroit.com
Quintaine Americana [w] www.quintaine.com
Random Road Mother [w] www.roadmother.com
Rat Daddy [w] www.ratdaddy.co.uk
Rebel Rebel [w] www.rebelrebel.org

Band / Artist Index

Art: Dee Rimbaud

Gigs From Hell We Want Your Stories!

Gigs From Hell is an on-going project and material is presently being compiled for a future volume of this book, as well as for our website *www.headpress.com*.

If you would like to contribute, send your stories, artwork and/or photographs to one of the addresses below:

USA
Email thesleazegrinder@hotmail.com

ELSEWHERE
Email gigsfromhell@headpress.com

Alternatively, you can mail material directly to Headpress / Critical Vision,
PO Box 26, Manchester, M26 1PQ, UK

FORMAT
Submissions should be in the form of a PC text file, but we can accept hardcopy stories so long as they're typed and clearly legible.

BE SURE TO INCLUDE...
Please supply contact details on all correspondence, notably:

(1) YOUR NAME (as you would like it to appear in print)
(2) YOUR STREET ADDRESS and/or email address (for our records only)
(3) NAME OF BAND, and
(4) LOCATION (where you/your band are based)

All submissions become the property of Headpress/Critical Vision for publication in *Gigs from Hell* or on the Headpress website. Sorry, but we cannot pay for submissions.

I WAS ELVIS PRESLEY'S BASTARD LOVE-CHILD & Other Stories of Rock'n'Roll Excess
by Andrew Darlington

Andrew Darlington has been interviewing Rock's luminaries and legends for several decades.

This book collects together his timeless and engaging conversations with a diverse selection of incredible artists, including: Dave Davies, Gene Clark, Peter Green, Grace Slick, Robert Plant, the Stone Roses, Siouxie Sioux and many others.

"A big Rock journo of the old school variety" *Metal Hammer*

"A book that really captures the maximum voltage rush" *HotPress*

"Well written and researched" *Classic Rock*

ISBN **1-900486-17-2** | **224pp**
Price **£13.99 / $19.95**

GG Allins' final gig!

A Richard Kern show brought to a (perfect) halt by violent leftists!

Schönherr's strange invitation to Russia for the screening of anti-Communist propaganda!

A trip across America in a dodgy vehicle loaded with reels of film!

Wild cinematic discoveries at New York's cheapest film-to-video transfer shop!

Nick Zedd being attacked by feminists in Nuremberg, Germany!

TRASHFILM ROADSHOWS Off the Beaten Track with Subversive Movies
by Johannes Schönherr

In this book are drawn the very frontiers of outlaw cinema. For Johannes Schönherr, no place has proven too distant nor too strange that he cannot screen or hunt down obscure underground trash movies. From the bowels of NY's Lower East Side, ruins in Detroit and punk clubs in San Francisco, to Moscow on a fake visa and Pyongyang, North Korea, Schönherr is a cinéaste on a mission. *Trashfilm Roadshows* tells of the trials and tribulations met by Schönherr on the road, including his eyewitness account of GG Allin's last gig; advice on disposing of a stash of Heroin unearthed while renovating a movie theatre; and of being branded an 'imperialist spy' in North Korea.

"Schönherr is the last man standing in the battle against the warm fuzzy cocoon of home entertainment" *sleazegrinder.com*

ISBN **1-900486-19-9** | **176pp**
Price **£14.99 / $19.95**

NEW FROM CRITICAL VISION!

SPOOKY ENCOUNTERS
A Gwailo's Guide to Hong Kong Horror
By Daniel O'Brien | Tsui Hark's *A Chinese Ghost Story* in 1987 gave many Western viewers their first taste of supernatural thrills, Oriental style. Yet the film was a comparatively late entry in a well-established genre, producing a stylish and distinctive body of work that compares with the best of Universal and Hammer. Pub **July 2003**
ISBN **1-900486-31-8** | 192pp | **£13.99 / $17.95**

BETTER TO REIGN IN HELL
Serial Killers, Media Panics and the FBI
By Stephen Milligen | Credited with superhuman intellect and abilities, the 'serial' sex killer emerged in the 1980s as a dominant figure in American popular culture, accused of attacking the traditional values underpinning society. This book examines the people and events which led to and perpetuate this panic, and the repercussions the serial killer has had on society. Pub **Sept 2003**
ISBN **1-900486-29-6** | 256pp | **£13.99 / $19.95**

GIGS FROM HELL
True Stories from Rock'n'Roll's Frontline
Ed. Sleazegrinder | From the dankest basements to flash arenas, here is a wild ride through rock'n'roll's nightmare moments. Rife with hellfire confessionals straight from the bruised lips of jobbing bands, *Gigs from Hell* strips the mythology and starry-eyed allure of life on the road to its barest essentials — puke, rip-offs, come-downs and the odd stab at glory. Pub **Sept 2003**
ISBN **1-900486-34-2** | 192pp | **£14.99 / $19.95**

GUIDE TO THE COUNTERCULTURE
A Sourcebook for Modern Readers
Ed. Temple Drake & David Kerekes | An indispensable sampling of the vast assortment of publications which exist as an adjunct to the mainstream press, or which promote themes and ideas that may be defined as pop culture, alternative, underground or subversive. Updated and revised from the pages of *Headpress* journal. Pub **Feb 2004**
ISBN **1-900486-35-02** | 224pp | **£14.99 / $19.95**

DIAGONAL FICTION!

Ports of Hell
by Johnny Strike

A picaresque story that borrows from all the pulps, including crime, sci-fi, fantasy, adventure and horror.

Ports Of Hell tells the story of Jamie Coates, a young man who falls in with Elias who claims to be from Lemuria. On Elias' instructions, Coates travels to Thailand and Mexico, and later Hawaii and Sri Lanka, acquiring brutal enemies and caught in a struggle that threatens his sanity and life…

Johnny Strike is a founding member of the seminal US Punk band Crime.

ISBN **1-900486-33-4**
£8.99 / $13.95
Pub **Mar 2004**

Creatures of Clay and Other Stories of the Macabre
by Stephen Sennitt

Disturbing horror tales which plumb the depths of nightmare, madness and the supernatural.

Creatures of Clay represents Stephen Sennitt's best work as exhumed from small press horror zines — much of it long out of print. Juxtaposing the elegant nightmare prose of Robert Aickman and Thomas Ligotti, *Creatures of Clay* has a lurid pulp aesthetic, derived from Lovecraft's Cthulhu Mythos and the Skywald Horror-Mood comics of the seventies.

ISBN **1-900486-25-3**
£7.99 / $12.99
Available Now